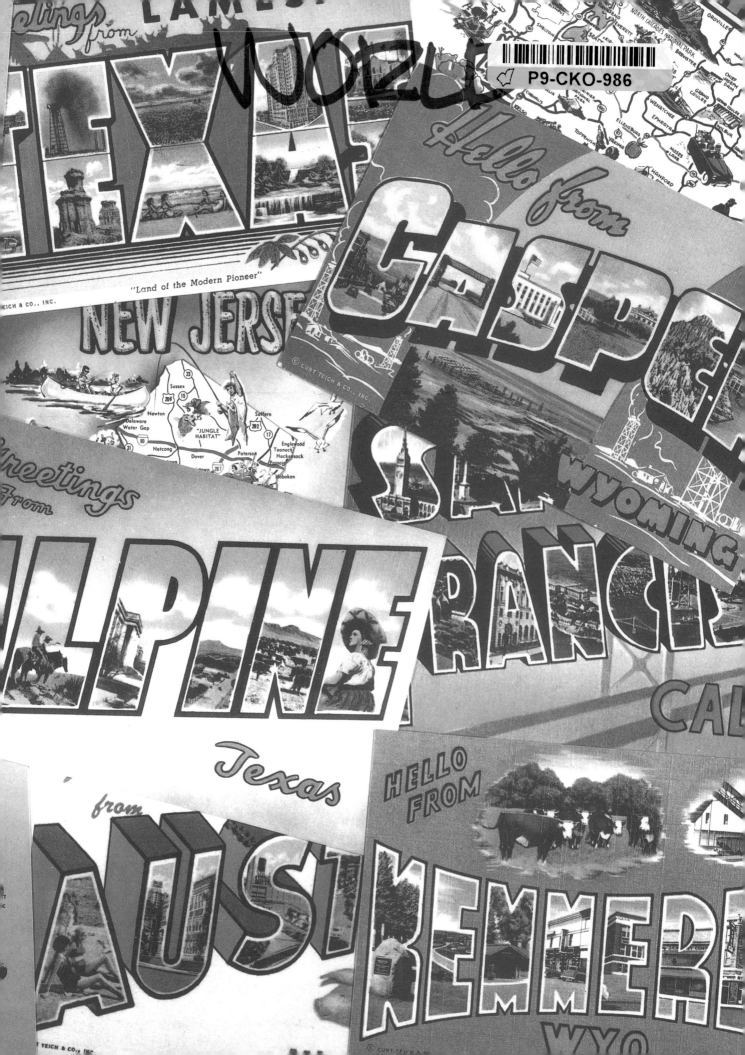

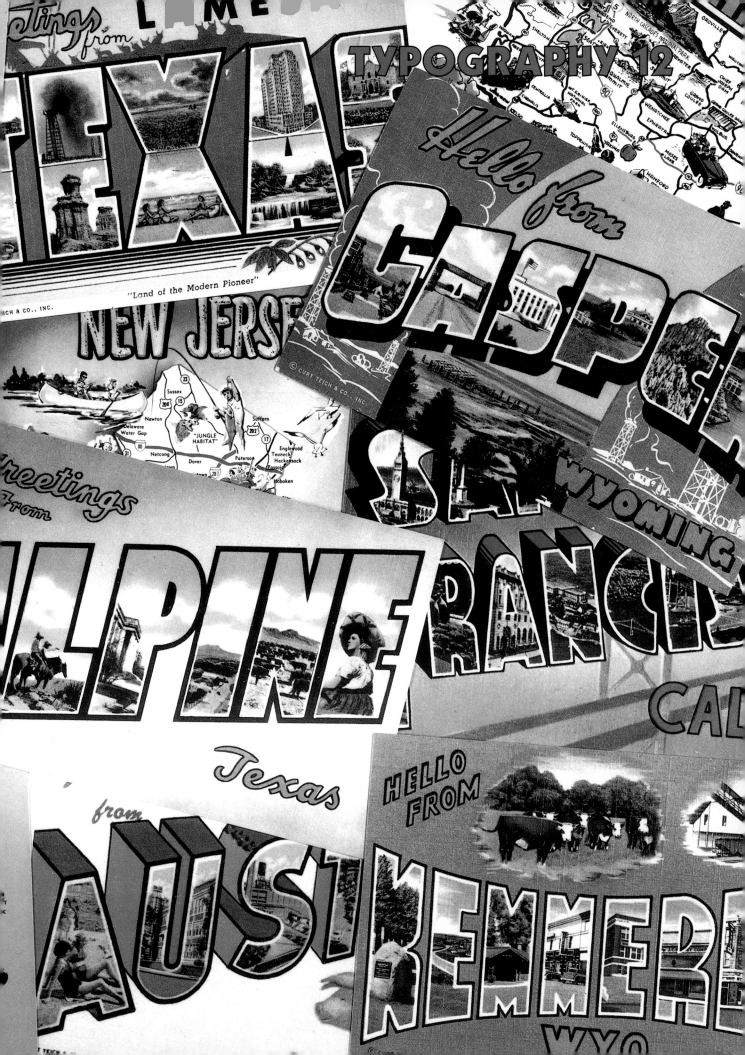

TYPOGRAPHY

TWELVE

THE ANNUAL OF THE TYPE DIRECTORS CLUB

WATSON-GUPTILL PUBLICATIONS
NEW YORK

First published in 1991 by Watson-Guptill Publications,
a division of BPI Communications, Inc.,
1515 Broadway, New York, N.Y. 10036

The Library of Congress has cataloged this serial title as
follows:
 Typography (Type Directors Club [U.S.])
Typography: the annual of the Type Directors Club.—1—
New York: Watson-Guptill Publications, 1980–
v.: ill.; 29 cm.

Annual.
ISSN 0275-6870 = Typography (New York, N.Y.)

1. Printing, Practical—Periodicals. 2. Graphic arts—
periodicals. 1. Type Directors Club (U.S.)
Z243.A2T9a 686.2′24 81-640363
AACR 2 MARC-S
Library of Congress [8605]

Distributed outside the U.S.A. and Canada by RotoVision,
S.A., Route Suisse 9, CH-1295 Mies, Switzerland

Manufactured in Japan

First Printing, 1991

1 2 3 4 5 6 7 8 9 10 / 96 95 94 93 92 91

CONTENTS

TDC 37

 Chairman's Statement 8

 Judges 10

 Judge's Choice 15

 Call for Entries 32

 Entries Selected for Typographic Excellence 34

THE BEST OF ADVERTISING TYPOGRAPHY, 1980–1990

 Chairman's Statement 204

 Judge's Choice 205

 Call for Entries 214

 Entries Selected for Typographic Excellence 216

Type Directors Club Officers and Members 257

Index 262

ALAN PECKOLICK

s chairman of TDC 37 I made the commitment to introduce a greater eclecticism to the show. It seemed to me that the past few shows were light on classic typography in their enthusiasm for the stimulating new trends.

The emphasis had been increasingly on new typography—primarily computer-generated type. While there were numerous fine examples of contemporary typographic trends, superb examples of classic typography were lacking, not only in our shows but in the industry itself. The typographic artist's beacon—the creation of beautiful typefaces used in beautiful ways—seemed to be dimming as technology became an end in itself.

I started looking for ways to regain an appropriate balance between innovation and classicism. I decided to bring together an eclectic group of judges, representing the West Coast, the UK, Europe, and, of course, New York, and hoped that by constituting a panel with breadth as well as depth of experience, we could reevaluate our craft, ideally setting a new standard. I hope our work on this show will help set such a standard, permitting the craftsperson, the artist, and the computer to work more harmoniously.

The number of entries was down from a high of five thousand last

year to approximately four thousand this year. This can be attributed to many factors, including the economy, the fact that we were on the brink of war, or possibly less interest in our craft. The reduced number is surprising, however, given that the TDC show is the only one dedicated solely to typographic design; all others are judged on total pieces. Among the entries, however, there was a satisfying cross-section of annual reports, logo designs, advertising booklets, brochures, promotional pieces, posters, and more.

The ubiquitous use of computers and the plethora of design possibilities have given designers powerful tools to develop great ideas and to extend typographic and design prowess into new horizons. But it was obvious by many of the entries that a Macintosh does not a typographer make. With the era of the computer finally upon us we had hoped for more innovation.

We mustn't lose sight of the fact that the essence of typography remains communication on several levels. Intellectually, typography means write it, set it, read it. But successful typography adds something to the message; the message itself is enhanced by the medium. This enhancement can emerge from the simple selection of the right typeface or the use of letterforms to create the ultimate, subliminal graphic message. You must decide if the selections, which we consider the year's best, adheres to the highest standards.

Alan Peckolick is a native of New York and a 1961 graduate of Pratt Institute. In recent years, Peckolick had been senior vice-president and director of design of Addison New York, and he is currently the president of Peckolick and Partners.

Peckolick has achieved international recognition for his elegant typographic designs. His talents have been used by worldwide corporations for award-winning logo designs, posters, packaging, annual reports, corporate identity, and publications. His work has been the subject of many articles and widely exhibited in the United States and abroad. As the recipient of many prestigious awards, he is a frequent juror and guest lecturer.

A member of the Board of Directors of the New York Type Directors Club, Peckolick is also affiliated with the New York Art Directors Club; the Art Directors Club of Bergen, Norway; the Alliance Graphique Internationale; and the Herb Lubalin Study Center at Cooper Union in New York.

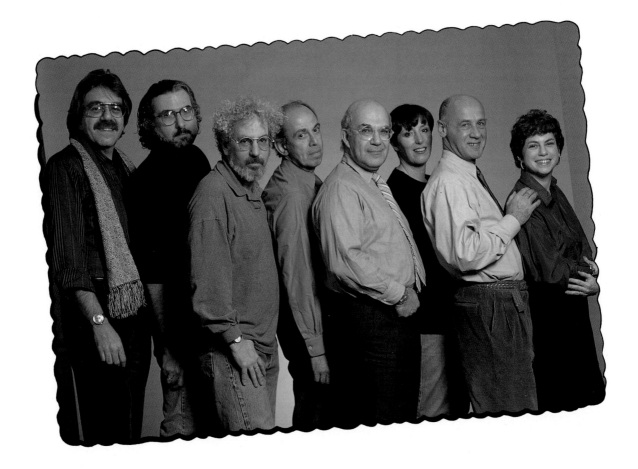

RUTH ANSEL

Ruth Ansel, who served as a cojudge for TDC 37 with Lloyd Ziff, was born in New York City, attended the High School of Music and Art, and studied fine arts and design at Alfred University. In the early 1960s, she was briefly an assistant art director at *McCall's* magazine and then a promotion art director at Columbia Records. In 1963 she formed part of the legendary young art-directing team of *Harper's Bazaar* together with the late Bea Feitler. After ten years at *Harper's Bazaar*, Ansel left to become art director of the *New York Times Magazine*, where she helped create a new journalistic style for the 1970s. She stayed with the *Times* for eight years. Then in 1982 she was appointed editorial design director for Condé Nast's *House and Garden* magazine, which she completely redesigned. A short time later, *Vanity Fair* needed her help, and Tina Brown asked her to create the new look for the magazine, which Ansel accomplished over the next four years. After that it was on to *Vogue* as creative director for a year, then back to the newly named *HG*

(*House and Garden*) magazine in 1988.

Ansel is also a book designer. Some notable titles she has designed include Richard Avedon's *Alice in Wonderland,* a unique photographic essay of Andre Gregory's famous theater piece; *The Tiffany Touch,* for Tiffany & Company; and *The End of the Game,* by Peter Beard.

She has created posters for the International Center of Photography and numerous book jackets over the years and worked on a fashion campaign for Karl Lagerfeld with the celebrated photographer Bruce Weber.

Among the awards Ansel has received are the Gold and Silver medals from the Art Directors Club in New York and Awards of Merit and Distinction from the American Institute of Graphic Arts, the Society of Illustrators, and the Society of Publication Designers.

She has had articles published in *Graphis, Print, Art Direction,* and *Metropolis* magazines.

Recently, Ruth Ansel has designed the worldwide spring campaign for Gucci 1991 and the Baryshnikov/Mark Morris Dance Project book, photographed by Annie Leibowitz. She has also created a new design studio for herself called Ruth Ansel Design.

SAMUEL N. ANTUPIT

Samuel N. Antupit has devoted his working life to editorial design, beginning with *Harper's Bazaar* and *Show* magazines, then moving to Condé Nast Publications, where he designed for *Vogue, Glamour, House and Garden,* and *Mademoiselle.* His firm, Antupit and Others, serves as consultants and designers for book and magazine publishers. Among the many magazines he has designed for are *The New York Review of Books, Foreign Policy, Art in America,* and *Harper's.* He was art director of *Esquire* from 1964 to 1968 and in 1977. Antupit currently serves as vice-president, director of art and design, at Harry N. Abrams, Inc., publishers of fine illustrated books. He is a member of Alliance Graphique Internationale and serves on the Board of Directors of both the American Institute of Graphic Arts and Documents of American Design. Antupit is also proprietor of the Cycling Frog Press, a printer of small books and ephemera.

MADELEINE BENNETT

Madeleine Bennett began her design career with the Pentagram design group. She then became design director at the Michael Peters Group in London before starting her own practice.

Among the groups that have honored her work are the Art Directors Club of New York, which gave her the Award of Merit in 1979 for her work on Penhaligon and for her work on Michael Barry Menswear; the Design and Art Directors Association, which presented her with its Silver Medal for "The Most Outstanding Range of Packaging" in 1981 (Elsenham's Jams), 1982 (Penhaligon's Victorian Posy), and 1986 (Joseph Perfume); the Clio Awards for International Packaging Design,

which acknowledged her for "Best Special Packaging" in 1982 (Michael Barry Menswear) and in 1990 (Giorgio Armani eyewear); and *Communication Arts*, which gave her their Award of Excellence in 1986 (Joseph Perfume packaging) and in 1990 (Giorgio Armani eyewear packaging).

BEN BOS

Born Amsterdam in 1930, Ben Bos graduated with honors from both the Amsterdam Graphic School and IVKNO (Rietveld Academy, Amsterdam). He was a freelance journalist, copywriter, and industrial editor before switching over to design and art direction. Bos joined Total Design, Amsterdam, the first Dutch design group, when it was founded in 1963 and has been its creative director ever since. Currently, he is also responsible for Total Design Brussels.

Among the many national publicity and design awards he has received is the Duwaer Typographic Award of Amsterdam. His international awards include those from Typomundus, Sofia, Ljubljana, and Brno. Bos also won the international design competition for the Kiel Week 1991.

Ben Bos teaches and lectures in various countries and is also an author of articles and books on corporate identity and the design profession.

He is a board member of the Dutch society of designers, BNO; president of the Dutch section of the Alliance Graphique Internationale; and has had an exhibition in Breda, Holland, in 1988.

BOB DEFRIN

Born in New York City in the pre-desktop publishing era, Bob Defrin decided at an early age that he would never succeed at any worthwhile profession, so he immediately started drawing. It didn't take long before he realized that he would never earn a living with illustration, so he took the only road open to anyone with absolutely no drawing ability whatsoever —graphic design. "At last," he thought, "a way to earn money by tracing type and cropping photographs. Imagine, hiring others to do the hard work and then taking credit for their labors." He had found his niche.

Currently, he is vice-president and creative director of graphics for Atlantic Records. He is the recipient of numerous awards from the Art Directors Club (Los Angeles and New York), including the Gold Medal from the New York chapter, the Type Directors Club, the Society of Illustrators, and the AIGA.

Defrin also has four Grammy nominations for record album packaging and two posters in the permanent collection of the Museum of Modern Art in New York.

He is a member of the National Academy of Recording Arts & Sciences, the Art Directors Club of New York, the Type Directors Club, and the AIGA.

BEVERLY F. SCHRAGER

Shortly before graduating from Cooper Union, Beverly F. Schrager impulsively ordered every annual report available from the *New York Times*

business section. The mail carrier arrived each day in a truck. The reports piled up. Her mother suggested that she think about getting a job and moving out.

Over the following fifteen years, Schrager went on to design over seventy-five annual reports. Today she is vice-president and design group director at Addison Corporate Annual Reports, Inc., in New York City. Her work has been recognized with awards from the Art Directors Club of Los Angeles, the IABC, and the prestigious *Financial World* magazine annual reports competition. In her role as design group head, Schrager has trained many young designers to know that there is more to type than "10/12."

Schrager serves on the membership committee of the Art Directors Club of New York, and she has been a guest lecturer at Parsons School of Design. She lives in New York City with her husband, Steve Laise, who is a historian, along with a collection of classic toys and vintage Roseville pottery.

ARNOLD SCHWARTZMAN

Arnold Schwartzman began his career in television graphics, moving on to become the concept planning executive for Erwin Wasey Advertising. He moved from his native London to Hollywood in 1978 to become the design director for Saul Bass and Associates.

A former board member of the Conran Design Group, he has won numerous international film and design awards, including three Silver awards from the Designers and Art Directors Association of London.

An illustrator for many years for the London *Sunday Times*, he also designed two award-winning supplements for the *Sunday Times Magazine:* "Eureka" and "The Facts of Life."

In 1982, Schwartzman was appointed the director of design for the 1984 Los Angeles Olympic Games.

He has designed many posters, including one for the Simpson Paper Sequences series, which was a typographic interpretation of Shakespeare's "Seven Ages of Man."

Schwartzman has produced, directed, and written the screenplay for several documentary films. His most recent documentary feature film is *Echoes That Remain*, which received critical acclaim at its Los Angeles, Toronto, and New York premieres in 1991. His documentary film *Building a Dream*, the story of the 1932 Los Angeles Olympic Games, was released in 1989. In 1982, Schwartzman won an Academy Award (the "Oscar") for his documentary feature film *Genocide*.

Arnold Schwartzman is also the author and coauthor of a number of books, including *Airshipwreck* (1978) with Len Deighton, and *Flicks: The Evolution of the Moving Image*, a pop-up book on the subject of pre-cinema history. Among his current books are *Wall to Wall*, a visual anthology of walls, and *Graven Images*, a photographic collection of graphic images on gravestones (forthcoming).

A past member of the executive

committee of the Designers and Art Directors Association of London, he is a founder and now board member of the British Academy of Film and Television Arts, Los Angeles, a member of the Academy of Motion Picture Arts and Sciences, a member of the Advisory Board of the American Institute of Graphic Arts/Los Angeles chapter, and was elected to the Alliance Graphique Internationale in 1974.

LLOYD ZIFF

Lloyd Ziff, who served as a cojudge for TDC 37 with Ruth Ansel, received his BFA in graphic design from Pratt Institute. He is currently president of the Lloyd Ziff Design Group. Ziff is also an educator and teaches at Parsons School of Design in New York, a position he has held since 1983. He began teaching at the Art Center College of Design in Pasadena in 1977 and also taught from 1980 to 1982 at the School of Visual Arts in New York.

Before forming his own company in 1988, Ziff was the design director of *Condé Nast Traveler* magazine. From 1983 to 1986, he was the design director of *House and Garden* magazine. Among other positions, Ziff has been the art director of several prominent publications, including *Vanity Fair* and *New West* magazines, and he has designed such books as *Still Life*, by Diane Keaton and Marvin Heiferman (Callaway Editions, Inc., 1983); *Visual Aid,* edited by James Danzinger (Pantheon, 1986); and *LBJ: The White House Years*, by Harry Middleton (Harry N. Abrams, Inc., 1990).

As a photographer, Ziff has had work published in *Interview, Arts & Architecture, GQ, Rolling Stone, New West, House and Garden*, and the *Chicago Tribune.*

A member of the Board of Directors of the American Institute of Graphic Arts/New York chapter in 1989, 1990, and 1991, Lloyd Ziff has received many awards from professional organizations, including the New York, Los Angeles, San Francisco, and Chicago Art Directors Clubs; the American Institute of Graphic Arts; and the Society of Publication Designers. He was also nominated for a Grammy award for "Album Cover of the Year."

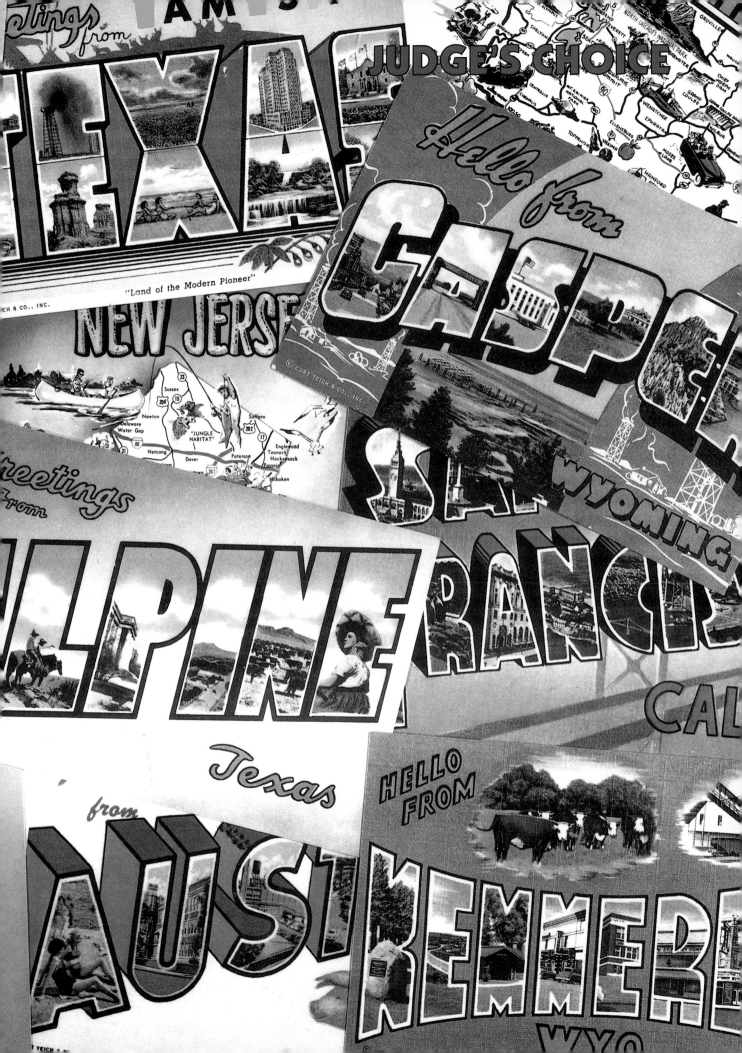

JUDGE'S CHOICE

RUTH ANSEL

We live in a world where we are surrounded by more type design and visual images than ever before in history. And these images are coming at us in different forms faster than ever.

This collective visual chorus consists of film, television, newspapers, magazines, books, brochures, videos, laserdiscs, and even CNN, our recently celebrated, 'round-the-clock war coverage channel. These elements are surfaces and images about other surfaces and images, miniaturized, colorized, and often idealized. They offer up a very personal view of what makes up the stuff of our lives, a screen or page presenting or selling something "to us about us." Depending on who is interpreting them, these real-life moments either distance us more from events, people, ideas, and words or make these things more meaningful.

That is why I am so thrilled to have come across the stylish, surprising, and inventive book *Listen Up: The Lives of Quincy Jones*. It leaped out at me when I walked past tables covered with hundreds of entries that called for my attention yet for the most part didn't offer much competition. This book promised surprise and it delivered.

From the front cover to the back, no page was like any other. Each was unique yet clearly part of a whole design concept. And it was beautifully executed, printed, and bound.

The designer understood and recognized the various origins and styles of his subject, Quincy Jones. He was influenced by sources from the great fifties jazz album covers of Dizzy and Duke and Basie, which clearly inspired this bold sans serif type design, to the MTV jump-cut videos of rap and rock. Superimposed type dances and deconstructs in front of your eyes. The type was made to splinter, slice, grow larger and smaller, appear, disappear, enter top, bottom, left and right, change colors, and slide over either a stark studio background or over a photographic image of a face, event, or recording session. It's masterfully executed and amazingly entertaining. When all is said and done, I felt the type had "sound." I heard it as well as saw it. The designer did this with a sense of no boundaries, limitations, or preconceived ideas about what he should do or how far he should go. And that's what this book projects and captures so vividly.

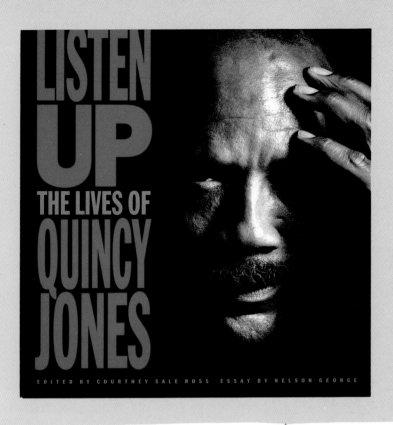

LISTEN UP THE LIVES OF QUINCY JONES

EDITED BY COURTNEY SALE ROSS · ESSAY BY NELSON GEORGE

If Ray had followed the strict commercial line, he may have had more hits, but he would have had less meaning. People buy an armful of Ray Charles cassettes or discs, and what they're buying is an armful of **integrity.** –Jesse Jackson

"Every music has its soul. And if you really are sincere and surrender to it and explore it, it's all soulful." –Ray Charles

106

*When he became the vice president in charge of **A**rtists & **R**epertoire of Mercury Records, the first black person to reach that level, I absolutely was so proud, it was just unbelievable. And then he says, "I'm going out to Hollywood!!"–Lloyd Jones*

I just dropped everything and just took that chance. I said, "Maybe I won't make it out there, but **I'm going!"** –Quincy

107

BOOK
TYPOGRAPHY/DESIGN RIKI SETHIADI, JOHAN VIPPER, AND THOMAS BRICKER, NEW YORK, NEW YORK
CREATIVE DIRECTORS KENT HUNTER AND DANNY ABELSON
TYPOGRAPHIC SOURCE IN-HOUSE
AGENCY FRANKFURT GIPS BALKIND
CLIENT WARNER BOOKS
PRINCIPAL TYPES FRANKLIN GOTHIC HEAVY AND BOLD, SABON REGULAR AND ITALIC
DIMENSIONS 11¹⁄₁₆ × 11¼ IN. (28.1 × 28.6 CM)

JUDGE'S CHOICE

SAMUEL N. ANTUPIT

The two pieces which I have selected, a poster by Makoto Ito (opposite) and a greeting card by Paul Shaw (page 153), exemplify the ever-changing nature of typography. Design with letterforms knows no technological bounds, all techniques are valid, and, regardless of when they were introduced, are still in use.

Here we are, approaching a new millennium, and we are given a witty statement set by hand, in metal type, and printed on fine paper on a hand-fed press, while we are also able to view a cool typographic image which was created electronically and reproduced on high-speed automated equipment. One craft is five hundred years older than the other; one is language-based, the other can be appreciated solely as an image. What they have in common is what intrigues me: A mind has forced machinery to surpass its innate qualities.

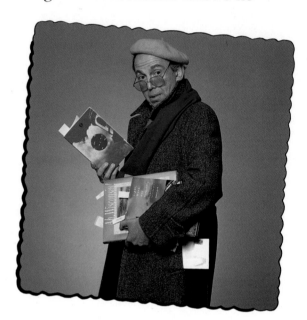

LEXIS

POSTER
TYPOGRAPHY/DESIGN MAKOTO ITO, KITAKU, OSAKA, JAPAN
TYPOGRAPHIC SOURCE IN-HOUSE
STUDIO PACKAGING CREATE INC.
CLIENT MORISAWA
DIMENSIONS 28⅔ × 40½ IN. (72.8 × 103 CM)

MADELEINE BENNETT

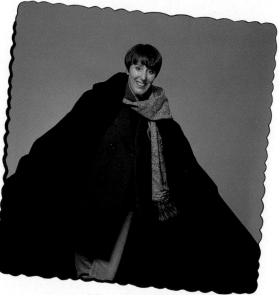

I chose this poster for its elegance of solution. It has a very strong central image using the poster subject, photography, to create the character *P*. The title interspersed between paragraphs of text has a strength and simplicity which communicates the purpose of the poster clearly and adds texture to the total composition.

The subject of photography offers a broad spectrum of visual solutions. In this case its essence of light and shade has been applied to two objects, a three-dimensional cone and a graded tonal strip. These shapes are juxtaposed to form the central character. This both illustrates the purpose of the poster and forms a typographical solution relating to the poster title *Photo*.

In incorporating justified paragraphs of text between the characters of the title, texture has been added to the composition in a considered way. This, together with restrained use of color, minimal imagery, and strong typography, has created a dynamic poster which communicates its subject matter to us on several levels. This solution has a simplicity and elegance which I admire.

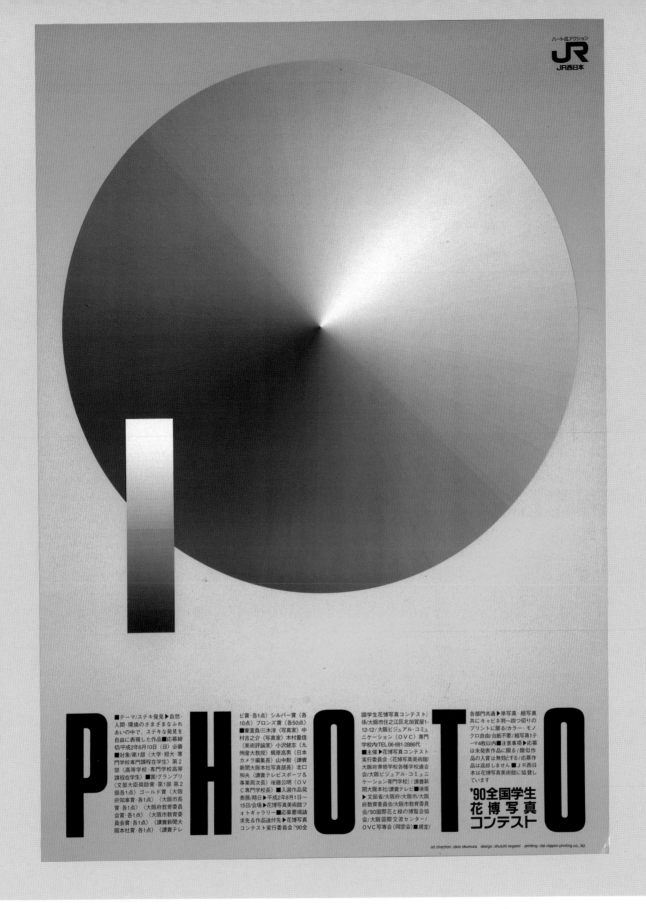

POSTER
TYPOGRAPHY/DESIGN SHUICHI NOGAMI, KITAKU, OSAKA, JAPAN
TYPOGRAPHIC SOURCE IN-HOUSE
STUDIO PACKAGING CREATE INC.
CLIENT FLOWER EXPO '90
DIMENSIONS 28⅔ × 40½ IN. (72.8 × 103 CM)

JUDGE'S CHOICE

BEN BOS

This years show was a beautiful mixture of excellent pieces, as well as pieces for which one would have to question the aspirations of those who entered them. Being European and not coming to America very frequently makes it difficult for me to compare this show to those of the past. I did get the impression, however, that last year the judges were charmed by the whole visual image of a piece rather than by its typographical merit.

I do see certain parallels between the work done in Holland and Europe and the pieces submitted here, which are, for the most part, American. Both sides of the Atlantic are very much influenced by the new technology; the way in which people can work on the Macintosh to create shapes which were previously unknown. I believe that in the graphic design profession there are meeting points where technology opens new possibilities. When we went from hot-metal to film composition and later moved to more advanced composing techniques, we also saw an immediate input on the design product as we are seeing today. It is my conviction that designers have to learn to get used to these new tools and techniques, and hopefully they will come back to their own feelings and inner power rather than simply playing around with what technology offers. What I saw in this show is that you could recognize the machinery, the sophisticated computer, but not the person behind it anymore, and I'd much rather see the person, for, after all, this is a people industry.

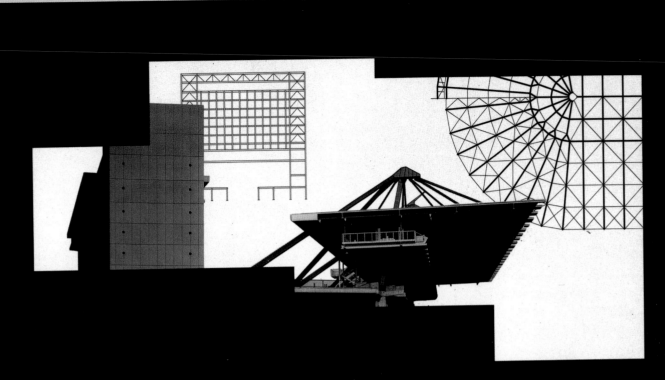

Planners Architects Engineers

NIKKEN
SEKKEI

Building Modern Japan
1900-1990

BOOK
TYPOGRAPHY/DESIGN WILLI KUNZ AND THOMAS COX, NEW YORK, NEW YORK
TYPOGRAPHIC SOURCE IN-HOUSE
STUDIO WILLI KUNZ ASSOCIATES, INC.
CLIENT NIKKEN SEKKEI LTD.
PRINCIPAL TYPE UNIVERS
DIMENSIONS 10 × 10 IN. (25 × 25 CM)

BOB DEFRIN

In thinking back to the judging for this year's show, I am convinced that the reason I was so impressed by the *Rolling Stone* editorial spread was nostalgia. It was, I believe, a desire to go back to a simpler time when thinking preceded software.

Although I have little doubt that a Mac was employed in the design of these spreads, it seems apparent to me that a brain and a pair of eyes were used as well. I am particularly impressed with the liberty taken with the type size and design in conjunction with other artwork. These spreads have style and taste, something I find lacking in many areas of graphics today, where a sameness has settled in.

I learned an interesting lesson a few weeks ago when we needed a logo designed practically over a weekend. I contacted as many people as I could locate on a Friday afternoon and asked their help. I could give them little direction except for a name and some demographics. What showed up on Monday gave me disturbing insight as to what is going on in our profession. Almost all the designs from these four or five people had a "look." All were crisp and clean and very sterile. Several examples were almost identical. How could this happen? I can only assume that these people looked into their software and not their heads for solutions.

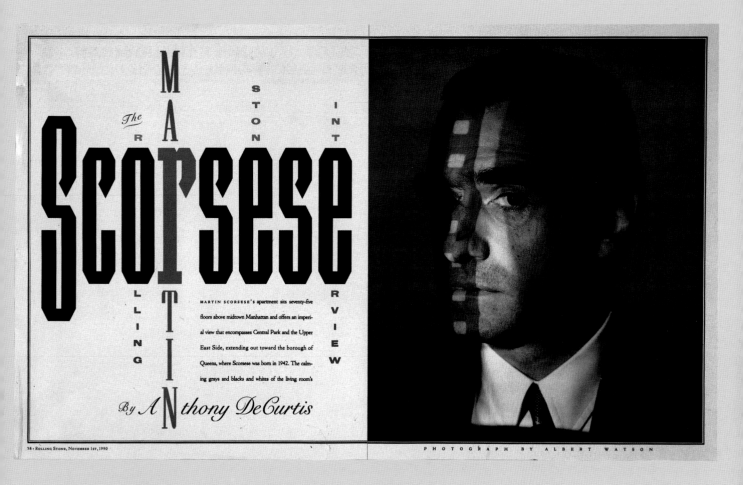

The ROLLING STONE INTERVIEW

MARTIN Scorsese

MARTIN SCORSESE's apartment sits seventy-five
floors above midtown Manhattan and offers an imperi-
al view that encompasses Central Park and the Upper
East Side, extending out toward the borough of
Queens, where Scorsese was born in 1942. The calm-
ing grays and blacks and whites of the living room's

*By A*N*thony DeCurtis*

58 · ROLLING STONE, NOVEMBER 1ST, 1990

PHOTOGRAPH BY ALBERT WATSON

MAGAZINE SPREAD
TYPOGRAPHY/DESIGN FRED WOODWARD, NEW YORK, NEW YORK
LETTERER DENNIS ORTIZ-LOPEZ
TYPOGRAPHIC SOURCE IN-HOUSE
CLIENT ROLLING STONE
PRINCIPAL TYPE GRECIAN BOLD CONDENSED
DIMENSIONS 12 × 20 IN. (30.5 × 50.8 CM)

BEVERLY F. SCHRAGER

Opposites attract, and I was attracted to all the visual components of the "Australia" kit. They are in direct opposition to the milieu I usually work in—the world of full-color, large-size, type-filled, shiny annual reports.

But beyond the immediate tactile impact of shirt-cardboard stock, twine-knotted binding, and muted earth-tone palette in this diminutive piece is a splendid integration of typography and design.

The letterforms are hand-cut and handwritten. However, unlike many submissions which use handwriting, the piece integrates this very personal typography with powerful, naive illustrations which are evocative of block prints. The primitive aboriginal-style of the graphics harmonize with the immediacy of the handwritten text.

Can we divorce this joyful work from its exotic subject matter, the land down under? Well, no, the rugged type is wholly appropriate and it is effective in its context. That is the source of my delight. So I conclude by using the vocabulary that I picked up from the "Australia" kit glossary, the one component of the kit that is actually typeset, and saying, "It's a ripper. Strewth!"

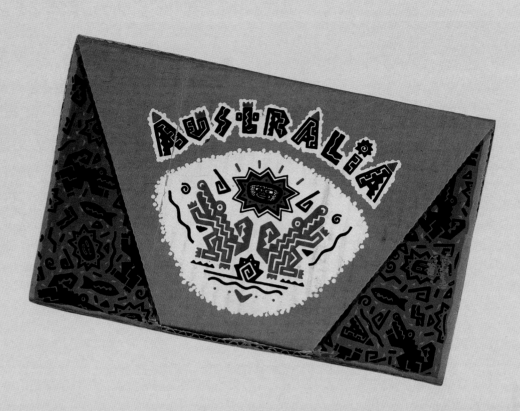

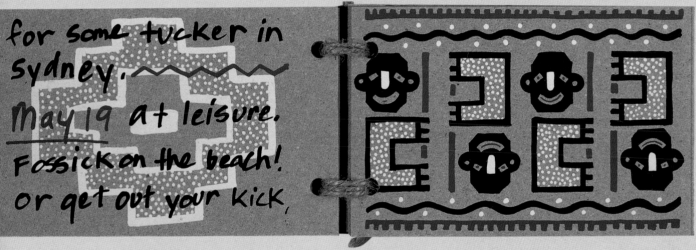

for some tucker in
Sydney.
May 19 At leisure.
Fossick on the beach!
Or get out your kick,

BROCHURE
TYPOGRAPHY/DESIGN JOHN SAYLES, DES MOINES, IOWA
CALLIGRAPHERS JOHN SAYLES AND JOE BUSTAD
STUDIO SAYLES GRAPHIC DESIGN
CLIENT CENTRAL LIFE ASSURANCE
PRINCIPAL TYPE HANDLETTERING
DIMENSIONS 4½ × 7 IN. (11.4 × 17.8 CM)

ARNOLD SCHWARTZMAN

My first choice of this year's show is this German 1991 diary. It utilizes sans serif typefaces in a most original layout, disseminating information in a very unique fashion.

The calendar echoes the freshness and innovation of the school of Jan Tschichold, while also achieving a nineties look.

It is particularly difficult to achieve originality when working on such a subject as a diary, an item that almost all designers must deal with at one time or another.

The design integrates type with illustrations without the typographic clichés so prevalent today. It is refreshing to have come across a contemporary piece that is so devoid of the "rubber type" syndrome.

CALENDAR
TYPOGRAPHY/DESIGN MICHEL CEVEY AND ROGER QUANDEL, FRANKFURT AM MAIN, GERMANY
TYPOGRAPHIC SOURCE TYPOBACH
AGENCY CEVEYCONCEPT
CLIENTS CEVEYCONCEPT AND TYPOBACH
PRINCIPAL TYPES AKZIDENZ LIGHT CONDENSED, AG OLD FACE BOLD, AND GARAMOND
DIMENSIONS 8¼ × 8¼ IN. (21 × 21 CM)

LLOYD ZIFF

For a magazine junkie like me, it was obvious that a show devoted to the best of typography from a club of typographers should honor a magazine about typography.

I chose AGFA's new magazine *26* because it is surprising, gutsy, and contemporary. The magazine's 114 pages are devoted to an exploration of typography from almost as many sources, and still the publication stands as a coherent whole. It was one of the few pieces in the show that I wished I had done.

schlang schlecht schlemazel

Yiddish from Schlang to Schvantz. Yes, it's just the sch- words. Conveniently arranged in alphabetical order. They

schlemiel schlep schleppy

mean pretty much what you expect them to mean. All spellings approximate (and flexible). Meanings, too. Enjoy.

schlock schlockmeister schlong

1 n penis 2 adj bad 3 (shleMAHzel) n pitiful person 4 (shleMEEL) n klutz 5 v to carry 6 adj klutzy

schlontz schloomp schlub

7 n junk 8 n maker or seller of junk 9 n see schlang 10 n see schlang and schlong 11 (SHLooMP) n klutz

schmaltz schmancy schmatte

v loaf 12 n boor 13 n cloyingly sweet as in music, theater, film, n rendered fat (especially chicken)

schmear schmear schmeck

14 see fancy · schmancy 15 (SHMAHte) n a rag 16 v to bribe, n dab of cream cheese 17 v to slander

schmegeggy schmendrick schmo

18 n a little, a taste 19 n see schlemiel 20 n see schlemiel 21 n a naive and helpless person 22 v (or

schmooz schmuck schmutz

schmoozle) to converse lengthily and cozily 23 n see schlang, schlong, schlontz 24 n dirt 25 adj drunk

schnockered schnook schnorrer

26 n patsy 27 n moocher 28 n haggler 29 n (or schnozzle or schnozzola) nose, especially a large one 30 n

schnorrer schnozz schpritz

a bit, a touch 31 n tough guy 32 n a theatrical bit 33 n a stinker 34 v ask around about this one 35 n you

schtarker schtick schtoonk

need one to schtup, see schlang, schlong, schlontz, schmuck

schtup schvantz

TIBOR KALMAN, 1990

PAULA SCHER, 1990

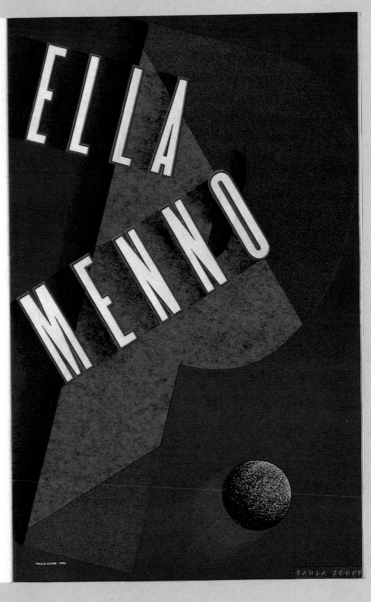

ELLA MENNO

PAULA SCHER

MAGAZINE
TYPOGRAPHY/DESIGN BOB MANLEY, GARY KOEPKE, AND MICHAEL TARDIF, MANCHESTER, NEW HAMPSHIRE
TYPOGRAPHIC SOURCE THE AGFA POSTSCRIPT TYPE COLLECTION
AGENCY ALTMAN & MANLEY/EAGLE ADVERTISING
STUDIO KOEPKE DESIGN GROUP
CLIENT AGFA COMPUGRAPHIC DIVISION, AGFA CORPORATION
PRINCIPAL TYPES HELVETICA, GARAMOND, ITC GALLIARD, TIMES, AND BODONI
DIMENSIONS 11 × 17 IN. (27.9 × 43.2 CM)

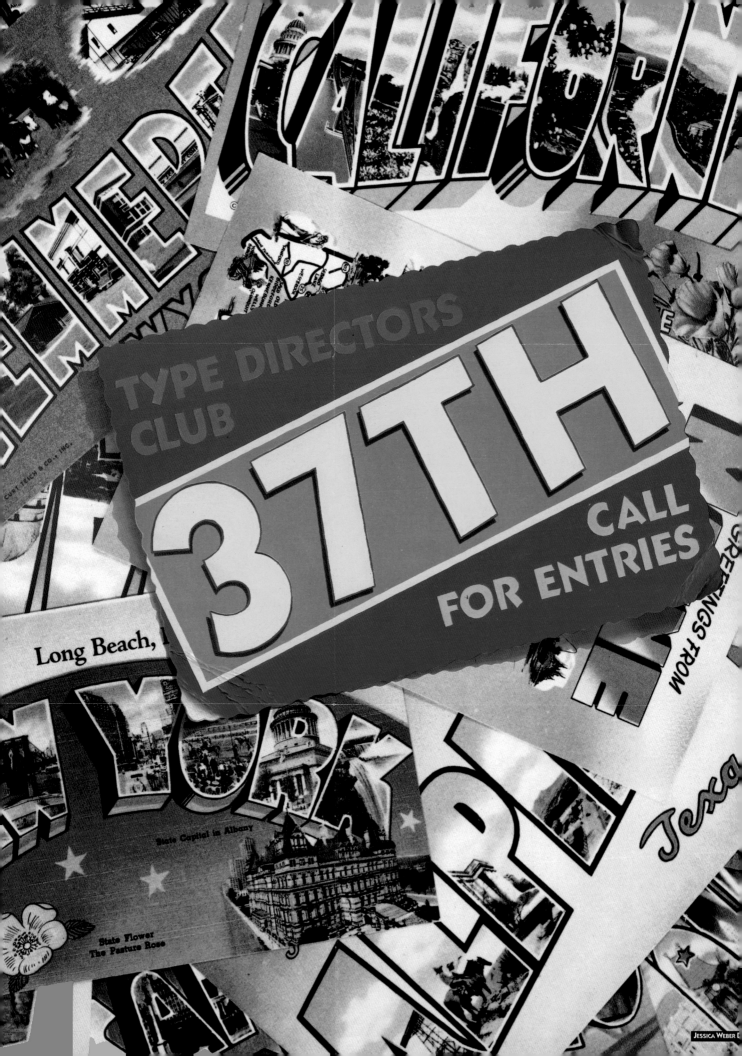

TYPE DIRECTORS CLUB

37TH

CALL FOR ENTRIES

Long Beach, L

State Capital is Albany

State Flower
The Pasture Rose

GREETINGS FROM

Texa

JESSICA WEBER D

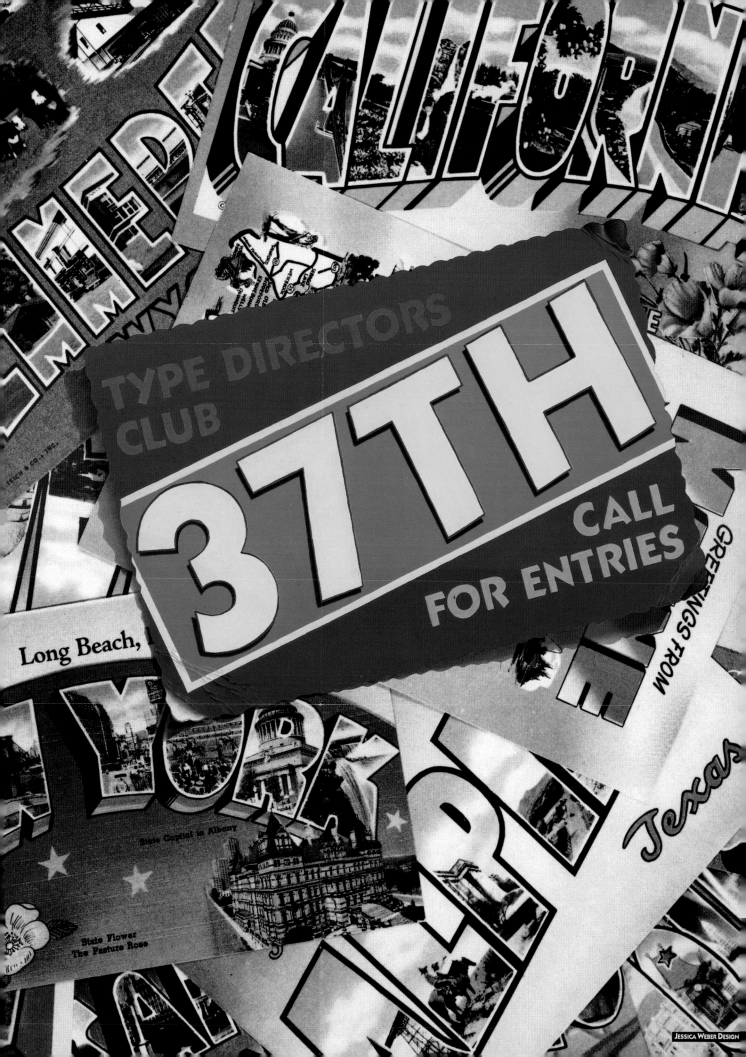

TYPE DIRECTORS CLUB

37TH

CALL FOR ENTRIES

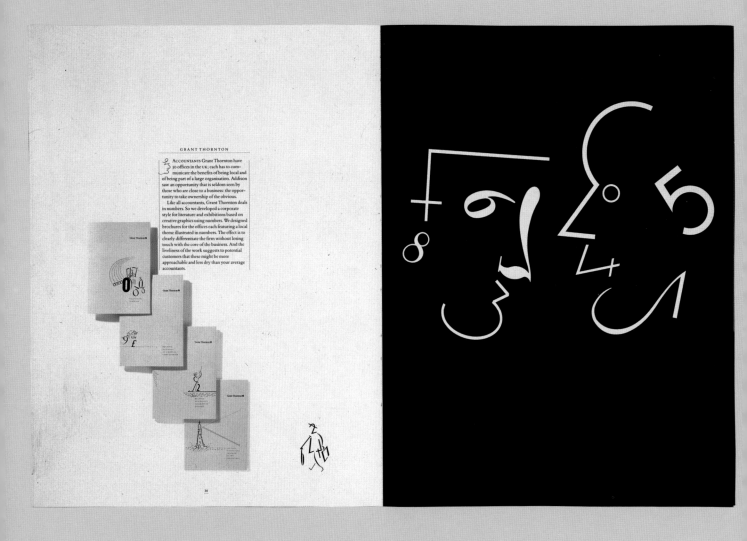

BROCHURE
TYPOGRAPHY/DESIGN MICHAEL WOLFF AND ROBERT MAUDE, LONDON, ENGLAND
TYPOGRAPHIC SOURCE TROY GRAPHICS, INCORPORATED
STUDIO ADDISON CORPORATE ANNUAL REPORTS, INC.
CLIENT ADDISON WORLDWIDE LIMITED
PRINCIPAL TYPE BEMBO
DIMENSIONS 9⅝ × 12¾ IN. (24.4 × 32.5 CM)

Tamil, used in south India, northern and eastern Ceylon, Singapore, and Malaysia.

From left to right: *Malayalam*, used in southwest India, *Thai*, used in Thailand, *Devanagari*, used for writing Sanskrit and various languages spoken in India, *Hebrew*, used in Isreal, and *Kanarese*, used in parts of India.

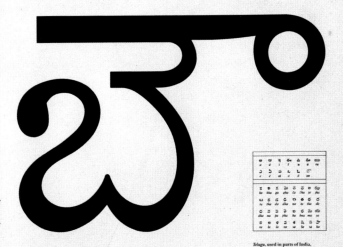

Telagu, used in parts of India, with sample of other characters

中国の旅から戻り、早速、ナシ族トンパ文字による新作を6点制作した。西田龍雄先生にナシ族に伝わることわざを書いていただきテキストにした。1枚だけ何とか撮影した経典の写真を拡大して壁に貼り、まるで今から文字を制作しようとするシャーマンの精神にまで自分を高めようとするかのように、何日間も眺め続けたり、またイタリアで出版されているロック博士の字典をとりよせたり、一字一字へのアプローチを行っていった。そして、まず何万枚もの和紙に筆でトンパ文字を書き、カリグラフィとして満足のいく作品を制作し、その部分にハードエッジを入れることにより、トンパ文字のもっている造形性を現代的な作品に仕上げていったのである。

この作業の時には、19才から25才まで日本のタイポグラフィに多大な影響を残した佐藤敬之輔タイポグラフィ研究所で活字の設計をしていた頃の経験が大いに役に立った。この頃に僕は1mmの中に10本の罫を引くというトレーニングを行い、それを見事に達成したエピソードは、日本のデザイン界ではちょっとした語り草になっているのだ。

A further trip by car, which took one whole day, brought us to the main dwelling place of the Nakhi tribe, Lijiang. The town is situated at the foot of Yu Long Xue Shan, at the height of 2,000 metres; approximately 200,000 Nakhis live in the town.

The Nakhi pictographic script is employed by the shamans in charge of the particular religion of the Nakhi tribe. The *sutras*, which the shamans read out on the occasion of religious ceremonies, are stories handed down over the generations in the tribe, such as the legend of the great flood; they are written in the Nakhi script.

At Lijiang, there is a research institute which studies the Nakhi religious culture and intends to hand down their records to the future. The institute keeps many *sutras* written in the Nakhi pictographic script. I met a shaman who is nearly eighty years old, and asked him to read this strange script. The *sutras* are exhibited behind glass, and photography is strictly forbidden. I could only take notes by the primitive method of copsing the characters by hand. I made my utmost effort in copying them out. The *sutras* were written with speed with a special bamboo pen. For the script to have penetrated the culture without ever becoming extinct, many artists within the tribe with a highly developed sense of expression must have existed.

After coming back from the trip, I made six pieces of art which make use of the Nakhi pictographic scripts. I asked Professor Nishida to write Nakhi proverbs in the Nakhi pictographic scripts and made them my text. I enlarged the only photograph of the *sutra* which I could take and put it up on the wall.

CATALOG
TYPOGRAPHY/DESIGN MARGARET MORTON, NEW YORK, NEW YORK
TYPOGRAPHIC SOURCES THE COOPER UNION AND OFF TYPO, INC., JAPAN
STUDIO MARGARET MORTON DESIGN
CLIENT THE COOPER UNION
PRINCIPAL TYPES ITC NEW BASKERVILLE AND MM-A-OKL
DIMENSIONS 8¼ × 10¾ IN. (21 × 27.3 CM)

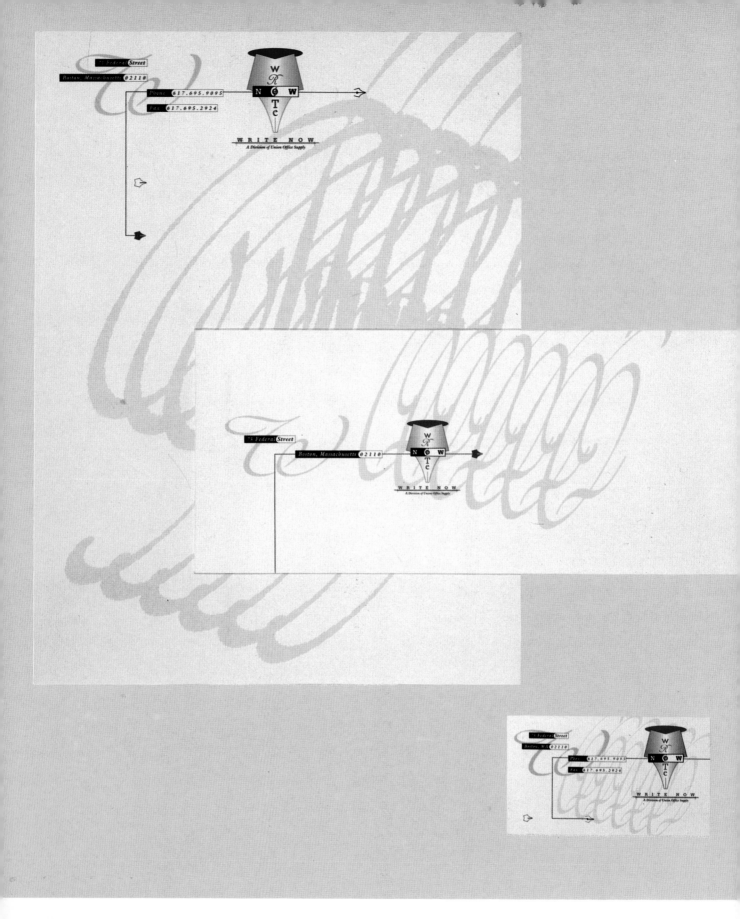

STATIONERY
TYPOGRAPHY/DESIGN MARK D. SYLVESTER AND NANCY SKOLOS, BOSTON, MASSACHUSETTS
TYPOGRAPHIC SOURCE IN-HOUSE
STUDIO SKOLOS/WEDELL, INC.
CLIENT WRITE NOW, INC.
PRINCIPAL TYPES SERIFA, GALLIARD, AND FUTURA
DIMENSIONS 8½ × 11 IN. (21.6 × 27.9 CM)

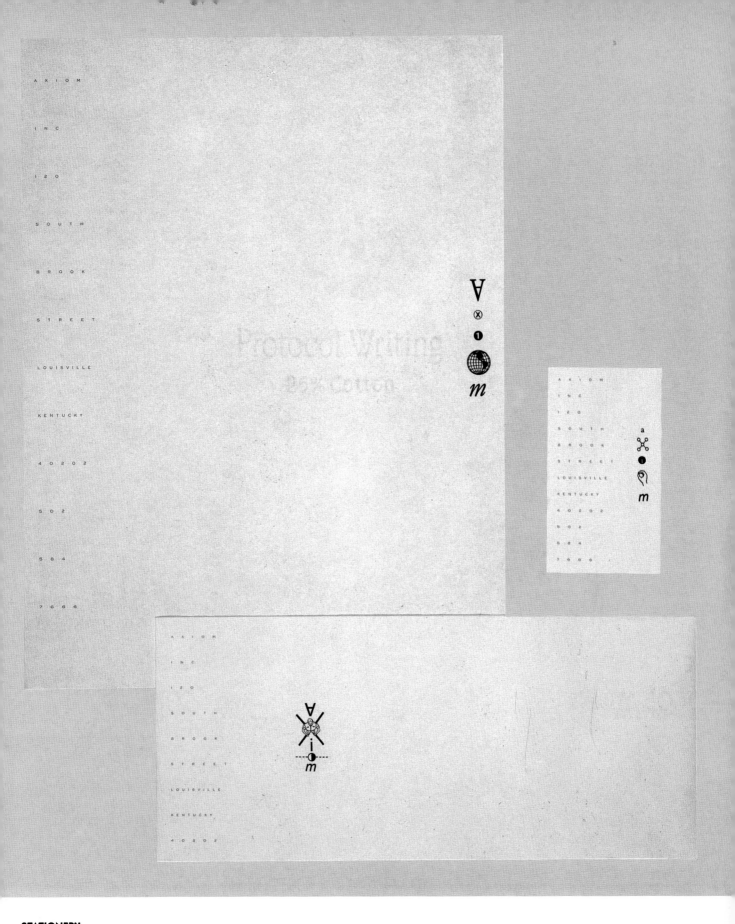

STATIONERY
TYPOGRAPHY/DESIGN WALTER McCORD, LOUISVILLE, KENTUCKY
LETTERER WALTER McCORD
TYPOGRAPHIC SOURCE HARLAN TYPOGRAPHIC
STUDIO WALTER McCORD GRAPHIC DESIGN
CLIENT AXIOM, INC.
PRINCIPAL TYPES FOUR-LINE BLOCK GOTHIC AND HANDLETTERING
DIMENSIONS 8½ × 11 IN. (21.6 × 27.9 CM)

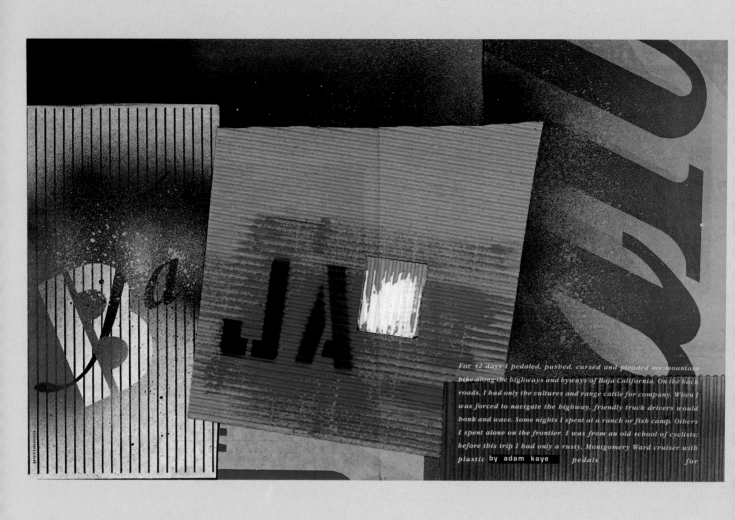

For 42 days I pedaled, pushed, cursed and pleaded my mountain bike along the highways and byways of Baja California. On the back roads, I had only the vultures and range cattle for company. When I was forced to navigate the highway, friendly truck drivers would honk and wave. Some nights I spent at a ranch or fish camp. Others I spent alone on the frontier. I was from an old school of cyclists: before this trip I had only a rusty, Montgomery Ward cruiser with plastic by adam kaye pedals for

MAGAZINE SPREAD
TYPOGRAPHY/DESIGN GERALD BUSTAMANTE, SAN DIEGO, CALIFORNIA
LETTERER GERALD BUSTAMANTE
TYPOGRAPHIC SOURCE STENCILS
STUDIO STUDIO BUSTAMANTE
CLIENT BEACH CULTURE MAGAZINE
PRINCIPAL TYPES VARIOUS
DIMENSIONS 12 × 20 IN. (30.5 × 50.8 CM)

BROCHURE
TYPOGRAPHY/DESIGN JOE DUFFY, SHARON WERNER, HALEY JOHNSON, GLENN TUTSSEL, AND GARRICK HAMM,
MINNEAPOLIS, MINNESOTA, AND LONDON, ENGLAND
LETTERERS SHARON WERNER, HALEY JOHNSON, TODD WATERBURY, AND LYNN SCHULTE
TYPOGRAPHIC SOURCES TYPESHOOTERS AND TYPEMASTERS
STUDIO THE DUFFY DESIGN GROUP
CLIENTS THE DUFFY DESIGN GROUP AND MICHAEL PETERS GROUP
PRINCIPAL TYPES BODONI ITALIC AND HANDLETTERING
DIMENSIONS 9 × 11½ IN. (22.9 × 29.2 CM)

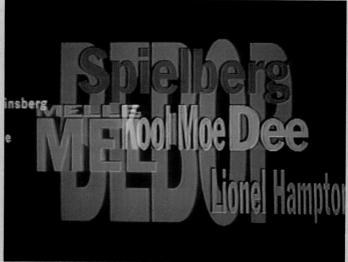

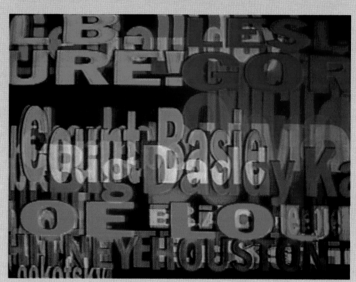

VIDEO
TYPOGRAPHY/DESIGN RIKI SETHIADI, NEW YORK, NEW YORK
TYPOGRAPHIC SOURCE IN-HOUSE
AGENCY FRANKFURT GIPS BALKIND
CLIENT WARNER BROS.
PRINCIPAL TYPE FRANKLIN GOTHIC

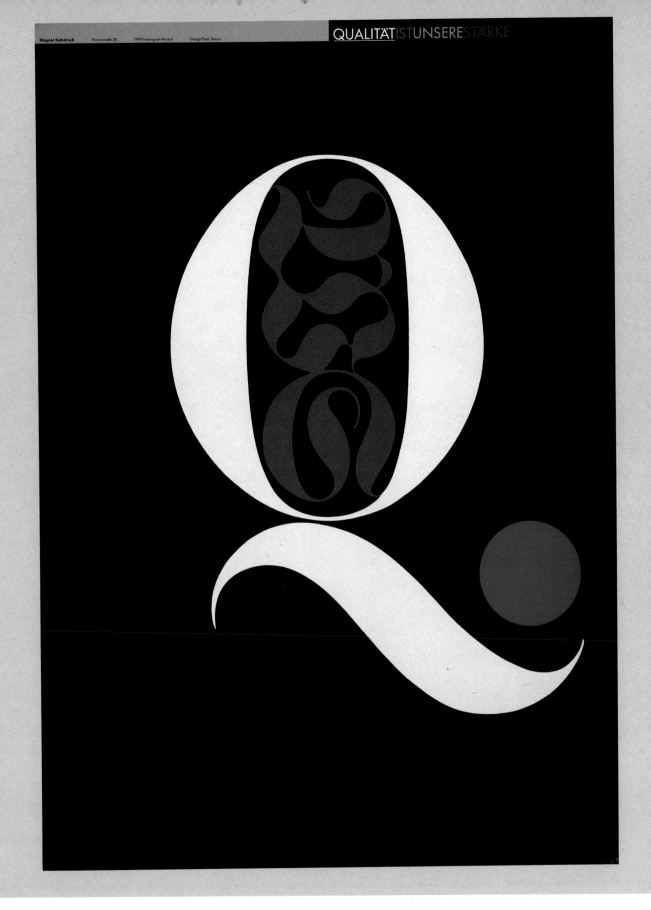

POSTER
TYPOGRAPHY/DESIGN PETER STEINER, STUTTGART, GERMANY
CALLIGRAPHER PETER STEINER
AGENCY WAGNER SIEBDRUCK
CLIENT WAGNER SIEBDRUCK
PRINCIPAL TYPES FUTURA AND HANDLETTERING
DIMENSIONS 23½ × 33 IN. (59.4 × 84 CM)

PACKAGING
TYPOGRAPHY/DESIGN JACK ANDERSON, JULIA LAPINE, AND BRIAN O'NEILL, SEATTLE, WASHINGTON
TYPOGRAPHIC SOURCE IN-HOUSE
STUDIO HORNALL ANDERSON DESIGN WORKS
CLIENT GENERAL INFORMATION, INC.
PRINCIPAL TYPES BODONI AND FUTURA
DIMENSIONS 6¾ × 9 × 2³⁄₁₆ IN. (17 × 22.8 × 5.5 CM)

POSTER
TYPOGRAPHY/DESIGN CRAIG FRAZIER, SAN FRANCISCO, CALIFORNIA
TYPOGRAPHIC SOURCE DISPLAY LETTERING & COPY
STUDIO FRAZIER DESIGN
CLIENT THE AMERICAN INSTITUTE OF GRAPHIC ARTS/SAN FRANCISCO CHAPTER
PRINCIPAL TYPES CITY MEDIUM AND HELVETICA CONDENSED
DIMENSIONS 23 × 36 IN. (58.4 × 91.4 CM)

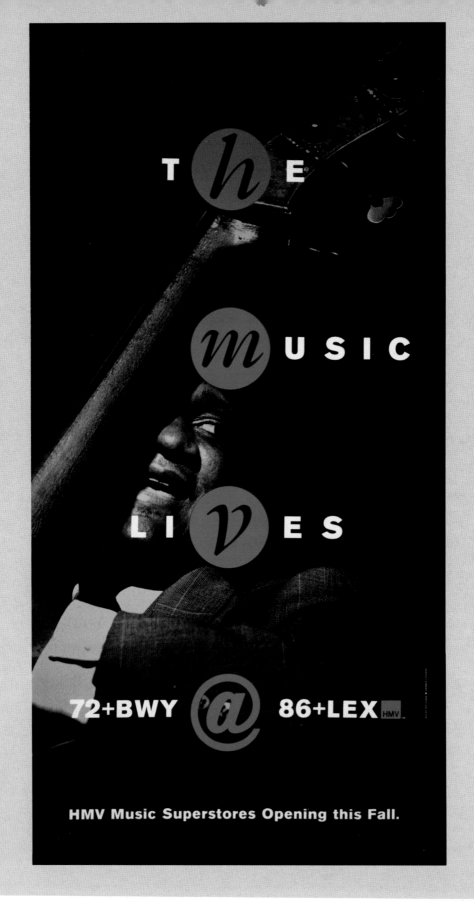

POSTER
TYPOGRAPHY/DESIGN JOHAN VIPPER, NEW YORK, NEW YORK
TYPOGRAPHIC SOURCE IN-HOUSE
AGENCY FRANKFURT GIPS BALKIND
CLIENT HMV
PRINCIPAL TYPES GALLIARD (MODIFIED) AND AKZIDENZ GROTESK
DIMENSIONS 26 × 50 IN. (66 × 127 CM)

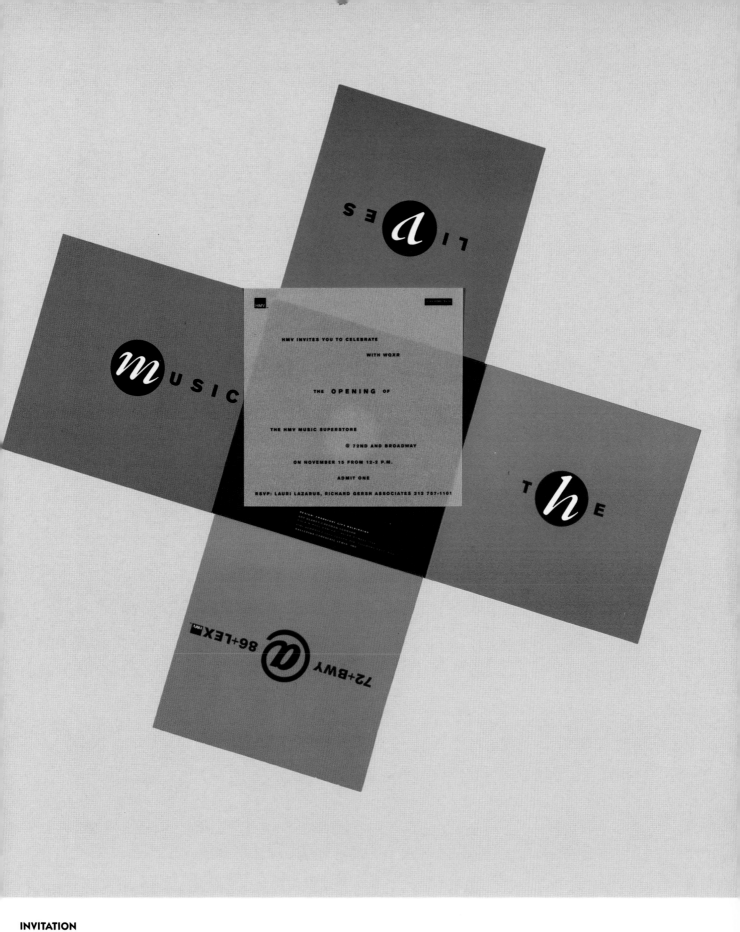

INVITATION
TYPOGRAPHY/DESIGN DAVID SUH, NEW YORK, NEW YORK
CREATIVE DIRECTOR KENT HUNTER
TYPOGRAPHIC SOURCE IN-HOUSE
AGENCY FRANKFURT GIPS BALKIND
CLIENT HMV
PRINCIPAL TYPES GALLIARD (MODIFIED) AND AKZIDENZ GROTESK
DIMENSIONS 5 × 5 IN. (12.7 × 12.7 CM)

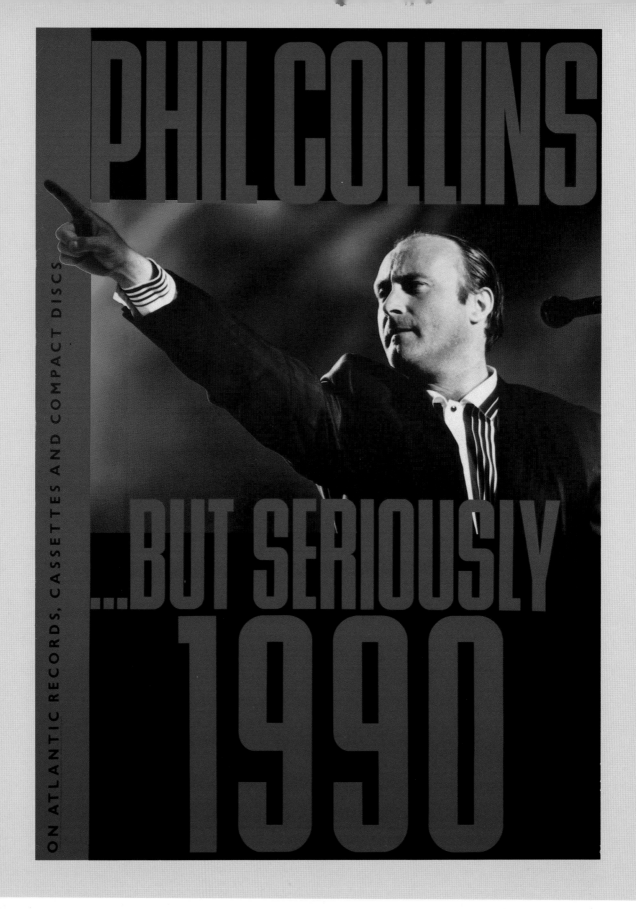

POSTER
TYPOGRAPHY/DESIGN BOB DEFRIN, NEW YORK, NEW YORK
TYPOGRAPHIC SOURCE THE GRAPHIC WORD
CLIENT ATLANTIC RECORDS
PRINCIPAL TYPE BINDER STYLE
DIMENSIONS 42 × 60 IN. (106.7 × 152.4 CM)

POSTER
TYPOGRAPHY/DESIGN SHIN MATSUNAGA, TOKYO, JAPAN
TYPOGRAPHIC SOURCE IN-HOUSE
STUDIO SHIN MATSUNAGA DESIGN INC.
CLIENT DAIICHISHIKO CO., LTD.
PRINCIPAL TYPE HANDLETTERING
DIMENSIONS 40½ × 28⅔ IN. (103 × 72.8 CM)

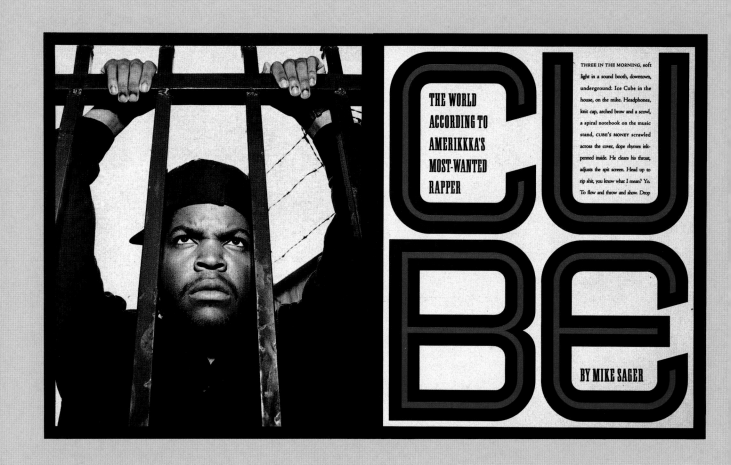

THE WORLD
ACCORDING TO
AMERIKKKA'S
MOST-WANTED
RAPPER

CU
BE

THREE IN THE MORNING, soft light in a sound booth, downtown, underground. Ice Cube in the house, on the mike. Headphones, knit cap, arched brow and a scowl, a spiral notebook on the music stand, CUBE'S MONEY scrawled across the cover, dope rhymes ink-penned inside. He clears his throat, adjusts the spit screen. Head up to rip shit, you know what I mean? Yo. To flow and throw and show. Drop

BY MIKE SAGER

MAGAZINE SPREAD
TYPOGRAPHY/DESIGN GAIL ANDERSON, NEW YORK, NEW YORK
LETTERER DENNIS ORTIZ-LOPEZ
TYPOGRAPHIC SOURCE IN-HOUSE
CLIENT ROLLING STONE
PRINCIPAL TYPE POSTER GOTHIC
DIMENSIONS 12 × 20 IN. (30.5 × 50.8 CM)

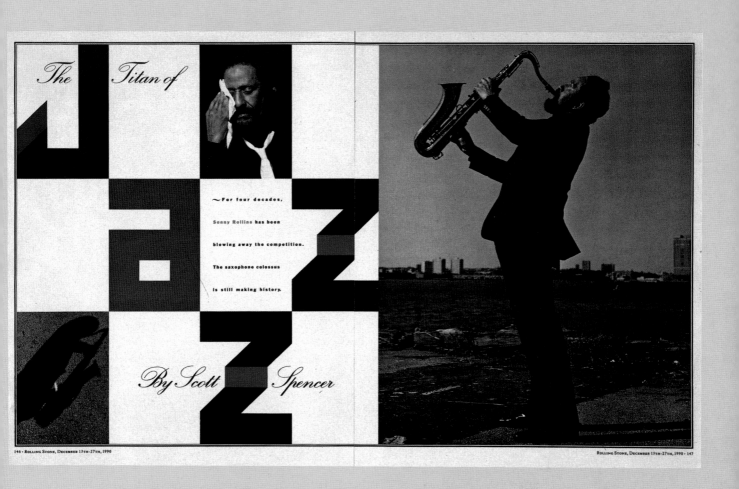

The Titan of JAZZ

By Scott Spencer

~For four decades, Sonny Rollins has been blowing away the competition. The saxophone colossus is still making history.

MAGAZINE SPREAD
TYPOGRAPHY/DESIGN FRED WOODWARD, NEW YORK, NEW YORK
TYPOGRAPHIC SOURCES IN-HOUSE AND PINEAPPLE BOOK
CLIENT ROLLING STONE
PRINCIPAL TYPES PINEAPPLE FACE AND EXCELSIOR
DIMENSIONS 12 × 20 IN. (30.5 × 50.8 CM)

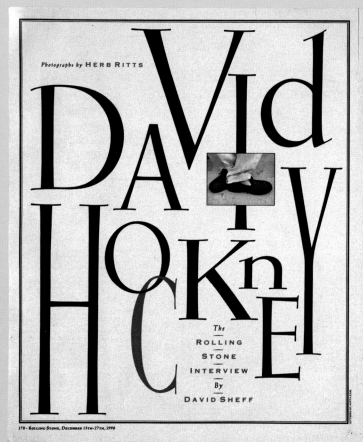

Photographs by HERB RITTS

DAVID
HOCKNEY

The ROLLING STONE INTERVIEW *By* DAVID SHEFF

MAGAZINE SPREAD
TYPOGRAPHY/DESIGN CATHERINE GILMORE-BARNES, NEW YORK, NEW YORK
LETTERER ANITA KARL
TYPOGRAPHIC SOURCE IN-HOUSE
CLIENT ROLLING STONE
PRINCIPAL TYPE WEISS INITIAL CAP (MODIFIED)
DIMENSIONS 12 × 20 IN. (30.5 × 50.8 CM)

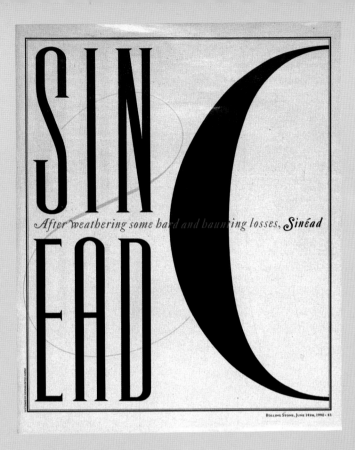

After weathering some hard and haunting losses, Sinéad

Rolling Stone, June 14th, 1990 • 43

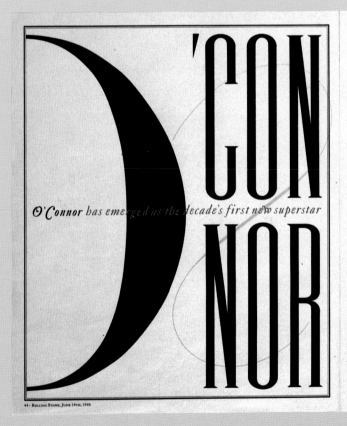

O'Connor has emerged as the decade's first new superstar

44 • Rolling Stone, June 14th, 1990

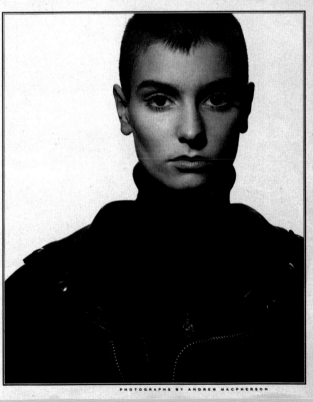

PHOTOGRAPHS BY ANDREW MACPHERSON

MAGAZINE SPREAD
TYPOGRAPHY/DESIGN FRED WOODWARD, NEW YORK, NEW YORK
LETTERER DENNIS ORTIZ-LOPEZ
TYPOGRAPHIC SOURCE IN-HOUSE
CLIENT ROLLING STONE
PRINCIPAL TYPE MODIFIED EMPIRE
DIMENSIONS 12 × 20 IN. (30.5 × 50.8 CM)

THE ROLLING STONE INTERVIEW WITH DAVID LYNCH BY DAVID BRESKIN

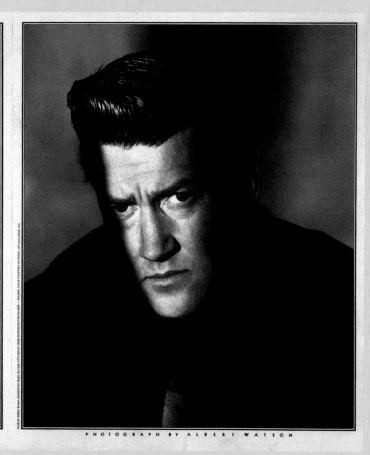

HAIR BY KERRY WARN. MAKEUP BY MARK PHELPS. STYLING BY JESSE RODRIGUEZ FOR BAGGERY • ENAMEL CHAIR COURTESY OF NEWEL ART GALLERIES, INC.

PHOTOGRAPH BY ALBERT WATSON

MAGAZINE SPREAD
TYPOGRAPHY/DESIGN FRED WOODWARD, NEW YORK, NEW YORK
TYPOGRAPHIC SOURCE IN-HOUSE
CLIENT ROLLING STONE
PRINCIPAL TYPE KABEL
DIMENSIONS 12 × 20 IN. (30.5 × 50.8 CM)

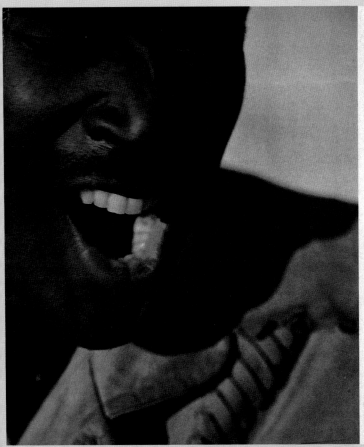
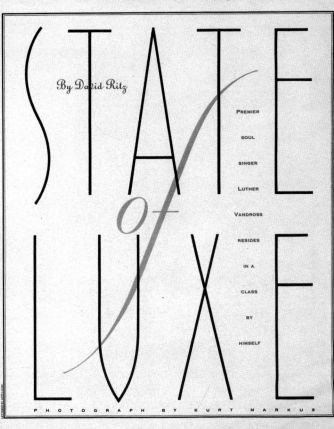

STATE
By David Ritz
of
LUXE

PREMIER SOUL SINGER LUTHER VANDROSS RESIDES IN A CLASS BY HIMSELF

PHOTOGRAPH BY KURT MARKUS

MAGAZINE SPREAD
TYPOGRAPHY/DESIGN ANGELA SKOURAS, NEW YORK, NEW YORK
LETTERER ANITA KARL
TYPOGRAPHIC SOURCE IN-HOUSE
CLIENT ROLLING STONE
PRINCIPAL TYPE ART DECO FONT
DIMENSIONS 12 × 20 IN. (30.5 × 50.8 CM)

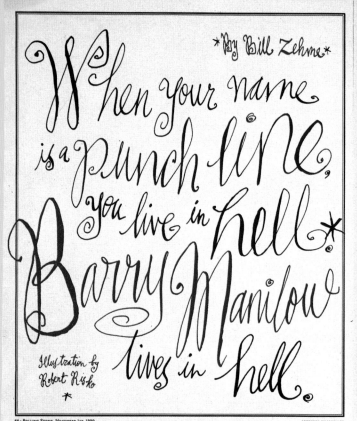

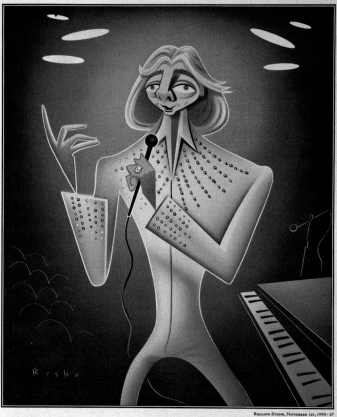

MAGAZINE SPREAD
TYPOGRAPHY/DESIGN ANGELA SKOURAS, NEW YORK, NEW YORK
LETTERER JOHN LEE, SINGAPORE
TYPOGRAPHIC SOURCE IN-HOUSE
CLIENT ROLLING STONE
PRINCIPAL TYPE HANDLETTERING
DIMENSIONS 12 × 20 IN. (30.5 × 50.8 CM)

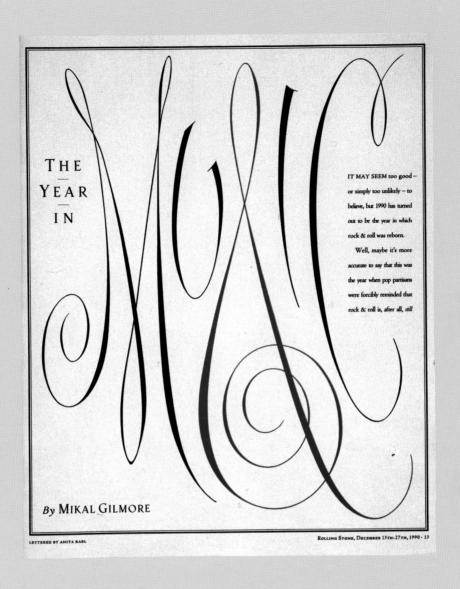

MAGAZINE SPREAD
TYPOGRAPHY/DESIGN GAIL ANDERSON, NEW YORK, NEW YORK
LETTERER ANITA KARL
TYPOGRAPHIC SOURCE IN-HOUSE
CLIENT ROLLING STONE
PRINCIPAL TYPE HANDLETTERING
DIMENSIONS 12 × 20 IN. (30.5 × 50.8 CM)

STAND-UP TRAGEDY

Stand-Up Tragedy
by Bill Cain
Directed by Ron Link
Original Music by
Shabba-Doo &
Yolanda Fresh J
Choreography by
Shabba-Doo
Marines Memorial
Theatre

AUDIENCES IN LOS ANGELES AND HARTFORD, CONNECTICUT WERE ELEC-
TRIFIED BY THIS MARK TAPER FORUM PRODUCTION. WITH BRUTAL HON-
ESTY, PLAYWRIGHT BILL CAIN EXAMINES LIFE IN A CONTEMPORARY
INNER-CITY SCHOOL AND THE RELATIONSHIP BETWEEN TEACHER AND
STUDENTS STRUGGLING TO OVERCOME THE STRANGLING BUREAU-
CRACY OF OUR EDUCATION SYSTEM. GENUINE ACTS OF HEROISM
EMERGE: THE TEACHER MUST FORFEIT HIS PRIVACY, HIS JOB AND EVEN
HIS DEEPEST PRINCIPLES. THE STUDENT IS FORCED TO BATTLE OVER-
WHELMING ODDS THAT HIS TROUBLED HOME LIFE INFLICTS ON HIS TIME
IN THE CLASSROOM.
INCORPORATING THE MUSIC AND DANCE OF TODAY, RON LINK'S DIREC-
TION CREATES AN EXHILARATING THEATRICAL EXPERIENCE.
"VIRTUALLY EVERY AMERICAN IS AWARE THAT OUR CITIES AND THE
SCHOOLS WITHIN THEM ARE IN TROUBLE. THE DEGREE OF AWARENESS
IS DETERMINED BY WHERE WE GET OUR INFORMATION: TWO-LINE NEWS
CRUNCH HEADLINES ON TELEVISION. EMPTY ELECTION PROMISES FROM
'EDUCATION' POLITICIANS. OR ACTIVE DUTY ON THE URBAN SCHOLAS-
TIC BATTLEFIELD. THE MEDIA LIKE TO EXPOSE THE PHENOMENA OF
DRUGS AND GANGS—THIS IS MISLEADING. DRUGS AND GANGS ARE
MERELY EXTERNAL SYMPTOMS OF A LARGER, MORE INSIDIOUS AILMENT.
IN A SOCIETY WHERE WE ARE BOMBARDED BY INFORMATION, WE ARE
OFTEN BEREFT OF KNOWLEDGE AND DEVOID OF CARING." RON LINK
THE PLAY CONTAINS STRONG LANGUAGE.

"*Stand-Up Tragedy* is every bit as spell-
binding as the *Phantom of the Opera*.
And Bill Cain's play represents a unique
phenomenon rivaling phantomania
in originality…"
Richard Stayton
Los Angeles Herald Examiner

"Plays about urban poverty are often
too preachy to be theatrical or too trivial
to be believed. But Bill Cain's *Stand-Up
Tragedy*…is different: it has lots to say
but fascinating ways of saying it. When
speech stops, rap songs begin, and it all
hits a nerve about every two minutes or
so—for all the right reasons."
David Patrick Stearns
USA Today

"*Stand-Up Tragedy* at the Mark Taper
Forum is theatrical to its core, and grabs
the audience at the gut level."
Bernard Weiner
San Francisco Chronicle

"The play becomes the dramatic equiv-
alent of the jagged, jarring rhythms and
the nervous energy of break dancing
and rapping, which form a joint back-
ground motif."
Mel Gussow
The New York Times

"This makes for dynamic theater, always
a jump ahead of us, and yet in view."
Dan Sullivan
Los Angeles Times

"It will be a rare audience that does not
spring to its feet and offer waves of
applause to the production *Stand-Up
Tragedy*, a comic masterpiece of horror."
David Wilson
The New Haven Advocate

AUGUST

BROCHURE
TYPOGRAPHY/DESIGN MICHAEL VANDERBYL, SAN FRANCISCO, CALIFORNIA
TYPOGRAPHIC SOURCES SPARTAN TYPOGRAPHERS AND ANDRESEN TYPOGRAPHERS
STUDIO VANDERBYL DESIGN
CLIENT CAROLE SHORENSTEIN HAYS PRESENTS
PRINCIPAL TYPES BANK SCRIPT, FUTURA BOLD, COPPERPLATE GOTHIC, AND EMPIRE
DIMENSIONS 11 × 15 IN. (27.9 × 38 1 CM)

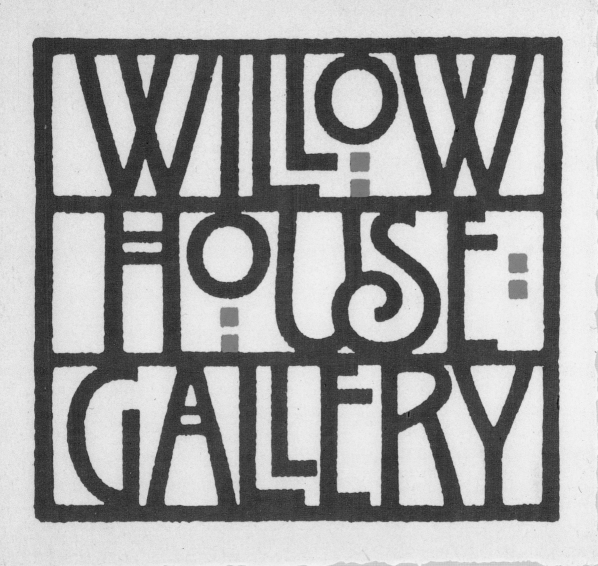

LOGOTYPE
TYPOGRAPHY/DESIGN TONY FORSTER, MANCHESTER, ENGLAND
LETTERER TONY FORSTER
STUDIO TONY FORSTER TYPOGRAPHICS
CLIENT WILLOW HOUSE GALLERY
PRINCIPAL TYPE HANDLETTERING

MEAD ANNUAL REPORT SHOW 1990. FOR 34 YEARS THE MEAD SHOW HAS CELEBRATED THE STATE OF THE ART IN ANNUAL REPORT DESIGN AND EACH YEAR THE DESIGN

M E A D

HAS SOARED TO EVEN GREATER HEIGHTS. FROM HUNDREDS OF ENTRIES OUR JUDGES SELECTED 24 WINNING REPORTS FOR THE SHOW: REPORTS WHOSE MISSIONS

ARE CLEAR AND EXECUTION FLAWLESS. EFFECTIVE REPORTS THAT CONVEY THE CORPORATE MESSAGE WITH COURAGE AND PRECISION. ELEGANT REPORTS THAT ARE

FINELY TUNED, CAREFULLY CRAFTED IN EVERY DETAIL. DARING REPORTS THAT TAKE CHANCES, EXHIBITING FRESH APPROACHES TO

OLD CHALLENGES. INSPIRED REPORTS THAT COMMUNICATE WITH INTELLIGENCE AND STYLE. EACH REPORT IS RIGHT ON TARGET AND EVERY REPORT IS A WINNER.

CATALOG
TYPOGRAPHY/DESIGN ANTHONY RUTKA AND MATTHEW DAVIS, BALTIMORE, MARYLAND
TYPOGRAPHIC SOURCE THE TYPE HOUSE
STUDIO RUTKA WEADOCK DESIGN
CLIENT MEAD FINE PAPER DIVISION
PRINCIPAL TYPE COPPERPLATE
DIMENSIONS 13 × 6¼ IN. (33 × 15.9 CM)

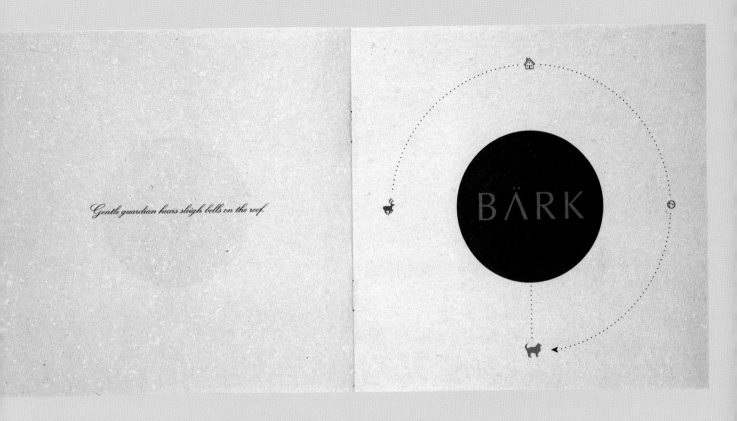

Gentle guardian hears sleigh bells on the roof.

BÄRK

PROMOTION
TYPOGRAPHY/DESIGN MARK OLDACH AND DON EMERY, CHICAGO, ILLINOIS
TYPOGRAPHIC SOURCE TYPECASTERS
STUDIO MARK OLDACH DESIGN
CLIENT FIRST IMPRESSION PRINTERS AND LITHOGRAPHERS, INC.
PRINCIPAL TYPES ITC GARAMOND CONDENSED AND FRANKLIN GOTHIC HEAVY
DIMENSIONS 4¾ × 15 IN. (12.1 × 38.1 CM)

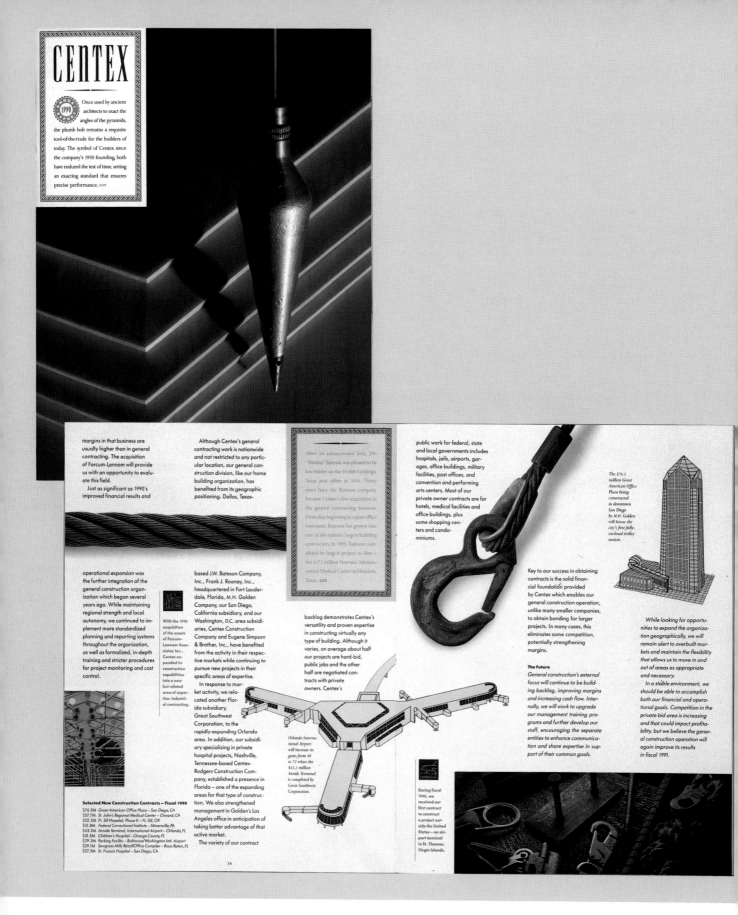

ANNUAL REPORT
TYPOGRAPHY/DESIGN BRYAN L. PETERSON, DALLAS, TEXAS
STUDIO PETERSON & COMPANY
CLIENT CENTEX CORPORATION
PRINCIPAL TYPES PERPETUA AND FUTURA MEDIUM MODERNA
DIMENSIONS 8½ × 11 IN. (21.6 × 27.9 CM)

Electro-optical components

Power supplies

Laser accessories for beam alignment

Laser heat exchangers

Laser measurement and analysis instruments

Precision optics

Ultraviolet coatings and filters

Bar code scanner optics

Optics for blood analysis equipment

Optics for infrared security systems

Maintaining market leadership means pioneering accessories that support laser use. Coherent's Components Group equips the industry with a variety of such performance tools. Leveraging Coherent's expertise in basic laser engineering, the Components Group develops and manufactures precision optics, computerized analytical instruments, and electronic subassemblies that augment established laser applications and inspire new ones.

27

ANNUAL REPORT
TYPOGRAPHY/DESIGN STEVEN TOLLESON AND DONNA ANDERSON, SAN FRANCISCO, CALIFORNIA
TYPOGRAPHIC SOURCE SPARTAN TYPOGRAPHERS
STUDIO TOLLESON DESIGN
CLIENT COHERENT
PRINCIPAL TYPE FUTURA
DIMENSIONS 7½ × 11¾ IN. (19.1 × 29.8 CM)

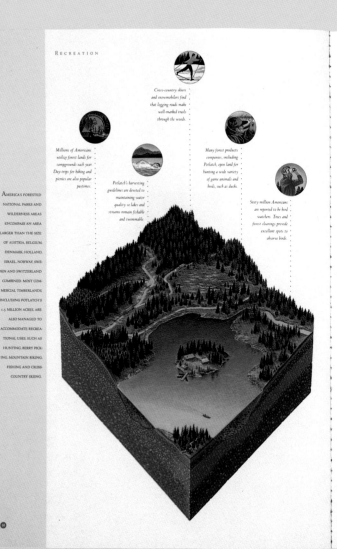

Cross-country skiers and snowmobilers find that logging roads make well-marked trails through the woods.

Millions of Americans utilize forest lands for campgrounds each year. Day-trips for hiking and picnics are also popular pastimes.

Many forest products companies, including Potlatch, open land for hunting a wide variety of game animals and birds, such as ducks.

Potlatch's harvesting guidelines are devoted to maintaining water quality so lakes and streams remain fishable and swimmable.

Sixty million Americans are reported to bird watchers. Trees and forest clearings provide excellent spots to observe birds.

AMERICA'S FORESTED NATIONAL PARKS AND WILDERNESS AREAS ENCOMPASS AN AREA LARGER THAN THE SIZE OF AUSTRIA, BELGIUM, DENMARK, HOLLAND, ISRAEL, NORWAY, SWEDEN AND SWITZERLAND COMBINED. MOST COMMERCIAL TIMBERLANDS, INCLUDING POTLATCH'S 1.5 MILLION ACRES, ARE ALSO MANAGED TO ACCOMMODATE RECREATIONAL USES, SUCH AS HUNTING, BERRY PICKING, MOUNTAIN BIKING, FISHING AND CROSS-COUNTRY SKIING.

methods to ensure natural regrowth. Federal and state agencies are planting about 900,000 seedlings daily as well. Equally important, we are learning how to get more wood from less land by eliminating waste and employing sophisticated timber management methods.

Forestry is now an applied science encompassing a range of practices unheard of a half century ago. Selective breeding of trees has produced genetically improved seedlings with greater growth capacity and resistance to insects and disease. In some cases, Potlatch foresters allow nature to reseed harvested areas by providing the right environment; in others, we assist nature by hand-planting seedlings, many of which come from seeds bred in company seed orchards and germinated in company nurseries. Nurtured under optimum conditions, these seedlings have a head start over competition when placed in the woods.

Today timber-stand management and harvesting methods are designed, at a minimum, to protect basic soil and water resources. In recent years, this protection

has been extended to fisheries and wildlife.

Modern forest management tends to emulate natural processes. Mother Nature has long used cataclysmic events — wildfire, windstorms and insect infestations — to renew the forest. The resulting openings provided sunlight and space for young trees to take root. Foresters now aim for the same results, but with less waste and destruction, through carefully planned timber harvests.

The choice of harvesting methods is the result of a wide range of environmental, economic and silvicultural considerations. Though many protective measures are mandated by law, Potlatch has its own internal guidelines which often exceed legal requirements. Such care only makes sense. Potlatch is in business for the long term, and maintaining resources to continue the cycle of growth and harvest is essential.

Potlatch, as well as many other companies in the industry, employs clearcutting in some areas. Clearcutting is considered the best method for regenerating

SOME 39.8 MILLION FRESHWATER FISHERMEN IN THE U.S. SPENT AN AVERAGE OF 21 DAYS ON THE SPORT IN 1985. EACH YEAR THOUSANDS OF ANGLERS FISH ON WATERWAYS THAT CROSS POTLATCH TIMBERLANDS. ARKANSAS' MEANDERING RIVERS SUPPORT SPECIES LIKE CATFISH, BASS, CRAPPIE AND BREAM. IDAHO'S COLD, RAPID WATERS ABOUND WITH TROUT AND STEELHEAD, WHILE MINNESOTA'S LAKES TEEM WITH WALLEYE PIKE AND BASS.

ANNUAL REPORT
TYPOGRAPHY/DESIGN PENTAGRAM DESIGN, SAN FRANCISCO, CALIFORNIA
TYPOGRAPHIC SOURCE REARDON & KREBS
STUDIO PENTAGRAM DESIGN
CLIENT POTLATCH CORPORATION
PRINCIPAL TYPE CENTAUR
DIMENSIONS 8½ × 11 IN. (21.6 × 27.9 CM)

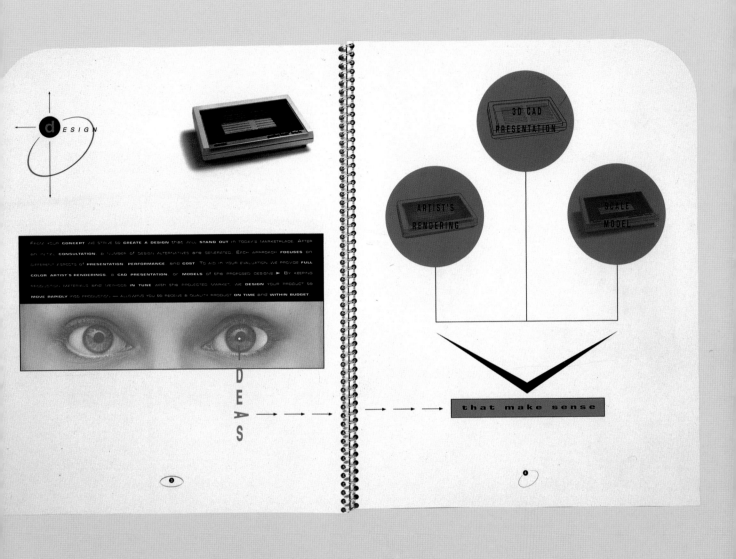

BROCHURE
TYPOGRAPHY/DESIGN JOE PARISI AND TIM THOMPSON, BALTIMORE, MARYLAND
LETTERER JOE PARISI
TYPOGRAPHIC SOURCE IN-HOUSE
STUDIO GRAFFITO
CLIENT APOGEE DESIGNS, LTD.
PRINCIPAL TYPES EUROSTYLE AND HELVETICA
DIMENSIONS 8½ × 11 IN. (21.6 × 27.9 CM)

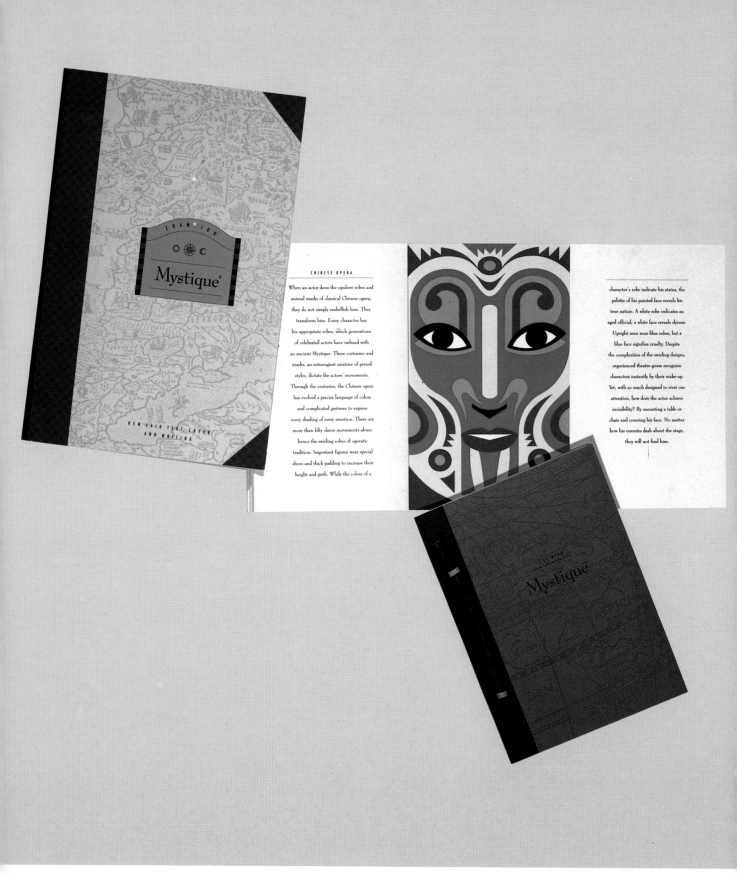

Mystique®

CHINESE OPERA

When an actor dons the opulent robes and
animal masks of classical Chinese opera,
they do not simply embellish him. They
transform him. Every character has
his appropriate robes, which generations
of celebrated actors have imbued with
an ancient Mystique. These costumes and
masks, an extravagant mixture of period
styles, dictate the actors' movements.
Through the centuries, the Chinese opera
has evolved a precise language of colors
and complicated gestures to express
every shading of every emotion. There are
more than fifty sleeve movements alone;
hence the swirling robes of operatic
tradition. Important figures wear special
shoes and thick padding to increase their
height and girth. While the colors of a

character's robe indicate his status, the
palette of his painted face reveals his
true nature. A white robe indicates an
aged official; a white face reveals slyness.
Upright men wear blue robes, but a
blue face signifies cruelty. Despite
the complexities of the swirling designs,
experienced theatre-goers recognize
characters instantly by their make-up.
Yet, with so much designed to rivet our
attention, how does the actor achieve
invisibility? By mounting a table or
chair and covering his face. No matter
how his enemies dash about the stage,
they will not find him.

Mystique

PROMOTION
TYPOGRAPHY/DESIGN MICHAEL GERICKE, WOODY PIRTLE, AND JAMES ANDERSON, NEW YORK, NEW YORK
TYPOGRAPHIC SOURCE MONOGRAM
STUDIO PENTAGRAM
CLIENT CHAMPION INTERNATIONAL
PRINCIPAL TYPES BERNHARD ROMAN AND FUTURA LIGHT CONDENSED (ALTERED)
DIMENSIONS 6 × 9 IN. (15.2 × 22.9 CM)

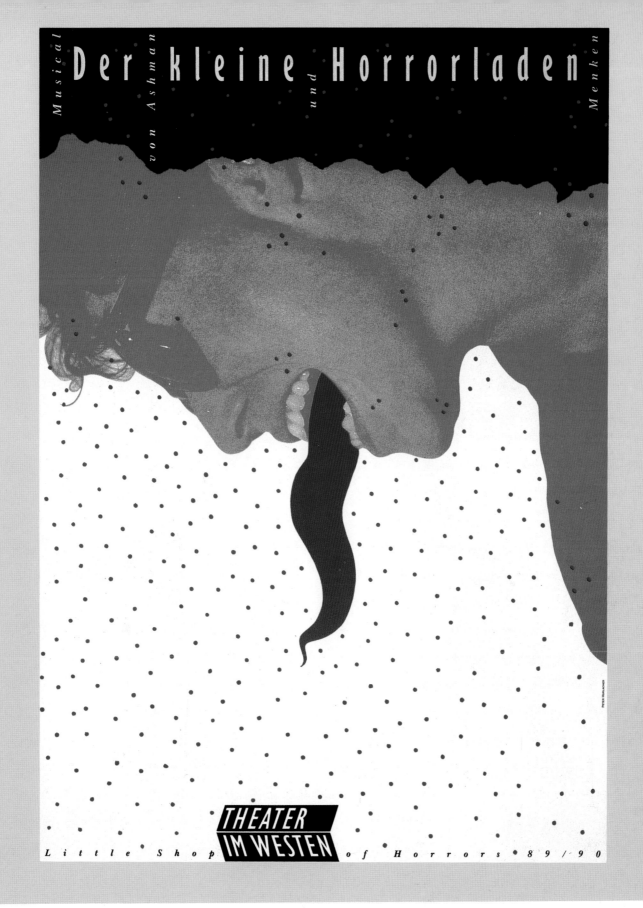

POSTER
TYPOGRAPHY/DESIGN PETER HORLACHER, STUTTGART, GERMANY
TYPOGRAPHIC SOURCE "TYPES" GMBH FOTOSETZEREI
STUDIO PETER HORLACHER
CLIENT THEATER IM WESTEN
PRINCIPAL TYPES GILL SANS BOLD EXTRA CONDENSED AND NEW BASKERVILLE BOLD ITALIC
DIMENSIONS 20 × 27 IN. (50.8 × 68.9 CM)

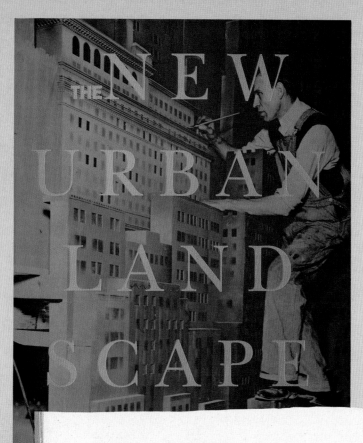

YEARS AGO

WHEN THE COUNTRY WAS MORE OPTIMISTIC, LE CORBUSIER WENT TO INDIA TO DESIGN HIS MODEL MODERN CITY, AND IN THE MIDDLE OF THAT CITY HE PLACED A MONUMENTAL SCULPTURE OF "THE OPEN HAND," HIS SYMBOL OF RECIPROCITY AND THE MAJESTY OF TOOLS.

In today's urban landscape a different open hand greets us—the hand of the homeless man or woman—often several times on a single block, and we are less confident that architecture offers us a solution to the kind of social problem that hand symbolizes.

Two blocks from my apartment there's a sign posted on a building: "What can you do about the homeless?" Well, what I can do first of all is try my best not to join them. I can also: give them a quarter; send in a check; raise the subject over dinner; or, since writing about architecture is how I keep a roof over my head, I even go as far as to ask how the question might apply to architects.

If you provide a homeless person with shelter, he is no longer homeless; in theory, if you create enough shelters, the problem of homelessness disappears. But architecture is not just a matter of physical shelter. Architects do not only build buildings; they also build consciousness, not only in the sense of motivating solutions to problems but also in trying to define them. To the extent that solutions depend on an understanding of causes, homelessness is a conceptual as well as a material problem. Like "mental illness," another social problem which plagues an estimated one-third of the homeless population, homelessness is a way of thinking about certain people who do not conform to social expectations. Prior to the sixteenth century, as Michel Foucault recounted, there were mad people, but the concept of mental illness awaited the emergence of reason as a governing cultural norm.

Ten years ago, many cities had "street people," a term which carried the more positive connotation of staking a claim to a part of urban space. There's nothing new about poor people, but the term homelessness defines them in a negative relation to our contemporary conception of the home—or perhaps our failure to clarify what the idea of home means to us. I once suggested that the quickest (not the best) design solution to homelessness was to install doorbells inside the door of every building in New York (a bit like smoke detectors), with the requirement that we ring them every time we go out and let the homeless—whether or not they want to—receive us. The point of the bell was to remind us of the odd nature of "public space" in a culture of private enterprise.

Many are disturbed by the "privatization" that occurred during the Reagan years, from the demands for tax credits for private education, with its implications for public schools, to the ersatz "public spaces" private developers have been encouraged to provide in zoning trade-offs for increased building size. But the problem didn't start in 1980. "The most disturbing aspect of life in the United States today," wrote James Marston Fitch in 1966, a time of national affluence, "is the widening discrepancy between privatized luxury and public amenity." Though that gap is no narrower today, an affliction of our time is that, relative to the expectations of those who grew up amid postwar abundance, we now have privatized poverty as well.

Privatization in postwar years unfolded chiefly in the suburbs (where the only "public space," apart from the highway, was the living room, symbolically cordoned off from family use), with consequences that are only now being felt. To a large extent, the city today has become a "homeless shelter" even for those with homes. It is a refuge for the middle-class generation that grew up in the suburbs and was economically expelled from them when they went off to college. The yuppie lifestyle, it has been pointed out, is one of downward mobility. As Michael Kinsley observed, "affordable luxuries," like designer chocolate chip cookies, "serve as consolation for the lack of unaffordable luxuries like a large house." Or even a decent apartment.

It's arguable to what extent this suburban counter-migration has displaced the urban poor onto the streets. What isn't arguable is that this phenomenon has much to do with the way the homelessness problem has been conceptualized. The problem is not only that some have and others don't. It is that many of those who have so little have it so precariously. Many urban dwellers today who grew up surrounded by the suburbs' signs of stability and plenty now pay through the nose to share spaces only marginally better than the cardboard-box hovel in the alley. I don't mean to minimize the value of that margin and I'm not trying to drum up sympathy for yuppies. A roof over your head is not nothing. And, in fact, that is not a minor part of the role the homeless play in consciousness. Like the "Home" section in the newspaper, which does not so much report on our homes as, in effect, replace them, the homeless make it easier to accept that home can come in a box.

The visions of architects have yet to catch up to the message the homeless hold in their hands. The "solution" to homelessness lies not only in providing beds for the night, jobs and training for the unemployed, but also in the ability of architects to reconceive the home with imagery capable of persuading public and private developers to support it. Just as Frank Lloyd Wright demonstrated with the Usonian Houses that it was possible to devise a compelling image of the suburban home as an extension of the car, so architects now must configure the urban home as an extension of the appointment book, a living diary.

Partly as a consequence of eroded optimism, and of

HERBERT
MUSCHAMP

Quicker Than the Eye

A CRITIC'S DIALOGUE *of the* PUBLIC *and* PRIVATE SPACE *for the* CONTEMPORARY CITY

belief in their own powers of invention, this is a conservative time which architects and developers have tried to serve by going back to old models for their ideas, giving us surface illusions of old-fashioned luxury, of pre-war residential architecture (doesn't everyone want a pre-war building in a stable neighborhood?). These buildings borrow forms from old urban architecture but in spirit they embody a wholly suburban craving for cosmetic illusions of stability and order. This direction has not been without value; it has helped restore a needed sense of continuity to a streetscape battered by decades of modern upheaval.

But in the long run it cannot be much more than a holding action, a transition leading to the emergence of a new building type that reflects with clarity the movement of our lives today. This architecture will be wholly modern in design but less disruptive to the street; flexible in building size, interior disposition, externally applied form and terms of occupancy; linked, physically or financially, to employment or profession; spare as a running outfit; a type something like a college dormitory, something like a storage warehouse, something like an SRO hotel, something like a shopping cart, an architecture that is not embarrassed but in fact jubilant to partake of what Christopher Isherwood called our "reduction of the material plane to mere symbolic convenience." The ingredients of this architecture have been around for a long time; what remains is for architects to create from them imagery sufficiently compelling to enter our consciousness of options.

The position of New York City's government is that it doesn't want to make homeless shelters "too nice" because then people will want to stay in them forever, that is, render them a home. The real danger, of course, is that any minimally livable accommodation would be indistinguishable from apartments renting for thousands a month, which would blow the illusion architects carefully orchestrate for developers that these apartments are "luxurious." Architects should be working overtime precisely to blow that illusion.

48

49

BOOK
TYPOGRAPHY/DESIGN ANDREW GRAY, NEW YORK, NEW YORK
ART DIRECTOR STEPHEN DOYLE
TYPOGRAPHIC SOURCES IN-HOUSE AND TYPOGRAM
STUDIO DRENTTEL DOYLE PARTNERS
CLIENTS THE WORLD FINANCIAL CENTER AND OLYMPIA & YORK
PRINCIPAL TYPES NEW BASKERVILLE AND FRANKLIN GOTHIC
DIMENSIONS 9 × 11 IN. (22.9 × 28 CM)

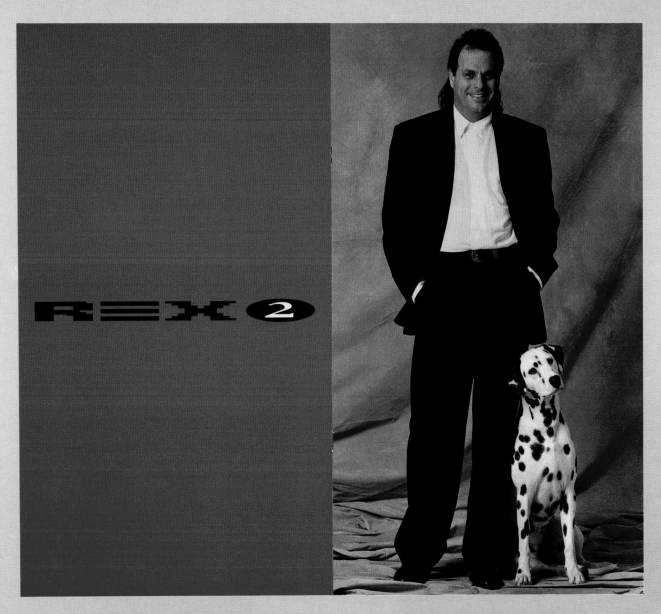

BROCHURE
TYPOGRAPHY/DESIGN LISA ASHWORTH, MIAMI, FLORIDA
LETTERER RALF SCHUETZ
CREATIVE DIRECTOR JOEL FULLER
TYPOGRAPHIC SOURCE IN-HOUSE
STUDIO PINKHAUS DESIGN
CLIENT REX THREE
PRINCIPAL TYPES MATRIX AND HANDLETTERING
DIMENSIONS 7⅞ × 14 IN. (20 × 35.6 CM)

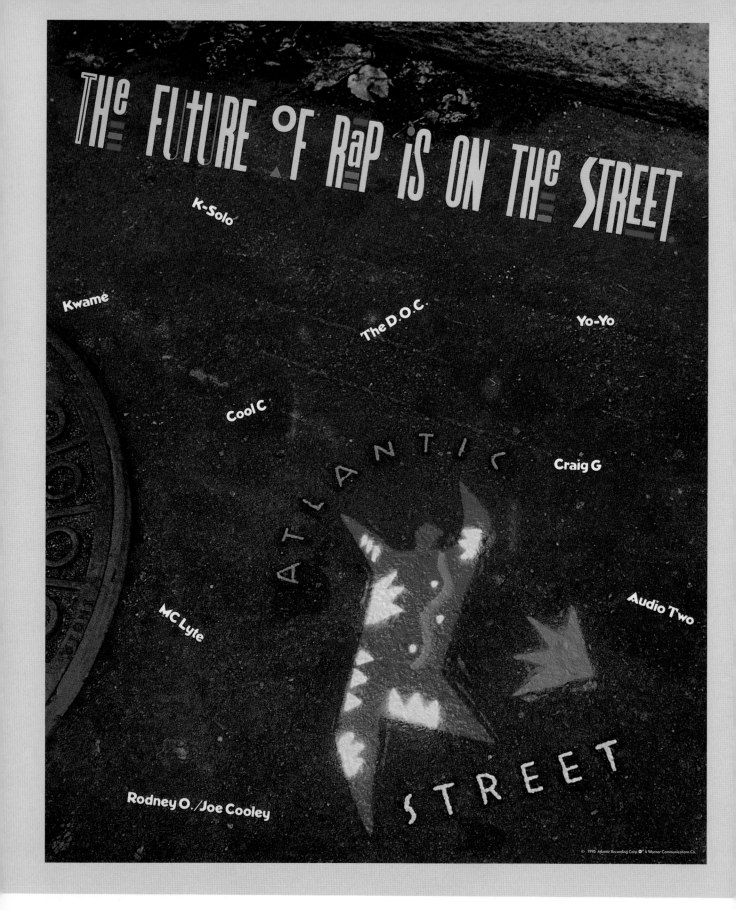

ADVERTISEMENT
TYPOGRAPHY/DESIGN ELIZABETH BARRETT, NEW YORK, NEW YORK
LETTERER ELIZABETH BARRETT
TYPOGRAPHIC SOURCES EXPERTYPE AND GRAPHIC WORD
CLIENT ATLANTIC RECORDS
PRINCIPAL TYPES LONG TALL GOOD WOOD AND EAGLE BOLD
DIMENSIONS 11 × 13½ IN. (27.9 × 34.3 CM)

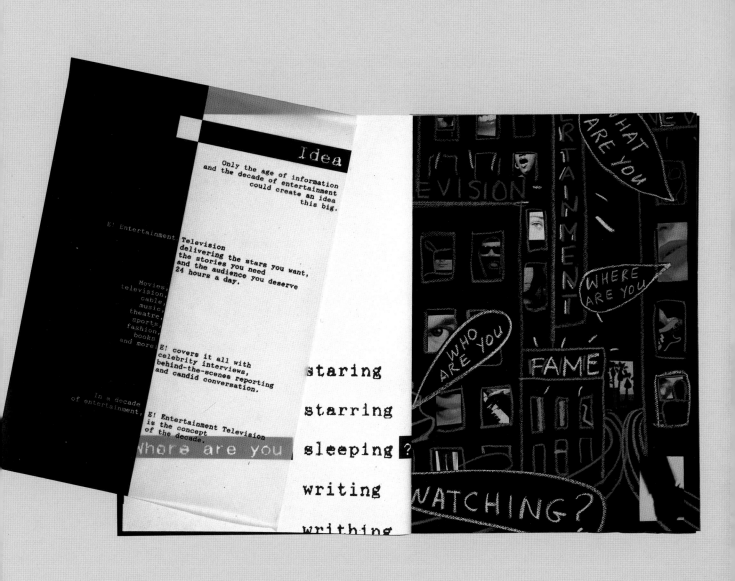

SALES KIT
TYPOGRAPHY/DESIGN PETRULA VRONTIKIS, LOS ANGELES, CALIFORNIA
TYPOGRAPHIC SOURCE SHARP FAX FO-210
STUDIO VRONTIKIS DESIGN OFFICE
CLIENT E! ENTERTAINMENT TELEVISION
PRINCIPAL TYPE SERIF REGULAR
DIMENSIONS 19 × 25 IN. (47.8 × 63.5 CM)

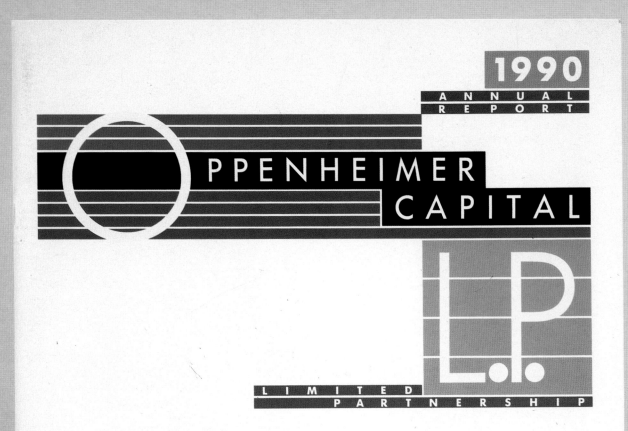

ANNUAL REPORT
TYPOGRAPHY/DESIGN JULIE KLEIN, NEW YORK, NEW YORK
ART DIRECTOR ALAN PECKOLICK
TYPOGRAPHIC SOURCE TROY GRAPHICS, INCORPORATED
STUDIO ADDISON CORPORATE ANNUAL REPORTS, INC.
CLIENT OPPENHEIMER CAPITAL, L.P.
PRINCIPAL TYPES FUTURA AND FENICE
DIMENSIONS 8½ × 11 IN. (21.6 × 27.9 CM)

MARSH &
McLENNAN
COMPANIES

PAST AND PRESENT—

FOUNDATION

FOR THE FUTURE

PAST AND
PRESENT—
FOUNDATION
FOR THE

In the final years of the 20th century, technology is refashioning the world as the advances of each decade outpace those of the last. Yet, many of the dramatic changes we have witnessed have been a result of incremental progress. Long periods frequently separate the invention of a technology from its successful marketing and from the time it makes an impact.

An understanding of history balanced with reasonable expectations for the future helps one to weigh the short-term benefits of change against its long-term implications. Widespread refinement, analysis and, more importantly, public acceptance have contributed to major transformations that we recognize by looking back to the turn of the century.

In the 1890s, steam powered the railroads and industrial and farm machinery; yet horses were

used for most other transport. Communication depended primarily on the written word, although the telephone and telegraph were well-established technologies. Long-distance telephone lines linked New York, Philadelphia and Boston by 1887.

In cities, the air was sullied by coal and wood smoke. Infectious diseases were a major cause of death; health standards were only just being developed. Immunization through vaccination was becoming a standard treatment. The average life expectancy in 1890 was about 40 years.

Today, as the 21st century approaches, we face a complicated, competitive, interrelated world. Telecommunication has gone beyond telephone lines to global networks of information. Transportation allows access to virtually any part of the world in less than 24 hours.

Genetic engineering techniques, still being refined, are used not only in medical science but also in industry and agriculture. Information technology systems, once viewed primarily as a means of reducing costs and increasing productivity, are creating entirely new products and services.

Because we have become acutely aware that the earth's natural resources are finite and require safekeeping, environmental issues are no longer viewed as solely one country's problems. Managing human resources effectively to satisfy the needs of a changing work force is a growing concern of corporations worldwide. These trends did not appear overnight— although we must contend, all at once, with their implications.

Marsh & McLennan Companies faces the challenges of the future from a heritage of solid

performance, adaptability and forward thinking. The Company was founded at the height of the industrial era when Henry Marsh and Donald McLennan helped pioneer the concept of risk management. They also established a standard for precise research into clients risk exposures and for innovative ways to cover these risks.

Each Marsh & McLennan operating company traces its origin to the strong entrepreneurial spirit of its founders. In the 1920s, Guy Carpenter originated the highly specialized area of risk coverage called excess of loss reinsurance. "The Carpenter Plan" was the first to utilize loss experience over a period of time as the basis for reinsurance costs, rather than on a flat-rate basis, with the insured and the reinsurer each accepting a percentage of the risk. In 1937, George Putnam founded the first mutual fund in

the United States to offer a balanced investment portfolio consisting of equities and fixed-income securities. And in the 1940s, William Mercer developed the idea that employee benefits plans should be individually designed by an independent consultant.

Many of our clients are credited with the major industrial and technological breakthroughs of the past century and are spearheading new ones. Through our continuous, long-term interaction with them, we acquire a thorough understanding of their goals and concerns at all stages of development and adapt our services and build our expertise to meet their changing needs. Our philosophy of providing the finest professional advice and dedicated service to clients has remained constant over the century.

On the next several pages we consider the past and the present

and wonder what the future may hold in such areas as transportation, energy, the environment, health, the work force and information technology. Advances in each have produced achievements unimagined years ago, but such fundamentals as concern for risk limitation and security for the future have not changed.

The effects of change—no matter what the pace—inevitably pose new challenges. Addressing those challenges requires the same careful analysis, understanding and good judgment that our predecessors applied to the urgent problems of their times.

Looking ahead, the demands on professional services firms will be complex and varied. We are ready for the future at Marsh & McLennan Companies, as we have been ready for the future at every stage of our history.

8

9

ANNUAL REPORT
TYPOGRAPHY/DESIGN ALAN PECKOLICK, NEW YORK, NEW YORK
TYPOGRAPHIC SOURCE TROY GRAPHICS, INCORPORATED
STUDIO ADDISON CORPORATE ANNUAL REPORTS, INC.
CLIENT MARSH & McLENNAN COMPANIES, INC.
PRINCIPAL TYPE GARAMOND
DIMENSIONS 8½ × 11 IN. (21.6 × 27.9 CM)

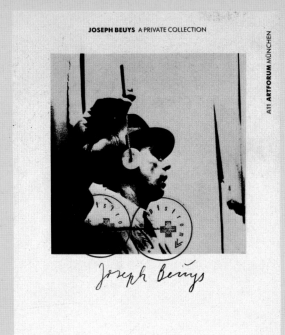

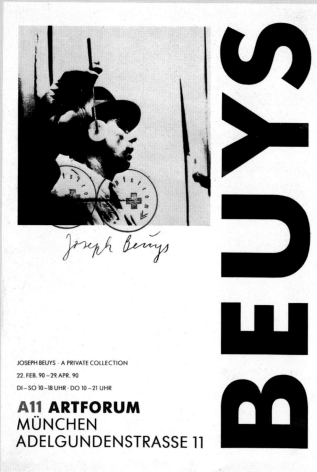

POSTER AND CATALOG
TYPOGRAPHY/DESIGN KNUT MAIERHOFER, MICHAEL KELLER, AND JÜRGEN SCHROEDER, MUNICH, GERMANY
TYPOGRAPHIC SOURCE GLOOR SATZ REPRO GMBH
AGENCY KMS TEAM
STUDIO KMS GRAPHIC
CLIENT A 11 ARTFORUM, GALERIE THOMAS
PRINCIPAL TYPES FUTURA LIGHT AND BOLD
DIMENSIONS VARIOUS

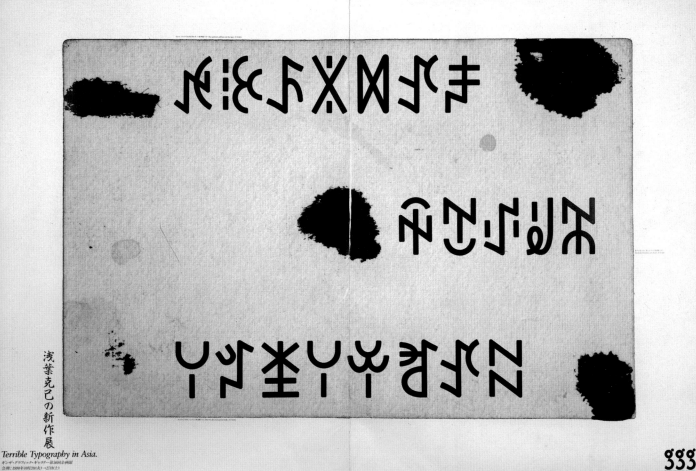

POSTER
TYPOGRAPHY/DESIGN KATSUMI ASABA, TOKYO, JAPAN
CALLIGRAPHER KATSUMI ASABA
TYPOGRAPHIC SOURCE IN-HOUSE
STUDIO ASABA DESIGN CO., LTD.
PRINCIPAL TYPE NAKHI PICTOGRAPHIC SCRIPT
DIMENSIONS VARIOUS

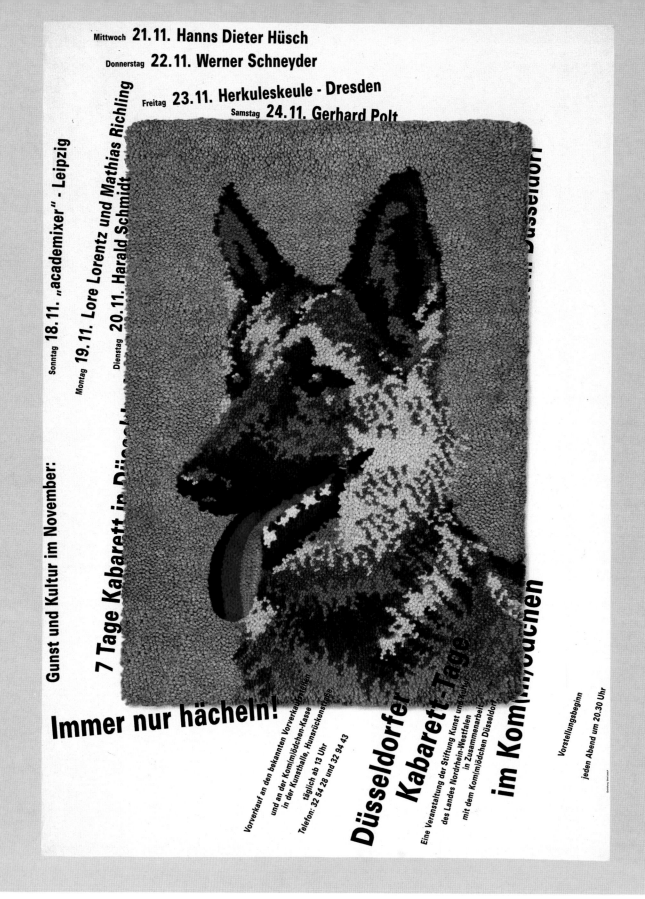

Mittwoch **21.11. Hanns Dieter Hüsch**

Donnerstag **22.11. Werner Schneyder**

Freitag **23.11. Herkuleskeule - Dresden**

Samstag **24.11. Gerhard Polt**

Sonntag **18.11.** „academixer" - Leipzig

Montag **19.11.** Lore Lorentz und Mathias Richling

Dienstag **20.11.** Harald Schmidt

Gunst und Kultur im November:

7 Tage Kabarett in Düsseldorf

Immer nur hächeln!

Vorverkauf an den bekannten Vorverkaufsstellen
und an der Kom(m)ödchen-Kasse
in der Kunsthalle, Hunsrückenstraße.
täglich ab 13 Uhr
Telefon: 32 54 28 und 32 94 43

Düsseldorfer
Kabarett-Tage

Eine Veranstaltung der Stiftung Kunst und Kultur
des Landes Nordrhein-Westfalen
in Zusammenarbeit
mit dem Kom(m)ödchen Düsseldorf,

im Kom(m)ödchen

Vorstellungsbeginn

jeden Abend um 20.30 Uhr

POSTER
TYPOGRAPHY/DESIGN UWE LOESCH, DÜSSELDORF, GERMANY
TYPOGRAPHIC SOURCE IN-HOUSE
CLIENT STIFTUNG KUNST UND KULTUR DES LANDES NRW
PRINCIPAL TYPE UNIVERS 75 (70% CONDENSED)
DIMENSIONS 33⅛ × 46¾ IN. (84.1 × 118.8 CM)

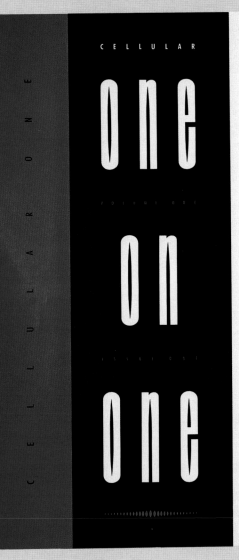

CELLULAR ONE

CELLULAR

one on one

VOLUME ONE

ISSUE ONE

Motorola has recently introduced the Micro TAC, the world's smallest cellular phone, and in doing so has introduced the future of cellular communications. At only 5 1/2 inches tall, and weighing a mere 11 ounces, the Micro TAC can be carried easily in any purse or pocket, and travel anywhere you go. — The Micro TAC is part of a technological revolution in the cellular business. No longer are cellular phones limited to car usage. Now, they are as much a personal accessory as a pocket calculator or an address book. — Though the Micro TAC is the smallest phone in the world, sound quality has not been sacrificed for size. In repeated field testing, the Micro TAC delivered as good and reliable a call as the larger portable models - some of which are twice its size. The Micro TAC includes two rechargeable batteries which together provide over 100 minutes of continuous conversation. — The technological accomplishment of incorporating the usually large, irregularly shaped electronic components which make up a cellular phone into a package as small as the Micro TAC has not gone unnoticed: Micro TAC was recently recognized by Popular Science magazine as the best electronics achievement of 1989. — To learn more about the Motorola Micro TAC, call your Cellular One sales representative for a demonstration.

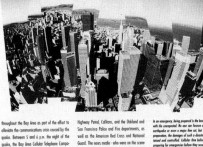

Sixteen minutes after the first tremors of the October 17, 1989 earthquake shook California's Bay Area, McCaw Cellular Communications, which provides Cellular One service in over 101 cities across the country, had begun to implement its emergency communications program. Along with Uniden, Motorola, and Ericsson Radio Systems, McCaw worked to provide consistent communications relief for the disaster-shaken Bay area, while proving the reliability of the cellular system under the most severe conditions. • Cellular communications, by its non-wire nature, presents excellent opportunities during times when wires have been damaged or are overloaded - a fact many businesses already take advantage of in order to protect phone, computer and alarm systems when wire lines have been damaged by an unforeseen disaster or emergency. As the largest operator of cellular systems in the United States, McCaw felt an obligation to do two main things after the quake: To help make sure the cellular system remained operational, and to provide any emergency assistance which was required. • In the first hours after the quake, McCaw Cellular Communications' personnel were busy assessing the communications needs of the region, and beginning the allocation of manpower and equipment. Within hours, the first shipment of portable telephones had arrived in Oakland. In the days to follow, almost 2200 Motorola and Uniden cellular phones were distributed

throughout the Bay Area as part of the effort to alleviate the communications crisis caused by the quake. Between 5 and 6 p.m. the night of the quake, the Bay Area Cellular Telephone Company (BACTC), in which McCaw owns an interest, handled over 300,000 call attempts - compared to the usual 70,000 - while its processor was taxed to 95% of capacity. Along with the overloaded phone lines, a major problem in San Francisco was a complete lack of commercial power. • Ericsson, a supplier of McCaw's switching equipment, provided a shipment of portable generators, relieving the emergency backup generators that had been powering all calls for six and one-half hours. In the days to come, McCaw and its suppliers worked alongside AT&T to restore communications to the disaster-stricken area. • The primary recipients of the emergency cellular phones were the California Office of Emergency Services, the California

Highway Patrol, Caltrans, and the Oakland and San Francisco Police and Fire departments, as well as the American Red Cross and National Guard. The news media - who were on the scene in the first moments after the quake filing stories back to their respective bureaus - also made use of cellular portables during the crisis. • The recent earthquake was the ultimate test of the cellular system, proving the reliability of the system in a way ordinary use could never do. Most disasters are unforeseeable, but with advance planning and the use of both cellular and traditional means of communication, damages to business and personal communication systems can be minimized.

In an emergency, being prepared is the best way to cope with the unexpected. No one can foresee a tornado, an earthquake or even a major line cut, but with advance preparation, the damages of such a disaster can be contained and controlled. Cellular One believes firmly in preparing for emergencies before they occur, and we can help you audit your business for disaster preparedness. Here's a quick checklist:

1. Consider the benefits of "backing-up" your communications systems with cellular. A cellular system can operate in tandem with your existing systems, serving as an emergency back-up for phone lines, as well as computer and alarm systems.

2. Make sure your communications system is designed to withstand the extraordinary, not just the ordinary. You may assure this through:

A) Successful interconnections between your local telephone company, your long distance carrier and your cellular company.

B) Fully operational back-up generators and battery power sufficient to last up to eight hours, which may be appropriate depending on your business needs.

3. Maintain your equipment in good working order at all times, so you will be prepared for that instance when your system must be stretched to its limits.

4. Employ diverse communications options, so you don't rely too heavily on any one system. By using a combination of systems - such as cellular and land line phones and pagers - you have more communications options in an emergency.

Q: How do I contact Cellular One Client Services from my mobile phone? How much does the call cost?

A: To obtain billing assistance, report phone difficulties, or to inquire about your cellular service, simply dial 611, and press the send button from your cellular phone. The call is free, with no air time billed. Client Services is available 24 hours a day, seven days a week.

Q: What should I do if my cellular phone is lost or stolen?

A: If your phone is lost or stolen, contact Client Services immediately. The line will be disconnected to prevent fraudulent use of your cellular telephone. Be sure to ask about Cellular One's loaner phone program when you call. Also, notify your insurance company.

Q: I am interested in having call waiting on my phone. What do I need to know?

A: Call waiting can be activated almost immediately by Cellular One Client Services. Using call waiting is simple: When receiving a call, you will hear a short alert tone. To answer the call, press the send button. This automatically puts your first call on hold, while you speak to the second caller. To alternate between the two calls, simply press the send button. Your phone will then ring and reconnect the other call.

Q: When I go to another city and my phone roam light comes on, how do I place a local call?

A: Your roam light indicates you've left your home system. To place a local call, you need to dial the area code of the city you're visiting, plus the seven digit local number of the person you're calling, as outlined in your roaming guide. If you still have difficulty, or would like a roaming guide, call Cellular One Client Services.

NEWSLETTER
TYPOGRAPHY/DESIGN JOHN NORMAN, DALLAS, TEXAS
LETTERER JOHN NORMAN
TYPOGRAPHIC SOURCE IN-HOUSE
AGENCY RICHARDS GROUP
STUDIO RICHARDS BROCK MILLER MITCHELL AND ASSOCIATES
CLIENT CELLULAR ONE
PRINCIPAL TYPES FUTURA BOLD AND FUTURA CONDENSED
DIMENSIONS 5¼ × 17 IN. (13.3 × 43.2 CM)

THE BOOK

TRANSLATED FROM THE HEBREW BY

DAVID ROSENBERG

INTERPRETED BY

HAROLD BLOOM

of J

BOOK JACKET
TYPOGRAPHY/DESIGN CARIN GOLDBERG, NEW YORK, NEW YORK
TYPOGRAPHIC SOURCES PHOTO-LETTERING, INC., AND THE TYPE SHOP
STUDIO CARIN GOLDBERG GRAPHIC DESIGN
CLIENT GROVE WEIDENFELD
PRINCIPAL TYPE ATLAS (REDRAWN)
DIMENSIONS 6¼ × 9¼ IN. (15.9 × 23.5 CM)

The importance of the song in Southern Africa lies in the avenue of verbal communication. Songs may deal with experiences of everyday life or the traditions, beliefs, and customs of a particular society. In most societies, there exist a song for just about every routine, chore, and social event. Included here are excerpts from songs which have perpetuated an endless stream of fascination and curiosity.

Where has your mother gone?
She has gone to fetch firewood.
What did she leave you?
She left some bananas.
May I have one?
No! I won't give you any.
Are you crying? You musn't.
Are you singing? You musn't.

Where are you going, morning star?
I am going to the kitchen of Komete's mother.
Whatever for?
To eat the guts of fish.
To Komete's mother for waste matter.
To Komete's mother for waste matter.

Little one, come let me feed you.
If you divorce me, you cannot take away
my child.
Little one, come let me feed.

That which befits a man—befits him.
But a rope around the neck does not fit a fowl.
Three ears do not fit a head.
Hired trousers and shirt can never fit a man.
Even if the trousers are not too tight around your legs,
The shirt will be too loose around your neck.

It is the ambition of the star to shine like the moon,
Although god never intended it.
If the fowl had a hoe,
It would have performed great deeds on the dunghill.

He sits under the short palm tree drinking palmwine.
Someday you will see our king.
Someday you will see our king.

2

3

BOOK
TYPOGRAPHY/DESIGN NEIL DOUGLAS POWELL, MINNEAPOLIS, MINNESOTA
LETTERER NEIL DOUGLAS POWELL
TYPOGRAPHIC SOURCE HARLAN TYPE
STUDIO NEIL DOUGLAS POWELL
CLIENT NEIL DOUGLAS POWELL
PRINCIPAL TYPES JANSON ROMAN, JANSON ITALIC, AND HANDLETTERING
DIMENSIONS 8¼ × 9 IN. (21 × 22.9 CM)

Köln,

Kunsthochschule für Medien

École Supérieure des Arts et Médias

Academy of Media Arts

POSTER
TYPOGRAPHY/DESIGN UWE LOESCH, DÜSSELDORF, GERMANY
TYPOGRAPHIC SOURCE IN-HOUSE
CLIENT KUNSTHOCHSCHULE FÜR MEDIEN KÖLN
PRINCIPAL TYPE FRUTIGER BOLD
DIMENSIONS 33⅛ × 46¾ IN. (84.1 × 118.8 CM)

Kontraste
und Kontinuität
Schmuck
von Erich Hergert

CATALOG
TYPOGRAPHY/DESIGN HARTMUT BRÜCKNER, BREMEN, GERMANY
TYPOGRAPHIC SOURCE HEADLINE FOTOSATZ
STUDIO HARTMUT BRÜCKNER DESIGN
CLIENT FOCKE-MUSEUM BREMEN
PRINCIPAL TYPE WALBAUM
DIMENSIONS 6⅔ × 8⅔ IN. (17 × 22 CM)

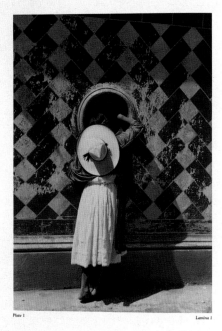

Plate 1 Lámina 1

LA HIJA DE LOS DANZANTES, 1933

The daughter of the dancers, 1933

There are many Manuel Alvarez Bravos. That is his power. There is the pre-Columbian Alvarez Bravo, a worshiper of bulls and sacrificer of virgins, who dances with Chac and Xipe and takes no prisoners. His work and thought abound with Mayan and Aztec symbols, the knitting together of life and death, and the cross-breeding of serpents and jaguars. This Alvarez Bravo is so far from being understood in the United States that he seems a shaman speaking in tongues, a primitive in paint and feathers.

There is another Alvarez Bravo who is purely Mexican in the revolutionary spirit. A *Villista*, a purveyor of the struggle of social forces, steeped in Mexican history, a comrade to the violence that is a necessary part of life. This Alvarez Bravo is a trenchant worshiper of justice, enemy of all oppressors, a proud eagle devouring a snake while perched on a cactus. An earthy, avenging angel, he is a *campesino*, speaking cheap puns and lewd double-entendres. He is leery of the United States, even hostile—a trickster outwitting the Anglo world. He seems innocent and playful. He giggles, but the joke

Manuel Alvarez Bravo es uno y muchos a la vez. Ahí reside su potencia. Hay el Alvarez Bravo precolombino, que adora toros, sacrifica vírgenes, danza con Chac y Xipe, y no se lleva prisioneros. En su obra y en su pensamiento abundan los símbolos mayas y olmecas, el entretejido de la vida y la muerte y el hibridismo de serpientes y jaguares. Este Alvarez Bravo está tan lejos de ser comprendido en los Estados Unidos, que nos parece un santón hablando en lenguas extrañas o un indígena adornado con pintura y plumas.

Hay otro Alvarez Bravo, de espíritu revolucionario puramente mexicano: un Villista que aviva la lucha de las fuerzas sociales, impregnado de la historia mexicana y camarada de la violencia que es parte necesaria de la vida. Este Alvarez Bravo es un firme defensor de la justicia, enemigo de todos los opresores, un águila orgullosa que, posada en un nopal, devora la serpiente. El es el ángel terrenal vengador, un campesino que habla utilizando equívocos vulgares y obscenidades de doble significado. Es suspicaz e incluso hostil a los Estado Unidos; un embaucador que sobrepasa en agudeza al mundo

9

BOOK
TYPOGRAPHY/DESIGN JOSEPH BELLOWS, LAURA COE, CAREY GERWIG, AND LAUREN BRUHN, SAN DIEGO, CALIFORNIA
TYPOGRAPHIC SOURCE IN-HOUSE
STUDIO LAURA COE DESIGN ASSOCIATES
CLIENT MUSEUM OF PHOTOGRAPHIC ARTS
PRINCIPAL TYPE GOUDY
DIMENSIONS 8½ × 11 IN. (21.6 × 27.9 CM)

D E C E M B E R

Sanctuary Blenny, Bahamas

CALENDAR
TYPOGRAPHY/DESIGN EMA DESIGN, DENVER, COLORADO
TYPOGRAPHIC SOURCE LINEAUX, INC.
STUDIO EMA DESIGN
CLIENT GRITZ-RITTER GRAPHICS
PRINCIPAL TYPE GARAMOND NO. 3
DIMENSIONS 6 × 9 IN. (15.2 × 22.9 CM)

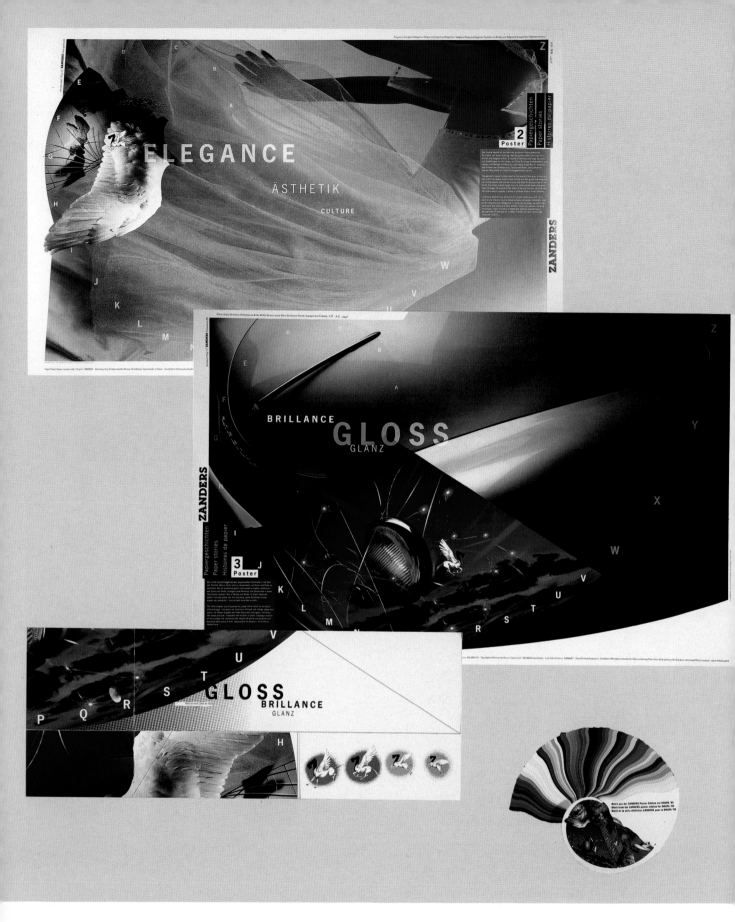

ADVERTISEMENT
TYPOGRAPHY/DESIGN TON VAN BRAGT, HÉLÉNE BERGMANS, AND MARC VAN BOKHOVEN, THE HAGUE, NETHERLANDS
TYPOGRAPHIC SOURCE EDUARD BOS
STUDIO STUDIO DUMBAR
CLIENT ZANDERS FEINPAPIERE AG
PRINCIPAL TYPES VARIOUS
DIMENSIONS VARIOUS

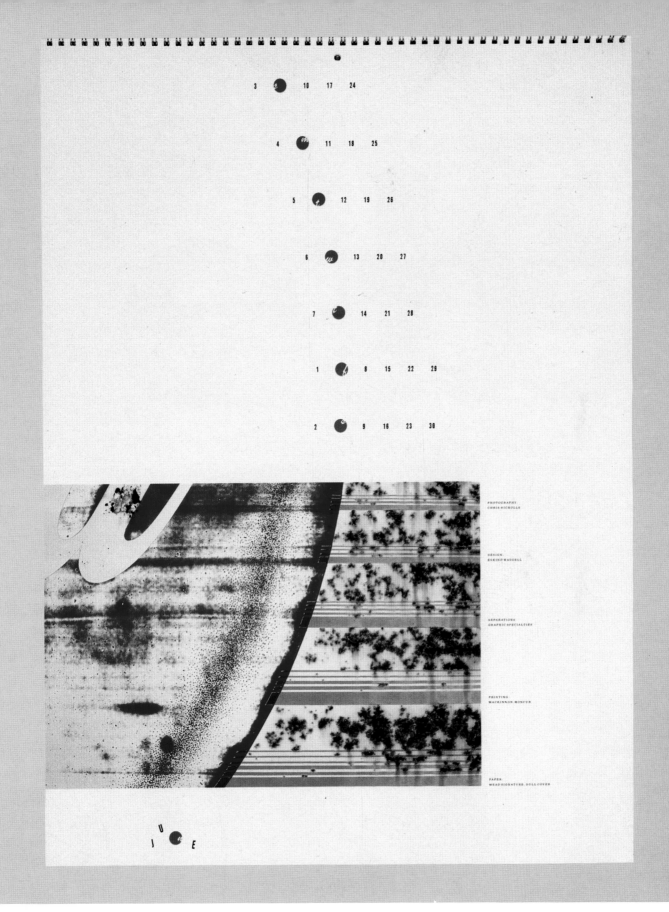

CALENDAR
TYPOGRAPHY/DESIGN ESKIND WADDELL, TORONTO, ONTARIO, CANADA
TYPOGRAPHIC SOURCE COOPER & BEATTY
STUDIO ESKIND WADDELL
CLIENTS CHRIS NICHOLLS, ESKIND WADDELL, GRAPHIC SPECIALTIES, MACKINNON-MONCUR LIMITED, AND MEAD PAPER
PRINCIPAL TYPE UNIVERS
DIMENSIONS 17 × 23 IN. (43.2 × 58.4 CM)

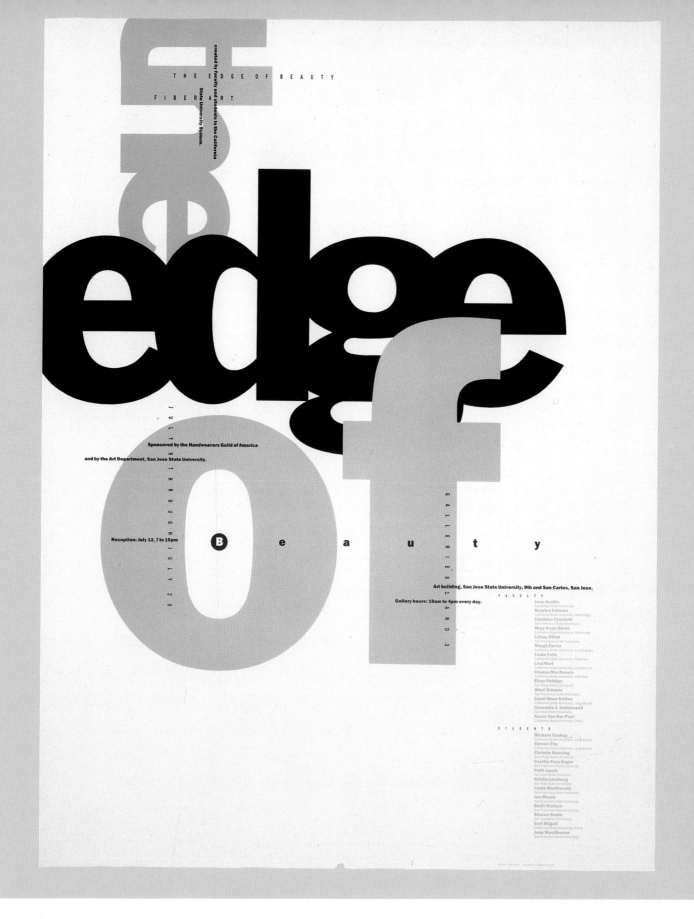

POSTER
TYPOGRAPHY/DESIGN JOE MILLER, SAN JOSE, CALIFORNIA
LETTERER JOE MILLER
TYPOGRAPHIC SOURCE FRANK'S TYPE
STUDIO JOE MILLER'S COMPANY
CLIENT SAN JOSE UNIVERSITY GALLERIES
PRINCIPAL TYPE FRANKLIN GOTHIC
DIMENSIONS 18 × 24 IN. (45.7 × 61 CM)

PACKAGING
TYPOGRAPHY/DESIGN DAVID BEARD, LONDON, ENGLAND
TYPOGRAPHIC SOURCE THE FACE PLACE
AGENCY LEWIS MOBERLY
CLIENT INNOXA
PRINCIPAL TYPE TRADE GOTHIC
DIMENSIONS VARIOUS

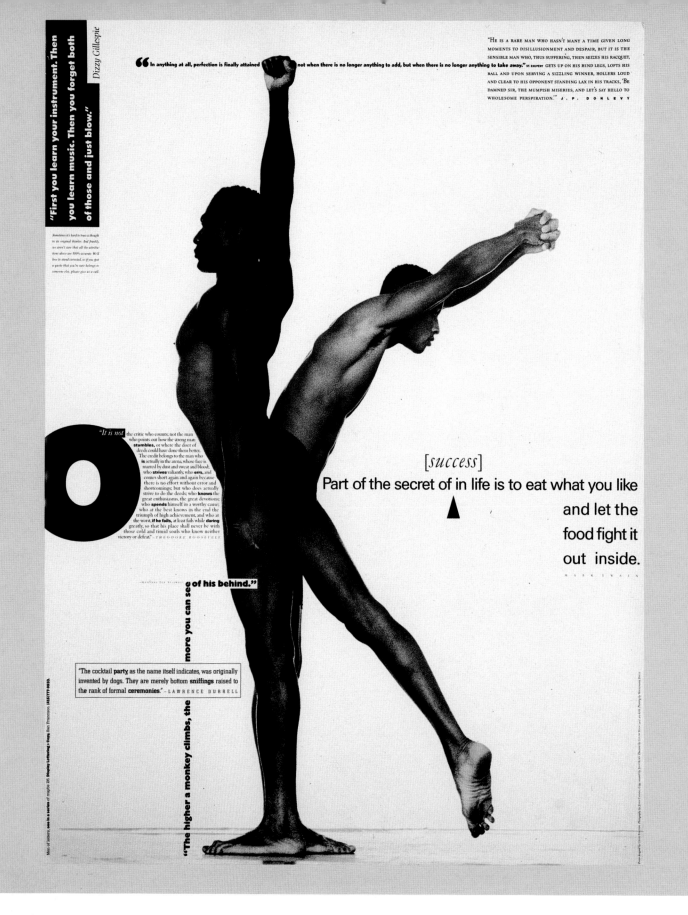

POSTER
TYPOGRAPHY/DESIGN CRAIG FRAZIER AND DEBORAH HAGEMANN, SAN FRANCISCO, CALIFORNIA
TYPOGRAPHIC SOURCE DISPLAY LETTERING & COPY
STUDIO FRAZIER DESIGN
CLIENT DISPLAY LETTERING & COPY
PRINCIPAL TYPES VARIOUS
DIMENSIONS 26¾ × 36¼ IN. (67.9 × 92.1 CM)

POSTER
TYPOGRAPHY/DESIGN JULIUS FRIEDMAN, LOUISVILLE, KENTUCKY
TYPOGRAPHIC SOURCE ADPRO
STUDIO IMAGES
CLIENT THE CONTEMPORARY ARTS CENTER
PRINCIPAL TYPE NOVARESE
DIMENSIONS 24 × 32 IN. (61 × 81.3 CM)

Power

Profit

Partners

Party!

INVITATION
TYPOGRAPHY/DESIGN MARGARET KIM, MOUNTAIN VIEW, CALIFORNIA
LETTERER BILL SHINNICK
TYPOGRAPHIC SOURCE OMNICOMP
AGENCY SUN CREATIVE SERVICES
CLIENT SUN MICROSYSTEMS, INC.
PRINCIPAL TYPE FRANKLIN GOTHIC HEAVY CONDENSED
DIMENSIONS 7½ × 16½ IN. (19.1 × 41.9 CM)

CORPORATE IDENTITY
TYPOGRAPHY/DESIGN MICHAEL VANDERBYL, SAN FRANCISCO, CALIFORNIA
TYPOGRAPHIC SOURCE RAPID TYPOGRAPHY
STUDIO VANDERBYL DESIGN
CLIENT PISCHOFF
PRINCIPAL TYPE GILL SANS
DIMENSIONS 8½ × 11 IN. (21.6 × 27.9 CM)

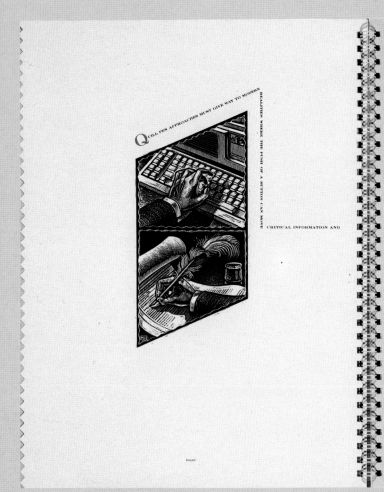

QUILL PEN APPROACHES MUST GIVE WAY TO MODERN REALITIES WHERE THE PUSH OF A BUTTON CAN MOVE CRITICAL INFORMATION AND NECESSARY FUNDING THOUSANDS OF MILES IN A MATTER OF SECONDS.

casualty, fidelity and surety coverages. ▶ More cooperative ventures such as these are likely to characterize the decade ahead.

REINSURANCE MARKET CONDITIONS

In contrast to the disarray in facultative markets, there were signs early in 1989 that the key treaty segment was maintaining better market discipline than the primary insurance market. Despite higher retentions by primary companies and much talk of a resulting decline in demand for reinsurance, rates and terms of business remained remarkably steady. ▶ The reinsurance market in 1989 had to absorb the impact of record catastrophes, the increased bite on primary carriers as a result of tax law changes, and the unusually high level of retentions by primary insurers. All this led to expectations that market tightening would be seen at the time of January 1, 1990, renewals. ▶ That was not the case. In fact, there were some signs of increasing competition in the form of more liberal terms of business. ▶ Behind this was the perception of an overcapitalized reinsurance industry in both the United States and Great Britain. Considering the substantial obligations of the industry, this perception of excess capital is likely an illusion. In any case, Kemper Re does not view writing business at a loss as an intelligent solution to this problem. ▶ An assessment of the state of the market has been somewhat complicated by changes in the most commonly used published data on

EIGHT

NINE

ANNUAL REPORT
TYPOGRAPHY/DESIGN GREG SAMATA, DUNDEE, ILLINOIS
TYPOGRAPHIC SOURCE TYPOGRAPHIC RESOURCE, LTD.
STUDIO SAMATA ASSOCIATES
CLIENT KEMPER REINSURANCE COMPANY
PRINCIPAL TYPES ENGRAVERS ROMAN AND SABON ANTIQUA
DIMENSIONS 8¾ × 11½ IN. (22.2 × 29.2 CM)

IFETIME HEALTH AND FITNESS AS WELL AS THE DEVELOPMENT OF TEAMWORK AND INDIVIDUAL SKILLS ARE PARAMOUNT FOR GROWTH INTO A COMPLETE PERSON. THEY ARE ALSO BASIC TO THE EPISCOPAL SCHOOL'S PHYSICAL EDUCATION, VARSITY ATHLETICS, AND CLUB SPORTS. EACH STUDENT AT THE SCHOOL VARIES HIS OR HER OWN PHYSICAL EDUCATION COURSES TO MEET INDIVIDUAL INTERESTS AND SKILLS— THE GOAL BEING A VIGOROUS, ATTAINABLE, AND RELEVANT FITNESS PROGRAM. IN EXTRACURRICULAR ATHLETIC ACTIVITY, THE SCHOOL OFFERS A PROGRAM FLEXIBLE ENOUGH TO ACCOMMODATE THE NOVICE ATHLETE, YET ADVANCED ENOUGH TO PREPARE THE MORE SKILLED ATHLETE FOR HIGHER LEVELS OF COMPETITION. THE EPISCOPAL EAGLES COMPETE IN MOST MAJOR SPORTS AGAINST OTHER INDEPENDENT PREPARATORY SCHOOLS IN DALLAS AND FORT WORTH AS WELL AS THE ENTIRE SOUTHWEST.

P H Y S I C A L

BROCHURE
TYPOGRAPHY/DESIGN BRIAN BOYD, DALLAS, TEXAS
TYPOGRAPHIC SOURCE CHILES & CHILES GRAPHIC SERVICES
AGENCY THE RICHARDS GROUP
STUDIO RICHARDS BROCK MILLER MITCHELL & ASSOCIATES
CLIENT EPISCOPAL SCHOOL OF DALLAS
PRINCIPAL TYPE TIMES ROMAN
DIMENSIONS 6½ × 12½ IN. (16.5 × 31.8 CM)

"In the past year, the full power of protein structure-based drug design to increase the odds of success in drug discovery has become clear. We have shown that it is possible to improve the rate of discovery of new chemical candidates for drug development 100-fold. And we have shown that it is possible to do so from a single molecular target in a single drug discovery project."

Agouron Pharmaceuticals, Inc. 1990 Annual Report

ANNUAL REPORT
TYPOGRAPHY/DESIGN RICK BESSER, SANTA MONICA, CALIFORNIA
TYPOGRAPHIC SOURCE COMPOSITION TYPE
STUDIO BESSER JOSEPH PARTNERS, INC.
CLIENT AGOURAN PHARMACEUTICALS, INC.
PRINCIPAL TYPES GARAMOND AND UNIVERS
DIMENSIONS 9½ × 12½ IN. (24.1 × 31.8 CM)

FITNESS / PROJECT HABITAT

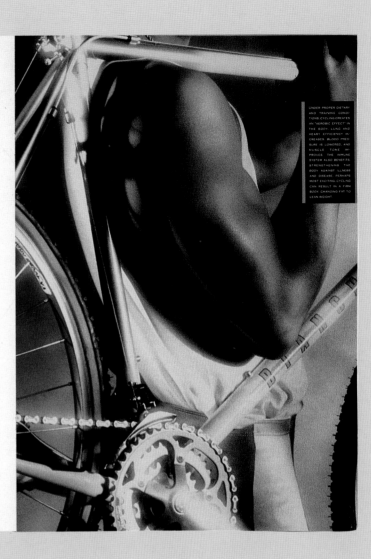

UNDER PROPER DIETARY AND TRAINING CONDITIONS, CYCLING CREATES AN "AEROBIC EFFECT" IN THE BODY. LUNG AND HEART EFFICIENCY INCREASES. BLOOD PRESSURE IS LOWERED, AND MUSCLE TONE IMPROVES. THE IMMUNE SYSTEM ALSO BENEFITS, STRENGTHENING THE BODY AGAINST ILLNESS AND DISEASE. PERHAPS MOST EXCITING, CYCLING CAN RESULT IN A FIRM BODY, CHANGING FAT TO LEAN WEIGHT.

CYCLING IS ONE OF THE BEST WAYS TO ACHIEVE ALL AROUND FITNESS. ALL YOU NEED IS YOUR BIKE, A PLACE TO RIDE, AND THE WILL TO GO FAR ENOUGH TO DO YOURSELF SOME GOOD. IT'S A DIRECT WAY TO INTERACT WITH YOURSELF AND YOUR ENVIRONMENT. THE BENEFITS OF CYCLING IN A PROPER PROGRAM OF DISTANCE AND SPEED YIELD VERY VISIBLE, DESIRABLE EFFECTS ON THE BODY.

TO REAP THESE BENEFITS, YOU NEED A BIKE THAT'S RESPONSIVE, QUICK, FUN TO RIDE AND, MOST OF ALL, COMFORTABLE. THAT SORT OF BIKE HAPPENS TO BE BIANCHI'S SPECIALITY.

WHILE WE'VE BEEN CREATING NEW FORMS OF CYCLING, WE'VE ALSO BEEN LOOKING AT THE IMPACT RIDING HAS ON THE ENVIRONMENT. OFF-ROAD RIDING HAS BEEN AFFECTED BY

ENVIRONMENTAL CONCERNS. RECKLESS RIDING CAN ENDANGER OTHERS WHO SHARE THE TRAILS AS WELL AS HABITATS OF INCREASINGLY RARE WILDLIFE. RESPONSIBLE RIDING ENSURES ACCESS TO OFF-ROAD TRAILS FOR THE RIDER, AND PROTECTION FOR THE CREATURES LIVING THERE. BIANCHI'S PROJECT HABITAT ADDRESSES THE OFF-ROAD ISSUE, WITH MOUNTAIN BIKES NAMED FOR ENDANGERED SPECIES AND GUIDELINES FOR SAFE RIDING. AS PART OF EVERY BIANCHI MOUNTAIN BIKE PURCHASE, WE MAKE A MONETARY CONTRIBUTION TO THE RAILS-TO-TRAILS CONSERVANCY, DEFENDERS OF WILDLIFE, OR YOUR PERSONAL CHOICE OF ENVIRONMENTAL GROUP.

IT'S A GREAT TIME TO GET FIT... AND TO MAKE A DIFFERENCE.

BROCHURE
TYPOGRAPHY/DESIGN MELINDA MANISCALCO, BURLINGAME, CALIFORNIA
LETTERER MELINDA MANISCALCO
TYPOGRAPHIC SOURCE EUROTYPE
STUDIO M DESIGN
CLIENT BIANCHI, U.S.A.
PRINCIPAL TYPE COPPERPLATE EXTENDED
DIMENSIONS 8½ × 11⅞ IN. (21.6 × 30.1 CM)

CHERRY HILL MALL

PACKAGING
TYPOGRAPHY/DESIGN JON FLAMING, DALLAS, TEXAS
TYPOGRAPHIC SOURCE IN-HOUSE
STUDIO SULLIVANPERKINS
CLIENT THE ROUSE COMPANY
PRINCIPAL TYPE FUTURA LIGHT CONDENSED
DIMENSIONS 14 × 18 × 6 IN. (35.6 × 45.7 × 15.2 CM)

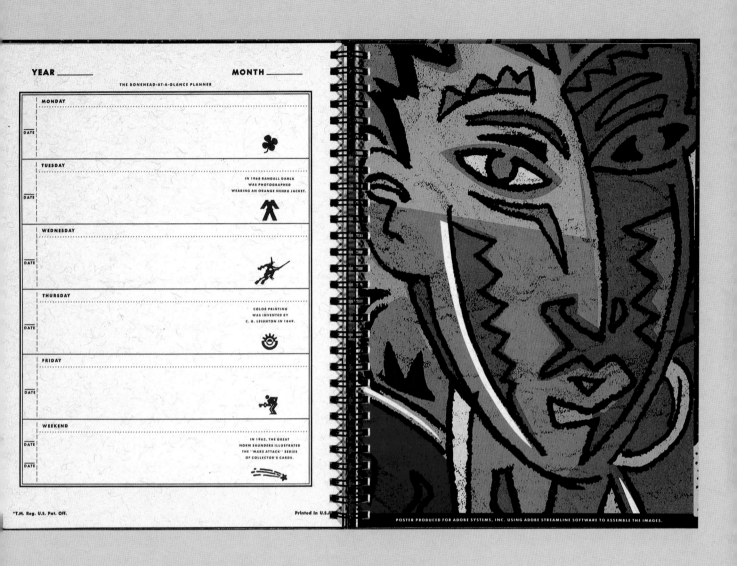

POSTER PRODUCED FOR ADOBE SYSTEMS, INC. USING ADOBE STREAMLINE SOFTWARE TO ASSEMBLE THE IMAGES.

CALENDAR
TYPOGRAPHY/DESIGN CHARLES S. ANDERSON AND DAN OLSON, MINNEAPOLIS, MINNESOTA
TYPOGRAPHIC SOURCE LINOTYPOGRAPHERS, FORT WORTH, TEXAS
STUDIO CHARLES S. ANDERSON DESIGN COMPANY
CLIENT CHARLES S. ANDERSON DESIGN COMPANY
PRINCIPAL TYPE SPARTAN
DIMENSIONS 8 × 10 IN. (20.3 × 25.4 CM)

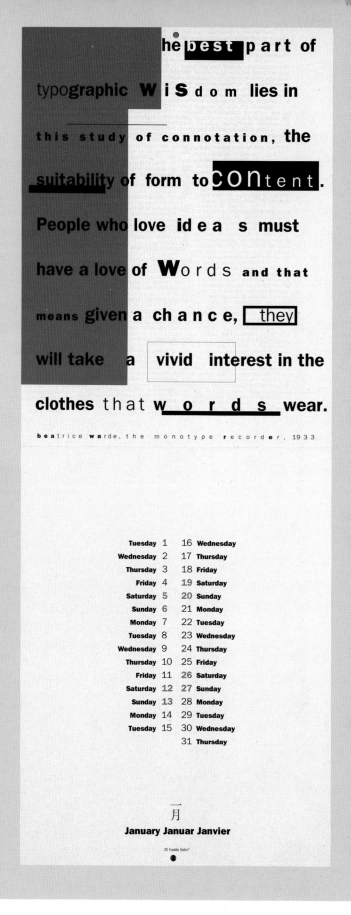

beatrice warde, the monotype recorder, 1933

Tuesday	1	16	Wednesday
Wednesday	2	17	Thursday
Thursday	3	18	Friday
Friday	4	19	Saturday
Saturday	5	20	Sunday
Sunday	6	21	Monday
Monday	7	22	Tuesday
Tuesday	8	23	Wednesday
Wednesday	9	24	Thursday
Thursday	10	25	Friday
Friday	11	26	Saturday
Saturday	12	27	Sunday
Sunday	13	28	Monday
Monday	14	29	Tuesday
Tuesday	15	30	Wednesday
		31	Thursday

一
月

January Januar Janvier

ITC Franklin Gothic®

CALENDAR
TYPOGRAPHY/DESIGN KAREN ANN, LORI BARNETT, ALICIA BUELOW, GAIL BLUMBERG, KIM BROWN, DON CRAIG, DEAN DAPKUS, EWA GAVRIELOV, KEALA HAGMANN, NAT ROBINSON, VERONICA RAMIREZ, LAURIE SZUJEWSKA, AND MIN WANG, MOUNTAIN VIEW, CALIFORNIA
TYPOGRAPHIC SOURCE IN-HOUSE
STUDIO ADOBE SYSTEMS, INC., ART DEPARTMENT
CLIENT ADOBE SYSTEMS, INC.
PRINCIPAL TYPES VARIOUS
DIMENSIONS 8½ × 11 IN. (21.6 × 27.9 CM)

96

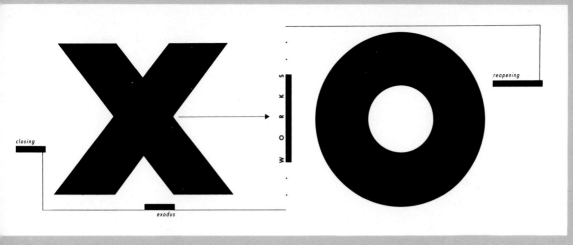

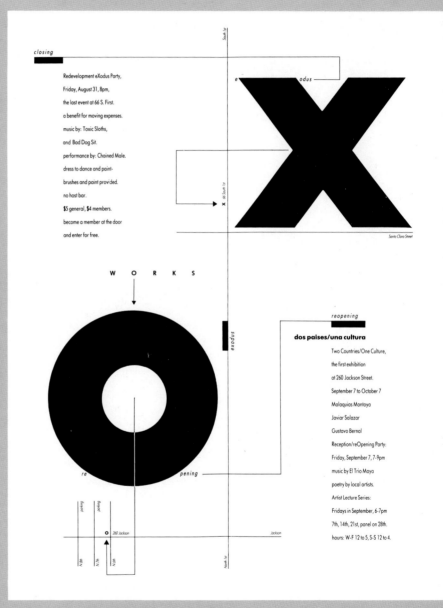

ANNOUNCEMENT
TYPOGRAPHY/DESIGN JOE MILLER, SAN JOSE, CALIFORNIA
LETTERER JOE MILLER
TYPOGRAPHIC SOURCE UNIVERSITY TYPOGRAPHICS
STUDIO JOE MILLER'S COMPANY
CLIENT WORKS GALLERY
PRINCIPAL TYPES FUTURA AND HANDLETTERING
DIMENSIONS 4¼ × 11 IN. (10.8 × 27.9 CM)

STATIONERY
TYPOGRAPHY/DESIGN DON ROOD, PORTLAND, OREGON
TYPOGRAPHIC SOURCE STUDIO SOURCE
STUDIO DON ROOD DESIGN
CLIENT DON ROOD DESIGN
PRINCIPAL TYPES FUTURA EXTRA BOLD, PEIGNOT DEMI BOLD, ITC BERKELEY, AND OLD STYLE BOLD
DIMENSIONS 8½ × 11 IN. (21.6 × 27.9 CM)

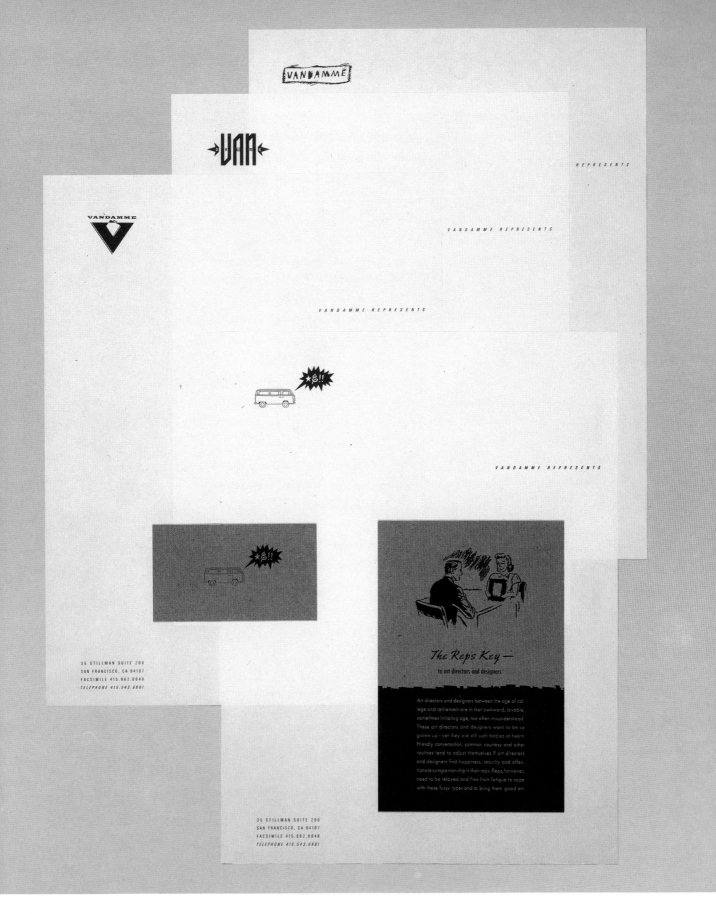

CORPORATE IDENTITY
TYPOGRAPHY/DESIGN DENNIS CROWE, JOHN PAPPAS, AND NEAL ZIMMERMANN, SAN FRANCISCO, CALIFORNIA
LETTERERS DENNIS CROWE, JOHN PAPPAS, AND NEAL ZIMMERMANN
TYPOGRAPHIC SOURCE EUROTYPE
STUDIO ZIMMERMANN CROWE DESIGN
CLIENT VANDAMME REPRESENTS, ARTIST'S REPRESENTATIVES
PRINCIPAL TYPES VARIOUS
DIMENSIONS VARIOUS

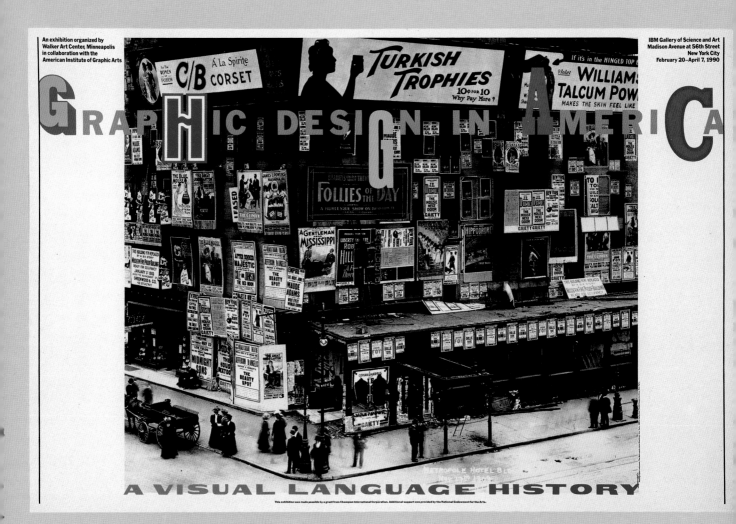

GRAPHIC DESIGN IN AMERICA

A VISUAL LANGUAGE HISTORY

This exhibition was made possible by a grant from Champion International Corporation. Additional support was provided by the National Endowment for the Arts.

POSTER
TYPOGRAPHY/DESIGN SEYMOUR CHWAST, NEW YORK, NEW YORK
STUDIO THE PUSHPIN GROUP
CLIENT IBM GALLERY
PRINCIPAL TYPE FRANKLIN GOTHIC
DIMENSIONS 36 × 24 IN. (91.4 × 61 CM)

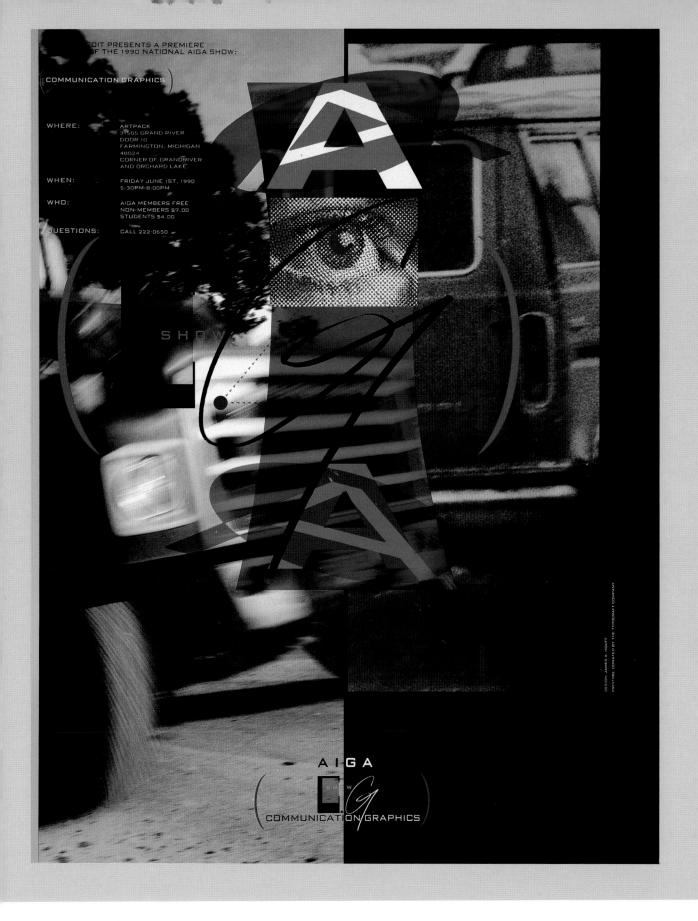

POSTER
TYPOGRAPHY/DESIGN JAMES A. HOUFF, GROSSE POINTE, MICHIGAN
CALLIGRAPHER JAMES A. HOUFF
TYPOGRAPHIC SOURCE IN-HOUSE
STUDIO JAMES A. HOUFF DESIGN
CLIENT THE AMERICAN INSTITUTE OF GRAPHIC ARTS/DETROIT CHAPTER
PRINCIPAL TYPES MAGNUM GOTHIC AND HANDLETTERING
DIMENSIONS 22 × 28 IN. (55.9 × 71.1 CM)

THE AIGA IS TURNING 75 YEARS OLD. SO?
SEVENTY-FIVE! THAT'S OLDER THAN YOU,
BUCKO. SO SNAP-TO AND SHOW A LITTLE
RESPECT. HAPPY BIRTHDAY TO YOU, HAPPY
BIRTHDAY TO YOU. IT'S A PARTY. THE BEST
BIRTHDAY PARTY YOU'VE BEEN INVITED TO
SINCE YOU WERE YAY-HIGH. AND HOSTED BY
YOUR FRIENDS AT THE MINNESOTA CHAPTER.
NOT EVERY KID GETS INTO THIS GIG. AIGA
MEMBERS ONLY, PLUS SPOUSES, SIGNIFICANT
OTHERS, AND A SELECT GROUP OF AIGA
VENDORS AND CHUMS. AND ZOWIE IT'S FREE.
FREE LIKE THE WIND AND TWICE AS COOL.
NOT A CHAPERONE IN SIGHT. A REAL LIVE
DJ, AND YOU GET TO STAY UP LATE. BETTER
WRITE THIS DOWN. MARCH ONE. 6 O'CLOCK.

INVITATION
TYPOGRAPHY/DESIGN SCOTT BARSUHN, MINNEAPOLIS, MINNESOTA
TYPOGRAPHIC SOURCES P & H PHOTO COMPOSITION, INC., AND LETTERWORX, INC.
STUDIO BARSUHN DESIGN
CLIENT THE AMERICAN INSTITUTE OF GRAPHIC ARTS/MINNESOTA CHAPTER
PRINCIPAL TYPE ALPHAVANTI EXTRA BOLD
DIMENSIONS 9 × 4¼ IN. (22.9 × 11.4 CM)

CHICAIGAO

N A T I O N A L I S S U E

AIGA in Chicago

A publication of the Chicago Chapter, the American Institute of Graphic Arts. This issue is supported by a grant from the National Endowment for the Arts, a Federal agency.

Spring 1990

**A Profession at the Crossroads—
Design Directions for the Coming Decade**
In this expanded edition of AIGA in Chicago, we have invited several leaders in design and related fields to share their visions of design for the 1990s.

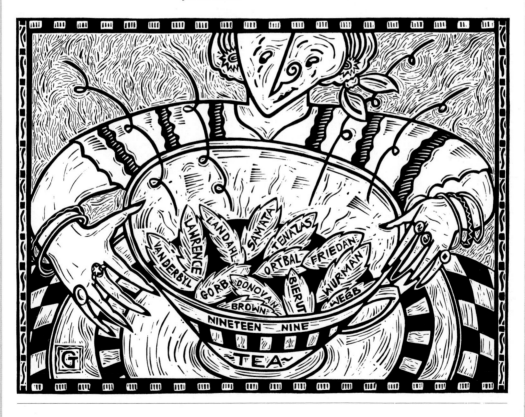

NEWSLETTER
TYPOGRAPHY/DESIGN BART CROSBY AND CARL WOHLT, CHICAGO, ILLINOIS
CALLIGRAPHER PATTI GREEN
TYPOGRAPHIC SOURCE SHORE TYPOGRAPHERS, INC.
STUDIO CROSBY ASSOCIATES, INC.
CLIENT THE AMERICAN INSTITUTE OF GRAPHIC ARTS/CHICAGO CHAPTER
PRINCIPAL TYPE ALPHA BODONI BOOK
DIMENSIONS 11 × 17 IN. (27.9 × 43.2 CM)

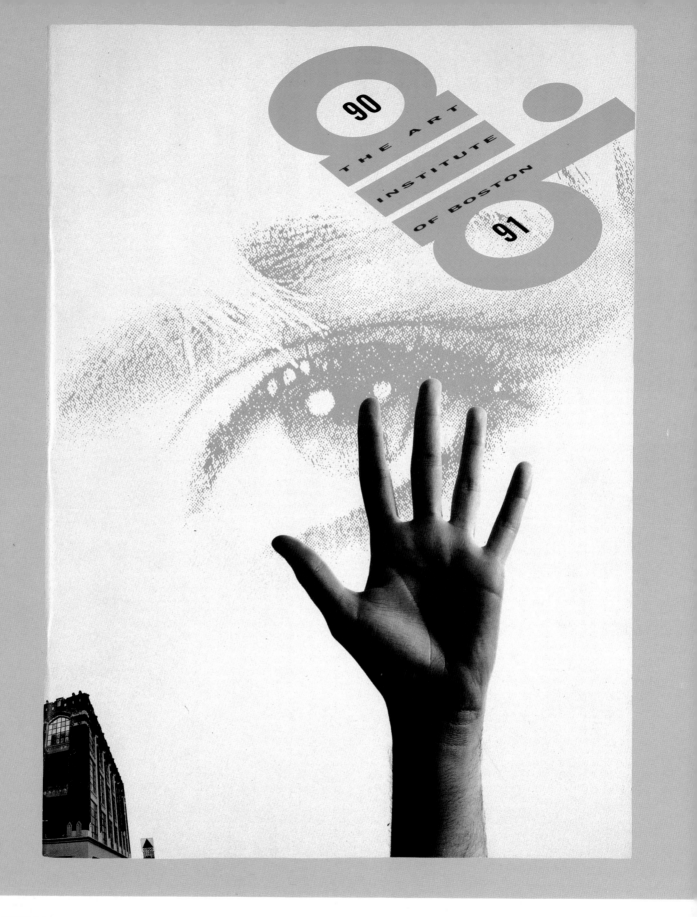

CATALOG
TYPOGRAPHY/DESIGN CLIFFORD STOLTZE, CAROL SLY, AND KYONG CHOE, BOSTON, MASSACHUSETTS
TYPOGRAPHIC SOURCE IN-HOUSE
STUDIO CLIFFORD STOLTZE DESIGN
CLIENT THE ART INSTITUTE OF BOSTON
PRINCIPAL TYPES FUTURA, FRANKLIN GOTHIC, NEWS GOTHIC, AND BODONI
DIMENSIONS 11 × 15 IN. (27.9 × 96.5 CM)

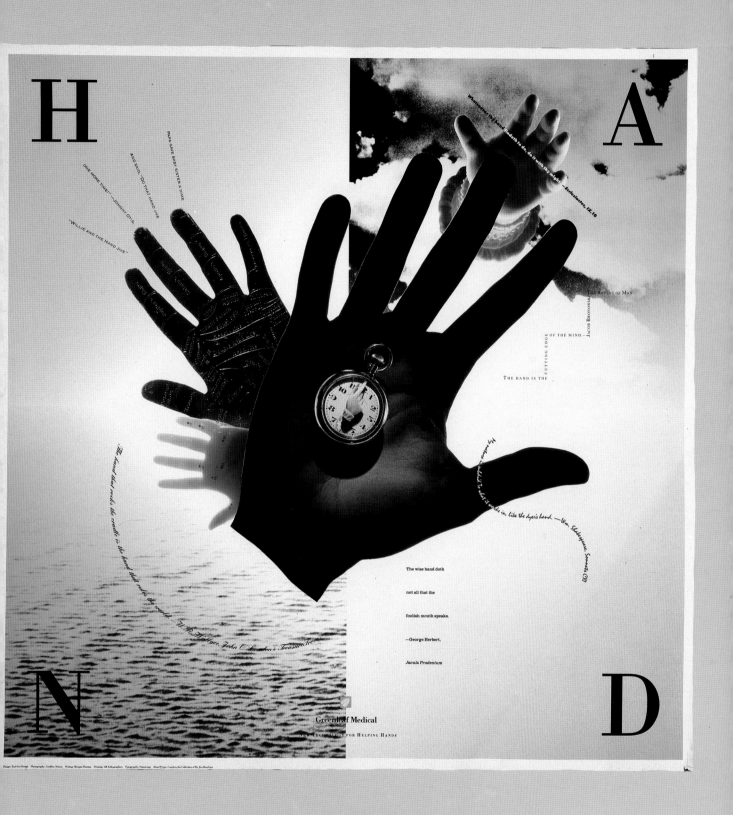

POSTER
TYPOGRAPHY/DESIGN EARL GEE, SAN FRANCISCO, CALIFORNIA
PHOTOGRAPHER GEOFFREY NELSON
WRITER MORGAN THOMAS
TYPOGRAPHIC SOURCE OMNICOMP
STUDIO EARL GEE DESIGN
CLIENT GREENLEAF MEDICAL
PRINCIPAL TYPES VARIOUS
DIMENSIONS 23¼ × 23¼ IN. (59.1 × 59.1 CM)

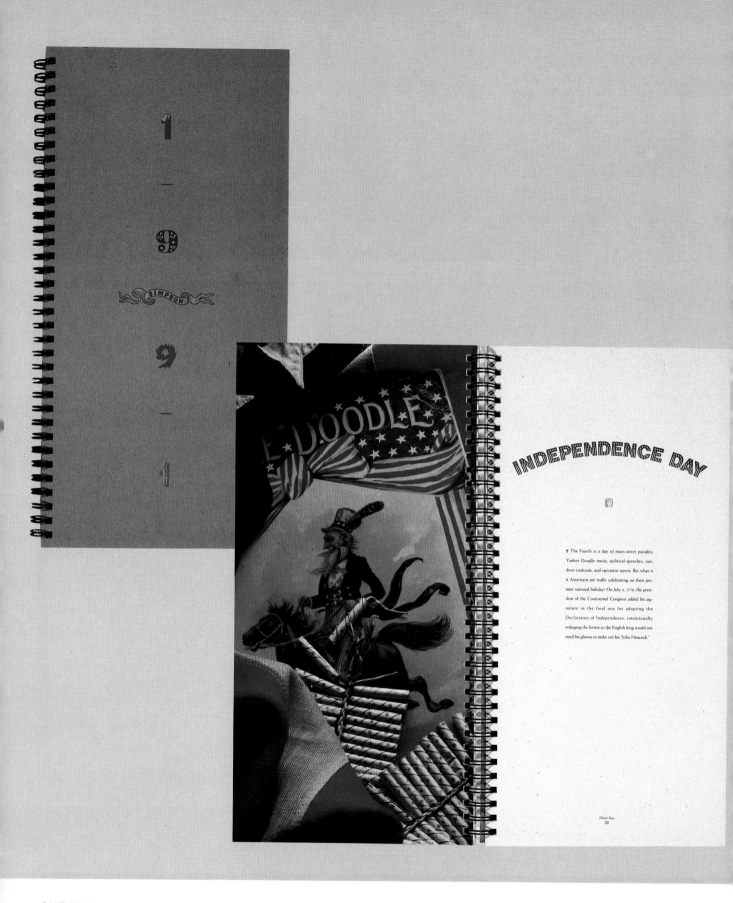

CALENDAR
TYPOGRAPHY/DESIGN STEVEN TOLLESON AND BOB AUFULDISH, SAN FRANCISCO, CALIFORNIA
TYPOGRAPHIC SOURCES SEVE'S HOUSE OF TYPE AND ANDRESEN TYPOGRAPHICS
STUDIO TOLLESON DESIGN
CLIENT SIMPSON PAPER COMPANY
PRINCIPAL TYPE FUTURA BOOK
DIMENSIONS 6¼ × 12 IN. (15.9 × 30.5 CM)

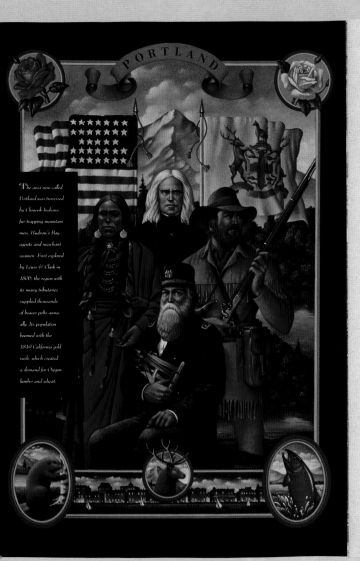

The area now called
Portland was traversed
by Chinook Indians,
fur-trapping mountain
men, Hudson's Bay
agents and merchant
seamen. First explored
by Lewis & Clark in
1806, the region with
its many tributaries
supplied thousands
of beaver pelts annu-
ally. Its population
boomed with the
1849 California gold
rush, which created
a demand for Oregon
lumber and wheat.

Portland got its
name through a toss of
a coin. In 1845, pio-
neer land developers
Asa L. Lovejoy and
Francis W. Pettygrove
set up a townsite on
the west bank of the
Willamette River to
serve as a trading cen-
ter for immigrants
arriving by wagon train.
The former New Eng-
landers debated what
to call the clearing that
they envisioned as a
future town. Lovejoy
who came from Mas-
sachusetts wanted
to name it Boston.
Pettygrove from Maine
thought that Portland
sounded more distin-
guished. To settle the
matter democratically,
they flipped a coin.

GAC traces its origins
to a high-quality letter-
press and stone lith-
ography company
founded in Portland
over a century ago.
We have encompassed
more than a dozen
printing and typogra-
phy firms and a bindery.
The knowledge and
expertise acquired
along the way have
helped us refine the
scope of our services
and develop resources
unsurpassed in the
printing industry today.

BROCHURE
TYPOGRAPHY/DESIGN PENTAGRAM DESIGN, SAN FRANCISCO, CALIFORNIA
TYPOGRAPHIC SOURCE SPARTAN TYPOGRAPHY
STUDIO PENTAGRAM DESIGN
CLIENT GRAPHIC ARTS CENTER/PORTLAND, OREGON
PRINCIPAL TYPES FUTURA LIGHT AND BERNHARD MODERN
DIMENSIONS 8 × 11¾ IN. (20.3 × 29.8 CM)

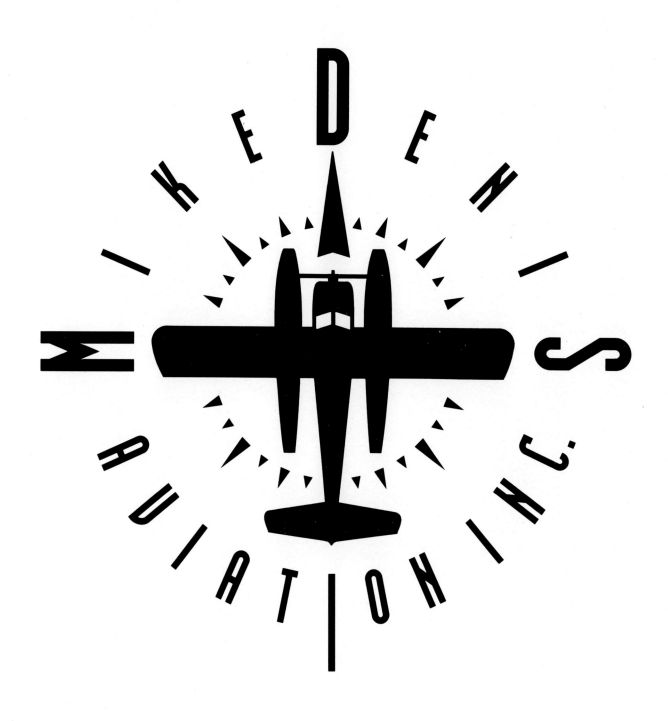

LOGOTYPE
TYPOGRAPHY/DESIGN PETER BAKER, BLUE SEA LAKE, QUEBEC, CANADA
TYPOGRAPHIC SOURCE EMIGRE GRAPHICS
STUDIO ISLAND #10
CLIENT MIKE DENIS
PRINCIPAL TYPE EMIGRE MODULA

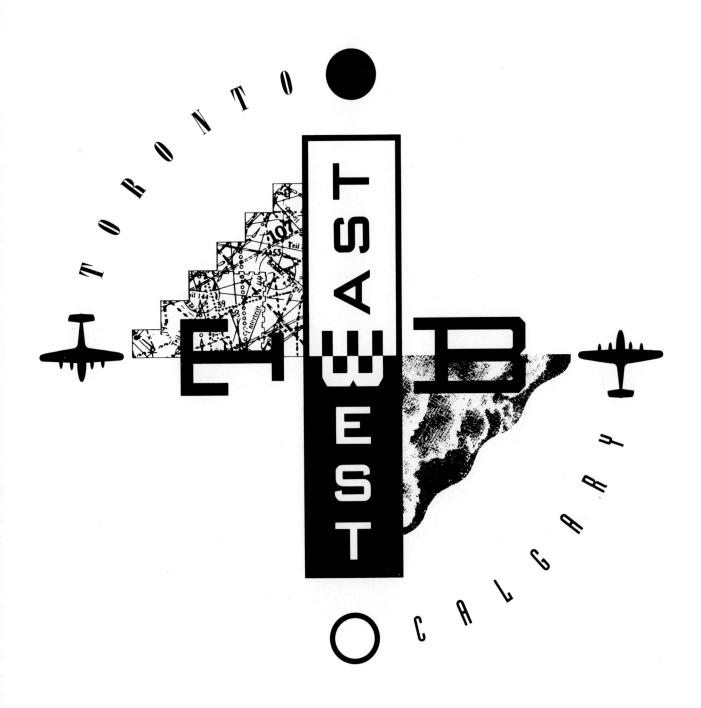

TORONTO

EAST

WEST

CALGARY

LOGOTYPE
TYPOGRAPHY/DESIGN PETER BAKER AND PAUL CAMPBELL, TORONTO, ONTARIO, CANADA
LETTERER DAVID DRUMMOND
STUDIO TAYLOR & BROWNING DESIGN ASSOCIATES
PRINCIPAL TYPE MAGNUM GOTHIC

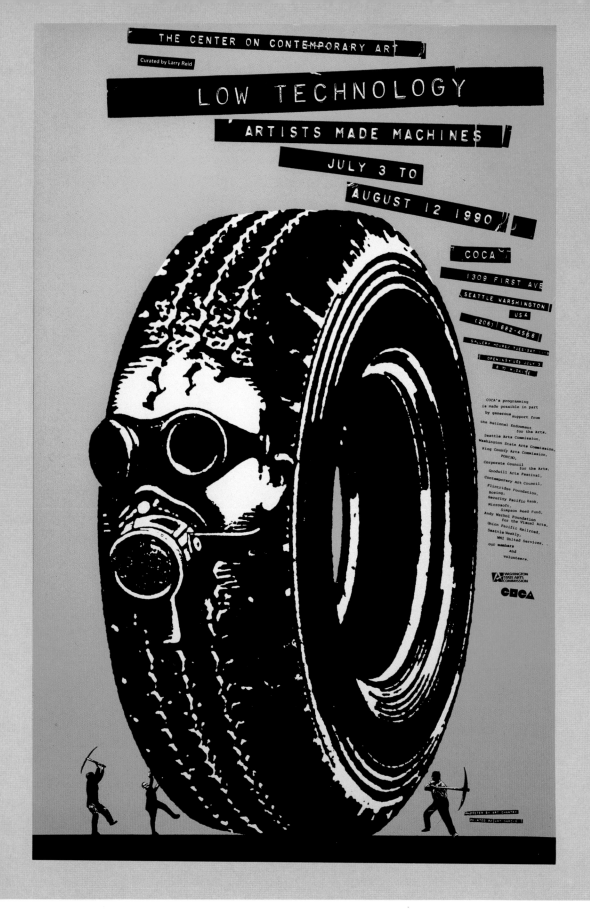

POSTER
TYPOGRAPHY/DESIGN ART CHANTRY, Seattle, Washington
TYPOGRAPHIC SOURCE ''MIGHTY MITE'' LABEL MAKER
STUDIO ART CHANTRY DESIGN
CLIENT CENTER ON CONTEMPORARY ART (COCA)
DIMENSIONS 19¾ × 30⅝ IN. (50.2 × 78 CM)

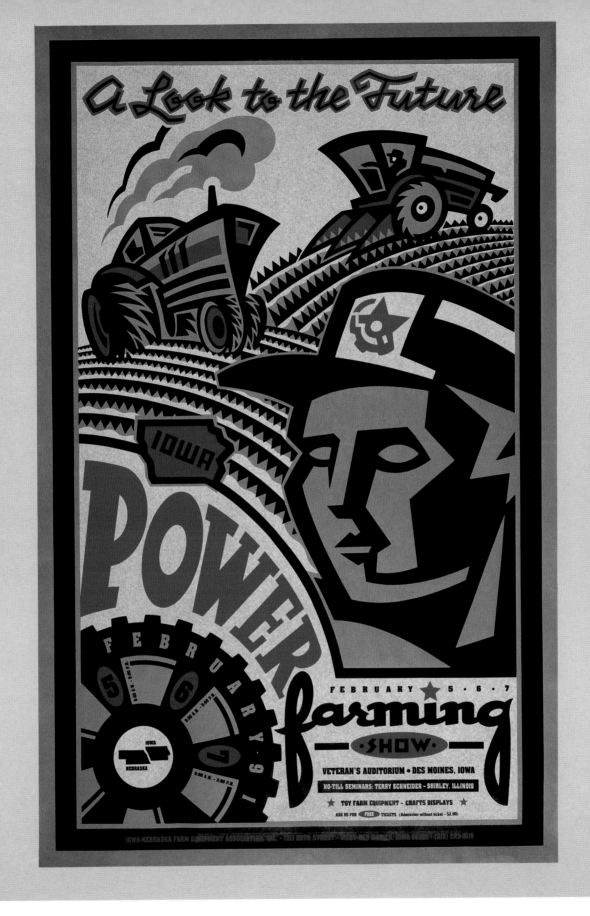

POSTER
TYPOGRAPHY/DESIGN JOHN SAYLES, DES MOINES, IOWA
CALLIGRAPHER JOHN SAYLES
TYPOGRAPHIC SOURCE PUSH-PEN, INC.
STUDIO SAYLES GRAPHIC DESIGN
CLIENT IOWA-NEBRASKA FARM EQUIPMENT ASSOCIATION
PRINCIPAL TYPES AACHEN BOLD CONDENSED AND HANDLETTERING
DIMENSIONS 32 × 50 IN. (81.3 × 127 CM)

PACKAGING
TYPOGRAPHY/DESIGN CHARLES S. ANDERSON AND DAN OLSON, MINNEAPOLIS, MINNESOTA
TYPOGRAPHIC SOURCE LINOTYPOGRAPHERS, FORT WORTH, TEXAS
STUDIO CHARLES S. ANDERSON DESIGN COMPANY
CLIENT LEVI STRAUSS CO.
PRINCIPAL TYPES VARIOUS
DIMENSIONS 14 × 10 IN. (35.6 × 25.4 CM)

LOGOTYPE
TYPOGRAPHY/DESIGN ED BENGUIAT, New York, New York
LETTERER ED BENGUIAT
TYPOGRAPHIC SOURCE PHOTO-LETTERING, INC.
STUDIO PHOTO-LETTERING, INC.
CLIENT ALPHABET & IMAGES, INCORPORATED
PRINCIPAL TYPE HANDLETTERING

LOGOTYPE
TYPOGRAPHY/DESIGN JOE DUFFY, MINNEAPOLIS, MINNESOTA
LETTERER LYNN SCHULTE
TYPOGRAPHIC SOURCE P & H PHOTO COMPOSITION
STUDIO THE DUFFY DESIGN GROUP
CLIENT GORBACHEV VISIT COMMITTEE/MINNEAPOLIS
PRINCIPAL TYPE HANDLETTERING

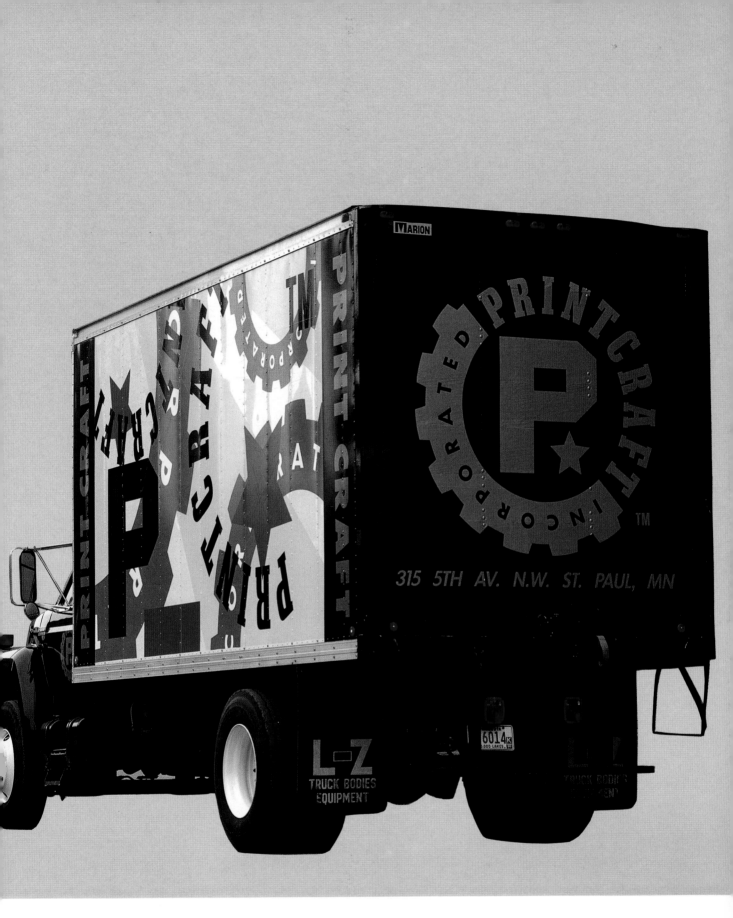

CORPORATE IDENTITY
TYPOGRAPHY/DESIGN CHARLES S. ANDERSON AND DAN OLSON, MINNEAPOLIS, MINNESOTA
TYPOGRAPHIC SOURCE LINOTYPOGRAPHERS, FORT WORTH, TEXAS
STUDIO CHARLES S. ANDERSON DESIGN COMPANY
CLIENT PRINT CRAFT, INC.
PRINCIPAL TYPE SPARTAN

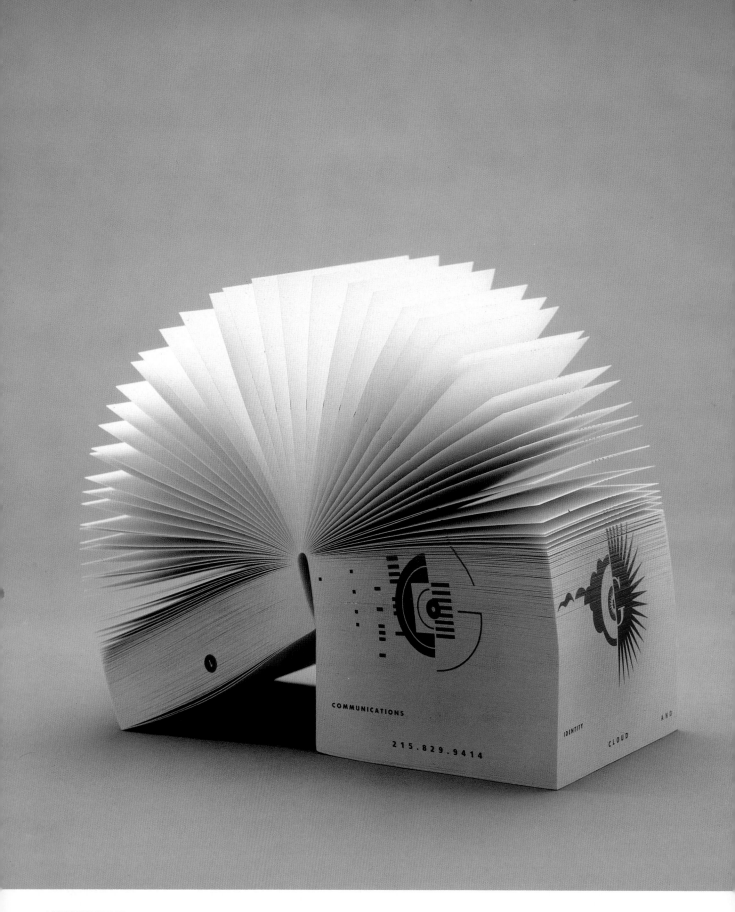

ADVERTISEMENT
TYPOGRAPHY/DESIGN JEROME CLOUD, PHILADELPHIA, PENNSYLVANIA
LETTERER JEROME CLOUD
TYPOGRAPHIC SOURCE IN-HOUSE
STUDIO CLOUD AND GEHSHAN ASSOCIATES, INC.
CLIENT CLOUD AND GEHSHAN ASSOCIATES, INC.
PRINCIPAL TYPES FRUTIGER, BODONI, AND HANDLETTERING
DIMENSIONS 3⅝ × 3⅝ IN. (9.2 × 9.2 × 9.2 CM)

WHY?

Cable

Time Warner Cable is the second-largest cable operator in the U.S., with systems in 35 states.

Time Warner Cable Group is:

American Television and Communications Corp. (ATC), 82% owned; Warner Cable Communications Inc., 100% owned.

Pro Forma* (in millions)	1989	1988
Revenues	$1,543	$1,268
EBITDA	$ 644	$ 444

Margin grew to 41.7%

*Includes 100% of the operating results of Warner Communications Inc. See Note 2 on page 40.

▶ Cable is the best entertainment value in the world today.

Cable operators have greatly expanded their channel capacity, offering more and varied options to the consumer. Prices on a per-channel basis have remained virtually flat, only increasing from $0.44 per month in 1986 to $0.46 in 1988.

Every year, the industry commits millions of dollars for plant upgrades to continually improve the value delivered to our customers. Time Warner Cable had capital expenditures in 1989 of $280 million and estimates $300 million for 1990.

■ Warner Cable Systems
△ ATC Systems

NEW ALL-TIME HIGHS

CLUSTERING

Major benefits:
• economies of scale
• operating efficiencies
• marketing efficiencies - advertising.

1989 Major Acquisitions: systems that built upon our cluster philosophy.

ATC added 105,000 subscribers in Florida. Warner Cable added 107,000 subscribers in Ohio.

• Time Warner Cable owns 25 of the top 100 systems in the U.S.
• Clustering in attractive, high-growth areas such as New York, Florida, Ohio and North Carolina

SUBSCRIBERS

SUBSCRIBER STATISTICS

	ATC 89	ATC 88	Warner Cable 89	Warner Cable 88	Time Warner Cable 89	Time Warner Cable 88
Homes Passed (mil.)	7.41	6.89	3.32	2.88	10.73	9.77
Basic Subscribers (mil.)	4.40	4.04	1.74	1.53	6.14	5.57
Basic Penetration	59.3%	58.6%	52.4%	53.1%	57.2%	57.0%
Pay Units (mil.)	3.22	3.13	1.52	1.34	4.74	4.47

Note: Includes unconsolidated systems.

New York City Territory includes Manhattan Cable, Paragon Manhattan, American Cablevision of Queens, Brooklyn Queens Cable, and Queens Inner Unity Cable.

NEW YORK CITY

(in thousands)	1989	1988
Basic Subscribers	619.8	516.4
Pay Units	715.8	554.6

Advertising and pay-per-view are the two greatest opportunities for incremental income.

ADVERTISING

Time Warner Cable advertising sales are continuing to grow strongly—37% increase in 1989.

Pay-per-view revenues grew over 49% in 1989. 77% of all subscribers are in addressable systems.

CABLE INDUSTRY

(in millions)	89	88	87	86	85
TV Households	90.2	88.6	87.4	85.9	84.9
Homes Passed	80.3	77.2	73.1	69.4	64.7
Basic Subscribers	49.4	45.7	42.6	39.7	36.7
Pay Units	41.9	38.8	34.8	32.1	30.6

Source: Paul Kagan Associates, Inc.

TECHNOLOGY

Time Warner Cable is enhancing its systems through the use of fiber optic "backbones" to bring even more channels, clearer pictures, and greater reliability.

In Rochester, N.Y., ATC launched a test: WGRC, the company's first independent cable station.

PROGRAMMING

Strong programming attracts and retains customers. New services added in 1989 included Turner Network Television, HBO's The Comedy Channel, and regional sports networks.

Time Warner owns 18% of Turner Broadcasting System.

CUSTOMER SERVICE

Subscriber satisfaction and customer service are a critical part of Time Warner Cable's strategy for improving operating results.

ATC and Warner Cable continued their commitment to customer service in 1989, concentrating on advanced training of customer service representatives, technicians, and installers. Our customer service standards are among the highest in the industry.

Time Warner Cable supports local community service activities such as:

• Muscular Dystrophy Association
• Time To Read, volunteer literacy program
• Holiday Food Harvest, aiding the homeless
• Make a Difference Foundation, supporting drug prevention
• Society to Prevent Blindness

ANNUAL REPORT
TYPOGRAPHY/DESIGN RIKI SETHIADI, NEW YORK, NEW YORK
CREATIVE DIRECTOR KENT HUNTER
TYPOGRAPHIC SOURCE IN-HOUSE
AGENCY FRANKFURT GIPS BALKIND
CLIENT TIME WARNER, INC.
PRINCIPAL TYPES FRANKLIN GOTHIC AND GARAMOND NO. 3
DIMENSIONS 9 × 11 IN. (22.9 × 27.9 CM)

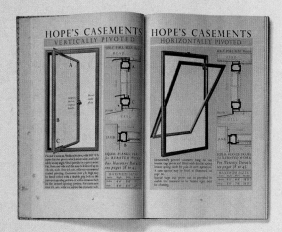

*The promotional material for
Henry Hope & Sons shows an exquisite
consistency of design. Early work produced
at the Kynoch Press through Herbert Simon
was continued when he joined his brother
Oliver at the Curwen Press in 1933.
This consistency, shown through the use of
the earlier Cloister and Caslon faces,
continued with Perpetua, seen in this example
of 1951, a bold use for such a subject but
nevertheless successful and much in keeping
with Curwen's 'spirit of joy' philosophy.*

22

O LORD and heavenly Father, the exalter
of the humble and the strength of thy
chosen, who by anointing with Oil didst
of old make and consecrate kings, priests,
and prophets, to teach and govern thy
people Israel: Bless and sanctify thy chosen
servant ELIZABETH, who by our office and
ministry is now to be anointed with this
Oil, and consecrated Queen: Strengthen
her, O Lord, with the Holy Ghost the Com-
forter; Confirm and stablish her with thy
free and princely Spirit, the Spirit of wisdom
and government, the Spirit of counsel and
ghostly strength, the Spirit of knowledge
and true godliness, and fill her, O Lord,
with the Spirit of thy holy fear, now and for
ever; through Jesus Christ our Lord.
R̃ Amen.

This prayer being ended, and the people
standing, the choir shall sing:

1 Kings i. 39, 40

Z ADOK the priest and Nathan the prophet
anointed Solomon king; and all the

*The Coronation, 1953.
Page from the 'Form and Order of Service'
made to the order of HMSO by the
Privilege Printers Eyre &, Spottiswoode.
Typography by H P R Finberg and hand-set
by V D Green at the Chiswick Press in
24pt Perpetua roman. Two separate revised
drafts in January 1953 necessitated over-
running. The special response mark, never
previously ordered for this size, was produced
by The Monotype Corporation in four days.
One of the 72 variant cards of admission
printed by Harrison & Sons.*

*Stuart Rose's redesign for the
GPO symbol, embodying the post-war
classical quality of elegance within a
contemporary fluid shape, setting free the
harsh geometry of its predecessor.*

23

JOURNAL
TYPOGRAPHY/DESIGN LEONARD CURRIE AND DAVID QUAY, LONDON, ENGLAND
PRINTER SPIN OFFSET LIMITED
TYPOGRAPHIC SOURCE MONOTEXT, SWEDEN
STUDIO STUDIO 12
CLIENT THE MONOTYPE CORPORATION PLC
PRINCIPAL TYPES GILL SANS, PERPETUA, AND JOANNA
DIMENSIONS 8¼ × 11¾ IN. (21 × 29.7 CM)

He was thirty when he first drew *A*n alphabet, forty-six *B*efore he counted himself a professional type designer. Yet by the end of his long life

Frederic Goudy

had become the most famous type designer in the world. This eccentric American *C*reated more than a hundred faces, including perhaps a *D*ozen that rank among the best ever made. He was an exasperating loner, but he used his celebrity to stimulate *&* enliven debates about type & typography that amounted to a kind of national education in the *E*sthetics of type design.

SWASH LETTER STUDIES

ORNATE TITLE

COPPERPLATE GOTHIC

GOUDY TEXT SHADED

GOUDY OLD STYLE ITALIC

CLOISTER INITIALS

D. J. R. BRUCKNER ❦ MASTERS OF AMERICAN DESIGN

BOOK
TYPOGRAPHY/DESIGN JOHN BAXTER, WICHITA, KANSAS
TYPOGRAPHIC SOURCE RICHARD BEATTY DESIGNS
STUDIO JOHN BAXTER DESIGN
CLIENT HARRY N. ABRAMS PUBLISHING/DOCUMENTS OF AMERICAN DESIGN
PRINCIPAL TYPES MONOTYPE BODONI BOOK AND KENNERLY XT
DIMENSIONS 9 × 12 IN. (22.9 × 30.5 CM)

Departmental Organization

The courses of study at Art Center are distributed among ten instructional departments, some of which in turn support additional major study areas. A careful reading of the catalog will provide a sense of collegewide structure, but essentially the departments are Advertising, Computer Graphics, Film, Fine Art, Foundation Programs, Graphic and Packaging Design, Illustration (including Fashion Illustration), Industrial Design (including Transportation Design, Product Design, and Environmental Design), Liberal Arts and Sciences, and Photography. Responsible for overseeing the educational policy, direction, course requirements, and overall curriculum of each department is an appointed chair. Several

21

BOOK
TYPOGRAPHY/DESIGN REBECA MÉNDEZ AND ELLEN EISNER, PASADENA, CALIFORNIA
TYPOGRAPHIC SOURCE IN-HOUSE
STUDIO ART CENTER COLLEGE OF DESIGN (DESIGN OFFICE)
CLIENT ART CENTER COLLEGE OF DESIGN
PRINCIPAL TYPES BASKERVILLE NO. 2A AND GILL SANS
DIMENSIONS 8½ × 7 IN. (21.6 × 17.8 CM)

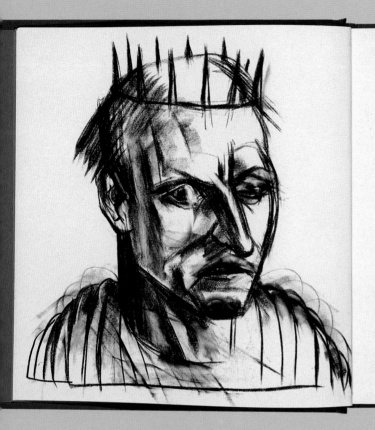

THE WINTER'S TALE

By WILLIAM SHAKESPEARE

DESIGN BY MARTIN SOLOMON
ILLUSTRATIONS BY ISADORE SELTZER

PUBLISHED BY
ROYAL COMPOSING ROOM, INC.
FINCH, PRUYN & COMPANY, INC.
HOROWITZ/RAE BOOK MANUFACTURERS, INC.

BOOK
TYPOGRAPHY/DESIGN MARTIN SOLOMON, New York, New York
TYPOGRAPHIC SOURCE ROYAL COMPOSING ROOM, INC.
STUDIO ROYAL COMPOSING ROOM, INC.
CLIENTS ROYAL COMPOSING ROOM, INC., FINCH, PRUYN & COMPANY, INC., AND HOROWITZ, RAE BOOK MANUFACTURERS, INC.
PRINCIPAL TYPE WEISS ROMAN
DIMENSIONS 8 × 8¼ IN. (20.3 × 20.6 CM)

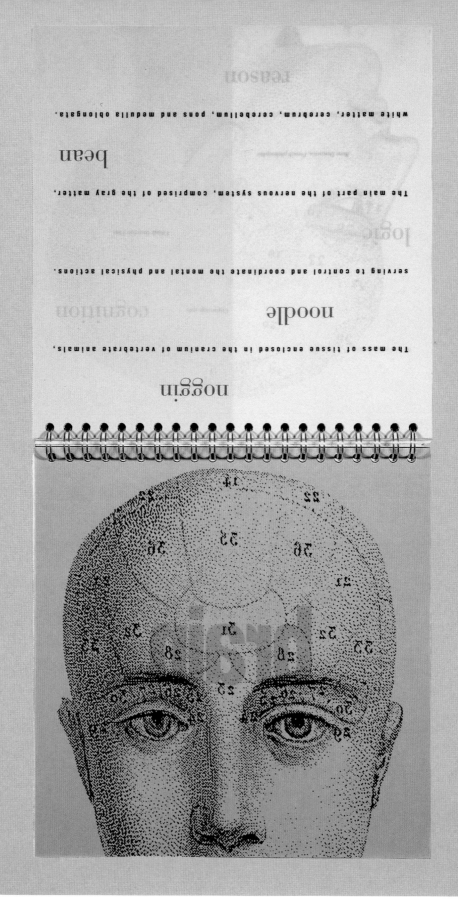

BOOK
TYPOGRAPHY/DESIGN MARK OLDACH, CHICAGO, ILLINOIS
TYPOGRAPHIC SOURCE MASTER TYPOGRAPHERS
STUDIO MARK OLDACH DESIGN
CLIENT USG INTERIORS, INC.
PRINCIPAL TYPES HELVETICA BLACK CONDENSED AND BAUER BODONI
DIMENSIONS 11 × 11 IN. (27.9 × 27.9 CM)

gold containing a large percentage of silver. [L., < Gr.*elektron*, amber.]

e-lec´tu-a-ry, 1 ɪ-lek´´chu-[*or* -tiu-]ē-ri; 2 e-lĕc´´chu-[*or* -tū-]ā-ry, *n.* [-RIES², *pl.*] A confection made by incorporating a medicine with some sweet substance. [< LL. *electuarium,* < Gr. *ekleikton,* < *ek,* out,+ *leicho* , lick.]

el´´e-e-mos´y-na-ry, ĕl´´e-e-mŏs´y-nā-ry. *adj.* **1.** Of, relating to, or contributed as charity. [< Gr. *eleēmosynē;* see ALMS.] **2.** A play by *Lee Blessing* in which three generations of women are bound together by the love and dreams they share. *Presented by* > [TheaterWorks] at the Bronson & Hutensky Theater – 233 Pearl Street, Downtown Hartford. January 11 through February 10, 1991. Performances Wednesdays through Saturdays at 8 p.m. and Sunday matinees at 2:30 p.m. *Tickets* $10; college students & seniors $8; high school students – free. For tickets *call* 527-7838. *Presented* with the cooperation of the Hartford Advocate and made possible by United Technologies Corporation.

el´e´-gant, 1 el´ɪ-gant; 2 ĕl´e-ḡant, *a.* **1.** Marked by refinement, grace, or symmetry; as of action, form or structure; also possessing or exhibiting refined taste. **2.** Possessing a fine sense

Kit: ℗ [design] Peter Good. ℗ [printing] Allied Printing Services, Inc. °& [posters] available at The David Byres Gallery - Hartford and Glastonbury.

POSTER
TYPOGRAPHY/DESIGN PETER GOOD, CHESTER, CONNECTICUT
TYPOGRAPHIC SOURCE KIMSET
STUDIO PETER GOOD GRAPHIC DESIGN
CLIENT THEATERWORKS
PRINCIPAL TYPE JANSON TEXT
DIMENSIONS 38 × 24 IN. (96.5 × 61 CM)

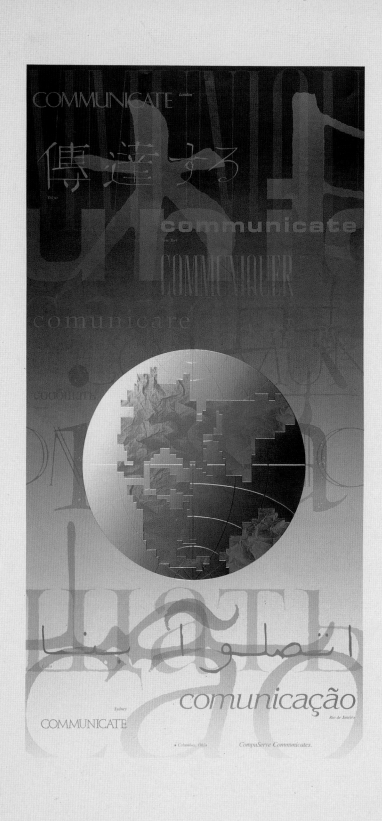

POSTER
TYPOGRAPHY/DESIGN LORI SIEBERT AND DAVID CARROLL, CINCINNATI, OHIO
LETTERER DAVID CARROLL
TYPOGRAPHIC SOURCE HARLAN TYPOGRAPHIC
AGENCY SIVE ASSOCIATES
STUDIO SIEBERT DESIGN ASSOCIATES
CLIENT COMPUSERVE
PRINCIPAL TYPES VARIOUS
DIMENSIONS 30¾ × 17¾ IN. (78.1 × 45.1 CM)

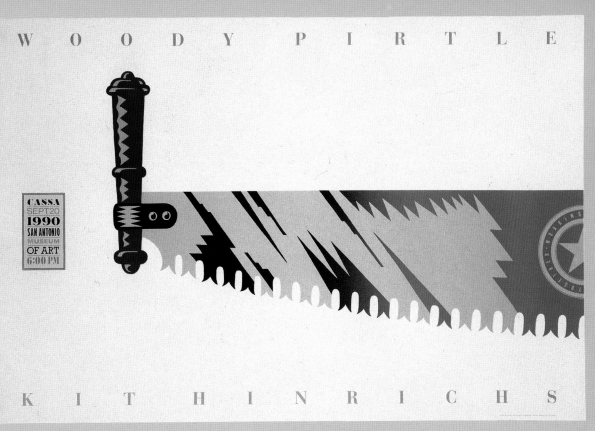

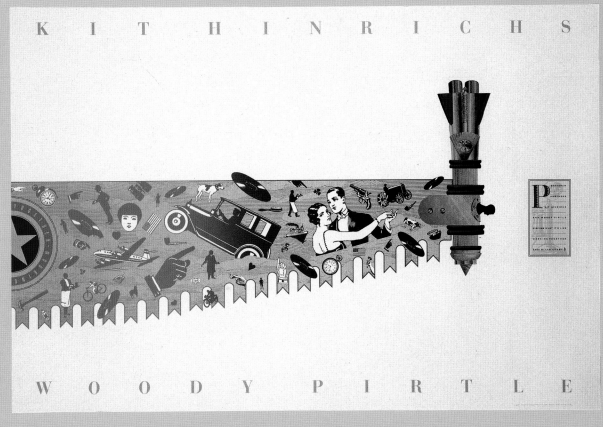

POSTER
TYPOGRAPHY/DESIGN KIT HINRICHS, WOODY PIRTLE, JENNIFER LONG, AND MATT HECK,
SAN FRANCISCO, CALIFORNIA, AND NEW YORK, NEW YORK
TYPOGRAPHIC SOURCE MONOGRAM
STUDIO PENTAGRAM DESIGN
CLIENT COMMUNICATION ARTS SOCIETY OF SAN ANTONIO
PRINCIPAL TYPES VARIOUS
DIMENSIONS 24 × 36 IN. (61 × 91.4 CM)

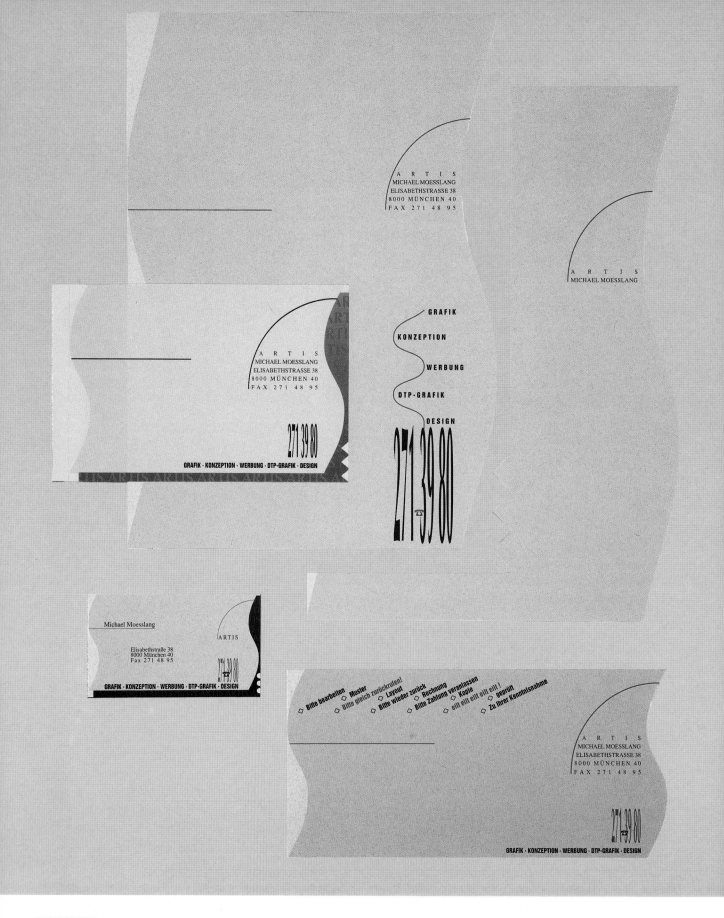

STATIONERY
TYPOGRAPHY/DESIGN MICHAEL MOESSLANG, MUNICH, GERMANY
TYPOGRAPHIC SOURCE IN-HOUSE
STUDIO ARTIS MICHAEL MOESSLANG
CLIENT ARTIS MICHAEL MOESSLANG
PRINCIPAL TYPES VARIOUS
DIMENSIONS 8½ × 11 IN. (21.6 × 27.9 CM)

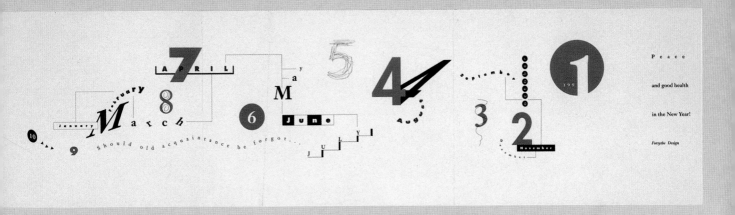

Should old acquaintance be forgot...

Peace

and good health

in the New Year!

Forsythe Design

GREETING CARD
TYPOGRAPHY/DESIGN JANE CUTHBERTSON, CAMBRIDGE, MASSACHUSETTS
LETTERER JANE CUTHBERTSON
TYPOGRAPHIC SOURCE GRAPHICS EXPRESS
STUDIO FORSYTHE DESIGN
CLIENT FORSYTHE DESIGN
PRINCIPAL TYPES VARIOUS
DIMENSIONS 15½ × 4¼ IN. (39.4 × 10.8 CM)

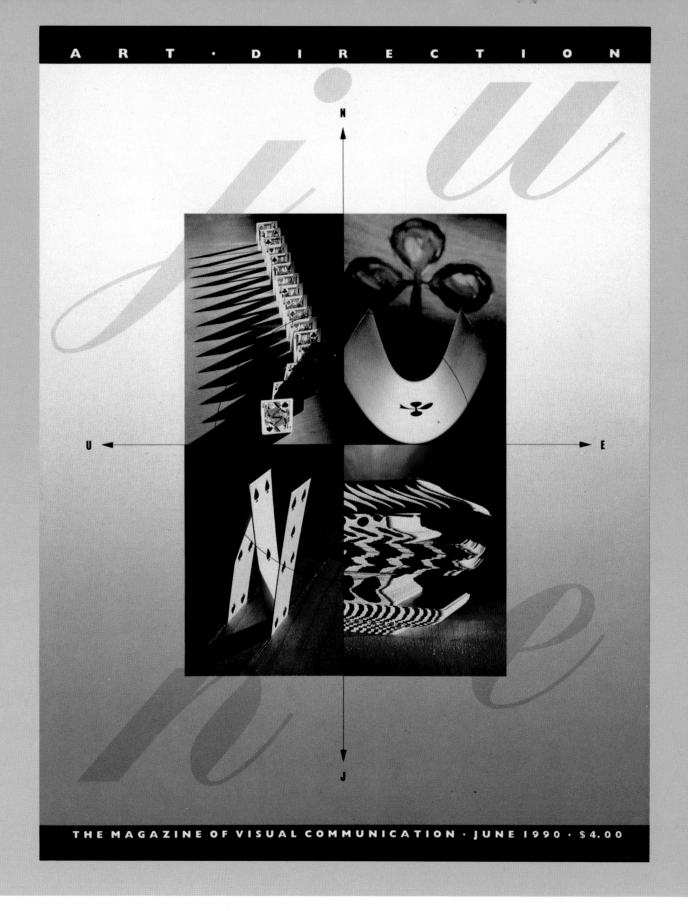

MAGAZINE COVER
TYPOGRAPHY/DESIGN VICTORIA PESLAK AND MELISSA NORTON, NEW YORK, NEW YORK
PHOTOGRAPHER JAMES WOJCIK
TYPOGRAPHIC SOURCES GERARD ASSOCIATES
STUDIO PLATINUM DESIGN, INC.
CLIENT ART DIRECTION MAGAZINE
PRINCIPAL TYPES GILL SANS EXTRA BOLD AND KUENSTLER BLACK
DIMENSIONS 8½ × 11¼ IN. (21.6 × 28.6 CM)

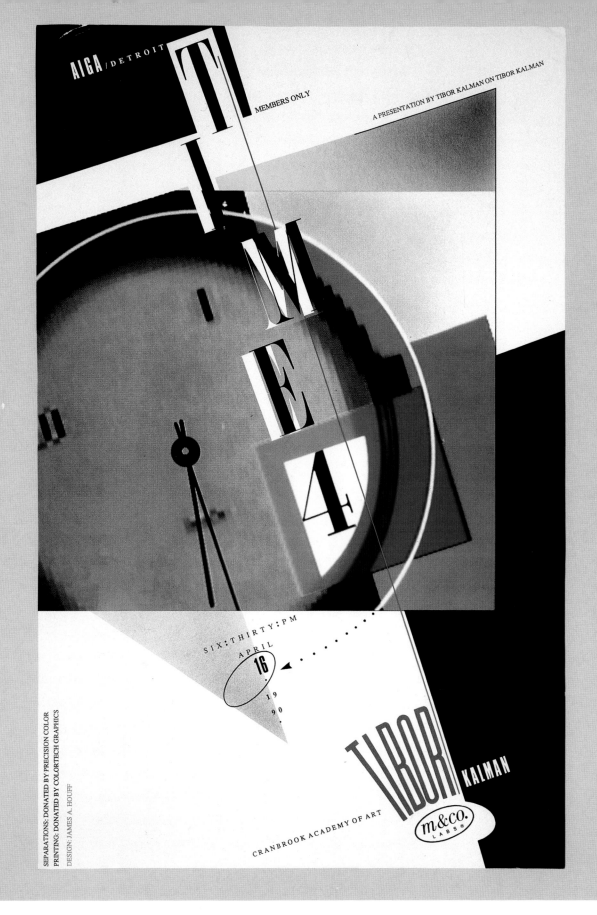

ANNOUNCEMENT
TYPOGRAPHY/DESIGN JAMES A. HOUFF, GROSSE POINTE, MICHIGAN
TYPOGRAPHIC SOURCE DICK MARTINI & ASSOCIATES, INC.
STUDIO JAMES A. HOUFF DESIGN
CLIENT THE AMERICAN INSTITUTE OF GRAPHIC ARTS/DETROIT CHAPTER
PRINCIPAL TYPE H5
DIMENSIONS 11 × 17 IN. (27.9 × 43.2 CM)

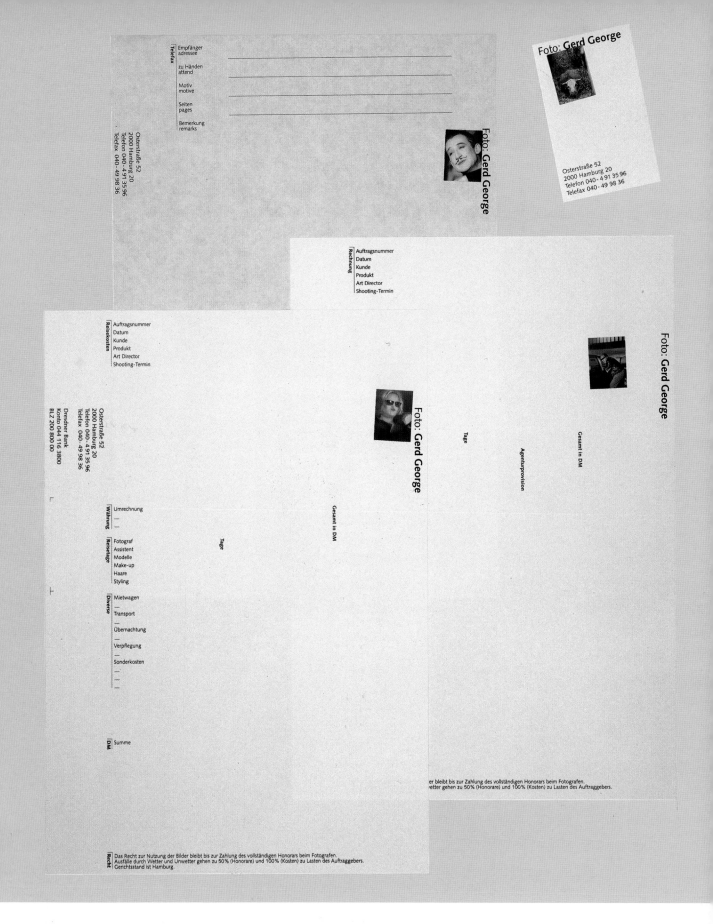

STATIONERY
TYPOGRAPHY/DESIGN GERHARD SCHMAL, DÜSSELDORF, GERMANY
TYPOGRAPHIC SOURCE IN-HOUSE
AGENCY HESSE BÜRO FÜR KOMMUNIKATION
CLIENT FOTO: GERD GEORGE
PRINCIPAL TYPE SYNTAX
DIMENSIONS 8¼ × 11⅝ IN. (21 × 29.7 CM)

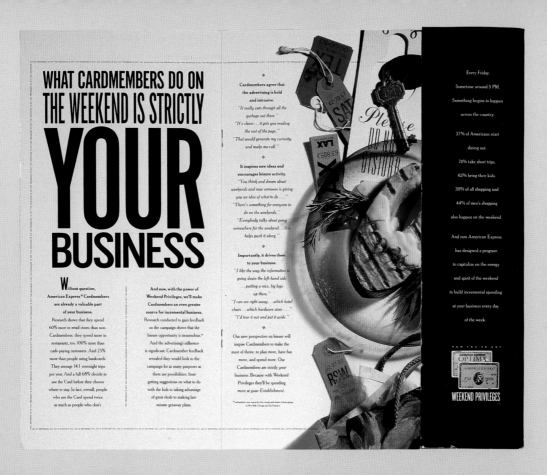

WHAT CARDMEMBERS DO ON THE WEEKEND IS STRICTLY YOUR BUSINESS

Without question, American Express® Cardmembers are already a valuable part of your business. Research shows that they spend 60% more in retail stores than non-Cardmembers; they spend more in restaurants, too. 100% more than cash-paying customers. And 25% more than people using bankcards. They average 14.1 overnight trips per year. And a full 68% decide to use the Card before they choose where to stay. In fact, overall, people who use the Card spend twice as much as people who don't.

And now, with the power of Weekend Privileges, we'll make Cardmembers an even greater source for incremental business. Research conducted to gain feedback on the campaign shows that the leisure opportunity is tremendous.* And the advertising's influence is significant. Cardmember feedback revealed they would look to the campaign for as many purposes as there are possibilities: from getting suggestions on what to do with the kids to taking advantage of great deals to making last-minute getaway plans.

Cardmembers agree that the advertising is bold and intrusive. "It really cuts through all the garbage out there." "It's clever...it gets you reading the rest of the page." "That would generate my curiosity and make me call."

It inspires new ideas and encourages leisure activity. "You think and dream about weekends and now someone is giving you an idea of what to do..." "There's something for everyone to do on the weekends." "Everybody talks about going somewhere for the weekend...this helps push it along."

Importantly, it drives them to your business. "I like the way the information is going down the left-hand side...putting a nice, big logo up there." "I can see right away...which hotel chain...which hardware store...." "I'd tear it out and put it aside."

Our new perspective on leisure will inspire Cardmembers to make the most of theirs: to plan more, have fun more, and spend more. Our Cardmembers are strictly your business. Because with Weekend Privileges they'll be spending more at your Establishment.

*Cardmembers were exposed to the concept and creative in focus groups in New York, Chicago and San Francisco.

Every Friday. Sometime around 5 P.M. Something begins to happen across the country. 37% of Americans start dining out. 74% take short trips. 62% bring their kids. 30% of all shopping and 44% of men's shopping also happen on the weekend. And now American Express has designed a program to capitalize on the energy and spirit of the weekend to build incremental spending at your business every day of the week.

NOW YOU'VE GOT
OPTIMA
WEEKEND PRIVILEGES

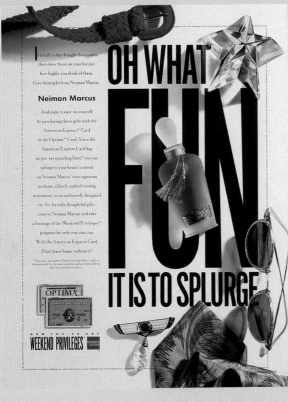

OH WHAT FUN IT IS TO SPLURGE

If it truly is the thought that counts, then show those on your list just how highly you think of them. Give them gifts from Neiman Marcus.

Neiman Marcus

And make it easy on yourself by purchasing those gifts with the American Express® Card or the Optima™ Card. Since the American Express Card has no pre-set spending limit,* you can splurge to your heart's content on Neiman Marcus' own signature perfume, a finely crafted writing instrument, or an exclusively designed tie. So, for truly thoughtful gifts, come to Neiman Marcus and take advantage of the Weekend Privileges® program the only way you can. With the American Express Card. Don't leave home without it.®

*Purchases are approved based on your ability to pay as demonstrated by your past spending and payment patterns and your personal resources.

NOW YOU'VE GOT
OPTIMA
WEEKEND PRIVILEGES

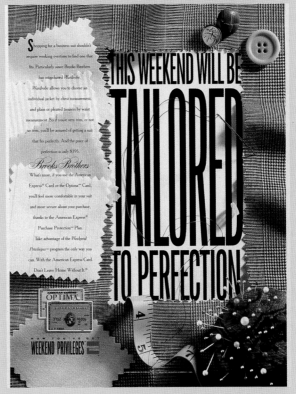

THIS WEEKEND WILL BE TAILORED TO PERFECTION

Shopping for a business suit shouldn't require working overtime to find one that fits. Particularly since Brooks Brothers has introduced Wardrobe. Wardrobe allows you to choose an individual jacket by chest measurement, and plain or pleated trousers by waist measurement. So if you're very trim, or not so trim, you'll be assured of getting a suit that fits perfectly. And the price of perfection is only $395.

Brooks Brothers

What's more, if you use the American Express® Card or the Optima™ Card, you'll feel more comfortable in your suit and more secure about your purchase, thanks to the American Express® Purchase Protection™ Plan. Take advantage of the Weekend Privileges® program the only way you can. With the American Express Card. Don't Leave Home Without It.®

NOW YOU'VE GOT
OPTIMA
WEEKEND PRIVILEGES

ADVERTISEMENT
TYPOGRAPHY/DESIGN HARVEY SPEARS AND ROBERT WAKEMAN, NEW YORK, NEW YORK
ART DIRECTORS MICHAEL RYLANDER, LORENZO BENNASSAR, MARK KELLY, ANTONIO NAVAS, SKIP FLANAGAN, WALT CONNELLY, AND LONA WALBURN
CREATIVE DIRECTORS GORDON BOWEN AND MARY ANN ZEMAN
TYPOGRAPHIC SOURCES PASTORE DePAMPHILIS RAMPONE AND BORO TYPOGRAPHERS
AGENCY OGILVY & MATHER
STUDIO NORA SCARLETT STUDIO
CLIENT AMERICAN EXPRESS
PRINCIPAL TYPES AMEX GOTHIC AND CHELTENHAM OLD STYLE
DIMENSIONS VARIOUS

PACKAGING
TYPOGRAPHY/DESIGN SHUICHI NOGAMI, KITAKU, OSAKA, JAPAN
TYPOGRAPHIC SOURCE IN-HOUSE
STUDIO PACKAGING CREATE INC.
CLIENT COW BRAND SOAP KYOSHINSHA
DIMENSIONS VARIOUS

Tahiti Twist
Shower & Bath
Gel

8 FL. OZ.

Narcissus
After Shower & Bath
Moisturizing Cream

8 FL. OZ.

Eye Gel

After Shave Splash

Foamless
Shave Cream

8 FL. OZ.

CORPORATE IDENTITY
TYPOGRAPHY/DESIGN JIM LIENHART, CHICAGO, ILLINOIS
TYPOGRAPHIC SOURCE IN-HOUSE
AGENCY MURRIE WHITE DRUMMOND LIENHART
CLIENT H2O PLUS, INC.
PRINCIPAL TYPE FUTURA
DIMENSIONS VARIOUS

PACKAGING
TYPOGRAPHY/DESIGN CHARLES STEWART, LONDON, ENGLAND
CALLIGRAPHER CHARLES STEWART
LETTERER PAUL GRAY
TYPOGRAPHIC SOURCE SPAN GRAPHICS, LTD.
STUDIO GRAY & STEWART DESIGN
CLIENT LA VINERAIE, FRANCE
PRINCIPAL TYPE BERLING ITALIC
DIMENSIONS 3⅝ × 4¾ IN. (9.2 × 12.1 CM)

PACKAGING
TYPOGRAPHY/DESIGN MARY LEWIS, LONDON, ENGLAND
CALLIGRAPHER MARY LEWIS
AGENCY LEWIS MOBERLY
CLIENT ASDA
PRINCIPAL TYPE HANDLETTERING
DIMENSIONS VARIOUS

THE
OREGON
COLLECTION

WILLAMETTE VALLEY
PINOT NOIR
ALCOHOL 12.5% BY VOLUME

PACKAGING
TYPOGRAPHY/DESIGN LAURIE VETTE AND TIM GIRVIN, SEATTLE, WASHINGTON
LETTERER TIM GIRVIN
TYPOGRAPHIC SOURCE THE TYPE GALLERY
STUDIO TIM GIRVIN DESIGN, INC.
CLIENT MALETIS BEVERAGE
PRINCIPAL TYPES MERIDIEN AND HANDLETTERING
DIMENSIONS VARIOUS

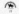

We expect this "resystemization" to revolutionize the way we serve our customers. We're already experimenting with systems that would allow customers—any time of day or night—to activate or disconnect basic phone service or the many enhanced features we offer. If these experiments are successful, the average wait for new service, or changes in service, would drop from a few days to a few minutes—essentially, "service on demand," a revolutionary concept for our industry. ◆ U S WEST NEWVECTOR GROUP: Our cellular and paging subsidiary had its most successful year ever. ◆ The number of cellular customers it serves increased 62 percent, to nearly 135,000. Revenues grew 42 percent, to $189.5 million. The revenue growth came from customer growth and new products such as Message Center, a voice mail

service that increased air time an average of 33 minutes a month among customers who use it. ◆ Under the FCC's cellular licensing system, we also obtained rights to expand into a number of rural service areas that will allow us to extend the range of our service. ◆ U S WEST Paging, NewVector's paging subsidiary, also continued its rapid growth, acquiring four new systems and ending the year with 134,300 pagers in service, a 48 percent increase over 1988. ◆ U S WEST INTERNATIONAL: Overseas, we're a partner in cable television franchises in Hong Kong, the United Kingdom and France with the potential to serve six million households. Most of these franchises include licenses to provide telecommunications services. ◆ We're building a cellular mobile phone system in Hungary, the

ANNUAL REPORT
TYPOGRAPHY/DESIGN PENTAGRAM DESIGN, SAN FRANCISCO, CALIFORNIA
TYPOGRAPHIC SOURCE SPARTAN TYPOGRAPHY
STUDIO PENTAGRAM DESIGN
CLIENT U S WEST INCORPORATED
PRINCIPAL TYPE GARAMOND OLD STYLE
DIMENSIONS 8½ × 10⅞ IN. (21.6 × 27.6 CM)

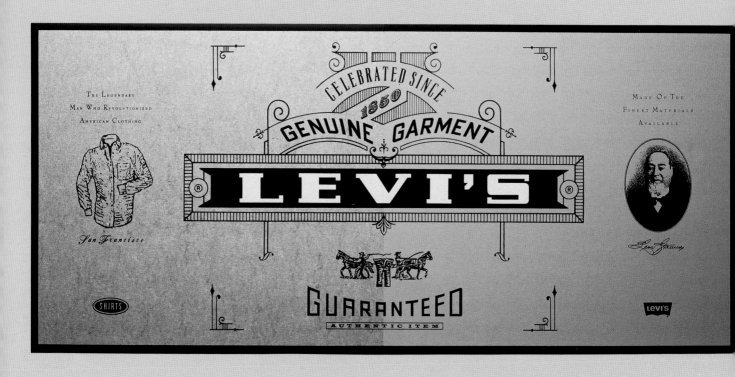

POSTER
TYPOGRAPHY/DESIGN NEAL ZIMMERMANN AND JOHN PAPPAS, SAN FRANCISCO, CALIFORNIA
LETTERERS JOHN PAPPAS AND SOLOTYPE
TYPOGRAPHIC SOURCE SOLOTYPE
STUDIO ZIMMERMANN CROWE DESIGN
CLIENT LEVI STRAUSS & CO.
PRINCIPAL TYPES VARIOUS
DIMENSIONS 44 × 19¾ IN. (111.8 × 50.2 CM)

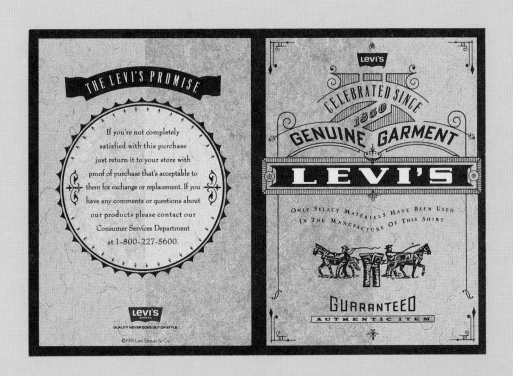

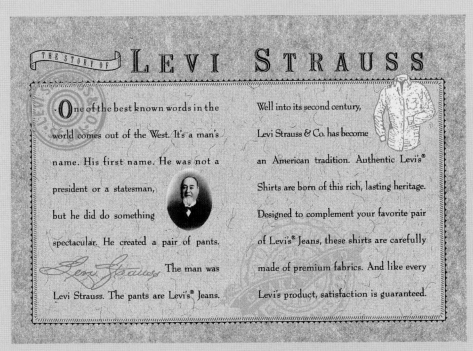

PACKAGING
TYPOGRAPHY/DESIGN NEAL ZIMMERMANN AND JOHN PAPPAS, SAN FRANCISCO, CALIFORNIA
LETTERERS JOHN PAPPAS AND SOLOTYPE
TYPOGRAPHIC SOURCES SOLOTYPE AND EUROTYPE
STUDIO ZIMMERMANN CROWE DESIGN
CLIENT LEVI STRAUSS & CO.
PRINCIPAL TYPES VARIOUS
DIMENSIONS 2⅜ × 3¼ IN. (6 × 8.3 CM)

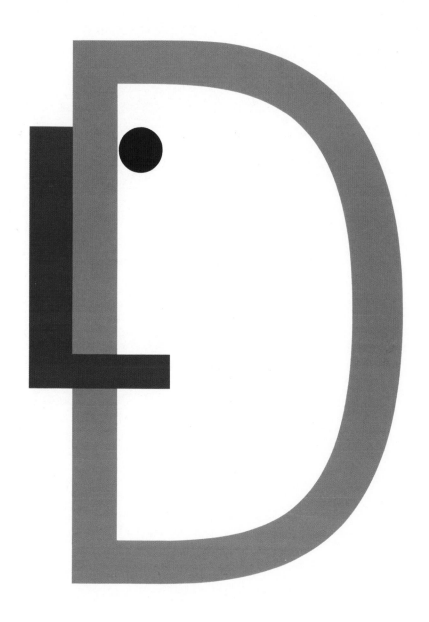

LOGOTYPE
TYPOGRAPHY/DESIGN HARTMUT BRÜCKNER, BREMEN, GERMANY
TYPOGRAPHIC SOURCE HEADLINE FOTOSATZ
STUDIO HARTMUT BRÜCKNER DESIGN
CLIENT DESIGNLABOR BREMERHAVEN
PRINCIPAL TYPE ROTIS GROTESK

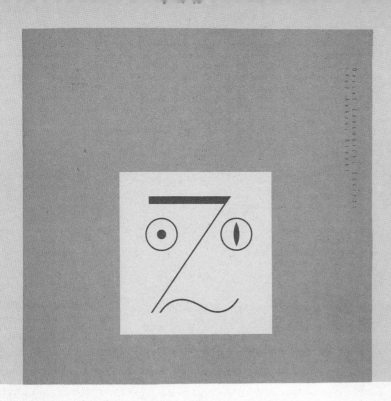

Research has been an integral part of the Zoo's agenda for many years. In 1989, the Zoo curators and staff continued to pursue aggressively their research goals, guided by the Research Master Plan. The Plan was established to co-ordinate both new and on-going research at the Zoo. ❧ Zoo curators and staff regularly publish papers in scientific journals of record, such as the *International Zoo Yearbook* and the *Bulletin of Psychonomics*; they also routinely present papers and monographs at scientific conferences and seminars, such as the American Society of Ichthyology meeting, the AAZPA conference, and meetings of the Texas Parks and Wildlife-Department. ❧ In 1989, the Zoo hosted a seminar, "Applying Behavioral Research to Animal Management," for the second consecutive year. Thirty-two scientists and zoologists representing 24 zoos from across the United States and as far away as Australia spent eight days at the Zoo attending lectures and conducting research. The purpose of the workshop was to offer participants an opportunity to study methods of research on animal behavior in zoos and to encourage the study of captive animal behavior. ❧ The opening of the Wilds of Africa has allowed the Zoo unprecedented opportunities to study animals in two different environments. Many of the Zoo's mammals were moved to unfenced, open habitats in the Wilds from more confining enclosures in ZooNorth. The Zoo staff used this once-in-a-lifetime opportunity to do pre- and post-occupancy studies of the gorillas, the mandrill baboons, and the okapi. A mother/infant study is being carried out on the okapi, as well as on the Speke's gazelle, the slender-horned oryx, and the dik-dik. ❧ Mammal research in 1989 included the Gorilla Ethology Study, an examination of the Zoo's four lowland gorillas which will provide a descriptive catalogue of many of their behaviors. ❧ In 1989, telemetry studies with the red (lesser) panda continued, as did the Zoo's participation in Chimpanzoo. The Chimpanzoo project collects data on captive chimps in various zoos and compares this data with information on wild chimps; it was created by Jane Goodall and her research teams in Africa and the United States. ❧ In 1989, the Bird Department conducted a study on the space utilization of a breeding pair of Goliath herons, to use as a pre-model for designing exhibit space in the Wilds of Africa. Bird Department staff continued field research on the black-capped vireo habitats in Texas. ❧ The Reptile Department continued studies on feeding and behavior of the bushmaster, as well as studying predatory behavior in this snake. The department also collected data on perch selection of the green tree python and conducted a study of Texas rat snakes.

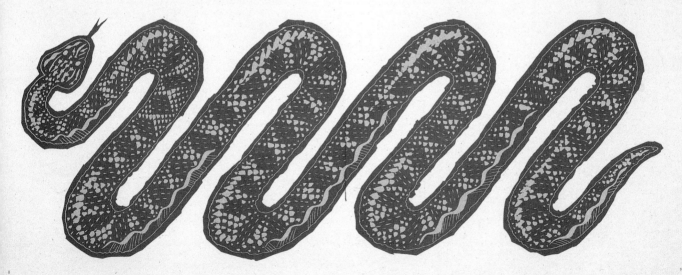

ANNUAL REPORT
TYPOGRAPHY/DESIGN SCOTT RAY, DALLAS, TEXAS
TYPOGRAPHIC SOURCE CREATIVE TYPOGRAPHY
STUDIO PETERSON & COMPANY
CLIENT DALLAS ZOOLOGICAL SOCIETY
PRINCIPAL TYPE ITC FENICE LIGHT
DIMENSIONS 9 × 12 IN. (22.9 × 30.5 CM)

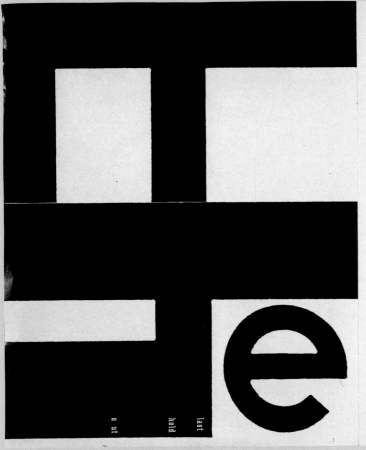

out hold last

Text: Neil Feineman Photo: Steve Sherman. To an untrained eye, the ramshackle house and the nondescript yard of brown dirt punctuated only by mottled green sagebrush is a far cry from Paradise. To an overtrained eye, the land is "agriculturally neutral," which is the government's way of saying it is ripe for development. But to Cynde and Howard Fisher, it is home.

Or at least it was. After spending the better part of 15 years fighting San Diego County, the Fishers have had enough. Although Fisher has been a beach person all his life and never thought he would move, he is packing up and moving inland, to Julian.

"I am certainly one of the last holdouts," he says. "But I am worn down. I can't even tell you how I feel about it from day to day. The only thing I am sure of is that you can't live in the past. And although I never planned on having to leave the beach, it is time to go."

Because the land had been in the Fisher family for generations, Fisher seemed as secure as anyone could be. His grandfather bought 300 acres of land in North County, a mile or so from the Del Mar beach, in 1947. The land was perfectly situated, just close enough to the beach to feel the sea breeze and just far enough away to beat the coastal fog.

When Fisher's grandfather died, the land was split up among the various children and, as the years wore on, the grandchildren. Then, for a variety of reasons, one by one the family members began selling off their land.

"My uncles had set various prices in their minds that they thought would set themselves up for the rest of their lives. When the land reached that price—whether it was $100,000 or $1 million—they sold. In retrospect, regardless of what price they took, they sold, too soon."

Since Fisher, who inherited 21 acres from his mother in the late Sixties, was happy right where he was, he thought he was immune to the real estate bug. But he hadn't counted on eminent domain ("a right of a government to take private property for public use by virtue of the superior dominion of the sovereign power over all lands within its jurisdiction." Webster's *New Collegiate Dictionary*), or on becoming an obstacle to so-called progress.

The problems started in the late Seventies, when government officials told Fisher he had to sell his land to them because they wanted to build a junior high school on part, and put high-density condominiums on the rest.

"It is just my opinion," says Fisher, "but I am sure the school was placed there because my family owns the land. It's not a conspiracy, but just a time-honored method the government and the developers use to make examples of people who don't want to sell. Those who hold out get the public facilities. If you say no, they break you until you have no fight left."

He speaks from experience. At considerable emotional and financial expense, he exhausted every legal avenue at his disposal. Finally, though, he ran out of options. Now his homestead is on its way to being a "yuppie anthill," and he and his family are looking east, not west, for their future.

Rather than becoming embittered, Fisher is drawing strength from his family and from the knowledge that you can't live in the past. "There used to be 40 of us out here. Now there are 40,000. It is still beautiful, and if I were one of those people who didn't know what it used to be like, it would be fine. But I do, and I can't help thinking about what we've lost.

"At the most obvious, we no longer have the intimacy of a small community. It was great when we knew everybody and could leave our doors unlocked and have open parties. We used to start at midnight and go till dawn at the beach, because there was just a handful of beach police, and they were on our side. We all lived here, and knew how to work around each other and get around the system. Now there are too many people trying to do that to make that sort of thing workable.

"It pretty much all comes down to that, that there are too many people who live here for it to be relaxed and simple. It used to be that there were only one or two stoplights on the way to the beach, and that you knew the person in the car next to you when you had to stop. Now there are 12 or 15 stoplights, and people race from red light to red light.

"I honestly don't know why they're always in a hurry, because the beach has become so regulated that it isn't even as much fun as it used to be. In the old days, we hung out at the beach all day, building polapas, making sculptures, playing soccer or frisbee, or running on the beach. We would catch fish and exchange them for hamburgers and fries; or go to the kelp beds and watch the whales.

"I wish my kids could have that. Today, the whales don't come, and neither do many of the locals, because there isn't free parking anymore. You can't bring the dog to the beach, or play frisbee or baseball—there are too many people on the beach. So unless there is a swell, the beach is real quiet and subdued—you hardly ever hear any laughter.

"Sometimes I get real emotional about what has happened, but I try not to dwell on what we've lost or on how much I'll miss Del Mar. Instead I think about how lucky we are that Julian is only an hour or so away, and that we've been living on borrowed time since the Seventies.

"So in the end I'm grateful for what I have and am ready to get on with the move. I fit it up there now where I can be just a country boy. As it stands, in Del Mar I feel like a duck in a dog kennel. Yes, I was here first but I just don't fit in anymore. So it's time to go." ✖

MAGAZINE SPREAD
TYPOGRAPHY/DESIGN DAVID CARSON, DEL MAR, CALIFORNIA
STUDIO CARSON DESIGN
CLIENT BEACH CULTURE MAGAZINE
PRINCIPAL TYPE HELVETICA
DIMENSIONS 12 × 20 IN. (30.5 × 50.8 CM)

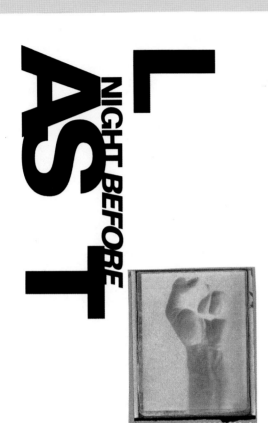

MAGAZINE SPREAD
TYPOGRAPHY/DESIGN DAVID CARSON, DEL MAR, CALIFORNIA
STUDIO CARSON DESIGN
CLIENT BEACH CULTURE MAGAZINE
PRINCIPAL TYPE FRANKLIN GOTHIC
DIMENSIONS 12 × 20 IN. (30.5 × 50.8 CM)

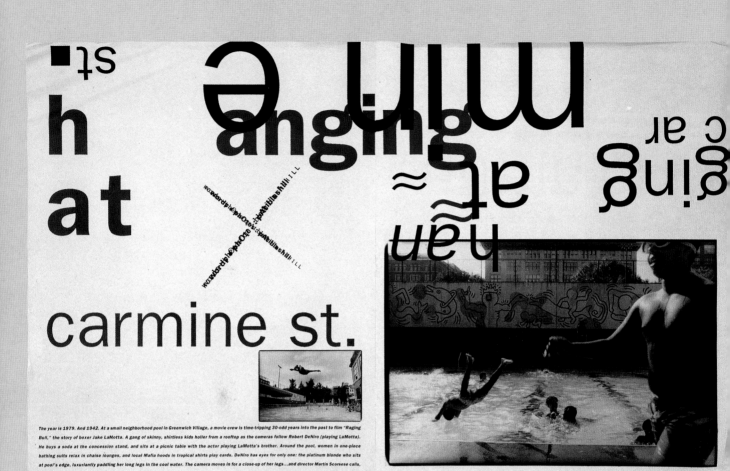

ts
h_{st.}
at
carmine st.

anging
at
han
≈

min'e

c ar
ging

The year is 1979. And 1942. At a small neighborhood pool in Greenwich Village, a movie crew is time-tripping 30-odd years into the past to film "Raging Bull," the story of boxer Jake LaMotta. A gang of skinny, shirtless kids holler from a rooftop as the cameras follow Robert DeNiro (playing LaMotta). He buys a soda at the concession stand, and sits at a picnic table with the actor playing LaMotta's brother. Around the pool, women in one-piece bathing suits relax in chaise lounges, and local Mafia hoods in tropical shirts play cards. DeNiro has eyes for only one: the platinum blonde who sits at pool's edge, luxuriantly paddling her long legs in the cool water. The camera moves in for a close-up of her legs...and director Martin Scorsese calls,

EDITORIAL
TYPOGRAPHY/DESIGN DAVID CARSON, DEL MAR, CALIFORNIA
STUDIO CARSON DESIGN
CLIENT BEACH CULTURE MAGAZINE
PRINCIPAL TYPE FRANKLIN GOTHIC
DIMENSIONS 12 × 20 IN. (30.5 × 50.8 CM)

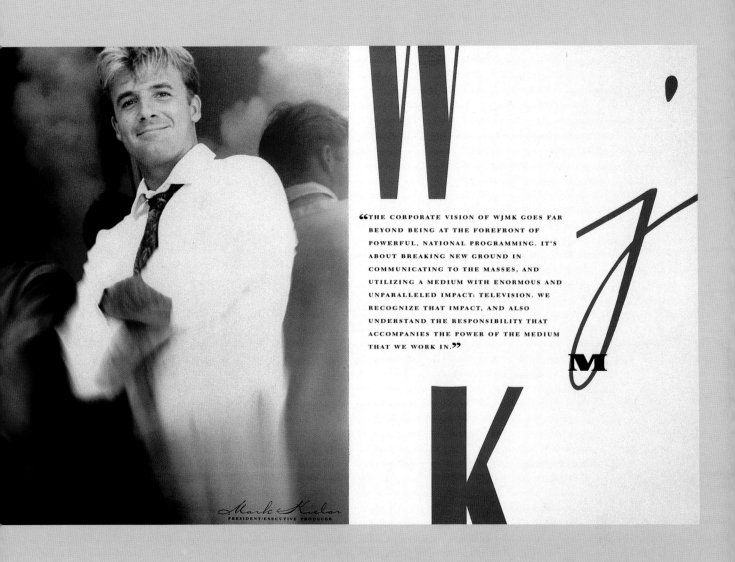

"THE CORPORATE VISION OF WJMK GOES FAR BEYOND BEING AT THE FOREFRONT OF POWERFUL, NATIONAL PROGRAMMING. IT'S ABOUT BREAKING NEW GROUND IN COMMUNICATING TO THE MASSES, AND UTILIZING A MEDIUM WITH ENORMOUS AND UNPARALLELED IMPACT: TELEVISION. WE RECOGNIZE THAT IMPACT, AND ALSO UNDERSTAND THE RESPONSIBILITY THAT ACCOMPANIES THE POWER OF THE MEDIUM THAT WE WORK IN."

Mark Kielor
PRESIDENT/EXECUTIVE PRODUCER

BROCHURE
TYPOGRAPHY/DESIGN TOM STERLING, MIAMI, FLORIDA
TYPOGRAPHIC SOURCES PHIL'S PHOTO AND TYPOSERVICE
STUDIO PINKHAUS DESIGN
CLIENT WJMK
PRINCIPAL TYPES ONYX, CARPENTER, AND CLARENDON
DIMENSIONS 9 × 12 IN. (22.9 × 30.5 CM)

RAYMOND F. BENTELE *Executive Vice President*

Our employees have always had an important stake in our success but ownership will stimulate additional interest, additional commitment.

Our new name will take on distinction as we perform. There's no name nor logo nor ticker symbol that will substitute for results.

Perhaps we're too simplistic in this, but our energies and resources are focused where the payoff is greatest. That's how we intend to make a name for ourselves.

It is a great personal satisfaction to assure you that there will be no faltering of our forward movement as we put in place management for the future.

Our companies have more than a wealth of talent. They have exceptional teams.

The two Mallinckrodt companies under the direction of Presidents Ray Holman and Mack Nichols have performed well beyond expectations even as they were assimilating the organizational apparatus they need to be fully accountable for themselves.

The ability of Pitman-Moore to blend so many new components into a world-class business in world-record time speaks volumes for the breadth and depth

of talent in that company. Progress will continue apace under new President Boyd Wainscott.

Blake Ingle and Ray Bentele deserve full marks for the job they've done in building those companies.

Our directors are pleased to provide them appropriate recognition by recommending them for election to the board at the annual meeting this October.

As a member of the executive office and a senior executive of the corporation, Ray will continue to contribute to the development of all of our companies.

Dr. Ingle has amply demonstrated his qualifications for the presidency of IMCERA and responsibilities of chief operating officer.

His work with Pitman-Moore speaks for itself. Prior to that, he was a very able chief of our corporate staff.

Take into account his guidance of our technical development and you can appreciate his multiple skills.

It's our plan that I'll turn over the chief executive's responsibility in October of 1991 and remain chairman of the board for two years thereafter.

You may recall that this same procedure provided for very smooth transition from Nelson White to Dick Lenon and from Dick to me. We intend that this one will be as calm and deliberate.

When we speak of organization, we give recognition and credit to our employees, and well we should. They continue to deliver in a most uncommon way. They earn all the praise we give them.

There's one part of our family that gets very little attention and even less applause.

Yet their courage and wisdom are essential to everything we undertake.

I refer to our directors.

In a time when good ones are scarce, we have a boardful.

The family of IMCERA is grateful for their support and the support of their constituents, our shareholders.

George D. Kennedy
Chairman and Chief Executive Officer
August 23, 1990

ONGOING OPERATING EARNINGS

MALLINCKRODT MEDICAL *(in millions)*

MALLINCKRODT SPECIALTY CHEMICALS *(in millions)*

PITMAN-MOORE *(in millions)*

• 1987
• 1988
• 1989
• 1990

ANNUAL REPORT
TYPOGRAPHY/DESIGN GREG AND PAT SAMATA, DUNDEE, ILLINOIS
TYPOGRAPHIC SOURCE TYPOGRAPHIC RESOURCE, LTD.
STUDIO SAMATA ASSOCIATES
CLIENT IMCERA GROUP, INC.
PRINCIPAL TYPE BERTHOLD GARAMOND
DIMENSIONS 9 × 11¼ IN. (22.9 × 28.6 CM)

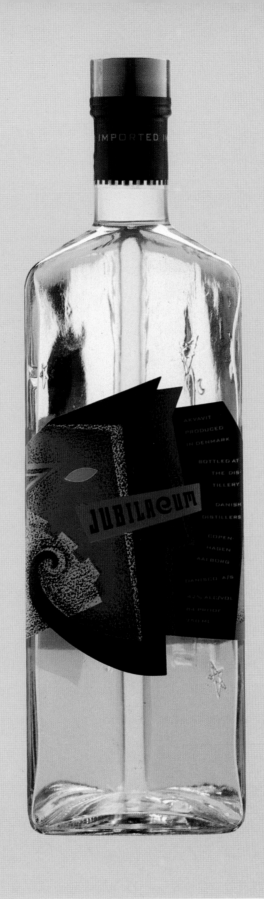

PACKAGING
TYPOGRAPHY/DESIGN TODD WATERBURY, MINNEAPOLIS, MINNESOTA
LETTERERS TODD WATERBURY AND LYNN SCHULTE
TYPOGRAPHIC SOURCE TYPEHOUSE
STUDIO THE DUFFY DESIGN GROUP
CLIENT JIM BEAM BRANDS COMPANY
PRINCIPAL TYPES BANK GOTHIC AND HANDLETTERING

Komag, Incorporated designs, manufactures, and markets the data storage industry's most *Komag's mission* advanced metallic disks for use in small-diameter, high-capacity Winchester disk drives. Founded in 1983, Komag has grown to become the world's largest independent supplier of sputtered, thin-film disks with manufacturing facilities in *Komag's mission* California and, through a joint venture, in Japan.

ANNUAL REPORT
TYPOGRAPHY/DESIGN STEVEN TOLLESON AND BOB AUFULDISH, SAN FRANCISCO, CALIFORNIA
TYPOGRAPHIC SOURCES SEVE'S HOUSE OF TYPE AND SPARTAN TYPOGRAPHERS
STUDIO TOLLESON DESIGN
CLIENT KOMAG, INC.
PRINCIPAL TYPE MATRIX
DIMENSIONS 8¾ × 8¾ IN. (22.2 × 22.2 CM)

CURATOR EMERITUS OF ORNITHOLOGY AND MAMMALOGY. Born 1908. B.S., D.Sc. University of San Francisco (1929, 1976); M.A., Ph.D. University of California, Berkeley (1931, 1937). Wildlife Technician, U.S. National Park Service (1935-36). Assistant Curator, California Academy of Sciences (1936-43); Associate Curator (1944); Curator (1945-75); Associate Director (1964-75); Senior Scientist (1975-); Curator Emeritus (1989-). Acting Instructor, Stanford University (1940). Visiting Professor, University of California, Berkeley (1962, 1965). Assistant Professor, University of San Francisco (1942-48); Associate Professor (1949-54); Professor (1955-64). Past President, Pacific Division of AAAS. Past President and Honorary Member: Cooper Ornithological Society, American Society of Mammalogists. Awarded California Academy of Sciences Fellows Medal (1973). Fellow: California Academy of Sciences, American Ornithologists Union, AAAS, Explorers Club.

Robert T. Orr

I have always been interested in animals and plants. As a premedical student, I fell under the influence of California's great naturalists Drs. Joseph Grinnell and E. Raymond Hall, who interested me in ornithology and mammalogy, and convinced me to pursue my doctorate in this field.

My scientific questing has covered a broad spectrum of subjects. I always wanted more variety than an intensive single genus study allowed, so my research has ranged from mammals such as rabbits, bats, and seals, through various birds, and even to mushrooms. When I walk through the forest, I want to know more than the name of the birds I might see: I want to know what tree they're sitting on and what they're eating.

I have studied primarily western American birds and mammals, from Alaska to the Galápagos Islands. In addition to doing taxonomic research, I have studied population dynamics, distribution, and behavior of rabbits, bats, and marine mammals of the Pacific coast.

Along with my scientific studies, I have been active since 1971 in developing the Academy tour program for members and have acted as leader and naturalist to such places as Europe, Africa, India, Nepal, Indonesia, Australia, New Zealand, Alaska, Mexico, Guatemala, the Galapagos Islands, Brazil, and a round-the-world trip by way of North and Central Asia.

In 1969 I was asked to develop a basic training course for docents at the Academy. This has been a most successful project for the past twenty years, and tens of thousands of school children have been taken on educational tours through the Academy's halls by docents. This course may be taken for four upper division units through San Francisco State University. ⌖

Orr, R. T. 1954. Natural history of the pallid bat, *Antrozous pallidus* (Le Conte). *Proceedings of the California Academy of Sciences* 28(4):165-246.

Orr, R.T. and M.C. Orr. 1974. *Wildflowers of Western America.* Alfred A. Knopf, New York.

Orr, R.T. and D.B. Orr. 1980. *Mushrooms of Western North America.* University of California Press, Berkeley.

Orr, R.T. 1982. *Vertebrate Biology.* 5th ed. W. B. Saunders Co., Philadelphia.

————. 1970. *Animals in Migration.* Macmillan Co., New York.

Orr, R.T. and R.C. Helm. 1989. *Marine Mammals of California,* new and revised ed. University of California Press, Berkeley.

The Department of Botany occupies the third floor of the Academy's Wattis Hall of Human Cultures. Its herbarium, with 1.6 million plant specimens, is housed in a modern compactorized storage system. The collection ranks sixth in size in the United States and constitutes a resource of international significance. Loans average about 11,500 specimens annually, and many visitors use the facilities each year. ⌖ The original herbarium, which became the largest and most important collection in western North America during its first fifty years, was almost completely destroyed by the earthquake and fire of 1906. The present herbarium dates from 1915 and includes approximately 2,000 type specimens saved from the devastation of 1906 by curator Alice Eastwood's heroic efforts. In 1976, the collection doubled with the incorporation of the Dudley Herbarium of Stanford University. ⌖ The collections of plants from California, the Galápagos Islands, Baja California, and Chiapas, Mexico are

Botany

among the most comprehensive in the world. Other strengths include large holdings from the western United States, Canada, Mexico, Central America, northern Argentina, and western Europe; the families Acanthaceae, Fagaceae, Melastomataceae, Onagraceae, and Polemoniaceae; and the largest collection of ornamental plants in California. ⌖ The Botany staff consists of six curators (three full-time, one part-time, two emeritus), a collections manager, two full-time and two half-time curatorial assistants, and a secretary. In addition to their departmental duties, collections manager, Dr. Bruce Bartholomew, and curatorial assistant Ms. Mona Bourell have research projects underway. ⌖ In an effort to augment its present staff and facilities, the Department of Botany hopes to add a curatorial chair in western American botany and a small greenhouse for growing and studying live plants. ⌖

BROCHURE
TYPOGRAPHY/DESIGN ROSS CARRON AND CAROLE JEUNG, SAN FRANCISCO, CALIFORNIA
TYPOGRAPHIC SOURCE IN-HOUSE
STUDIO ROSS CARRON DESIGN
CLIENT CALIFORNIA ACADEMY OF SCIENCES
PRINCIPAL TYPE ADOBE GARAMOND
DIMENSIONS 8½ × 11 IN. (21.6 × 27.9 CM)

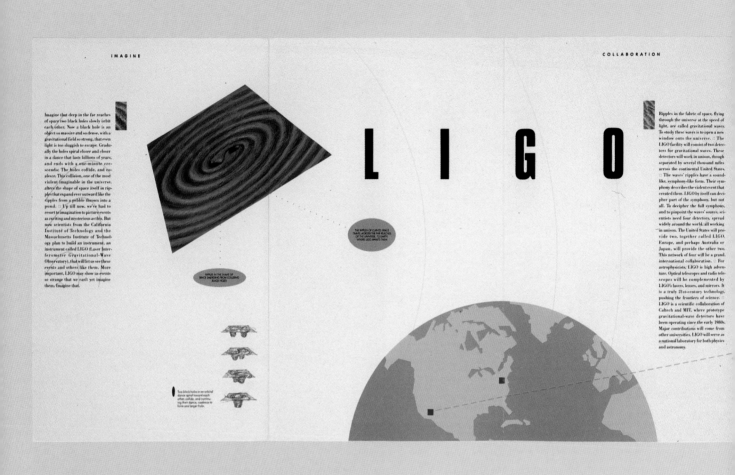

Imagine that deep in the far reaches of space two black holes slowly orbit each other. Now a black hole is an object so massive and so dense, with a gravitational field so strong, that even light is too sluggish to escape. Gradually the holes spiral closer and closer in a dance that lasts billions of years, and ends with a one-minute crescendo: The holes collide, and coalesce. This collision, one of the most violent imaginable in the universe, alters the shape of space itself in ripples that expand ever outward like the ripples from a pebble thrown into a pond. □ Up till now, we've had to resort to imagination to picture events as exciting and mysterious as this. But now scientists from the California Institute of Technology and the Massachusetts Institute of Technology plan to build an instrument, an instrument called LIGO (Laser Interferometer Gravitational-Wave Observatory), that will let us see these events and others like them. More important, LIGO may show us events so strange that we can't yet imagine them. Imagine that.

L I G O

Ripples in the fabric of space, flying through the universe at the speed of light, are called gravitational waves. To study these waves is to open a new window onto the universe. □ The LIGO facility will consist of two detectors for gravitational waves. These detectors will work in unison, though separated by several thousand miles across the continental United States. □ The waves' ripples have a sound-like, symphony-like form. Their symphony describes the violent event that created them. LIGO by itself can decipher part of the symphony, but not all. To decipher the full symphony, and to pinpoint the waves' source, scientists need four detectors, spread widely around the world, all working in unison. The United States will provide two, together called LIGO. Europe, and perhaps Australia or Japan, will provide the other two. This network of four will be a grand, international collaboration. □ For astrophysicists, LIGO is high adventure. Optical telescopes and radio telescopes will be complemented by LIGO's lasers, lenses, and mirrors. It is a truly 21st-century technology, pushing the frontiers of science. □ LIGO is a scientific collaboration of Caltech and MIT, where prototype gravitational-wave detectors have been operating since the early 1980s. Major contributions will come from other universities. LIGO will serve as a national laboratory for both physics and astronomy.

THE RIPPLES OF CURVED SPACE TRAVEL ACROSS THE FAR REACHES OF THE UNIVERSE, TO EARTH WHERE LIGO AWAITS THEM

RIPPLES IN THE SHAPE OF SPACE EMERGING FROM COLLIDING BLACK HOLES

Two black holes in an orbital dance spiral toward each other, collide, and continuing their dance, coalesce to form one larger hole.

BROCHURE
TYPOGRAPHY/DESIGN ELIZABETH BURRILL, PASADENA, CALIFORNIA
ART DIRECTOR MARGI DENTON
TYPOGRAPHIC SOURCE ELLA TYPE
STUDIO DENTON DESIGN ASSOCIATES
CLIENT CALIFORNIA INSTITUTE OF TECHNOLOGY
PRINCIPAL TYPES COMPACTA, FUTURA, AND BODONI
DIMENSIONS 6⅝ × 11 IN. (16.8 × 27.9 CM)

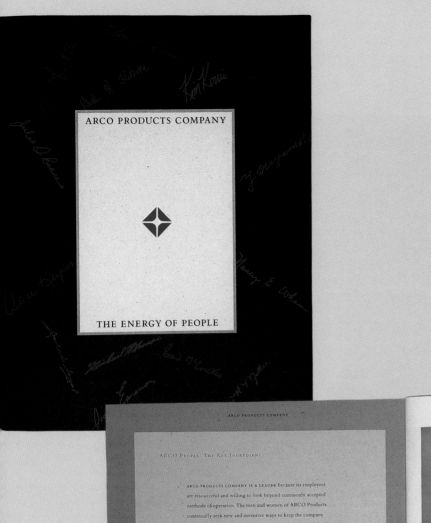

ARCO PEOPLE: THE KEY INGREDIENT

ARCO PRODUCTS COMPANY IS A LEADER because its employees are resourceful and willing to look beyond commonly accepted methods of operation. The men and women of ARCO Products continually seek new and inventive ways to keep the company on top in a rapidly changing business. They are the force behind ARCO's manufacturing efficiency, marketing innovations, and consistently high product quality. It is a diverse work force, with a strong representation of minority and female employees obtained through active recruitment and internship programs.

The Human Resources group acts as a catalyst to help employees and management maintain a strong, dynamic organization and a climate that encourages and rewards both individual contributions and team effort.

ARCO Products Company employees take community service seriously. They regularly volunteer their time to community organizations, from supporting the arts to tutoring disadvantaged children and feeding the hungry.

The company and its people are mindful that business success combines financial and social objectives. They factor such social concerns as pollution control, plant safety, and community involvement into their everyday business planning and operations. By these standards, as well as by conventional financial measurements, the company has blended efficiency, innovation, and compassion into a uniquely successful business enterprise.

Photo (left to right):
Mike Mullen Vice President, Human Resources
Dwaine Smith Senior Vice President, Manufacturing, Engineering, and Technology
Ken Riley Vice President, International Marketing Coordination and Product Supply
Dick Morse General Attorney
Walt Tsutsui Vice President, Planning and Control
Ed Reilly Senior Vice President, Marketing
George Babikian President, ARCO Products Company

thirty-six

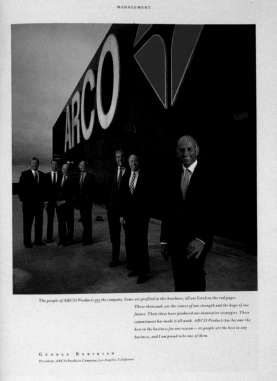

The people of ARCO Products are the company. Some are profiled in this brochure; all are listed on the end pages. These thousands are the source of our strength and the hope of our future. Their ideas have produced our innovative strategies. Their commitment has made it all work. ARCO Products has become the best in the business for one reason — its people are the best in any business, and I am proud to be one of them.

GEORGE BABIKIAN
President, ARCO Products Company, Los Angeles, California

thirty-seven

BROCHURE
TYPOGRAPHY/DESIGN RICK BESSER, SANTA MONICA, CALIFORNIA
TYPOGRAPHIC SOURCE COMPOSITION TYPE
STUDIO BESSER JOSEPH PARTNERS, INC.
CLIENT ARCO
PRINCIPAL TYPE BEMBO
DIMENSIONS 10½ × 13½ IN. (26.7 × 34.3 CM)

151

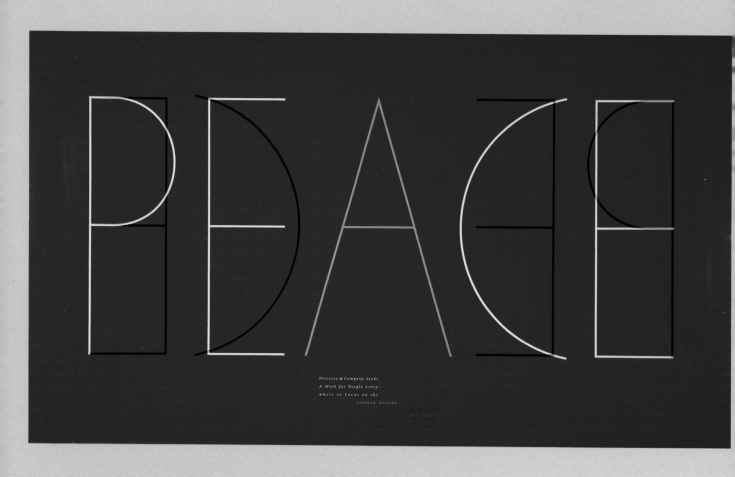

POSTER
TYPOGRAPHY/DESIGN SCOTT PARAMSKI, DALLAS, TEXAS
LETTERERS SCOTT PARAMSKI AND PHAM NHAN
TYPOGRAPHIC SOURCE CREATIVE TYPOGRAPHY
STUDIO PETERSON & COMPANY
CLIENT PETERSON & COMPANY
PRINCIPAL TYPES VARIOUS
DIMENSIONS 39¼ × 22¼ IN. (99.7 × 56.5 CM)

A new year's wish for peace, happiness, and love.

GREETING CARD
TYPOGRAPHY/DESIGN PAUL SHAW, NEW YORK, NEW YORK
PRINTER PETER KRUTY
TYPOGRAPHIC SOURCES CROSBY TYPOGRAPHERS AND TYPOGRAM
STUDIO PAUL SHAW/LETTER DESIGN
CLIENTS PAUL SHAW/LETTER DESIGN AND PETER KRUTY EDITIONS
PRINCIPAL TYPE CASLON 540 (FOUNDRY)
DIMENSIONS 3 × 22 IN. (7.6 × 55.9 CM)

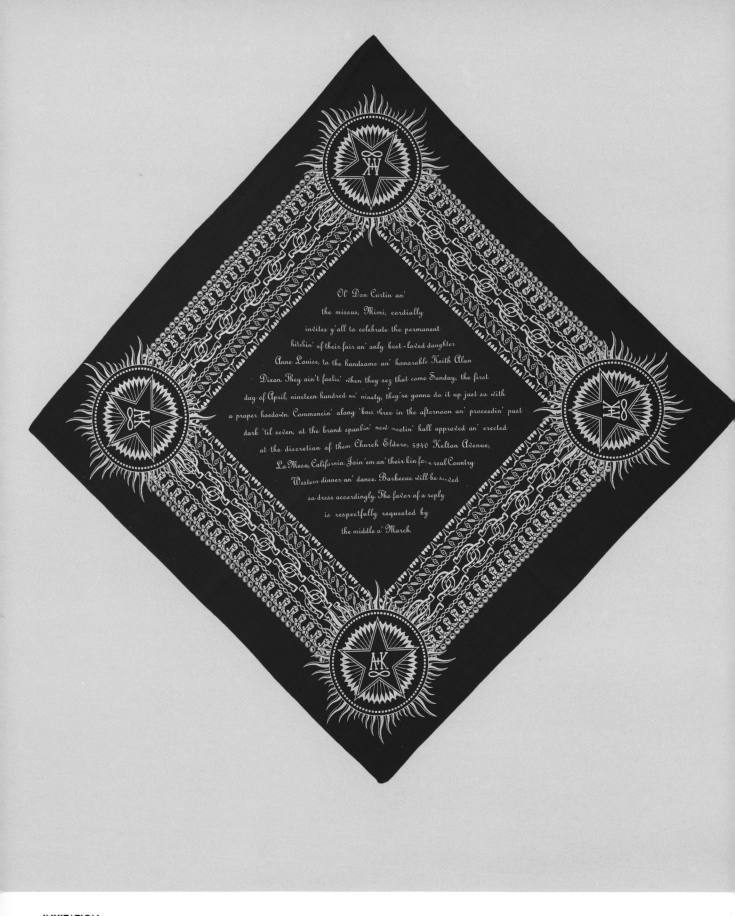

INVITATION
TYPOGRAPHY/DESIGN PETER LOCKE, SAN FRANCISCO, CALIFORNIA
TYPOGRAPHIC SOURCE IN-HOUSE
STUDIO PAUL CURTIN DESIGN
CLIENT DONALD AND MIMI CURTIN
PRINCIPAL TYPES LINOSCRIPT AND A + K (CUSTOM)
DIMENSIONS 12½ × 12¾ IN. (31.8 × 32.4 CM)

154

I care for riches, to make gifts

To friends, or lead a sick man back to health

With ease and plenty.

Else small aid is wealth.

For daily gladness; once a man be done

With hunger, rich and poor are as one.

-Euripides

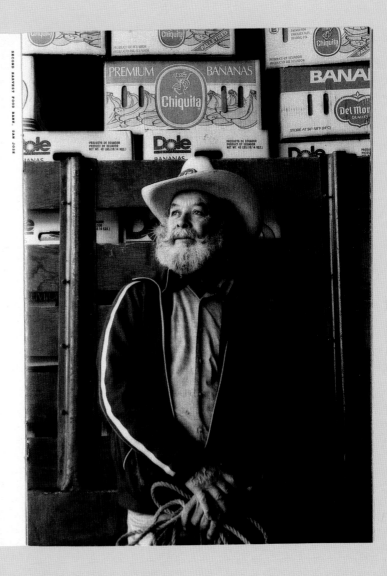

ANNOUNCEMENT
TYPOGRAPHY/DESIGN STEVEN TOLLESON AND BOB AUFULDISH, San Francisco, California
TYPOGRAPHIC SOURCE SEVE'S HOUSE OF TYPE
STUDIO TOLLESON DESIGN
CLIENT PACIFIC LITHOGRAPH
PRINCIPAL TYPE COURIER
DIMENSIONS 5 × 7 IN. (12.7 × 17.8 CM)

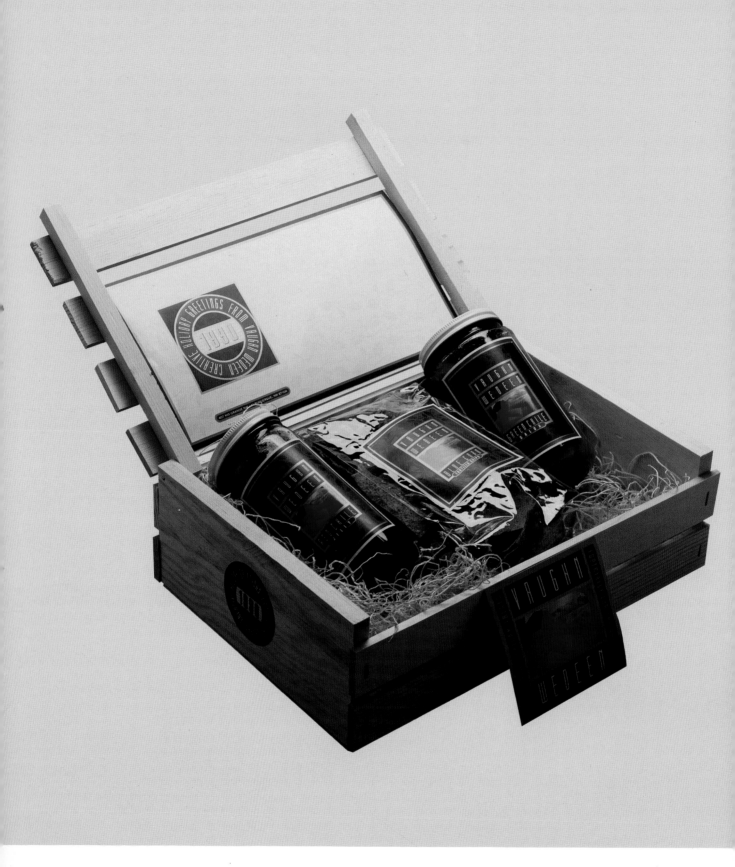

PACKAGING
TYPOGRAPHY/DESIGN DAN FLYNN, ALBUQUERQUE, NEW MEXICO
TYPOGRAPHIC SOURCE IN-HOUSE
STUDIO VAUGHN/WEDEEN CREATIVE, INC.
CLIENT VAUGHN/WEDEEN CREATIVE, INC.
PRINCIPAL TYPES ULTRA CONDENSED (MODIFIED) AND COMPACTA (MODIFIED)
DIMENSIONS 12 × 8¼ × 4 IN. (30.5 × 21 × 10.2 CM)

PACKAGING
TYPOGRAPHY/DESIGN ERIK VANTAL, BRUSSELS, BELGIUM
LETTERER ERIK VANTAL
TYPOGRAPHIC SOURCE DE LIGHT
STUDIO DESIGN BOARD/BEHAEGHEL & PARTNERS
CLIENT COMERCIAL SAIMAZA, SPAIN
PRINCIPAL TYPE FRITZ QUADRATA
DIMENSIONS 3¼ × 6⅞ IN. (8.2 × 17.4 CM)

PACKAGING
TYPOGRAPHY/DESIGN SALLY SWART, BRUSSELS, BELGIUM
TYPOGRAPHIC SOURCE GRAPHISERVICE
STUDIO DESIGN BOARD/BEHAEGHEL & PARTNERS
CLIENT INTERBREW
DIMENSIONS 3 × 2⅝ IN. (7.6 × 6.6 CM)

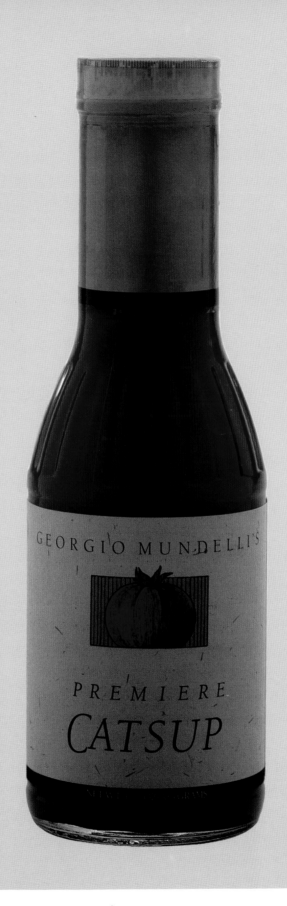

PACKAGING
TYPOGRAPHY/DESIGN LEILANI FORTUNE, WOODINVILLE, WASHINGTON
TYPOGRAPHIC SOURCE ART ATTACK
STUDIO FORTUNE DESIGN STUDIO
CLIENT PREMIERE FOODS
PRINCIPAL TYPE BERKELEY OLD STYLE

AUGUST MOON

August Reed Knape arrived at 6:10 P.M. on March 28, 1990.
She weighed 8 pounds 1 ounce and measured 20¼ inches. According to Susan, Anthony
and Jordan, she is the shining example of a perfect baby.

ANNOUNCEMENT
TYPOGRAPHY/DESIGN ALLEN WEAVER, JR., DALLAS, TEXAS
TYPOGRAPHIC SOURCE IN-HOUSE
AGENCY KNAPE&KNAPE
CLIENT ANTHONY AND SUSAN KNAPE
PRINCIPAL TYPE GOUDY
DIMENSIONS 4 × 5 IN. (10.2 × 12.7 CM)

CAMPAIGN
TYPOGRAPHY/DESIGN BRUCE HALE AND MARY MACINKA, SEATTLE, WASHINGTON
CALLIGRAPHER BRUCE HALE
TYPOGRAPHIC SOURCE THOMAS & KENNEDY
STUDIO BRUCE HALE DESIGN STUDIO
CLIENT SEATTLE SYMPHONY
PRINCIPAL TYPES BERLING AND HANDLETTERING
DIMENSIONS VARIOUS

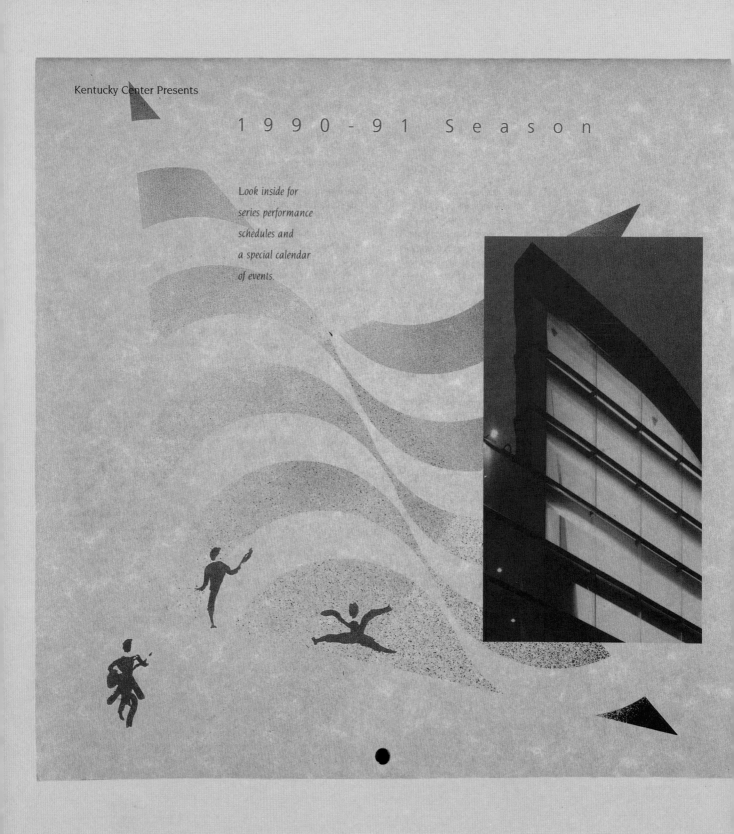

Kentucky Center Presents

1 9 9 0 - 9 1 Season

Look inside for
series performance
schedules and
a special calendar
of events.

BROCHURE
TYPOGRAPHY/DESIGN RUTH WYATT, LOUISVILLE, KENTUCKY
TYPOGRAPHIC SOURCE ADPRO
STUDIO GOOD DESIGN
CLIENT KENTUCKY CENTER FOR THE ARTS
PRINCIPAL TYPE NOVARESE
DIMENSIONS 8½ × 8½ IN. (21.6 × 21.6 CM)

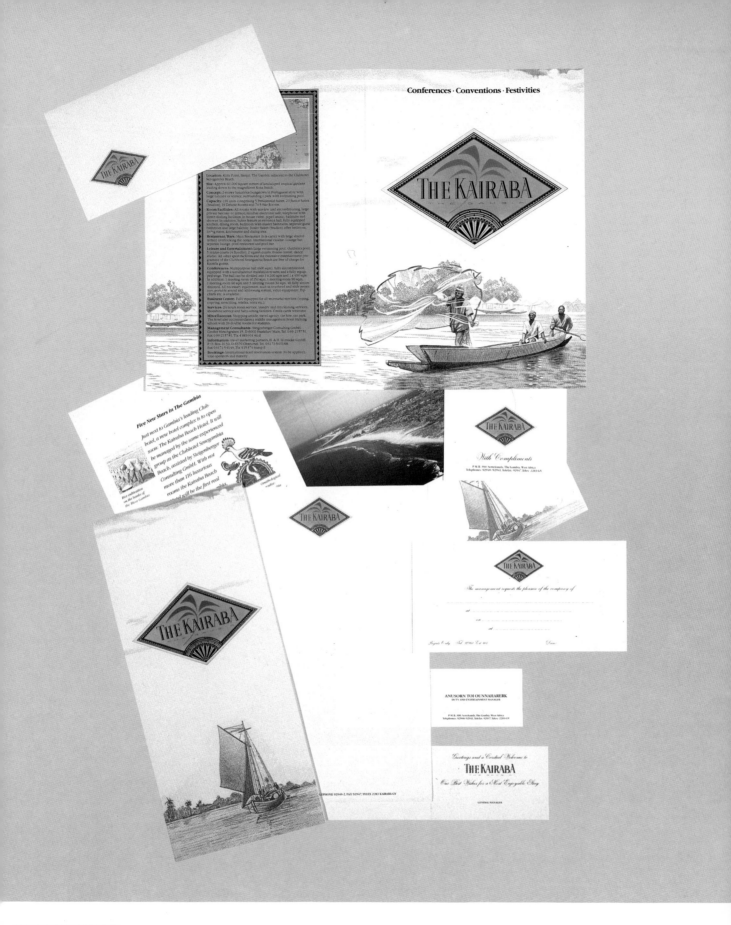

CORPORATE IDENTITY
TYPOGRAPHY/DESIGN ROLAND MEHLER, KELKHELM, GERMANY
CALLIGRAPHER ROLAND MEHLER
TYPOGRAPHIC SOURCE TEAM '80
STUDIO KNUT HARTMANN DESIGN
CLIENT STEIGENBERGER CONSULTING GMBH
PRINCIPAL TYPES ITC GARAMOND AND HANDLETTERING
DIMENSIONS 39⅓ × 27½ IN. (100 × 70 CM)

● The Brooklyn Hospital Center is proud that its Downtown Campus is among the most modern and technologically advanced healthcare complexes not only in Brooklyn, but in New York City. An $125 million construction and renovation program completed in 1985, provided new facilities for all of the Downtown Campus patient rooms, a new surgical suite including eight operating rooms with specialized capabilities such as built-in radiologic equipment and sophisticated communication systems to laboratories and specimen rooms; new recovery rooms and medical, surgical and cardiac intensive care units; new quarters for nuclear medicine, cardiology, vascular surgery and respiratory therapy; and a new emergency department. Continued facilities development over the past five years have kept pace with, even pioneering, advancing technology. A new Ambulatory Surgery Center was opened; a modern mammography center and a new ultrasound unit were installed; the new cardiac catheterization laboratory was opened in 1988; an advanced IBM AS400 operating systems computer was installed; and a digital angiography suite opened in 1989. Facilities and technology enhancement currently underway include the installation of peripheral vascular laser equipment and a new vascular surgery operating suite; the exceptionally powerful linear accelerator for safer and more precise radiation therapy; and the expansion of the Neonatal Intensive Care Unit and obstetrical service.

"The Brooklyn landscape is enriched when The Brooklyn Hospital Center's two modern campuses adjoin two of the boroughs' most beautiful parks."

Juergen Luehler
Director, Facilities Management

■ The Brooklyn Hospital Center's Caledonian Campus offers a completely modern facility for residents of Flatbush and central Brooklyn following the completion of a $25.8 million modernization program in 1989. The Caledonian Campus provides expanded emergency medical services and new ambulatory care clinics. While the modernization program added no new beds to the campus, a new patient wing, "C" Building houses 96 of the campus' 190 medical/surgical beds, as well as a new surgical suite, recovery rooms and intensive care unit. Extensive renovation of other campus buildings, in addition to modernizing the remaining 94 patient beds, has provided sophisticated, spacious facilities for ancillary services including radiology, nuclear medicine and other support departments. More recent additions to the campus include the opening of new doctors' private office suites and a new and expanded adolescent unit. Currently underway is the installation of a new CT scan unit. The Hospital Center's completion of a new Caledonian Campus is, indeed, the fulfillment of a long-standing promise to the community.

▲ Brooklyn's neighborhoods are enjoying a renaissance, a good barometer for New York's most populous borough. This resurgence has been particularly pronounced in the communities where the two modern campuses of The Brooklyn Hospital Center have risen by two of Brooklyn's great parks. Residents of Brooklyn Heights, Cobble Hill, Park Slope and Boerum Hill pioneered Brooklyn's brownstone revival, which has expanded to Clinton Hill and Fort Greene — all neighborhoods serviced by the Hospital Center's Downtown Campus. The Caledonian Campus, overlooking beautiful Prospect Park, is the primary medical resource for Flatbush, a community whose name is nearly synonymous with Brooklyn. Flatbush and central Brooklyn are neighborhoods of classic Victorian homes and substantial apartment buildings, and have become new centers for housing rehabilitation. Over the past decade, the rebuilding of both Hospital Center campuses has been viewed by community leaders as a cornerstone in the renewal of their respective neighborhoods.

BROCHURE
TYPOGRAPHY/DESIGN DEAN MORRIS, NEW YORK, NEW YORK
TYPOGRAPHIC SOURCE IN-HOUSE
STUDIO STYLISM
CLIENT THE BROOKLYN HOSPITAL CENTER
PRINCIPAL TYPE NEW BASKERVILLE ITALIC
DIMENSIONS 8½ × 8½ IN. (21.6 × 21.6 CM)

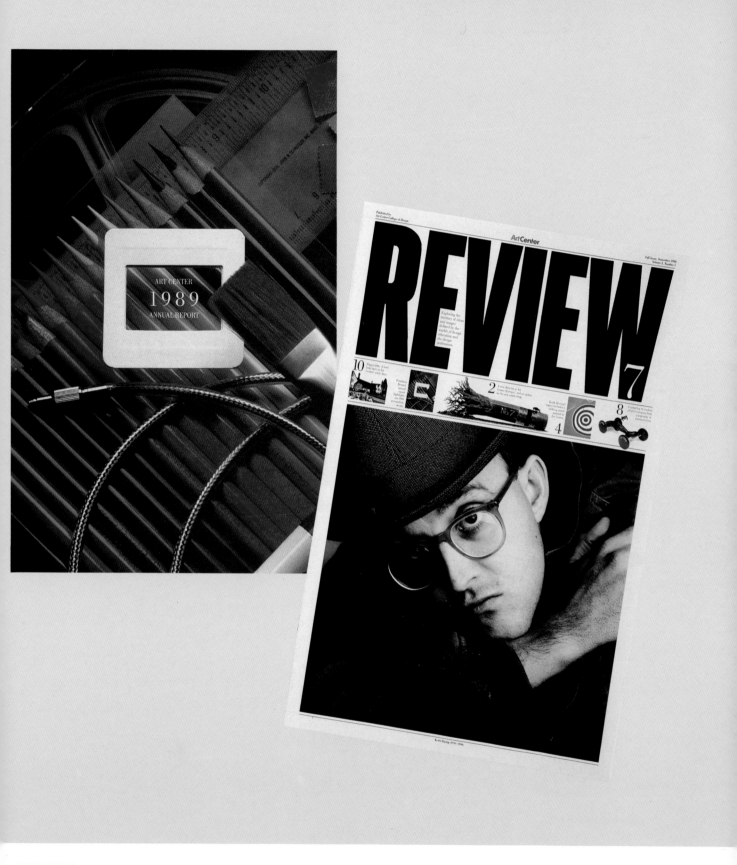

NEWSLETTER
TYPOGRAPHY/DESIGN PENTAGRAM DESIGN, San Francisco, California
TYPOGRAPHIC SOURCE SPARTAN TYPOGRAPHY
STUDIO PENTAGRAM DESIGN
CLIENT ART CENTER COLLEGE OF DESIGN
PRINCIPAL TYPE BODONI
DIMENSIONS 11 × 17 IN. (27.9 × 43.2 CM)

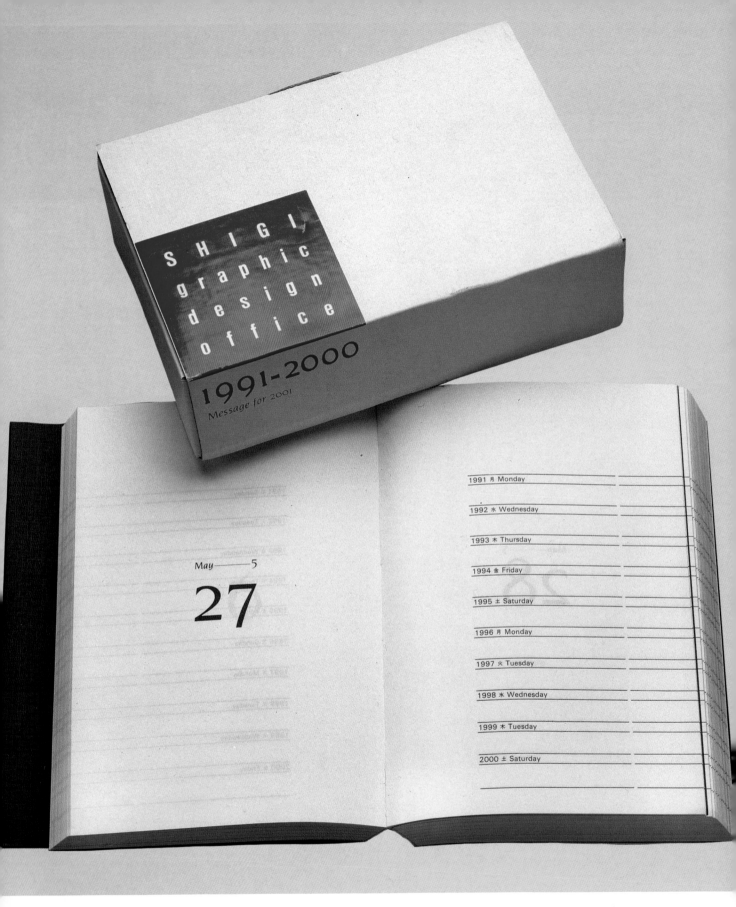

DIARY
TYPOGRAPHY/DESIGN SUSUMU SHIGI, OSAKA, JAPAN
TYPOGRAPHIC SOURCE IN-HOUSE
STUDIO SHIGI GRAPHIC DESIGN OFFICE
CLIENT SHIGI GRAPHIC DESIGN OFFICE
PRINCIPAL TYPE NOVARESE MEDIUM ITALIC
DIMENSIONS 7⅛ × 5⅛ IN. (18.2 × 13 CM)

CALENDAR
TYPOGRAPHY/DESIGN FRIEDRICH DON, WAIBLINGEN, GERMANY
PHOTOGRAPHER FRANZ WAGNER
TYPOGRAPHIC SOURCE STEFFEN HAHN, FOTOSATZ
AGENCY WAGNER SIEBDRUCK
CLIENT WAGNER SIEBDRUCK
PRINCIPAL TYPE AVANT GARDE GOTHIC CONDENSED
DIMENSIONS 23½ × 33 IN. (59.4 × 84 CM)

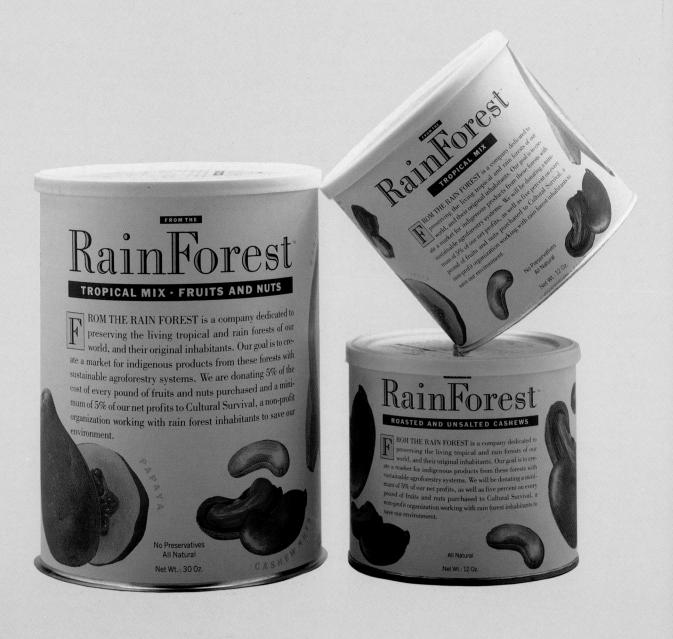

PACKAGING
TYPOGRAPHY/DESIGN PAULA SCHER, NEW YORK, NEW YORK
TYPOGRAPHIC SOURCE JCH GROUP
STUDIO PENTAGRAM DESIGN
CLIENT RAINFOREST INC.
PRINCIPAL TYPES BODONI AND BODONI OPEN FACE
DIMENSIONS VARIOUS

drinks, Pepsi snapped up 25 percent of KAS, and Schweppes took all of CIRSA. Reckitt bought childcare company Nenuco, and Benckiser purchased detergents leader Camp. Procter & Gamble now owns household products manufacturer Arbora, which was 50 percent Spanish-owned.

More Spanish firms are expected to forge associations with foreigners as Europe enters this crucial decade of economic integration. Analysts note that it will be hard for Spanish companies to boost their market penetration, as foreign firms dominate most food and drugstore markets in Spain. The three leaders in the food sector in 1988 were all multinationals — Nestle (sales of nearly 125 billion pesetas), Coca-Cola (115 billion pesetas), and Unilever (85 billion pesetas). A notable exception is in the cooking oil sector, where the newly formed Aceites Espanoles — a merger of national companies Elosua and Carbonell — boasts a 21 percent share of the market.

Possibilities in Portugal

It may sound contradictory, but Portugal's position as one of Western Europe's poorest countries creates some of the most interesting marketing opportunities in the European Community.

With EC membership and the business-supportive Social Democrats in power, the country has left behind the economic instability that followed the 1974 leftist revolution, and is in the midst of a frenetic expansion. New shopping centers provide an answer for those Portuguese searching for ways to spend more money. The futuristic pink and blue towers of Amoreiras — one of Europe's biggest malls — epitomize the revolution in shopping shaking up Portuguese patterns of living. A new type of weekend adventure — to one of the ten hypermarkets which have sprung up since 1985 — has begun to supplant other forms of recreation.

Imported cheeses, sugarless gum and other items which five years ago may have seemed like delicacies to the average Portuguese are now commonplace. Foreigners have been quick to capitalize on the trend, and are setting the pace in marketing and distribution. For instance, Nestle is the market leader in food, and Unilever in drugstore items. Kellogg's, General Foods and Cadbury-Schweppes and many other big foreign multinationals are in Portugal through agents and distributors, although Henkel and P&G have set up their own subsidiaries.

Markets for traditional Portuguese products such as canned fish and tinned sausages are still dominated by local firms, but most of these are seeking joint-venture associations with foreigners to gain know-how and build stronger competitive positions. The Oporto-based canned fish company Vasco de Gama is linking up with a Spanish firm on the export side, while Judice Fialho of the Algarve has been partially bought by H.J.Heinz. As for canned sausages, Lisbon-based Isidoro seems to be looking for a possible partner. Portuguese biscuit market leader Triunfo has a deal with Italy's Star to distribute pasta, P&G bought bleach firm Neoblanc in early 1990, marking the multinational's return to Portugal after an absence of several years.

With Spain bubbling and Portugal only a step or two behind, Iberia's glorious resurgence couldn't have come at a more propitious time. The economic realities of post-1992 Europe are fast narrowing the choices to fight or fade — compete on the level playing field now emerging, or relinquish that field to superior competitors. By all accounts, count Iberia in. ☙

Julia Montana is a freelance writer living in Europe who reports regularly on Spain and Portugal.

25 Candles

ALTHOUGH THE GROWTH OF THE SPANISH MARKET IS A RELATIVELY RECENT PHENOMENON, NIELSEN MARKET RESEARCH HAS BEEN TAKING IBERIA'S MEASURE FOR TWENTY-FIVE YEARS.

FOUNDED IN 1965, NIELSEN SPAIN HAS GROWN TO EMPLOY OVER FIVE HUNDRED RESEARCH PROFESSIONALS AND SUPPORT PERSONNEL IN FIVE OFFICES. THE NIELSEN RETAIL INDEX TRACKS A DIVERSE AND UTTERLY UNIQUE RETAIL ENVIRONMENT IN WHICH 41 PERCENT OF FOOD STORES ARE FAMILY-OWNED. NIELSEN ALSO SURVEYS ELECTRONICS AND APPLIANCE SALES IN THE DURABLE GOODS SECTORS. AFTER ACQUIRING A SPANISH COMPANY THAT SPECIALIZED IN MEASUREMENT OF ADVERTISING EXPENDITURES, NIELSEN DEVELOPED AN IMPRESSIVE CAPABILITY IN ADVERTISING AND MEDIA MEASUREMENT. TODAY, THE COMPANY TRACKS ADVERTISING FOR ADVERTISING AGENCIES, MEDIA AND MANUFACTURERS, EVALUATES STORY BOARDS, AND ISSUES STATISTICAL REPORTS ON ADVERTISING SPENDING.

"THE GROWTH AND EVOLUTION OF OUR BUSINESS IN SPAIN HAS BEEN EXTREMELY GRATIFYING," SAYS MR. EMANUELE DE NATALE, EXECUTIVE VICE PRESIDENT FOR ALL NIELSEN OPERATIONS IN EUROPE. "TODAY, SPAIN HOLDS ITS RIGHTFUL PLACE ALONGSIDE FRANCE, GERMANY, ITALY AND BRITAIN AS A FULL PARTNER IN THE PROGRESS OF EUROPE. WE'RE ESPECIALLY PLEASED TO BE ABLE TO TRACK THAT PROGRESS, AND IN OUR OWN WAY, TO CONTRIBUTE TO IT."

STORE-SPECIFIC SPACE MANAGEMENT

BY FRANCIS X. PIDERIT

A chain store manager in need of a fitting epitaph for a tombstone might choose something like "Here rests a retailer who always had the right product, in the right place, at the right time."

To the typical customer, a supermarket shelf must seem like one of nature's great givens: here is the canned corn, there are the cookies, and where do they keep the molasses? Little do consumers realize how much time, effort and anxiety go into selection, design and arrangement, or how closely retailers track the performance of every brand, size and facing. Buying, merchandising, warehousing and the other disciplines in the modern retailing company all exist for one purpose: to make sure that when customers seek, they find.

Of late, merchandisers and space planners are being asked to do still more before they get into retailing heaven. The standard for sanctity has been raised to include the right *group* of products, in the *assortment* and *arrangement* yielding the greatest possible profit. A retailer's ability to maximize the performance of merchandise

on the shelf is all the more critical in today's environment, with its torrent of line extensions and intense competition for shelf space.

Happily, specialized software programs for space planning are coming to the rescue. These new products free space planners from the burden of having to prepare manually the hundreds and even thousands of planograms needed to depict shelf arrangement of products for the average chain-store company.

By general industry agreement, one of the most sophisticated new programs is Spaceman®, The Third Generation (referred to as Spaceman III), developed by Logistics Data Systems, a subsidiary of Nielsen Marketing Research. In its basic applications, Spaceman III makes shelf management a vastly more efficient tactical tool for

increasing sales. Fully implemented, Spaceman III becomes the merchandising equivalent of a corporation's core management information system — the place where management, buying, merchandising, floor planning, warehousing and other functions meet to answer the strategic question: "What products should we carry to meet our goals as a company?"

A global tour of retailers and other food-industry professionals dramatizes the varying speeds at which companies are adopting computerized space planning. Some companies discussed in this article

MAJOR RETAILERS WORLDWIDE ARE WORKING ON THE EDGE OF AN INTERIOR FRONTIER: COMPUTERIZED PLANNING OF SHELF SPACE.

MAGAZINE
TYPOGRAPHY/DESIGN KIN YUEN, NEW YORK, NEW YORK
CREATIVE DIRECTOR KENT HUNTER
TYPOGRAPHIC SOURCE IN-HOUSE
AGENCY FRANKFURT GIPS BALKIND
CLIENT A. C. NIELSEN
PRINCIPAL TYPES UNIVERS 47, BERKELEY, FUTURA HEAVY, AND COPPERPLATE GOTHIC
DIMENSIONS 8½ × 12 IN. (20.3 × 30.5 CM)

ABCDEFGHIJKLMNO
PQRSTUVWXYZ
ABCDEFGHIJKLMNO
PQRSTUVWXYZ
-?!ßs(.,:'')%£&-
ÁÈÇÎÖÑØÆ
123456

PACKAGING
TYPOGRAPHY/DESIGN BRUCE HALE, SEATTLE, WASHINGTON
LETTERER BRUCE HALE
STUDIO BRUCE HALE DESIGN STUDIO
CLIENT THE BON MARCHÉ
PRINCIPAL TYPE HANDLETTERING
DIMENSIONS VARIOUS

Componist
david dramm
edwin kolpa Toneelbeeld
marc van gelder Licht
bianca van dillen Kostuums
Choreografie
¹ phil griffin
² dries van der post en
³ guido severien
dansproduktie

POSTER
TYPOGRAPHY/DESIGN KOEWEIDEN-POSTMA, AMSTERDAM, NETHERLANDS
LETTERER KOEWEIDEN-POSTMA
TYPOGRAPHIC SOURCE SSP-DRUKKERIJ/ZETTERIJ
STUDIO KOEWEIDEN-POSTMA
CLIENT DANSPRODUKTIE
PRINCIPAL TYPES FRUTIGER AND HANDLETTERING
DIMENSIONS 33¹⁄₁₆ × 23½ IN. (84 × 59.5 CM)

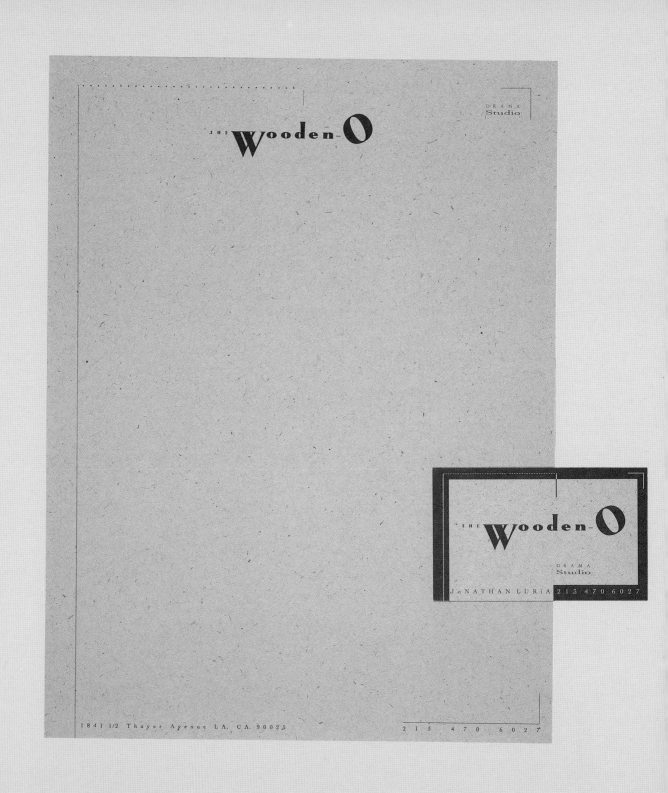

STATIONERY
TYPOGRAPHY/DESIGN KIM SAGE, LOS ANGELES, CALIFORNIA
TYPOGRAPHIC SOURCE IN-HOUSE
STUDIO SAGE DESIGN
CLIENT THE WOODEN-O DRAMA STUDIO
PRINCIPAL TYPES METROPOLIS AND COCHIN
DIMENSIONS 8½ × 11 IN. (21.6 × 27.9 CM)

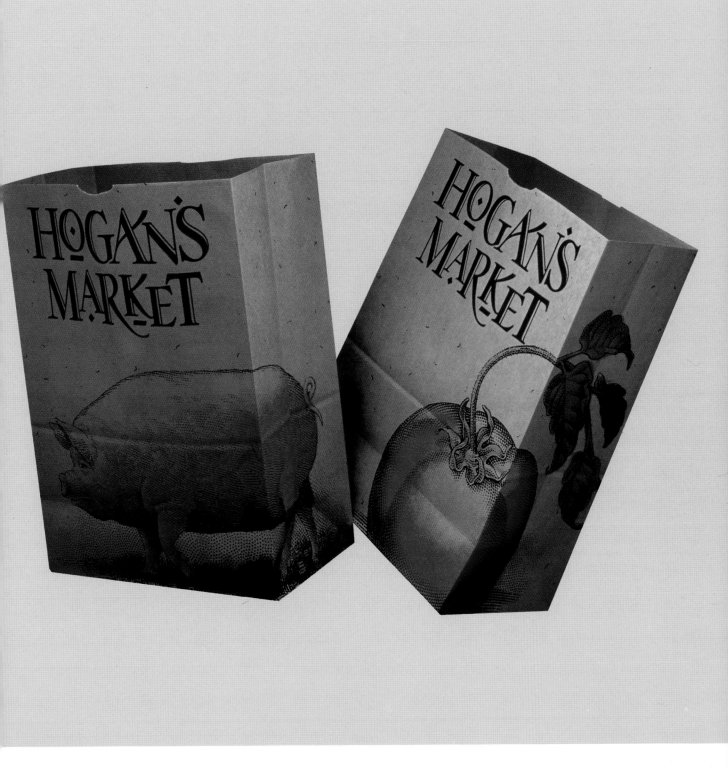

PACKAGING
TYPOGRAPHY/DESIGN JACK ANDERSON, JULIA LAPINE, DENISE WEIR, AND LIAN NG, SEATTLE, WASHINGTON
LETTERER NANCY STENZ
STUDIO HORNALL ANDERSON DESIGN WORKS
CLIENT PUGET SOUND MARKETING COMPANY
PRINCIPAL TYPE HANDLETTERING
DIMENSIONS 11¹³⁄₁₆ × 16¹³⁄₁₆ × 7 IN. (30.1 × 42.8 × 17.8 CM)

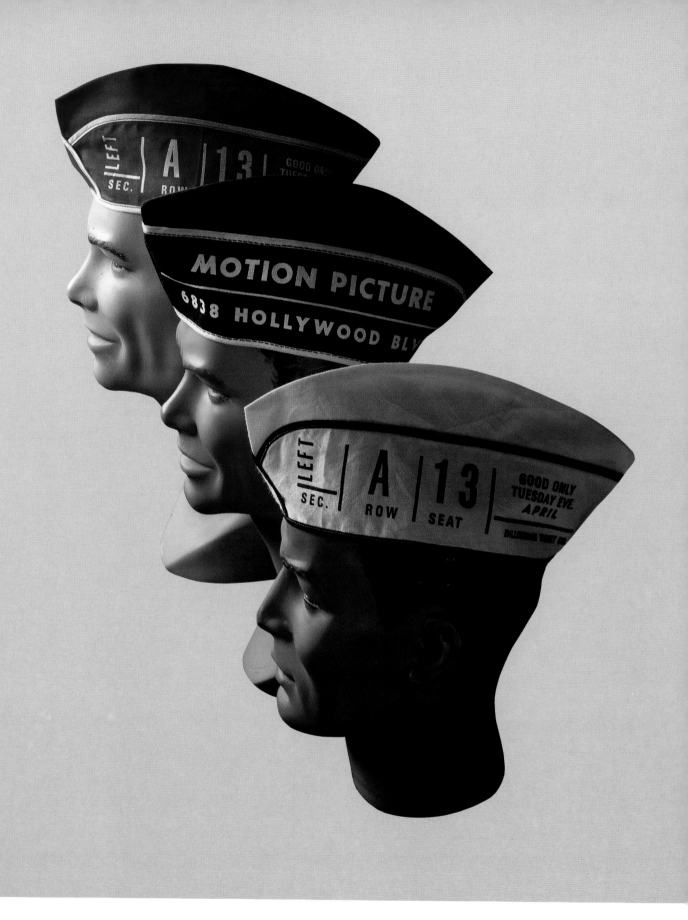

PACKAGING
TYPOGRAPHY/DESIGN CHARLES S. ANDERSON, DAN OLSON, AND HALEY JOHNSON, MINNEAPOLIS, MINNESOTA
TYPOGRAPHIC SOURCE LINOTYPOGRAPHERS, FORT WORTH, TEXAS
STUDIO CHARLES S. ANDERSON DESIGN COMPANY
CLIENT PARAMOUNT PRODUCTS
PRINCIPAL TYPE SPARTAN
DIMENSIONS 9 × 6 IN. (22.9 × 15.2 CM)

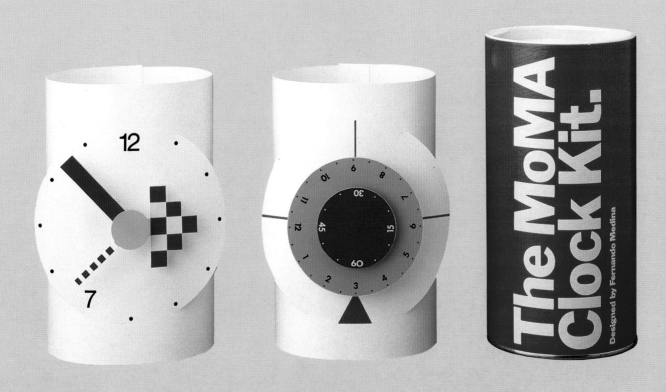

PACKAGING
TYPOGRAPHY/DESIGN FERNANDO MEDINA, MONTREAL, QUEBEC, CANADA
LETTERER FERNANDO MEDINA
TYPOGRAPHIC SOURCE LETRASET
STUDIO TRIOM DESIGN INC.
CLIENT THE MUSEUM OF MODERN ART OF NEW YORK
PRINCIPAL TYPES FRANKLIN GOTHIC AND HELVETICA

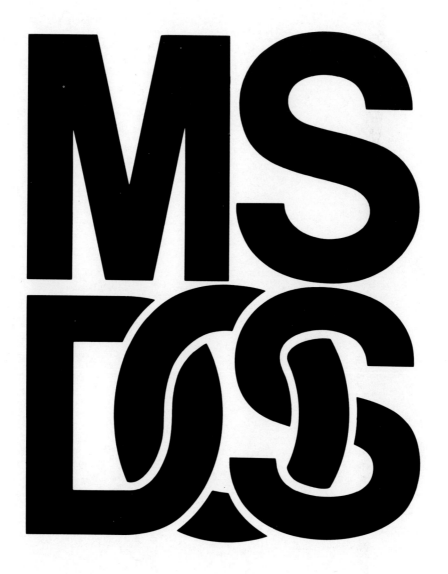

LOGOTYPE
TYPOGRAPHY/DESIGN JOHN FORTUNE, REDWOOD, WASHINGTON
LETTERER LEILANI FORTUNE
STUDIO MICROSOFT CORPORATE COMMUNICATIONS
CLIENT MICROSOFT CORPORATION
PRINCIPAL TYPE HELVETICA BLACK (MODIFIED)

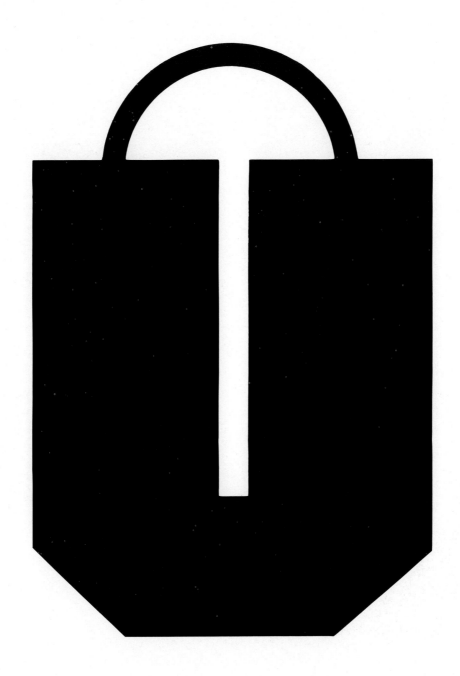

LOGOTYPE
TYPOGRAPHY/DESIGN SUPON PHORNIRUNLIT, WASHINGTON, D.C.
LETTERER SUPON PHORNIRUNLIT
TYPOGRAPHIC SOURCE PHIL'S PHOTO
STUDIO SUPON DESIGN GROUP, INC.
CLIENT ULMAN PAPER BAG COMPANY
PRINCIPAL TYPE MACHINE BOLD (CUSTOMIZED)

The New City YMCA sits between the Cabrini-Green public housing complex and the North River Industrial Corridor. As upscale residents move into this area, converting warehouses into condominiums, the manufacturing base shrinks, driving low-skill, high-paying jobs from the city. To combat this spiral of unemployment and poverty, New City Executive Director Perry Gunn offers a continuum of services that prepares community residents for jobs, while L.E.E.D. Council's Executive Director Donna Ducharme fights to retain those jobs. Through these two arms, New City maintains six tutoring sites in Cabrini-Green that encourage children to stay in school. It also offers adult literacy services and trains 300 people a year in job readiness skills. With help from retailers, trade schools and colleges, New City's innovative refrigeration repair program teaches residents a trade, provides them with a job and offers the Chicago Housing Authority much needed appliance repair services. The L.E.E.D. Council further develops this continuum by helping new entrepreneurs create business plans, fund their start-ups and receive expert volunteer assistance. It also links local talent with companies looking to fill positions. And through its membership of area manufacturers and related firms, the YMCA's L.E.E.D. Council develops policy for industrial retention and influences legislation to protect this vital community resource.

Refrigeration Repair Technician. Industrial Retention. Homework Before Play Tutoring in Cabrini-Green. Adult Literacy Program

ANNUAL REPORT
TYPOGRAPHY/DESIGN PAT. AND GREG SAMATA, DUNDEE, ILLINOIS
TYPOGRAPHIC SOURCES IN-HOUSE AND K. C. YOON
STUDIO SAMATA ASSOCIATES
CLIENT YMCA OF METROPOLITAN CHICAGO
PRINCIPAL TYPE MODULA
DIMENSIONS 11 × 12 IN. (27.9 × 30.5 CM)

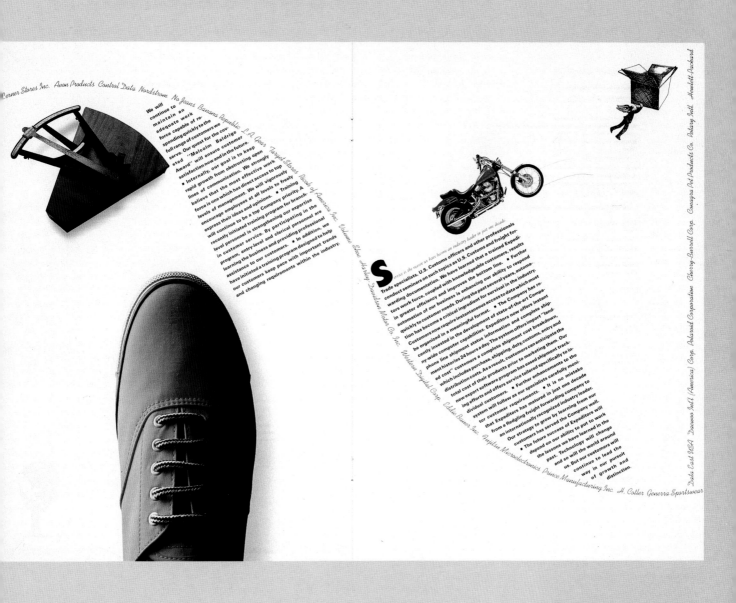

ANNUAL REPORT
TYPOGRAPHY/DESIGN JOHN VAN DYKE, SEATTLE, WASHINGTON
TYPOGRAPHIC SOURCE TYPEHOUSE
AGENCY VAN DYKE COMPANY
CLIENT EXPEDITORS INTERNATIONAL
PRINCIPAL TYPE UNIVERS
DIMENSIONS 8¼ × 11¾ IN. (21 × 29.8 CM)

JULY 8, 1990

For anyone, retracing roots is an emotional journey. But at a

BY
DANIEL
GOLDEN

time when the Berlin Wall has been reduced to graffiti-

painted chips, I have discovered how deeply my family history

RETURN

is connected to the sweep of change in Europe. Now that kudos for winning the

TO

Cold War are being handed out, the man who resurrected West Berlin's economy

BERLIN

after World War II should be remembered. He was my grandfather, Paul Hertz.

MAGAZINE COVER
TYPOGRAPHY/DESIGN LUCY BARTHOLOMAY, BOSTON, MASSACHUSETTS
TYPOGRAPHIC SOURCE IN-HOUSE
CLIENT THE BOSTON GLOBE MAGAZINE
PRINCIPAL TYPES SANS SERIF EXTRA BOLD CONDENSED, GOUDY, AND OLD FOUNDRY TYPE
DIMENSIONS 10½ × 12 IN. (26.7 × 30.5 CM)

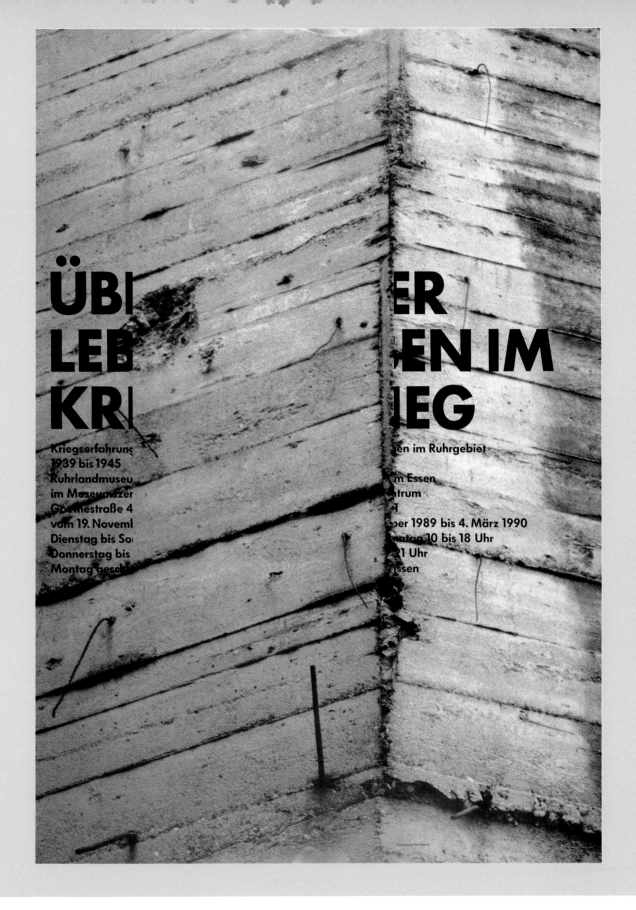

POSTER
TYPOGRAPHY/DESIGN UWE LOESCH, DÜSSELDORF, GERMANY
TYPOGRAPHIC SOURCE IN-HOUSE
CLIENT RUHRLANDMUSEUM ESSEN
PRINCIPAL TYPE FUTURA BOLD
DIMENSIONS 33⅛ × 46¾ IN. (84.1 × 118.8 CM)

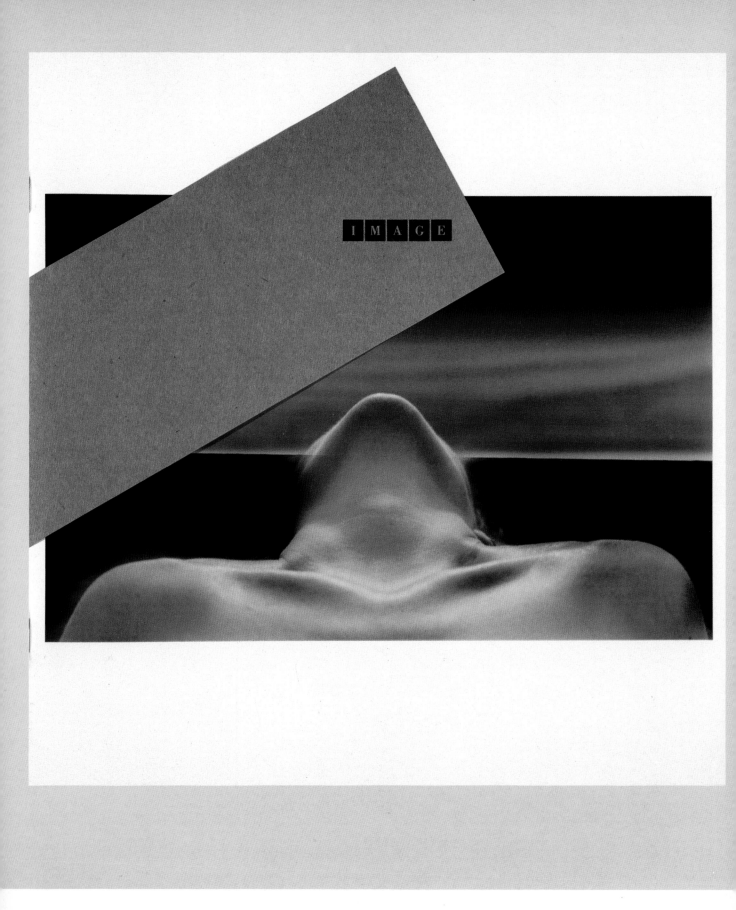

BROCHURE
TYPOGRAPHY/DESIGN BOB SALPETER, NEW YORK, NEW YORK
TYPOGRAPHIC SOURCE LIGHT PRINTING CO., INC.
STUDIO LOPEZ SALPETER & ASSOCIATES
CLIENT METROPOLITAN PRINTING SERVICE
PRINCIPAL TYPE BAUER BODONI
DIMENSIONS 9¾ × 9¾ IN. (24.8 × 24.8 CM)

Computer Graphics

Hugh Dubberly, Chairman, Computer Graphics Department

"Five years ago few designers used computers. Today I can't imagine designing without one. Designers and artists can use computers as tools for drawing, typography, photo retouching, three-dimensional modeling, animation, and more. Computers don't replace designers; they extend the designer's reach. More than mere tools, computers are also a medium, one that combines type, animation, sound, and video. And they are a source of information. Each screen can lead to other screens, connecting ideas, creating a web of information. The possibilities are limitless, and they are waiting to be explored."

From the invention of movable type in the mid-fifteenth century to the invention of moving pictures at the end of the nineteenth century, advances in technology have led to the development of new media and opened up new creative possibilities for artists and designers. Because of its versatility, the computer promises to transform the design professions in ways that we have only begun to imagine. Art Center's Computer Graphics program has three major objectives. The first is to integrate computers into the curricula of the other departments, to help students in every major discover new ways to solve traditional design problems. Advertising and graphic designers can use computers to format type, draw symbols, and lay out pages. Illustrators can draw and paint with them. Photographers can retouch and combine images. Industrial designers can create three-dimensional models of products, vehicles, and environments. Filmmakers can set these models in motion. Fine artists can investigate any of these applications and exploit the computer's ability to generate variations quickly. The department's second objective is to create a computer graphics major, to educate students to employ the computer as both a tool and a medium, a place to find information as well as a means to create and modify it. The third goal is to use computers to bridge the gap between studio and academic courses. Libraries of visual and verbal information—histories of painting, photography, and design—can be stored on disk, cross-referenced, linked to data banks in other disciplines. Students can follow these links or even create new ones. While computers seem complex, they are still in their infancy. So far they have been used primarily as production tools in the final stages of design. As computers become more sophisticated, they will play a greater role as planning tools, becoming an indispensable aid to the ideational process that is the starting point of all design.

CATALOG
TYPOGRAPHY/DESIGN REBECA MÉNDEZ, PASADENA, CALIFORNIA
TYPOGRAPHIC SOURCE DEE TYPOGRAPHY, INC.
STUDIO ART CENTER COLLEGE OF DESIGN (DESIGN OFFICE)
CLIENT ART CENTER COLLEGE OF DESIGN
PRINCIPAL TYPE GILL SANS
DIMENSIONS 12¼ × 7¾ IN. (31.1 × 19.7 CM)

RECORD ALBUM
TYPOGRAPHY/DESIGN NORMAN MOORE, LOS ANGELES, CALIFORNIA
LETTERER NORMAN MOORE
TYPOGRAPHIC SOURCE IN-HOUSE
AGENCY DESIGN/ART, INC.
CLIENT HEART/CAPITOL RECORDS
PRINCIPAL TYPE FUTURA BOLD CONDENSED
DIMENSIONS 5 × 5¾ IN. (12.7 × 14.6 CM)

PACKAGING
TYPOGRAPHY/DESIGN YUKICHI TAKADA, OSAKA, JAPAN
TYPOGRAPHIC SOURCE IN-HOUSE
STUDIO I.F. PLANNING
CLIENT YUKICHI TAKADA
PRINCIPAL TYPE ISOTRIC
DIMENSIONS VARIOUS

WASHINGTON IRVING GARY KELLEY

BOOK
TYPOGRAPHY/DESIGN RITA MARSHALL, LAKEVILLE, CONNECTICUT
TYPOGRAPHIC SOURCES AFFOLTER & GSCHWEND, BASEL, SWITZERLAND, AND DIX TYPE, SYRACUSE, NEW YORK
STUDIO DELESSERT-MARSHALL
CLIENTS STEWART, TABORI & CHANG AND CREATIVE EDUCATION, MANKATO
PRINCIPAL TYPES ANTIQUE WOOD AND SIMONCINI GARAMOND
DIMENSIONS 8 × 13 IN. (20.3 × 33 CM)

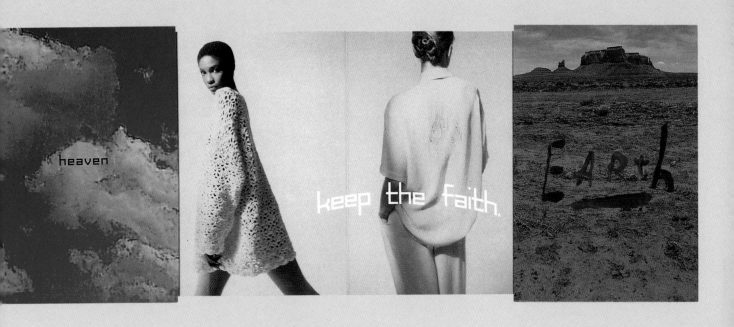

MAILER
TYPOGRAPHY/DESIGN AMY QUINLIVAN, MINNEAPOLIS, MINNESOTA
LETTERER LILLA ROGERS, NEW YORK, NEW YORK
TYPOGRAPHIC SOURCE IN-HOUSE
CLIENT DEPARTMENT STORE DIVISION OF DAYTON HUDSON CORPORATION
PRINCIPAL TYPE GILL SANS BOLD
DIMENSIONS 4⅜ × 6⅜ IN. (11.1 × 16.2 CM)

CORPORATE IDENTITY
TYPOGRAPHY/DESIGN KOEWEIDEN-POSTMA, AMSTERDAM, NETHERLANDS
TYPOGRAPHIC SOURCE DRUKKERIJ ROSBEECK
STUDIO KOEWEIDEN-POSTMA
CLIENT THEUNIS-VAN DER ZANDEN
PRINCIPAL TYPE AKZIDENZ GROTESK
DIMENSIONS VARIOUS

The Adobe
Developers' Conference
Adobe Systems Inc.
1585 Charleston Road
Mountain View
California 94043
415-962-3737

Extending the
PostScript
Advantage

STATIONERY
TYPOGRAPHY/DESIGN NANCY WINTERS AND LUANNE COHEN, MOUNTAIN VIEW, CALIFORNIA
LETTERER PAUL WOODS, SAN FRANCISCO, CALIFORNIA
TYPOGRAPHIC SOURCE IN-HOUSE
STUDIO ADOBE SYSTEMS INC.
CLIENT ADOBE SYSTEMS INC.
PRINCIPAL TYPE FUTURA LIGHT
DIMENSIONS 8½ × 11 IN. (21.6 × 27.9 CM)

LOGOTYPE
TYPOGRAPHY/DESIGN GREG CLARKE AND VICKI KARTEN, Santa Monica, California
LETTERER GREG CLARKE
TYPOGRAPHIC SOURCE ANDRESEN TYPOGRAPHICS
STUDIO JOSH FREEMAN/ASSOCIATES
CLIENT SISLEY ITALIAN KITCHEN
PRINCIPAL TYPE HANDLETTERING

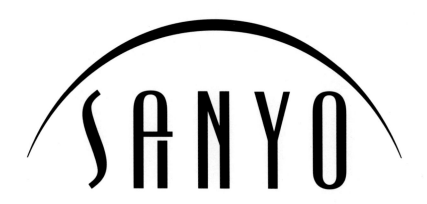

LOGOTYPE
TYPOGRAPHY/DESIGN KENICHI NISHIWAKI, SAN FRANCISCO, CALIFORNIA
LETTERER PROFILE DESIGN
STUDIO PROFILE DESIGN
CLIENT SANYO DEPARTMENT STORE
PRINCIPAL TYPE HANDLETTERING

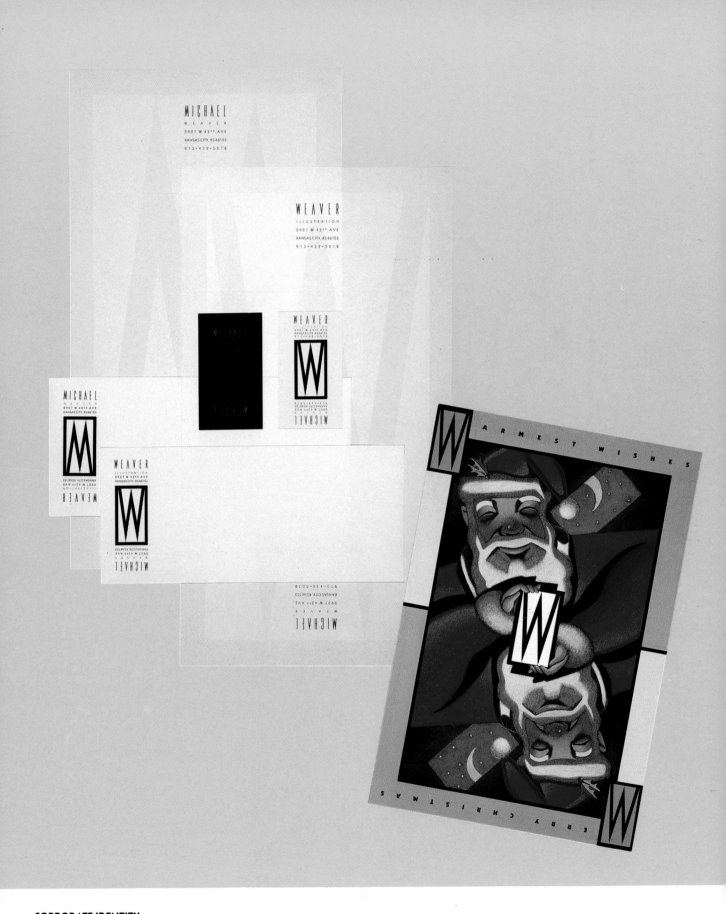

CORPORATE IDENTITY
TYPOGRAPHY/DESIGN PATRICE EILTS AND MICHAEL WEAVER, KANSAS CITY, MISSOURI
LETTERER PATRICE EILTS
TYPOGRAPHIC SOURCE LOPEZ GRAPHICS
AGENCY MULLER & COMPANY
STUDIO MICHAEL WEAVER ILLUSTRATION
CLIENT MICHAEL WEAVER ILLUSTRATION
PRINCIPAL TYPES KABEL AND HANDLETTERING
DIMENSIONS VARIOUS

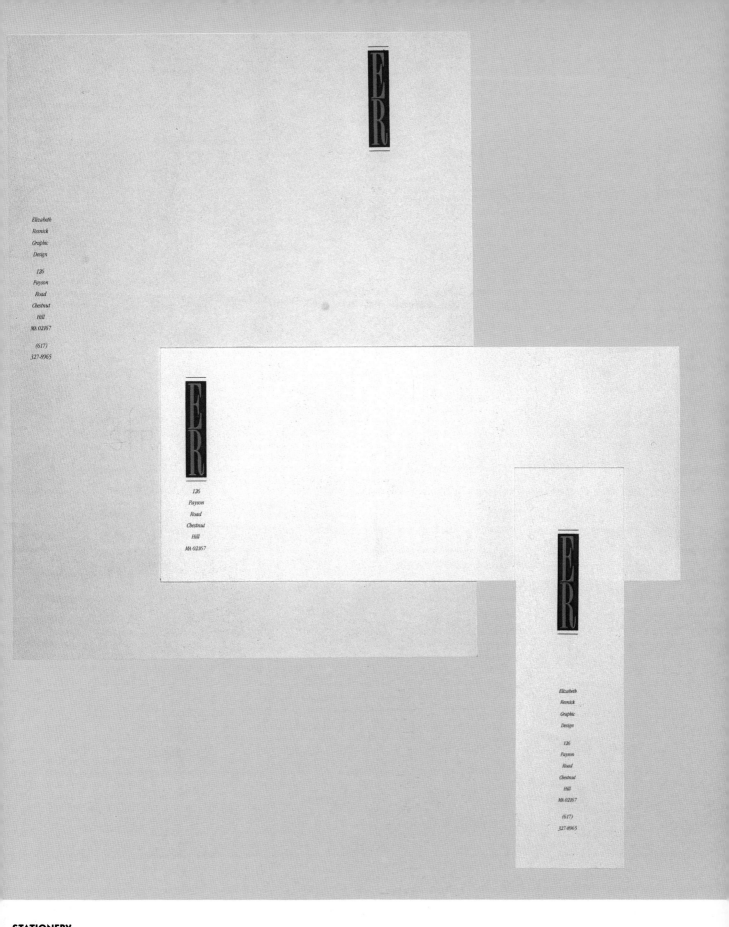

STATIONERY
TYPOGRAPHY/DESIGN ELIZABETH RESNICK, CHESTNUT HILL, MASSACHUSETTS
TYPOGRAPHIC SOURCES DON DEWSNAP TYPOGRAPHIC SERVICES AND LETRASET
STUDIO ELIZABETH RESNICK GRAPHIC DESIGN
CLIENT ELIZABETH RESNICK
PRINCIPAL TYPES BORDEAUX ROMAN AND GARAMOND CONDENSED ITALIC
DIMENSIONS 8½ × 11 IN. (21.6 × 27.9 CM)

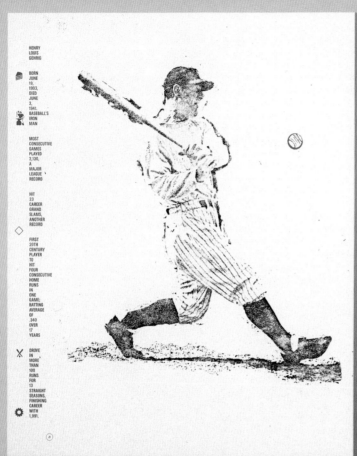

HENRY
LOUIS
GEHRIG

BORN
JUNE
19,
1903,
DIED
JUNE
2,
1941.
BASEBALL'S
IRON
MAN

MOST
CONSECUTIVE
GAMES
PLAYED
2,130,
A
MAJOR
LEAGUE
RECORD

HIT
23
CAREER
GRAND
SLAMS,
ANOTHER
RECORD

FIRST
20TH
CENTURY
PLAYER
TO
HIT
FOUR
CONSECUTIVE
HOME
RUNS
IN
ONE
GAME;
BATTING
AVERAGE
OF
.340
OVER
17
YEARS

DROVE
IN
MORE
THAN
100
RUNS
FOR
13
STRAIGHT
SEASONS,
FINISHING
CAREER
WITH
1,991.

Striking out ALS is the motivating factor behind ALSA's education and awareness programs. Those words were particularly fitting in fiscal 1990 when The ALS Association mounted a 50th Anniversary Tribute to Lou Gehrig. It was a team effort with Major League Baseball commemorating Gehrig's forced retirement from the game he loved because of a disease which would later take his name and his life.

The year-long national awareness campaign involved all major league clubs, several minor league teams and even those in the Florida Seniors' League. ALSA chapters and support groups joined forces with the ball teams to host Tribute events and ballpark ceremonies across the U.S. The campaign generated national and local media coverage. Millions of fans saw the tributes, the specially made videos and baseball public service announcements, and the personal stories of patients courageously fighting ALS.

Also, ALSA took part in the dedication of the Lou Gehrig commemorative postage stamp at the Baseball Hall of Fame and presented a bronze of Gehrig, now on permanent display in the Hall of Fame's museum.

"Lou Gehrig was the greatest ball player ever produced in New York. He was one of the greatest ball players ever produced anywhere."

James M. Kahn
New York Sun editorial
June 2, 1941

ANNUAL REPORT
TYPOGRAPHY/DESIGN ELIZABETH BURRILL, PASADENA, CALIFORNIA
ART DIRECTOR MARGI DENTON
TYPOGRAPHIC SOURCE ELLA TYPE
STUDIO DENTON DESIGN ASSOCIATES
CLIENT THE ALS ASSOCIATION
PRINCIPAL TYPES HELVETICA LIGHT CONDENSED, HELVETICA MEDIUM CONDENSED, AND DISKUS MEDIUM
DIMENSIONS 8⅞ × 11 IN. (22.5 × 27.9 CM)

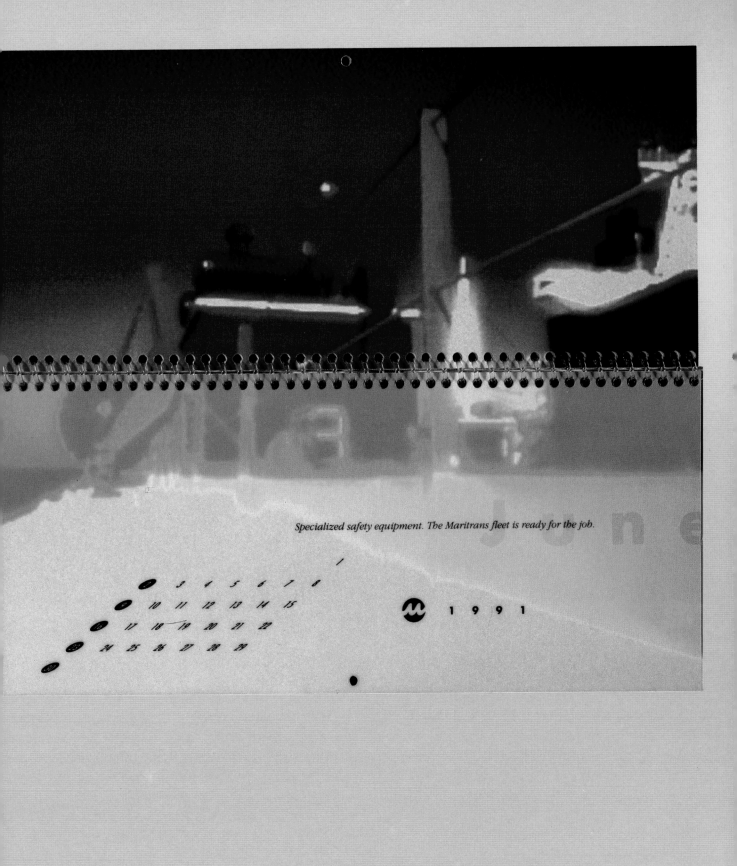

Specialized safety equipment. The Maritrans fleet is ready for the job.

1 3 4 5 6 7 8
10 11 12 13 14 15
17 18 19 20 21 22
24 25 26 27 28 29

1 9 9 1

CALENDAR
TYPOGRAPHY/DESIGN DAVE PLUNKERT AND TIM THOMPSON, BALTIMORE, MARYLAND
LETTERER DAVE PLUNKERT
TYPOGRAPHIC SOURCE IN-HOUSE
STUDIO GRAFFITO
CLIENT MARITRANS OPERATING PARTNERS, L.P.
PRINCIPAL TYPES FUTURA AND GARAMOND
DIMENSIONS 4 × 9 IN. (10.2 × 22.9 CM)

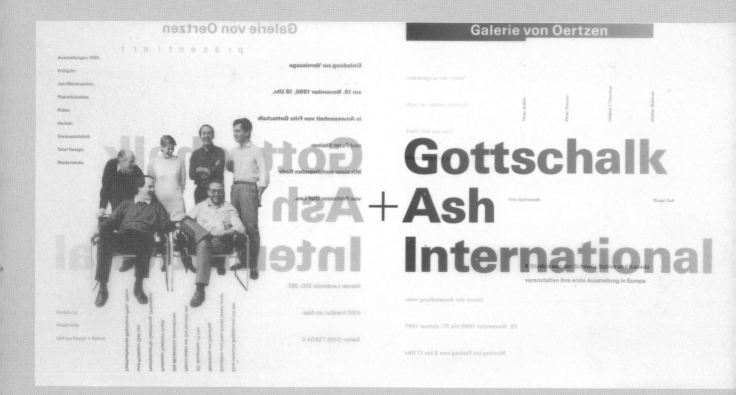

INVITATION
TYPOGRAPHY/DESIGN OLAF LEU DESIGN + PARTNER AND HARALD WELT, FRANKFURT AM MAIN, GERMANY
TYPOGRAPHIC SOURCE A. BERTHOLD AG
STUDIO OLAF LEU DESIGN + PARTNER
CLIENT VON OERTZEN GMBH & CO. KG
PRINCIPAL TYPE UNIVERS
DIMENSIONS 8¹⁄₁₆ × 4⅛ IN. (20.5 × 10.5 CM)

T
H
E
A
T
R
E

When sockeye salmon

leave the ocean

to battle their way upstream to spawn and die,

they exchange their sea-going grey

for rubies.

Like Shakespeare's Cleopatra,

they dress

for their final scene.

"Give me my robe,

put on my crown," she says,

preparing to apply the asp.

Passionate,

cruel, devoted,

capricious and bred to power,

she takes her leave like the salmon,

slipping at the last moment

into the gowns of her true and royal self,

dressed for immortality.

BROCHURE
TYPOGRAPHY/DESIGN JOHN VAN DYKE, SEATTLE, WASHINGTON
TYPOGRAPHIC SOURCE TYPEHOUSE
AGENCY VAN DYKE COMPANY
CLIENT MEAD PAPER
PRINCIPAL TYPES GARAMOND AND BODONI (CUSTOMIZED)
DIMENSIONS 15 × 6⅞ IN. (17.4 × 38.1 CM)

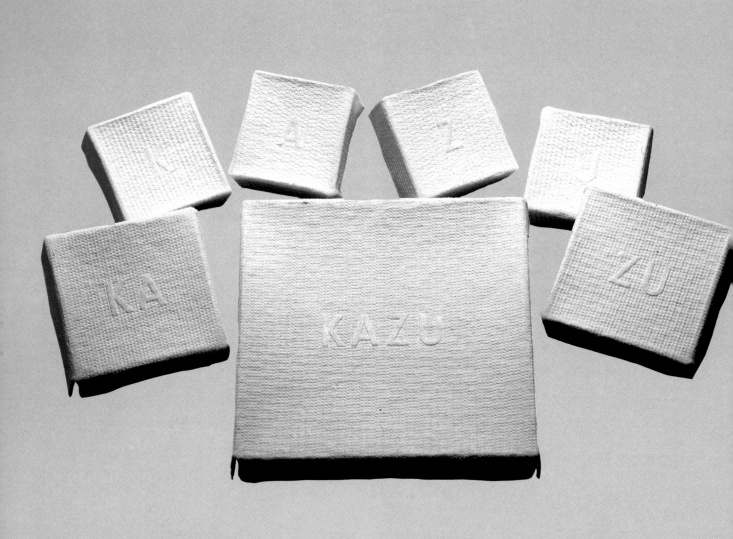

PACKAGING
TYPOGRAPHY/DESIGN AKIO OKUMURA, KITAKU, OSAKA, JAPAN
TYPOGRAPHIC SOURCE IN-HOUSE
STUDIO PACKAGING CREATE INC.
CLIENT KAZU JEWELRY DESIGN STUDIO
DIMENSIONS VARIOUS

ETIENNE DELESSERT

ASHES ASHES

BOOK
TYPOGRAPHY/DESIGN RITA MARSHALL, LAKEVILLE, CONNECTICUT
LETTERER ETIENNE DELESSERT
TYPOGRAPHIC SOURCE PRINTING PREP, BUFFALO, NEW YORK
STUDIO DELESSERT-MARSHALL
CLIENT STEWART, TABORI & CHANG
PRINCIPAL TYPE PIRANESI
DIMENSIONS 8½ × 11 IN. (21.6 × 27.9 CM)

ADVERTISEMENT
TYPOGRAPHY/DESIGN TONI BOWERMAN, BOSTON, MASSACHUSETTS
TYPOGRAPHIC SOURCE BERKELEY TYPOGRAPHERS
AGENCY CIPRIANI KREMER ADVERTISING
CLIENT COLE HAAN
PRINCIPAL TYPE ENGRAVERS ROMAN
DIMENSIONS 11 × 17 IN. (27.9 × 43.2 CM)

POSTER
TYPOGRAPHY/DESIGN UWE LOESCH, DÜSSELDORF, GERMANY
TYPOGRAPHIC SOURCE IN-HOUSE
CLIENT RUHRLANDMUSEUM ESSEN
PRINCIPAL TYPE FUTURA BOLD OBLIQUE
DIMENSIONS 31 × 45⅞ IN. (78.5 × 116.5 CM)

Type Directors Club
60 East 42nd Street
Suite 1416
New York, N.Y. 10165-0015

7 POINT

CALL FOR entries

8 POINT

CALL FOR entries

9 POINT

CALL FOR entries

10 POINT

CALL FOR entries

12 POINT

CALL FOR entries

14 POINT

CALL FOR entries

16 POINT

CALL FOR entries

18 POINT

CALL FOR entries

20 POINT

CALL FOR entries

24 POINT

CALL FOR entries

30 POINT

CALL FOR entries

36 POINT

CALL FOR entries

42 POINT

CALL FOR entries

THE BEST OF ADVERTISING TYPOGRAPHY, 1980–1990

48 POINT

THE BEST OF advertising type
1980-1990

60 POINT

THE BEST OF advertisin
1980-1990

72 POINT

THE BEST OF adver
1980-1990

84 POINT

THE BEST OF adv
1980-1990

96 POINT

HE BEST OF a

CHAIRMAN'S STATEMENT

GENE FEDERICO

Tschichold versus kitsch is one of the directionals that shaped my sense of typographic order. Tschichold, and others, made it clear that most presentation systems grow out of the heart of the material and that there are no limitations to the form the layout takes. Style *can* be used as a function of message. However, there is a device so overused and misused in today's advertising that it cries for discussion.

In the 69th *Art Director's Annual,* over 95 percent of the ad and promotion layouts rely on the centering of headline copy. Looking good seems to take precedence over reading better. Centered type worked on the title pages of books carrying one idea per line, but the restful, classical look works against the dynamics of today's headlines in advertising. In this TDC exhibition concentrating on advertising, despite its mere 46 selected pieces, one sees a greater variety of ways to present a client's message than noted in the bigger shows in town.

One campaign we selected, "Toyota, Investing in the Individual," gave rise to the theme of this statement. Initially, it made no impression on me, but after a second look, the spread with the sepia photo (reminiscent of old roto sections) caught me and led me to the headline. What seemed like banality wrapped up in kitsch was actually a message about how Toyota helps the small American communities in which it has plants. The art and copy are well integrated, and although four-color printing is used, the homey aura of the small town is unmistakable. The jumping sizes of Antique Shaded and Baskerville are inexplicable, but the system appears to work for the message. I admire this work for the consistent style and technique. It proves that even kitsch, if used intelligently, can work.

Gene Federico, a native New Yorker and a graduate of Pratt Institute, is currently a consultant to the firm of Brouillard Communications in New York.

Federico's work is represented in the poster and greeting card collections of the Museum of Modern Art in New York and in the Library of Congress Graphic Design Collection. His one man show appeared at the ITC Gallery in 1989.

In 1980, Federico was inducted into the New York Art Directors Club Hall of Fame. He has also been the recipient of many professional awards and honorary degrees, as well as serving on the boards of design-industry societies.

ADVERTISEMENT
TYPOGRAPHY/DESIGN RODD MARTIN AND BOBBI GASSY, NEW YORK, NEW YORK
TYPOGRAPHIC SOURCE PASTORE DePAMPHILIS RAMPONE
AGENCY OMON NEW YORK
CLIENT TOYOTA MOTOR CORPORATE SERVICES
PRINCIPAL TYPES ANTIQUE SHADED AND BASKERVILLE
DIMENSIONS 7 × 10 IN. (17.8 × 25.4 CM)

ROY CARRUTHERS

The process of refinement has a debilitating effect on any artistic enterprise. It saps its energy and extinguishes its vitality. That refinement and vitality seem unable to coexist is one of the crucial dilemmas of modern art. It is also true of typography.

By the late 1970s, the refinement of contemporary typography had advanced to a ludicrous point. In the most sophisticated circles the desire to produce immaculate typesetting led to the redesign of typeforms, usually with disastrous results.

Technical innovations allowed for extremely tight setting of type, the characters even touching, which did nothing for legibility but enhanced the refined tailored look. The tonal value of a line could now be controlled completely, sometimes to the point of distorting the type characters to do so.

The result was typographical constipation. Gridlock. Words so tightly spaced that they could hardly be separated or read. This tendency was especially predominant in advertising typography, where headlines and justified blocks of copy had grown almost impenetrable. The desire for perfection through refinement, however, came at a terrible cost. Somehow the vitality was lost. Typography was no longer alive. There was no longer room for evolution. Almost inevitably a change had to come.

The most exciting new typography we see today discards the rules, embraces a primitive stance, and replenishes the energy. "Crude" letter-forms. "Bad" spacing. "Clumsy" type sizes. "Ill-fitted" paragraphs. Rock-and-roll typography! What an exciting mess!

The current generation of designers is responding with immense enthusiasm to everything that the culture can toss up: the rapid-fire, disjointed, and often disorienting images of MTV; subway-car ads that tout relief from foot pain and hemorrhoids with a homemade quality that's as refreshing as it is dumb. Everything that can possibly upset the established order is being used by designers now to forge a new, freer aesthetic.

That this attitude has manifested itself in the usually conservative area of advertising is to be applauded. The long overdue awakening has come. Long live rock and roll!

Roy Carruthers was born in South Africa. He is currently senior art director/senior vice-president at Ogilvy & Mather.

ROCK N' ROLL TENNIS is not allowed at places where it is needed most. Rock n' Roll tennis is rugby with a racket. Rock n' Roll tennis is not the tennis your parents had in mind. Rock n' Roll tennis is hitting the ball as loud as you can. Rock n' Roll tennis is rated NC-17. Rock n'Roll tennis plays fair, but not by the rules. Rock n' Roll tennis doesn't have polite applause. Rock n' Roll tennis doesn't play on AM radio. Rock n' Roll tennis is a no-no in Britain. Rock n' Roll tennis doesn't send flowers.

If you want rock n' roll tennis, you want the Nike Air Tech Challenge 3/4.
If you want Nike-Air® cushioning, you want the Nike Air Tech Challenge 3/4. If you want a
Durathane™ toe piece for extra wear, you want the Nike Air Tech Challenge 3/4.
If you want flowers, you want another shoe.

ADVERTISEMENT
TYPOGRAPHY/DESIGN SUSAN HOFFMAN AND JANE OKESON, Portland, Oregon
TYPOGRAPHIC SOURCE IN-HOUSE
AGENCY WIEDEN & KENNEDY
CLIENT NIKE
PRINCIPAL TYPE FRANKLIN GOTHIC HEAVY
DIMENSIONS 17 × 11 IN. (43.2 × 27.9 CM)

JUDGE'S CHOICE

RICHARD MOORE

Good advertising is often about breaking the rules. Good typography is more often about following them. Yet in this decade span of work (skewed more to the later half of the decade and, with the economy's effect on agency submissions, not nearly an industry-wide representation), a great deal of what I found to make great advertising typography was typography which intentionally went against the grain of assumed aesthetics.

Traditional approaches of using type to create handsome forms and textures (such as in the Royal Viking and *Fortune* ads) and to illustrate a point (such as in the Oregon Convention Group and Ministry of Health ads) were well represented, but there was a surprising amount of awfully good typography used in ways we usually think of as awfully bad (such as the Nike and Toyota ads).

This shouldn't be surprising. Our television-spawned audience views the written word with growing irreverence, which in turn permits more liberties to be taken with its written form.

The American Express campaign definitely claims some of these liberties. Yet, classically, it relies upon a strong conversational tone of voice and distinctive typographic forms and textures to command attention. Without ever sacrificing legibility, it merges message, typography, and visual into some pretty powerful advertising.

After fourteen years as chief creative officer of Muir Cornelius Moore in New York City, Richard Moore has relaunched Richard Moore Associates, with clients in the United States, Canada, and Japan. Moore's experience ranges through all forms of communications media, as well as environmental and product design.

Moore has received numerous creative awards from, among others, the Art Directors Club, the One Club, the Clios, the AIGA, the Type Directors Club, and Industrial Design *magazine. His work has been featured in the national and international press. Moore has chaired design-related seminars for the AIGA, Pratt Institute, the Association of Professional Design Firms, and IBM. He is currently on the Board of Directors of the Type Directors Club.*

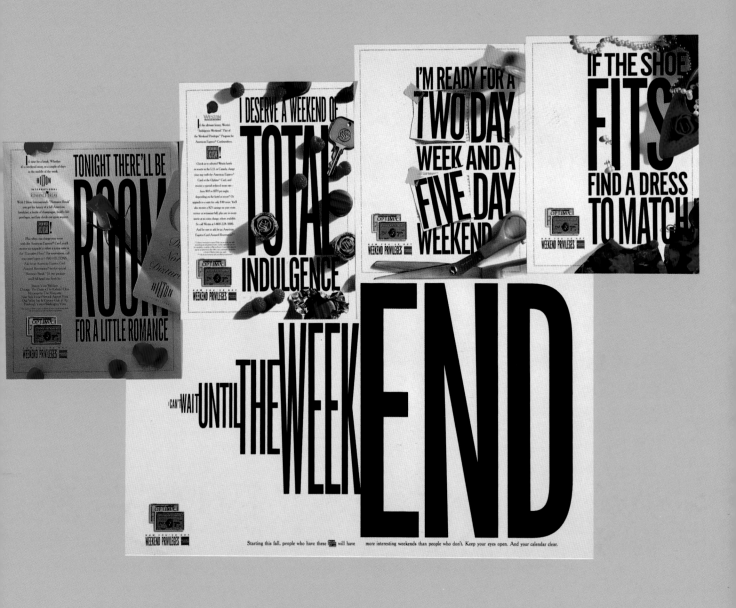

ADVERTISEMENT
TYPOGRAPHY/DESIGN MICHAEL RYLANDER, HARVEY SPEARS, AND ROBERT WAKEMAN, NEW YORK, NEW YORK
TYPOGRAPHIC SOURCE PDR COMPUTER IMPRESSIONS, INC.
AGENCY OGILVY & MATHER
CLIENT AMERICAN EXPRESS
PRINCIPAL TYPES AMEX GOTHIC AND CHELTENHAM OLD STYLE
DIMENSIONS 8 × 10¾ IN. (20.3 × 27.3 CM)

B. MARTIN PEDERSEN

The travel campaign developed by Goodby, Berlin, and Silverstein in San Francisco for Royal Viking is both memorable and classy.

In addition to great copy, it involves and invites the reader with spellbinding photography as well as the Royal Viking fleet of exotic locations.

The design of the ads further supports the travel escape theme by using a border enclosing the ad that lists destinations worldwide, copying the latitude and longitude scales of nautical charts. The type is smart and the end result is advertising that suggests adventure and travel in the fine old traditions of the past.

This campaign has justifiably won numerous awards for Mssrs. Goodby, Berlin, and Silverstein from its inception, and it seems to be continually doing so. Great ideas, poorly executed, work. Great ideas, with great execution, work even better.

B. Martin Pedersen's early career encompassed both advertising and corporate design. In 1986, Pedersen purchased Graphis Press, an international publishing firm that produces a high-quality magazine, as well as books and annuals, for the communications industry. In addition to his work with Graphis Press, Pedersen has designed many award-winning publications and is a consultant for numerous publishing firms and new ventures in publishing.

Pedersen has taught at schools and universities throughout the United States and is a frequent lecturer at design conferences and seminars. He has also served as chairman and juror for numerous major design shows and graphic competitions.

His awards include the first Herb Lubalin Memorial Award for contribution to editorial design from the Society of Publication Designers; the Columbia University National Magazine Award for the best-designed magazine in the industry, awarded by the American Society of Magazine Editors; seven Gold and three Silver awards from the New York Art Directors Club; and best-of-show awards two years in a row from the International Editorial Design Awards Show.

Pedersen's professional memberships include the Art Center (Europe) Board of Advisers; the American Institute of Graphic Arts; the New York Art Directors Club; Society of Illustrators; Society of Publication Designers; Type Directors Club Board of Directors; and the Alliance Graphique Internationale.

ARRIVING AT THE PROPER STATE OF MIND REQUIRES JUST THE RIGHT VEHICLE.

ADVERTISEMENT
TYPOGRAPHY/DESIGN BETSY ZIMMERMANN, SAN FRANCISCO, CALIFORNIA
CALLIGRAPHER BETSY ZIMMERMANN
TYPOGRAPHIC SOURCE MASTERTYPE
AGENCY GOODBY, BERLIN & SILVERSTEIN
CLIENT ROYAL VIKING LINE
PRINCIPAL TYPES RVL GOTHIC AND BERNHARD MODERN
DIMENSIONS 15 × 9⅞ IN. (38.1 × 25.1 CM)

JUDGE'S CHOICE

NANCY RICE

While this ad may not be the single most creative piece I judged for The Best of Advertising Typography, it was the most imaginative in its use of typography to point out the particular strengths of a product.

To state why would be redundant, one has to merely read the ad.

In addition, I'd like to commend the creative team for resisting the temptation (and most likely the client's insistence) to show yet another "spectacular view" of yet another cavernous convention center.

Well done, I wish I'd done it.

Nancy Rice graduated from the Minneapolis College of Art and Design in 1970 with honors and a BFA in graphic design. Upon graduation, she joined Knox Reeves Advertising (which merged with Bozell & Jacobs in 1974) as an assistant art director, later becoming a vice-president and senior art director.

During her eleven-plus years at Bozell & Jacobs, she won numerous Gold and Silver medals from, among others, the One Show, the Andy's, the Clios, the New York Art Directors Club, the Athenas, and Graphis. Nancy also handled several accounts as a freelancer including Weight Watchers, Inc., Aid Insurance, and Meredith Corporation.

In 1981, she left Bozell & Jacobs to form Fallon McElligott Rice with Pat Fallon and Tom McElligott. As partner, vice-president, and executive art director, she continued to handle major accounts and win top awards. In 1983, her agency was named "Agency of the Year" by Advertising Age. In 1985, she was named by Adweek as first runner-up for "Ad Woman of the Year."

In August 1985, Nancy resigned from Fallon McElligott Rice and joined Nick Rice to form Rice & Rice Advertising, Inc. In October 1986, she was honored as "Art Director of the Year" by the New York Art Directors Club and The Hall of Fame. In December 1986, she was featured in Esquire magazine's "Register 1986" as one of the people under forty who is changing the nation. In November 1989, her campaign for Rolling Stone magazine was chosen as third in the list of the "Ten Best Campaigns" of the decade. This was the only print campaign selected.

Why sit around and watch summer re-runs, when you can watch summer? Or see the kind of fall programming Mother Nature brings to trees?

A Pella® window brings new meaning to the expression

THE REASON SOME PEOPLE RUSH HOME FROM WORK ISN'T TO WATCH TV.

"a room with a view."

The fact is, Pella windows are preferred by more architects than any other window. And that's not just because they're well made. It's because they open up a wealth of new design

possibilities. Pella standard and custom windows not only make a house spectacular to look out of, but stunning to look at.

So if you're building or remodeling a home, come to the company that invented the idea of Windowscaping.™

And discover how beautiful the world can be when it's not confined to a 21″ screen.

If you'd like a little preview, call 1-800-524-3700 for a free Windowscaping Idea Book and the location of The Pella Window Store® nearest you.

BUILT TO IMPOSSIBLY HIGH STANDARDS. OUR OWN.™

And who wants to blow a less - than - once - in - a - lifetime opportunity?

One way to make sure you don't is by installing Pella® windows.

They are, quite arguably, the

IF THERE WAS SOMETHING YOU DID ONLY ONCE IN A LIFETIME, YOU'D DO IT RIGHT. THE AVERAGE AMERICAN BUYS WINDOWS LESS THAN ONCE.

best windows in the world. And it's not just us doing the arguing. With over 1,200 brands to choose from, more architects recommend Pella than any other window.

You also can't argue with the fact that we spend more money researching, developing and testing windows than any other company. Because we think a thing of beauty really should be a joy forever.

Replacing the windows in your home is a big investment. In the end, the question is not whether you can afford Pella. It's whether you can afford anything less.

BUILT TO IMPOSSIBLY HIGH STANDARDS. OUR OWN.™

It's funny how that happens.

Even the most modest folks feel like showing off a little after they've installed Pella® windows. So they may leave the stickers on just a week or two longer than necessary.

But that's pardonable.

After all, they've just purchased the best window in the world…the one that's chosen by more architects than any other kind.

And after the stickers come off, their satis-

As a builder, Pella stickers are a great ad for you. They build prospective buyers' confidence in a house. And the spectacular window and sunroom treatments possible with Pella windows greatly add to curb appeal.

SOMEHOW, PELLA STICKERS SEEM TO STAY ON WINDOWS LONGER. IT'S NOT BECAUSE OF THE GLUE.

faction doesn't end. Because Pella windows are built and tested to deliver years of trouble-free performance.

So when it comes to windows, it's not hard to figure out which one you should stick to, is it?

For a free Windowscaping® Idea Book, and the location of The Pella Window Store® nearest you, call 1-800-524-3700.

BUILT TO IMPOSSIBLY HIGH STANDARDS. OUR OWN.™

ADVERTISEMENT
TYPOGRAPHY/DESIGN FRANK TODARO, NEW YORK, NEW YORK
TYPOGRAPHIC SOURCE PASTORE DEPAMPHILIS RAMPONE
AGENCY SCALI, McCABE, SLOVES
CLIENT PELLA WINDOWS & DOORS
PRINCIPAL TYPES CENTAUR AND FRANKLIN GOTHIC CONDENSED
DIMENSIONS 11 × 17 IN. (27.9 × 43.2 CM)

Type Directors Club
60 East 42nd Street
Suite 1416
New York, N.Y. 10165-0015

7 POINT
CALL FOR entries

8 POINT
CALL FOR entries

9 POINT
CALL FOR entries

10 POINT
CALL FOR entries

12 POINT
CALL FOR entries

14 POINT
CALL FOR entries

16 POINT
CALL FOR entries

18 POINT
CALL FOR entries

20 POINT
CALL FOR entries

24 POINT
CALL FOR entries

30 POINT
CALL FOR entries

36 POINT
CALL FOR entries

42 POINT
CALL FOR entries

THE BEST OF advertising typogra 1980-1990

THE BEST OF advertising type 1980-1990

THE BEST OF advertisin 1980-1990

THE BEST OF adver 1980-1990

THE BEST OF adv 1980-1990

HE BEST O a

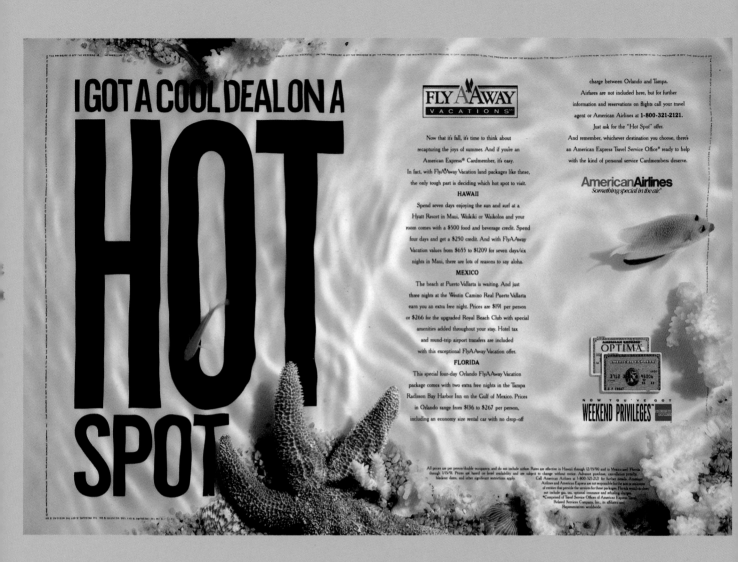

ADVERTISEMENT
TYPOGRAPHY/DESIGN MICHAEL RYLANDER, HARVEY SPEARS, AND ROBERT WAKEMAN, New York, New York
TYPOGRAPHIC SOURCE PDR COMPUTER IMPRESSIONS, INC.
AGENCY OGILVY & MATHER
CLIENTS AMERICAN EXPRESS AND AMERICAN AIRLINES
PRINCIPAL TYPES AMEX GOTHIC AND CHELTENHAM OLD STYLE
DIMENSIONS 17 × 10¾ IN. (43.2 × 27.3 CM)

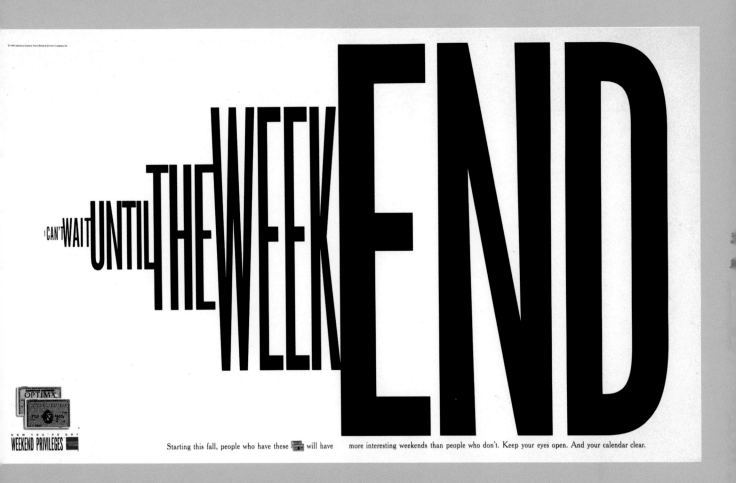

TYPOGRAPHY/DESIGN MICHAEL RYLANDER, HARVEY SPEARS, AND ROBERT WAKEMAN, NEW YORK, NEW YORK
TYPOGRAPHIC SOURCE PDR COMPUTER IMPRESSIONS, INC.
AGENCY OGILVY & MATHER
CLIENT AMERICAN EXPRESS
PRINCIPAL TYPES AMEX GOTHIC AND CHELTENHAM OLD STYLE
DIMENSIONS 17 × 10¾ IN. (43.2 × 27.3 CM)

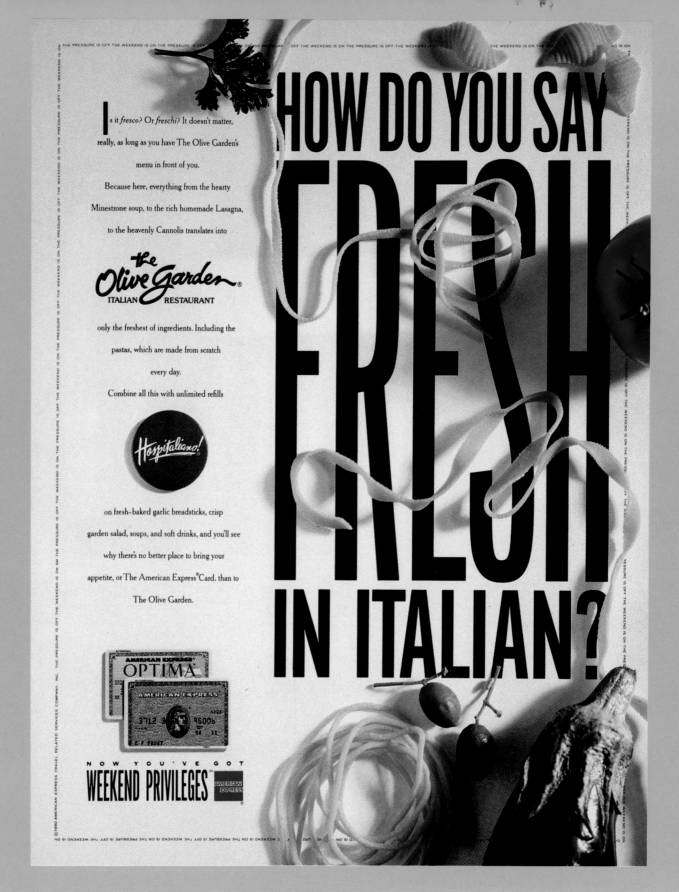

ADVERTISEMENT
TYPOGRAPHY/DESIGN MARK KELLY, MICHAEL RYLANDER, HARVEY SPEARS, AND ROBERT WAKEMAN, New York, New York
TYPOGRAPHIC SOURCE PDR COMPUTER IMPRESSIONS, INC.
AGENCY OGILVY & MATHER
CLIENTS AMERICAN EXPRESS AND THE OLIVE GARDEN
PRINCIPAL TYPES AMEX GOTHIC AND CHELTENHAM OLD STYLE
DIMENSIONS 8 × 10¾ (20.3 × 27.3 CM)

218

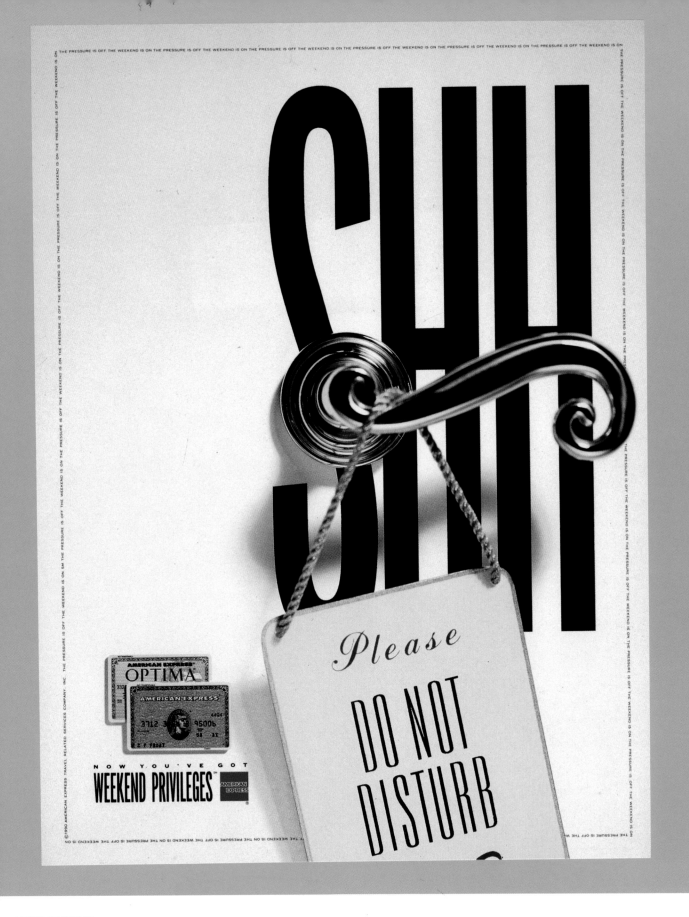

ADVERTISEMENT
TYPOGRAPHY/DESIGN MICHAEL RYLANDER, HARVEY SPEARS, AND ROBERT WAKEMAN, New York, New York
TYPOGRAPHIC SOURCE PDR COMPUTER IMPRESSIONS, INC.
AGENCY OGILVY & MATHER
CLIENT AMERICAN EXPRESS
PRINCIPAL TYPES AMEX GOTHIC AND CHELTENHAM OLD STYLE
DIMENSIONS 8 × 10¾ IN. (20.3 × 27.3 CM)

Hip is transitory. Smart endures. Hip is defined by others. Smart is defined by intelligence. Hip is only for the moment. Smart is timeless. Hip is driven by trends. Smart is driven by performance. Hip is perpetually looking over your shoulder. Smart is making your own decisions. Hip is mango-chestnut gelati. Smart is chocolate ice cream. Hip is often difficult to define. Smart is always logically defensible. Hip is flash. Smart is substance. Hip is something that looks cool. Smart is something that works. Hip talks the talk. Smart walks the walk. Hip gets you a $300 a week cocaine habit. Smart gets you a big raise and the corner office.

Hip vs. Smart

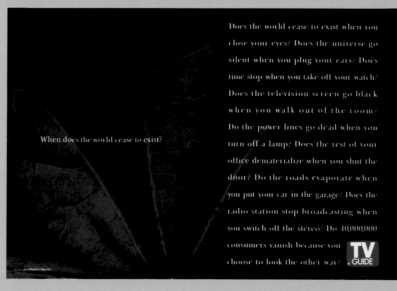

Are you afraid of looking stupid? Are you afraid of women? Are you afraid of men? Are you afraid of pet owners? Are you afraid of your boss? Are you afraid of flying? Are you afraid of technology? Are you afraid of your parents' friends? Are you afraid of fast food? Are you afraid of what people think? Are you afraid of power? Are you afraid of making a mistake? Are you afraid of being laughed at by the creative department? Are you afraid of teenagers? Are you afraid of losing your job? Are you afraid of being square? Are you afraid of success?

What are you afraid of?

Does the world cease to exist when you close your eyes? Does the universe go silent when you plug your ears? Does time stop when you take off your watch? Does the television screen go black when you walk out of the room? Do the power lines go dead when you turn off a lamp? Does the rest of your office dematerialize when you shut the door? Do the roads evaporate when you put your car in the garage? Does the radio station stop broadcasting when you switch off the stereo? Do 40,000,000 consumers vanish because you choose to look the other way?

When does the world cease to exist?

ADVERTISEMENT
TYPOGRAPHY/DESIGN WARREN EAKINS, PORTLAND, OREGON
TYPOGRAPHIC SOURCE SCHLEGEL TYPOGRAPHY
AGENCY WIEDEN & KENNEDY
CLIENT TV GUIDE
PRINCIPAL TYPE BASKERVILLE
DIMENSIONS 17 × 11 IN. (43.2 × 27.9 CM)

as seen on radio

AS SEEN IN TV GUIDE

If you want your program to get noticed, there's really no substitute for an ad in TV Guide. It's the one source of viewing advice and information people actually pay for. A tune-in ad anywhere else is just a whisper.

TV GUIDE

A Publication of Murdoch Magazines

ADVERTISEMENT
TYPOGRAPHY/DESIGN WARREN EAKINS AND STEVE SANDOZ, PORTLAND, OREGON
TYPOGRAPHIC SOURCE SCHLEGEL TYPOGRAPHY
AGENCY WIEDEN & KENNEDY
CLIENT TV GUIDE
PRINCIPAL TYPE FRANKLIN GOTHIC
DIMENSIONS 17 × 11 IN. (43.2 × 27.9 CM)

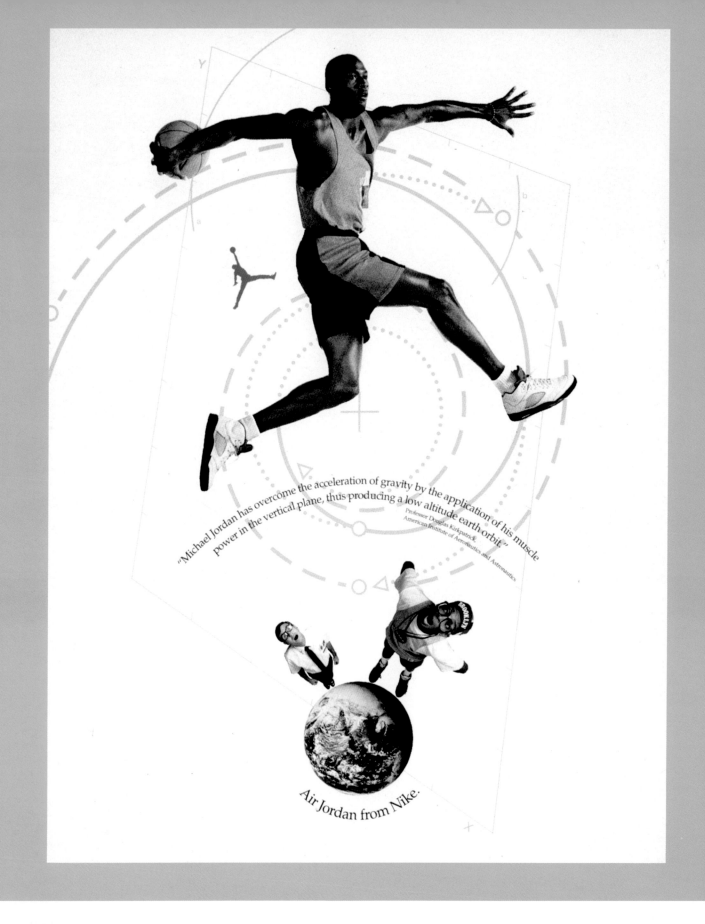

POSTER
TYPOGRAPHY/DESIGN MICHAEL PRIEVE, PORTLAND, OREGON
TYPOGRAPHIC SOURCE GEORGE VOGT
AGENCY WIEDEN & KENNEDY
CLIENT NIKE
PRINCIPAL TYPE PALATINO
DIMENSIONS 22 × 36 IN. (55.9 × 91.4 CM)

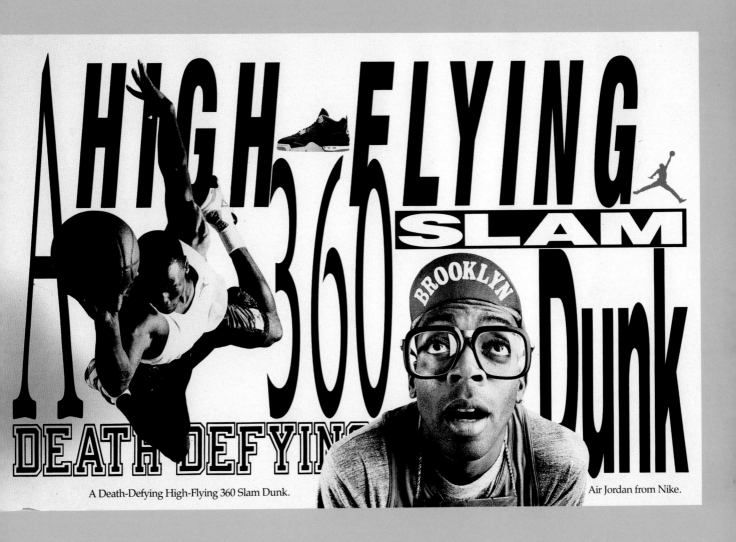

A Death-Defying High-Flying 360 Slam Dunk.

Air Jordan from Nike.

ADVERTISEMENT
TYPOGRAPHY/DESIGN MICHAEL PRIEVE, PORTLAND, OREGON
TYPOGRAPHIC SOURCE SCHLEGEL TYPOGRAPHY
AGENCY WIEDEN & KENNEDY
CLIENT NIKE
PRINCIPAL TYPES VARIOUS
DIMENSIONS 24 × 36 IN. (61 × 91.4 CM)

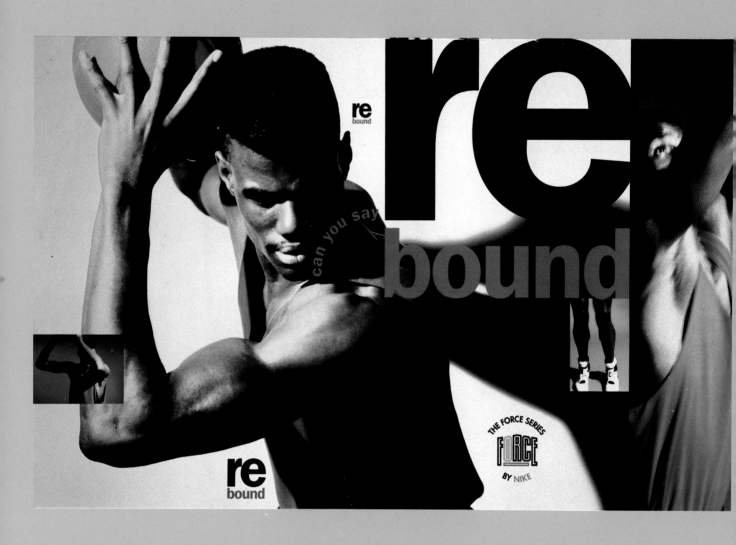

ADVERTISEMENT
TYPOGRAPHY/DESIGN MICHAEL PRIEVE AND PITTMAN-HENSLEY, PORTLAND, OREGON
TYPOGRAPHIC SOURCE PITTMAN-HENSLEY
AGENCY WIEDEN & KENNEDY
CLIENT NIKE
PRINCIPAL TYPE FRANKLIN GOTHIC
DIMENSIONS 23½ × 36 IN. (59.7 × 91.4 CM)

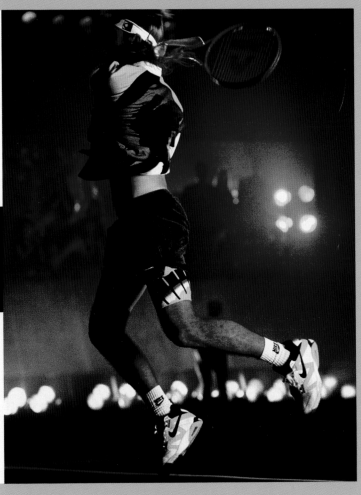

Hit the ball as loud as you can.

There's nothing quiet about the Nike Challenge Court Collection. But noise don't mean a thing unless you back it up. That's why our shirts are made of CoolMax® fabric to help your body breathe at high volume. And our Lycra® fabric shorts give your muscles extra support to keep you responsive. So now that you've got the gear, how can you tell if you're playing loud enough? The police will let you know.

Cool Max® and Lycra® are registered trademarks of E.I. du Pont de Nemours & Co.,Inc.

CHALLENGE COURT BY NIKE

ADVERTISEMENT
TYPOGRAPHY/DESIGN SUSAN HOFFMAN AND JANE OKESON, PORTLAND, OREGON
TYPOGRAPHIC SOURCE IN-HOUSE
AGENCY WIEDEN & KENNEDY
CLIENT NIKE
PRINCIPAL TYPE FRANKLIN GOTHIC HEAVY
DIMENSIONS 17 × 11 IN. (43.2 × 27.9 CM)

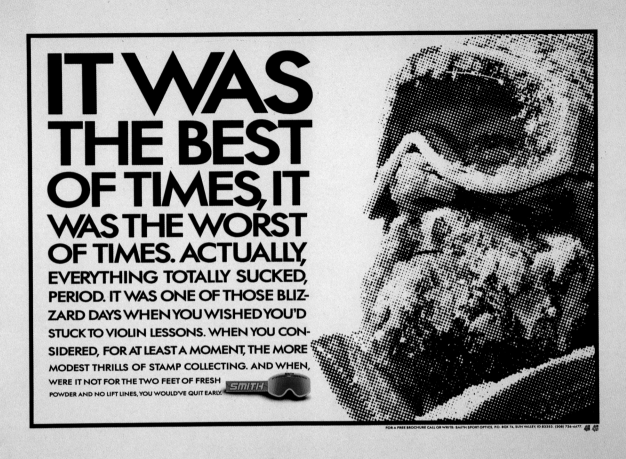

ADVERTISEMENT
TYPOGRAPHY/DESIGN TIM PARKER, PORTLAND, OREGON
TYPOGRAPHIC SOURCE VIP TYPOGRAPHERS
AGENCY BORDERS, PERRIN & NORRANDER
CLIENT SMITH SPORT OPTICS
PRINCIPAL TYPE AL FOTURA DEMI
DIMENSIONS 18 × 13⅛ IN. (45.7 × 33.3 CM)

"GOOD MORNING. YOUR EGGS ARE FRYING, YOUR BACON IS CRISP, AND YOU'VE JUST TRAVELED 400 MILES."

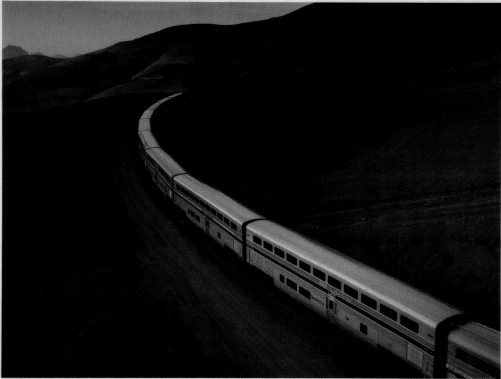

Amtrak's Coast Starlight near San Luis Obispo, California.

While you were sweet dreaming on your pillow, Amtrak was whisking you 400 miles closer to your destination, and you didn't even bat an eye.

Now Amtrak's full service kitchen is preparing breakfast to your order, and it will be served with a smile and a passing view. Where else but on one of the most advanced passenger train systems in the world...Amtrak.

In the last 10 years, Amtrak has replaced 75% of its trains with all new equipment, and has refurbished the other 25%. We boast one of the best on-time performance records of any carrier in the transportation industry. Our computerized reservations system is second to none, and now there are over 10,000 travel agents at your service.

So come and feel the magic, as 19 million riders a year do. Call your travel agent or call Amtrak at 1-800-USA-RAIL. You'll find traveling so easy, you can do it with your eyes closed.

ALL ABOARD AMTRAK

ADVERTISEMENT
TYPOGRAPHY/DESIGN STEVE SINGER, NEW YORK, NEW YORK
TYPOGRAPHIC SOURCE ROYAL COMPOSING ROOM, INC.
AGENCY NEEDHAM, HARPER, STEERS
CLIENT AMTRAK
PRINCIPAL TYPE FRANKLIN GOTHIC
DIMENSIONS 17 × 11 IN. (43.2 × 27.9 CM)

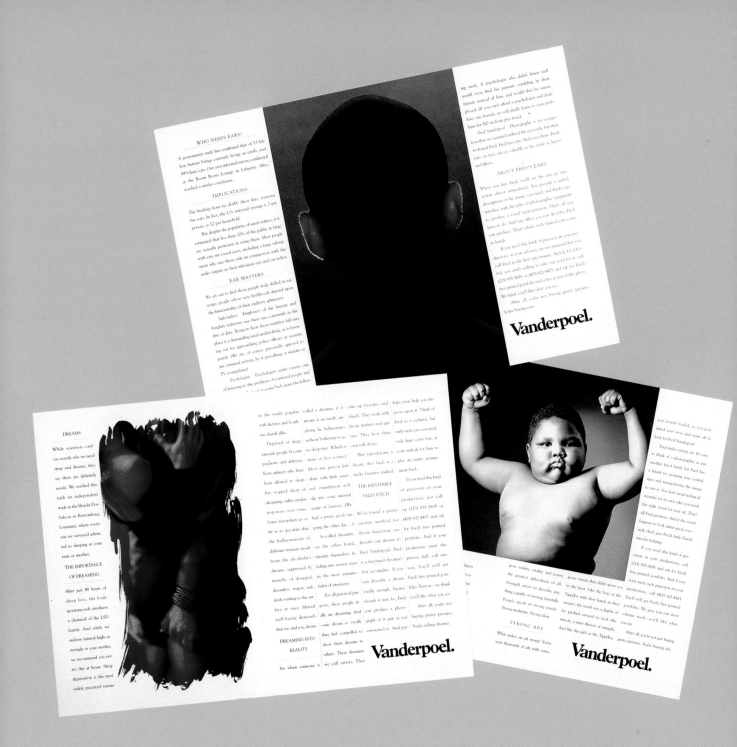

ADVERTISEMENT
TYPOGRAPHY/DESIGN TOM ROTH, SAN FRANCISCO, CALIFORNIA
TYPOGRAPHIC SOURCE ELECTRA TYPOGRAPHY
AGENCY ANDERSON & LEMBKE
CLIENT VANDERPOEL
PRINCIPAL TYPE GOUDY OLD STYLE
DIMENSIONS 16 × 11¼ IN. (40.6 × 28.6 CM)

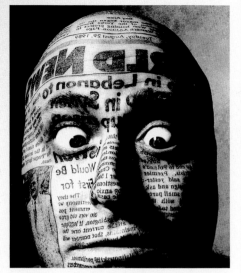

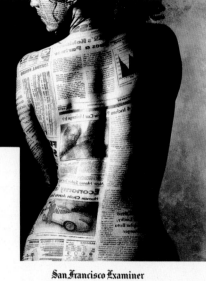

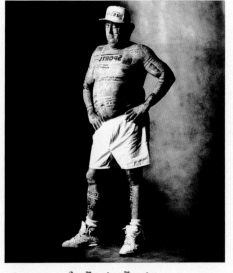

ADVERTISEMENT
TYPOGRAPHY/DESIGN STEVE STONE, NEW YORK, NEW YORK
LETTERERS DAN ESCOBAR, SAN FRANCISCO, CALIFORNIA, AND STEVE STONE
TYPOGRAPHIC SOURCES IN-HOUSE AND PHOTOCOPIED NEWSPRINT
AGENCY GOODBY, BERLIN & SILVERSTEIN
STUDIO DAN ESCOBAR PHOTOGRAPHY
CLIENT SAN FRANCISCO EXAMINER
PRINCIPAL TYPE CRAW MODERN BLACK
DIMENSIONS 36 × 72 IN. (91.4 × 182.9 CM)

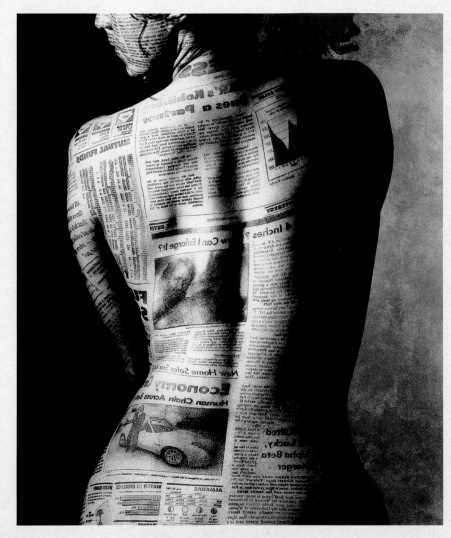

New non-rub ink covers the news, not you.

San Francisco Examiner
The Afternoon Paper

ADVERTISEMENT
TYPOGRAPHY/DESIGN STEVE STONE, NEW YORK, NEW YORK
LETTERERS DAN ESCOBAR AND STEVE STONE, SAN FRANCISCO, CALIFORNIA
TYPOGRAPHIC SOURCES IN-HOUSE AND PHOTOCOPIED NEWSPRINT
AGENCY GOODBY, BERLIN & SILVERSTEIN
STUDIO DAN ESCOBAR PHOTOGRAPHY
CLIENT SAN FRANCISCO EXAMINER
PRINCIPAL TYPE CRAW MODERN BLACK
DIMENSIONS 18 × 13 IN. (45.7 × 33 CM)

New non-rub ink covers the news, not you.

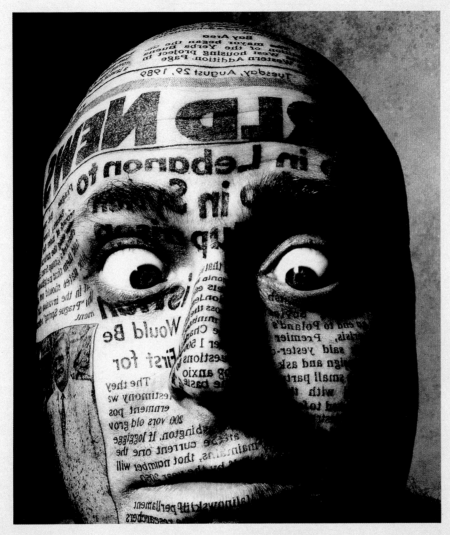

San Francisco Examiner
The Afternoon Paper

ADVERTISEMENT
TYPOGRAPHY/DESIGN STEVE STONE, NEW YORK, NEW YORK
LETTERERS DAN ESCOBAR AND STEVE STONE, SAN FRANCISCO, CALIFORNIA
TYPOGRAPHIC SOURCES IN-HOUSE AND PHOTOCOPIED NEWSPRINT
AGENCY GOODBY, BERLIN & SILVERSTEIN
STUDIO DAN ESCOBAR PHOTOGRAPHY
CLIENT SAN FRANCISCO EXAMINER
PRINCIPAL TYPE CRAW MODERN BLACK
DIMENSIONS 18 × 13 IN. (45.7 × 33 CM)

Inside the advertisement:

FORTUNE EDUCATION SERIES

"Education should
If 25% of all high school students drop out every year, what can American corporations do about it?
not compete with
To find out, Xerox has invested five million dollars in the Institute for Research on Learning. Using new
national defense,
computer technologies and artificial intelligence, Xerox is creating education programs to train the so-called
the trade deficit,
untrainable. As the founder of the Education Summit for business, FORTUNE supports the work of Xerox and
drugs or AIDS.
other corporations, large and small, that are fighting the battle for literacy. Because when an education system
Instead, think of it
stops working, the rest of society stops working too. To learn more about what other companies are doing, write
as a solution to
James B. Hayes, Publisher, FORTUNE, Time & Life Building, Rockefeller Center, New York, New York 10020-1393.
those problems."

–David Kearns, Chairman of Xerox Corporation

FORTUNE
Inside the mind of management.

ADVERTISEMENT
TYPOGRAPHY/DESIGN MICHAEL RYLANDER, HARVEY SPEARS, AND ROBERT WAKEMAN, NEW YORK, NEW YORK
TYPOGRAPHIC SOURCE PDR COMPUTER IMPRESSIONS, INC.
AGENCY OGILVY & MATHER
CLIENT FORTUNE MAGAZINE
PRINCIPAL TYPE HELVETICA
DIMENSIONS 17 × 10¾ IN. (43.2 × 27.3 CM)

"We expect our

If teachers have to make up for the deficiencies of society, the business community must help them

teachers to handle

teach more effectively. Apple has forged the way with a range of programs that stress teacher recognition,

teenage pregnancy,

increased technological literacy and strong public-private partnerships. As the founder of the Education

substance abuse,

Summit for business, FORTUNE supports the work of Apple and other corporations, both large and small,

and the failings of

that are fighting for real school reform. Because when an education system stops working, the rest of

the family. Then we

society stops working too. To learn more about what other companies are doing, write James B. Hayes,

expect them to edu-

Publisher, FORTUNE, Time & Life Building, Rockefeller Center, New York, New York 10020-1393.

cate our children."

–John Sculley, Chairman, President and CEO,
Apple Computer, Inc.

FORTUNE
Inside the mind of management.

ADVERTISEMENT
TYPOGRAPHY/DESIGN MICHAEL RYLANDER, HARVEY SPEARS, AND ROBERT WAKEMAN, NEW YORK, NEW YORK
TYPOGRAPHIC SOURCE PDR COMPUTER IMPRESSIONS, INC.
AGENCY OGILVY & MATHER
CLIENT FORTUNE MAGAZINE
PRINCIPAL TYPE HELVETICA
DIMENSIONS 17 × 10¾ IN. (43.2 × 27.3 CM)

"Education should not compete with national defense, the trade deficit, drugs or AIDS. Instead, think of it as a solution to those problems."

If 25% of all high school students drop out every year, what can American corporations do about it? To find out, Xerox has invested five million dollars in the Institute for Research on Learning. Using new computer technologies and artificial intelligence, Xerox is creating education programs to train the so-called untrainable. As the founder of the Education Summit for business, FORTUNE supports the work of Xerox and other corporations, large and small, that are fighting the battle for literacy. Because when an education system stops working, the rest of society stops working too. To learn more about what other companies are doing, write James B. Hayes, Publisher, FORTUNE, Time & Life Building, Rockefeller Center, New York, New York 10020-1393.

–David Kearns, Chairman of Xerox Corporation

FORTUNE
Inside the mind of management.

" We expect our teachers to handle teenage pregnancy, substance abuse, and the failings of the family. Then we expect them to edu- cate our children."

If teachers have to make up for the deficiencies of society, the business community must help them teach more effectively. Apple has forged the way with a range of programs that stress teacher recognition, increased technological literacy and strong public-private partnerships. As the founder of the Education Summit for business, FORTUNE supports the work of Apple and other corporations, both large and small, that are fighting for real school reform. Because when an education system stops working, the rest of society stops working too. To learn more about what other companies are doing, write James B. Hayes, Publisher, FORTUNE, Time & Life Building, Rockefeller Center, New York, New York 10020-1393.

–John Sculley, Chairman, President and CEO, Apple Computer, Inc.

FORTUNE
Inside the mind of management.

ADVERTISEMENT
TYPOGRAPHY/DESIGN MICHAEL RYLANDER, HARVEY SPEARS, AND ROBERT WAKEMAN, NEW YORK, NEW YORK
TYPOGRAPHIC SOURCE PDR COMPUTER IMPRESSIONS, INC.
AGENCY OGILVY & MATHER
CLIENT FORTUNE MAGAZINE
PRINCIPAL TYPE HELVETICA
DIMENSIONS 17 × 10¾ IN. (43.2 × 27.3 CM)

Brushing, flossing and seeing your dentist keeps your gums healthy and helps stop your falling out.

t_{ee}th

HEALTHY TEETH NEED HEALTHY GUMS. Ministry of Health

ADVERTISEMENT
TYPOGRAPHY/DESIGN GORDON TAN, SINGAPORE
TYPOGRAPHIC SOURCE THE FOTOSETTER
AGENCY KETCHUM ADVERTISING SINGAPORE
CLIENT MINISTRY OF HEALTH, SINGAPORE
PRINCIPAL TYPE TICONDEROGA
DIMENSIONS 18⅛ × 13 IN. (46 × 33 CM)

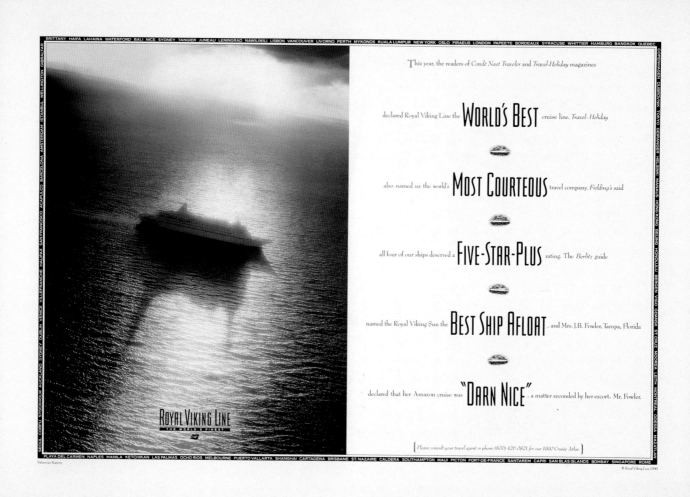

ADVERTISEMENT
TYPOGRAPHY/DESIGN TRACY WONG AND BETSY ZIMMERMANN, SAN FRANCISCO, CALIFORNIA
CALLIGRAPHER BETSY ZIMMERMANN
TYPOGRAPHIC SOURCE MASTERTYPE
AGENCY GOODBY, BERLIN & SILVERSTEIN
CLIENT ROYAL VIKING LINE
PRINCIPAL TYPES RVL GOTHIC AND BERNHARD MODERN
DIMENSIONS 15 × 9⅞ IN. (38.1 × 25.1 CM)

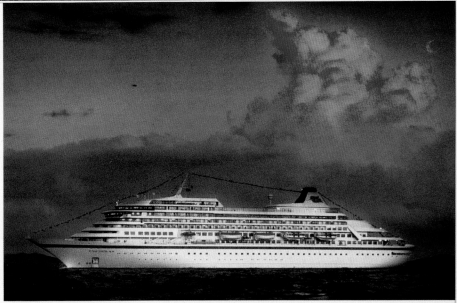

In a world so unfortunately ruled by a point-A-to-point-B mentality, allow us to suggest a unique sanctuary where *how* one arrives still fully eclipses *when*.

In this place you will find a restaurant with sweeping views of Leningrad, Hong Kong and the Great Barrier Reef; a ROYAL VIKING LINE hotel with one staff member for every two guests. You will find a sommelier who knows every bottle in a wine cellar of 17,000; and a kitchen filled with the delights of 33 chefs.

Where is this place? It is here: among the Scandinavian stewardesses. Here: among the butler, the harpist and the helpful concierge. Here: among the silver-set tables and single-seating dining.

It is here and only here: aboard the magnificent white ships of Royal Viking Line – four ships

7:32 p.m. Halfway between Sandakan and Singapore. As you prepare for dinner in your spacious cabin, a white-gloved waiter adds a finishing touch to your table: fresh yellow roses from the market at Bangkok.

in all; each but one part of an entire fleet holding the distinguished rating of five-stars-plus.

Isn't it time you joined us here? For details see your travel agent, or call (800) 426 - 0821. As always, we look forward to seeing you on board.

A TRULY GREAT SHIP IS SOMETHING OF A DESTINATION IN ITSELF.

ADVERTISEMENT
TYPOGRAPHY/DESIGN BETSY ZIMMERMANN AND JEREMY POSTAER, SAN FRANCISCO, CALIFORNIA
CALLIGRAPHER BETSY ZIMMERMANN
TYPOGRAPHIC SOURCE MASTERTYPE
AGENCY GOODBY, BERLIN & SILVERSTEIN
CLIENT ROYAL VIKING LINE
PRINCIPAL TYPES RVL GOTHIC AND BERNHARD MODERN
DIMENSIONS 15 × 9⅞ IN. (38.1 × 25.1 CM)

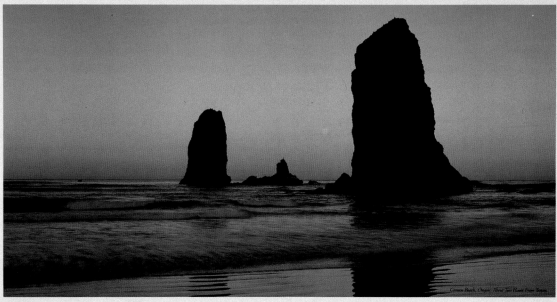

At Trojan, dedication to the job is rewarded every day after work. Here, you're never more than an hour or two from the beaches, the mountains, and all the mystique of Oregon.

You're also not very far from the culture and the excitement of an exceptionally liveable city: Portland, Oregon. And the job at Trojan will have its own rewards. We have a handsome new office complex, a new management team, an in-house simulator, and some very attractive openings.

Opportunities For Degreed Engineers With Backgrounds In: I&C ○Surveillance/Observation ○Auditing ○Statistical Analysis ○Work Planning ○Procurement ○Components (Pumps and Valves) ○Maintenance ○ASME XI/ Repair and Replacement ○Design ○Fire Protection ○Systems ○Pressure Testing ○Licensing/ Compliance ○HVAC ○Balance of Plant ○Nuclear Safety ○Local Leak Rate Testing ○NPRDS.

Opportunities In A Number Of Other Specialties: Certified Health Physicist ○Designers/Configuration Management ○Field Engineering ○Preventive Maintenance ○Plant Scheduling ○Outage Coordination ○Nuclear Plant Chemistry Technicians ○Operational Radiation Protection ○Degreed Nuclear Buyers.

Opportunities For Nuclear Instructors With A Background In: Emergency Planning ○Training Program Analysis and Development ○PWR SRO Certification or the equivalent ○Engineering-related training for Technical Staff/Managers.

So get in touch. After all, how many other employers offer such a nice bonus program after work?

Send your resume and your salary history to Portland General Electric, Staffing Services NN190, 121 South West Salmon, Portland, Oregon 97204.

Trojan: You'll Like The Benefits.

Cannon Beach, Oregon: About Two Hours From Trojan.

WORKING IN OREGON CAN EASILY BE CONFUSED WITH VACATIONING.

No agency referrals please. An equal opportunity employer. M/F/H/V

ADVERTISEMENT
TYPOGRAPHY/DESIGN KENT SUTER, PORTLAND, OREGON
ART DIRECTOR TERRY SCHNEIDER
TYPOGRAPHIC SOURCE GEISY TYPOGRAPHY
AGENCY BORDERS, PERRIN & NORRANDER
CLIENT PORTLAND GENERAL ELECTRIC
PRINCIPAL TYPE BERNHARD MODERN
DIMENSIONS 16½ × 11 IN. (41.9 × 27.9 CM)

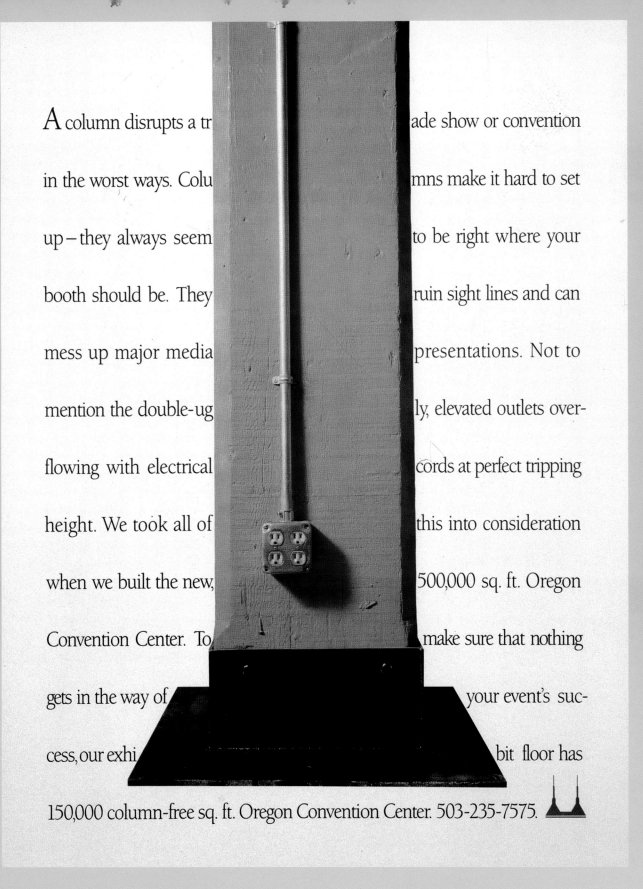

A column disrupts a trade show or convention in the worst ways. Columns make it hard to set up – they always seem to be right where your booth should be. They ruin sight lines and can mess up major media presentations. Not to mention the double-ugly, elevated outlets over-flowing with electrical cords at perfect tripping height. We took all of this into consideration when we built the new, 500,000 sq. ft. Oregon Convention Center. To make sure that nothing gets in the way of your event's suc-cess, our exhibit floor has 150,000 column-free sq. ft. Oregon Convention Center. 503-235-7575.

ADVERTISEMENT
TYPOGRAPHY/DESIGN TOM KELLY, PORTLAND, OREGON
TYPOGRAPHIC SOURCE BP&N TYPESETTING
AGENCY BORDERS, PERRIN & NORRANDER
CLIENT OREGON CONVENTION CENTER
PRINCIPAL TYPE BERKELEY OLD STYLE
DIMENSIONS 8½ × 11 IN. (21.6 × 27.9 CM)

SHIPWRECK

SHANE

VERTIGO

DUCK SOUP

COMMERCIAL
TYPOGRAPHY/DESIGN WARREN EAKINS, PORTLAND, OREGON
TYPOGRAPHIC SOURCE SCHLEGEL TYPOGRAPHY
AGENCY WIEDEN & KENNEDY
CLIENT TV GUIDE
PRINCIPAL TYPE HELVETICA

We now have
a group policy

that covers
long-term
health care

in the place
elderly people
want it most.

Aetna.
A policy to do more.

COMMERCIAL
TYPOGRAPHY/DESIGN CLEM McCARTHY AND DAVID FOWLER, New York, New York
TYPOGRAPHIC SOURCE CHARACTERS TYPOGRAPHIC SERVICES, INC.
AGENCY AMMIRATI & PURIS
CLIENT AETNA LIFE AND CASUALTY COMPANY
PRINCIPAL TYPE BODONI BOLD

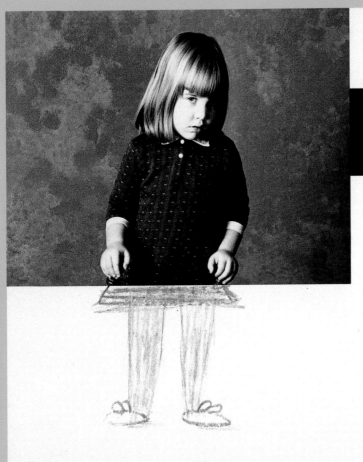

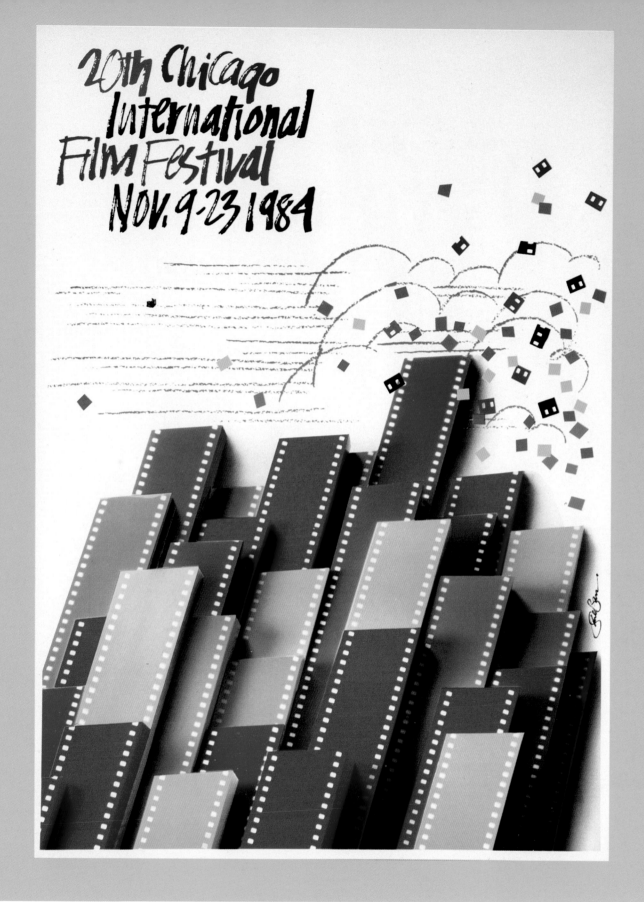

POSTER
TYPOGRAPHY/DESIGN SAUL BASS, LOS ANGELES, CALIFORNIA
LETTERER SAUL BASS
STUDIO BASS/YAGER AND ASSOCIATES
CLIENT CHICAGO INTERNATIONAL FILM FESTIVAL
PRINCIPAL TYPE HANDLETTERING
DIMENSIONS 25 × 33 IN. (63.5 × 83.3 cm)

BY L. BAKER RUNYAN

Is your life complete without a potato-powered clock?

This is a clock for people who work indoors

but whose hearts are, well, elsewhere. Should you have married that ski instructor instead? Been a forest ranger? Will you some-day have that little cabin out there where men are men, women are women, so on and so forth? Yeah, maybe.

"Grocer, two of your most accurate tubers, please."

meadow by the creek. Stuff like that. A master-ful balance of digital watch technology (and isn't *that* still amazing) and two russets, white roses, bentjes, or kennebecs, this clock will give you honest time. Real time. Tater time. It tells month and date, too. It even runs on soda pop (if that ruins the karma for you, forget we said it).

But while you're hanging around waiting to see how it all shakes out, wouldn't this clock be a nice way to count the minutes?

You need not be present to shop. Our catalog, 1-800-227-1114.

At every glance, you'll be hiking, biking, breathing clean air, eating sandwiches smashed in the bottom of your pack. You'll be birding with Sven, having his children. Or you'll be walking with Gwenne in that secret

THE NATURE COMPANY

And one more thing. That ski instructor? A bum. You just forgot. $16.95.

Thank you.

ADVERTISEMENT
TYPOGRAPHY/DESIGN TRACY WONG, SAN FRANCISCO, CALIFORNIA
TYPOGRAPHIC SOURCE MASTERTYPE
AGENCY GOODBY, BERLIN & SILVERSTEIN
CLIENT THE NATURE COMPANY
PRINCIPAL TYPES BERLING AND KENNERLY
DIMENSIONS 13 × 20½ IN. (33 × 52.1 CM)

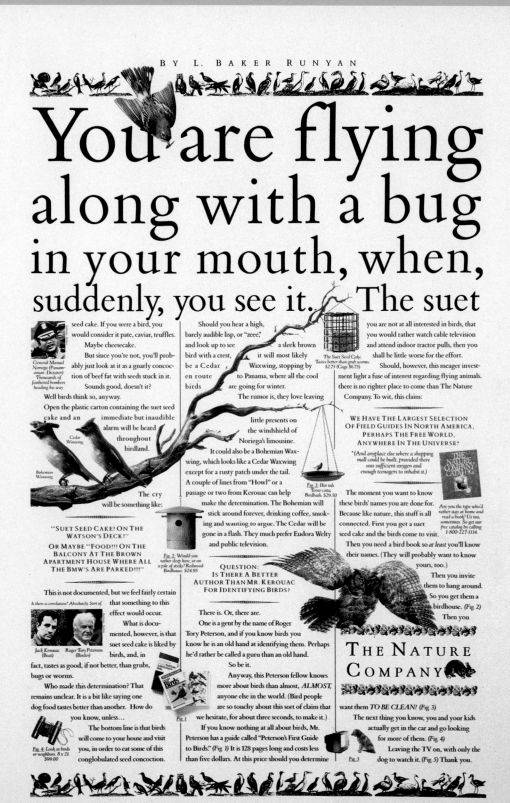

BY L. BAKER RUNYAN

You are flying along with a bug in your mouth, when, suddenly, you see it. The suet

seed cake. If you were a bird, you would consider it pate, caviar, truffles.

Maybe cheesecake.

But since you're not, you'll probably just look at it as a gnarly concoction of beef fat with seeds stuck in it.

Sounds good, doesn't it?

Well birds think so, anyway.

Open the plastic carton containing the suet seed cake and an immediate but inaudible alarm will be heard throughout birdland.

General Manuel Noriega (Panamanian Dictator) Thousands of feathered bombers heading his way.

Cedar Waxwing

Bohemian Waxwing

The cry will be something like:

"SUET SEED CAKE! ON THE WATSON'S DECK!"

OR MAYBE "FOOD!!! ON THE BALCONY AT THE BROWN APARTMENT HOUSE WHERE ALL THE BMW'S ARE PARKED!!!"

This is not documented, but we feel fairly certain that something to this effect would occur.

Is there a correlation? Absolutely. Sort of

Jack Kerouac (Beat) *Roger Tory Peterson (Birder)*

What is documented, however, is that suet seed cake is liked by birds, and, in fact, tastes as good, if not better, than grubs, bugs or worms.

Who made this determination? That remains unclear. It is a bit like saying one dog food tastes better than another. How do you know, unless…

The bottom line is that birds will come to your house and visit you, in order to eat some of this conglobulated seed concoction.

Fig. 4: Look at birds or neighbors. 8 x 21. $99.00

Should you hear a high, barely audible lisp, or "zeee," and look up to see a sleek brown bird with a crest, it will most likely be a Cedar Waxwing, stopping by en route to Panama, where all the cool birds are going for winter.

The rumor is, they love leaving little presents on the windshield of Noriega's limousine.

It could also be a Bohemian Waxwing, which looks like a Cedar Waxwing except for a rusty patch under the tail. A couple of lines from "Howl" or a passage or two from Kerouac can help make the determination. The Bohemian will stick around forever, drinking coffee, smoking and wanting to argue. The Cedar will be gone in a flash. They much prefer Eudora Welty and public television.

QUESTION: IS THERE A BETTER AUTHOR THAN MR. KEROUAC FOR IDENTIFYING BIRDS?

There is. Or, there are.

One is a gent by the name of Roger Tory Peterson, and if you know birds you know he is an old hand at identifying them. Perhaps he'd rather be called a guru than an old hand.

So be it.

Anyway, this Peterson fellow knows more about birds than almost, *ALMOST*, anyone else in the world. (Bird people are so touchy about this sort of claim that we hesitate, for about three seconds, to make it.)

If you know nothing at all about birds, Mr. Peterson has a guide called "Peterson's First Guide to Birds." *(Fig. 1)* It is 128 pages long and costs less than five dollars. At this price should you determine

Fig. 1

The Suet Seed Cake. Tastes better than grub worms. $2.75 (Cage $6.75)

Fig. 2: Would you rather sleep here, or on a pile of sticks? Redwood Birdhouse. $24.95

Fig. 3: Hot tub. Terra-cotta Birdbath. $29.50

you are not at all interested in birds, that you would rather watch cable television and attend indoor tractor pulls, then you shall be little worse for the effort.

Should, however, this meager investment light a fuse of interest regarding flying animals, there is no righter place to come than The Nature Company. To wit, this claim:

WE HAVE THE LARGEST SELECTION OF FIELD GUIDES IN NORTH AMERICA, PERHAPS THE FREE WORLD, ANYWHERE IN THE UNIVERSE.*

**(And anyplace else where a shopping mall could be built, provided there was sufficient oxygen and enough teenagers to inhabit it.)*

The moment you want to know these birds' names you are done for. Because like nature, this stuff is all connected. First you get a suet seed cake and the birds come to visit.

Then you need a bird book so *at least* you'll know their names. (They will probably want to know yours, too.)

Are you the type who'd rather stay at home and read a book? Us too, sometimes. So get our free catalog by calling 1-800-227-1114.

Then you invite them to hang around. So you get them a birdhouse. (Fig. 2)

Then you

THE NATURE COMPANY

want them *TO BE CLEAN!* (Fig. 3)

The next thing you know, you and your kids actually get in the car and go looking for more of them. (Fig. 4)

Leaving the TV on, with only the dog to watch it. (Fig. 5) Thank you.

Fig. 5

ADVERTISEMENT
TYPOGRAPHY/DESIGN TRACY WONG, SAN FRANCISCO, CALIFORNIA
TYPOGRAPHIC SOURCE MASTERTYPE
AGENCY GOODBY, BERLIN & SILVERSTEIN
CLIENT THE NATURE COMPANY
PRINCIPAL TYPES BERLING AND KENNERLY
DIMENSIONS 13 × 20½ IN. (33 × 52.1 CM)

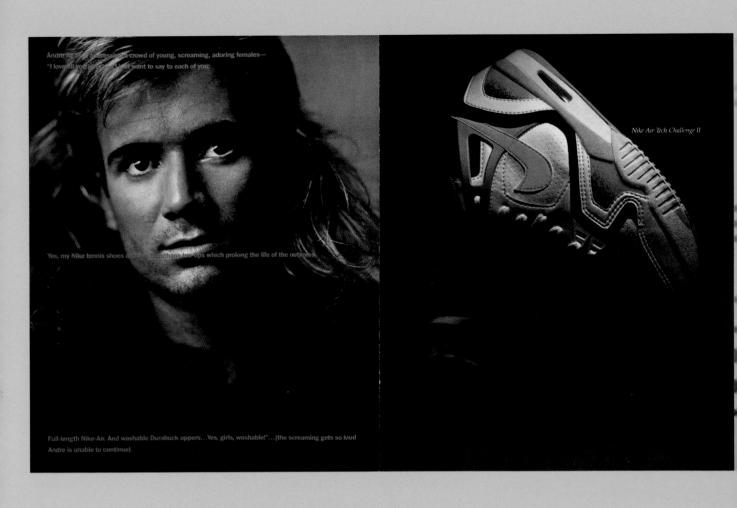

Nike Air Tech Challenge II

ADVERTISEMENT
TYPOGRAPHY/DESIGN SCHLEGEL TYPOGRAPHY AND DAVID JENKINS, PORTLAND, OREGON
PHOTOGRAPHER DENNIS MANARCHY, CHICAGO, ILLINOIS
TYPOGRAPHIC SOURCE SCHLEGEL TYPOGRAPHY
AGENCY WIEDEN & KENNEDY
CLIENT NIKE
PRINCIPAL TYPE FRANKLIN GOTHIC
DIMENSIONS 10 × 12 IN. (25.4 × 30.5 CM)

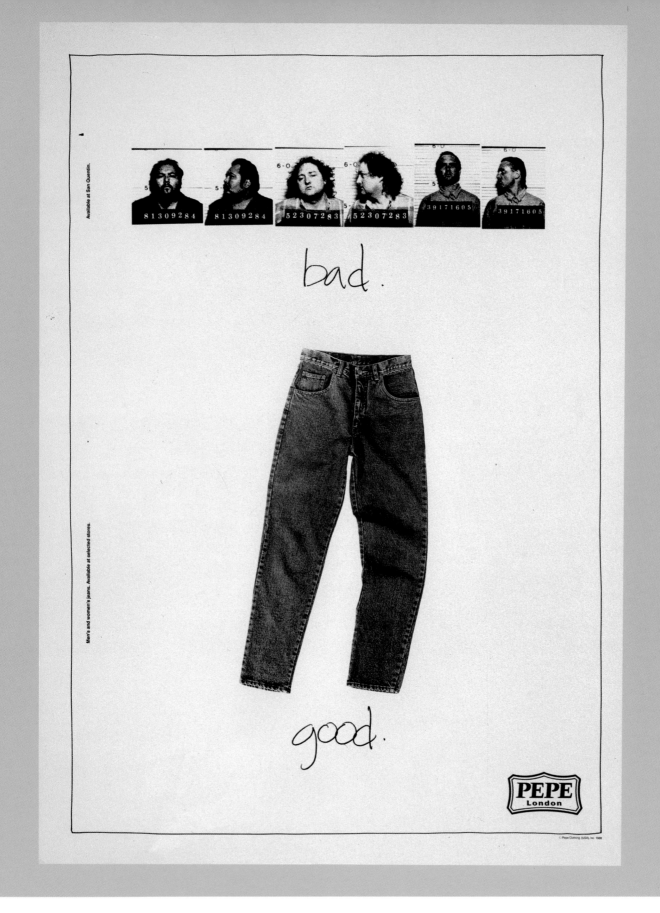

ADVERTISEMENT
TYPOGRAPHY/DESIGN MICHAEL PRIEVE, PORTLAND, OREGON
TYPOGRAPHIC SOURCE IN-HOUSE
AGENCY WIEDEN & KENNEDY
CLIENT PEPE CLOTHING USA
PRINCIPAL TYPE HANDLETTERING
DIMENSIONS 23½ × 32½ IN. (59.7 × 82.6 CM)

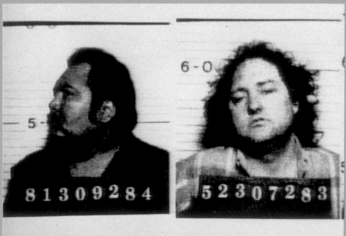

COMMERCIAL
TYPOGRAPHY/DESIGN MICHAEL PRIEVE, TIBOR KALMAN, AND EMILY OBERMAN, PORTLAND, OREGON, AND NEW YORK, NEW YORK
TYPOGRAPHIC SOURCE M & CO.
AGENCY WIEDEN & KENNEDY
CLIENT PEPE CLOTHING USA
PRINCIPAL TYPE FRANKLIN GOTHIC

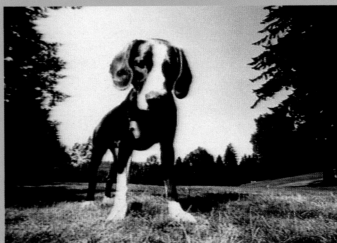

COMMERCIAL
TYPOGRAPHY/DESIGN MICHAEL PRIEVE, TIBOR KALMAN, AND EMILY OBERMAN, PORTLAND, OREGON, AND NEW YORK, NEW YORK
TYPOGRAPHIC SOURCE M & CO.
AGENCY WIEDEN & KENNEDY
CLIENT PEPE CLOTHING USA
PRINCIPAL TYPE FRANKLIN GOTHIC

THE NAME OF CANADA'S FAVORITE BOOT IS ON THE TIP OF EVERYONE'S TONGUE.

ADVERTISEMENT
TYPOGRAPHY/DESIGN TOM CHANDLER AND BOB MARIANI, Providence, Rhode Island
TYPOGRAPHIC SOURCE TYPESETTING SERVICE CORPORATION
AGENCY MARIANI, HURLEY & CHANDLER
STUDIO MYRON
CLIENT KODIAK CANADA
PRINCIPAL TYPE MACHINE BOLD
DIMENSIONS 16¼ × 11 IN. (41.3 × 27.9 CM)

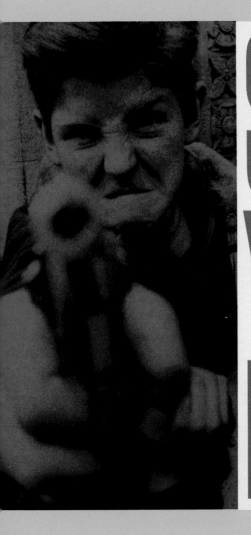

SUPPORT YOUR LOCAL MUGGER

This kid doesn't need your wallet. He needs your help. What can you do about street kids? Easy. Come see a play. It's at the Julia Richman High School on April 23, 1990 and it's about today's youth issues. As performed by today's youth. The play is called "No Laughing Matter" and in it you'll see drugs, teenage pregnancy and violence. As well as singing, dancing and some inspirational acting. Show starts at 7:30 p.m., 317 East 67th Street (between 2nd and 3rd Avenues). Tickets are $12, students $5 and that money goes to the New York Youth at Risk Program. Come see "No Laughing Matter" by the Positive Youth Troupe. Be warned: These kids may steal your heart.

POSTER
TYPOGRAPHY/DESIGN RODD MARTIN AND BOBBI GASSY, New York, New York
TYPOGRAPHIC SOURCE PASTORE DePAMPHILIS RAMPONE
AGENCY OMON NEW YORK
CLIENT YOUTH AT RISK
PRINCIPAL TYPE EUROSTYLE
DIMENSIONS 16 × 10¾ IN. (40.6 × 27.2 CM)

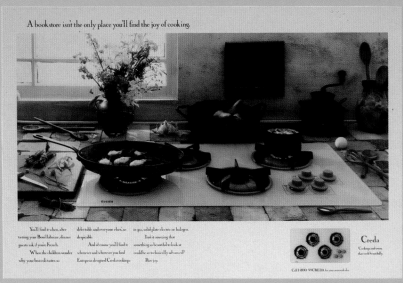

A bookstore isn't the only place you'll find the joy of cooking.

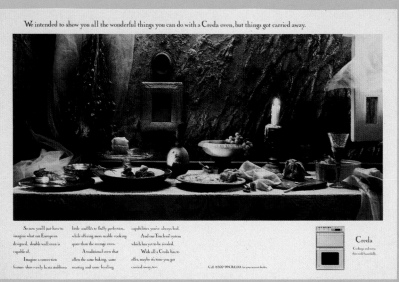

We intended to show you all the wonderful things you can do with a Creda oven, but things got carried away.

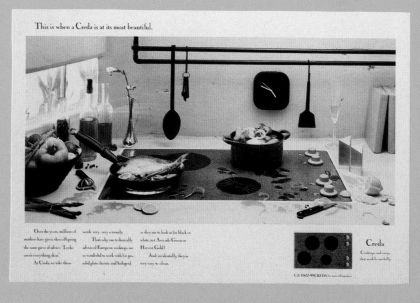

This is when a Creda is at its most beautiful.

ADVERTISEMENT
TYPOGRAPHY/DESIGN BETH KOSUK, CHICAGO, ILLINOIS
TYPOGRAPHIC SOURCE RYDERTYPES
AGENCY CRAMER KRASSELT/CHICAGO
CLIENT CREDA
PRINCIPAL TYPE LE MERCURE
DIMENSIONS 11 × 16½ IN. (27.9 × 40.6 CM)

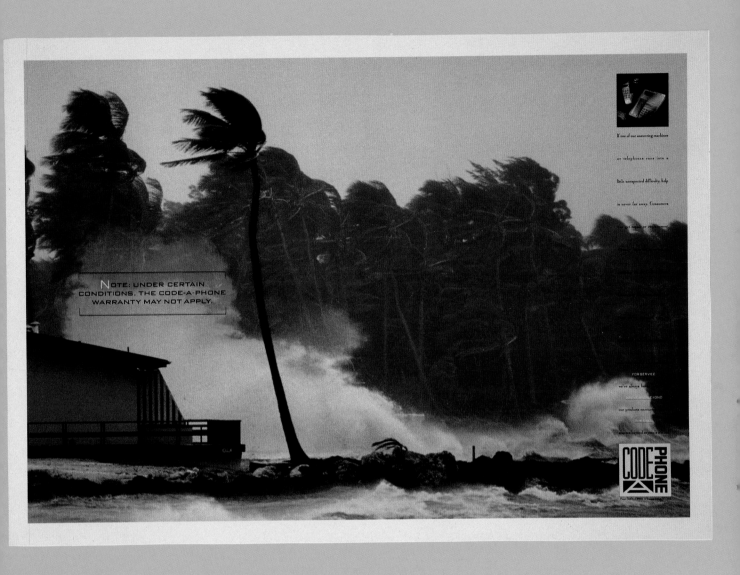

ADVERTISEMENT
TYPOGRAPHY/DESIGN TIM PARKER, PORTLAND, OREGON
TYPOGRAPHIC SOURCE BP&N TYPESETTING
AGENCY BORDERS, PERRIN & NORRANDER
CLIENT CODE-A-PHONE
PRINCIPAL TYPE TYPO ROMAN
DIMENSIONS 22½ × 15¼ IN. (57.2 × 38.7 CM)

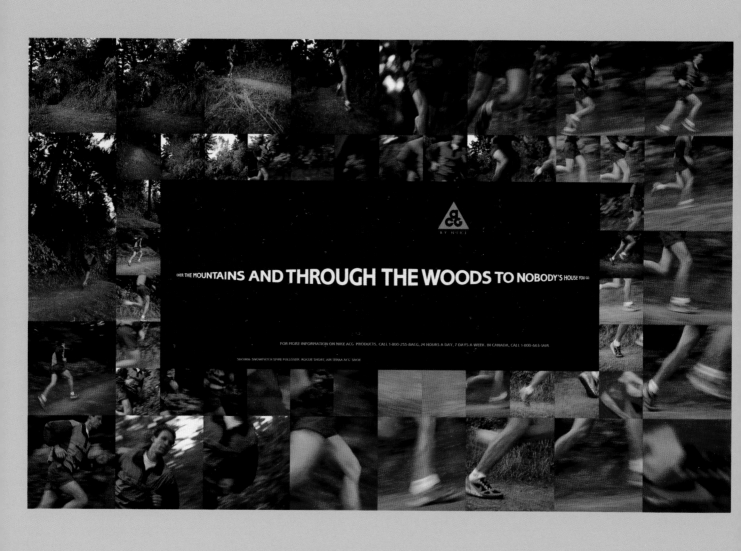

ADVERTISEMENT
TYPOGRAPHY/DESIGN MICHAEL PRIEVE AND GEORGE VOGT, PORTLAND, OREGON
TYPOGRAPHIC SOURCE GEORGE VOGT
AGENCY WIEDEN & KENNEDY
CLIENT NIKE
PRINCIPAL TYPE CORINTHIAN BOLD
DIMENSIONS 17 × 11 IN. (43.2 × 27.9 CM)

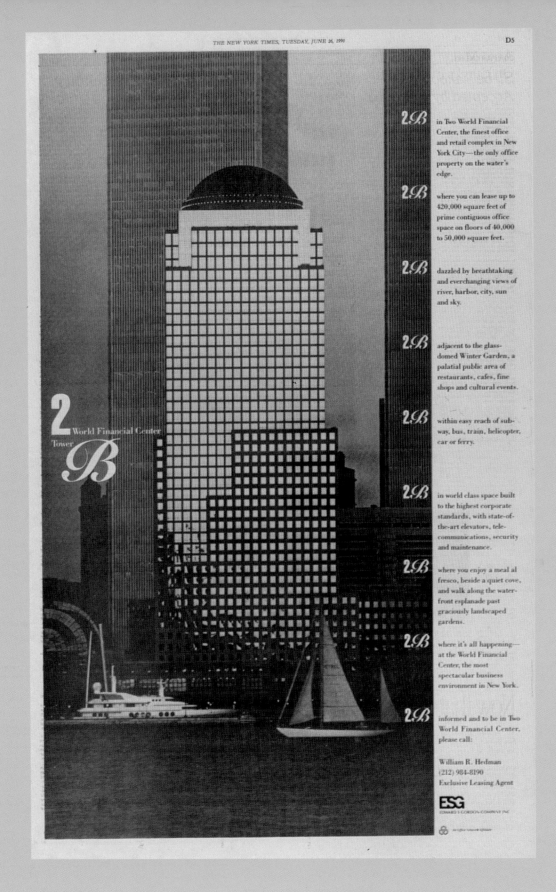

ADVERTISEMENT
TYPOGRAPHY/DESIGN BOB PAGANUCCI, NEW YORK, NEW YORK
TYPOGRAPHIC SOURCE LIGHT PRINTING
AGENCY BOB PAGANUCCI DESIGN
CLIENTS MERRILL LYNCH AND EDWARD S. GORDON COMPANY
PRINCIPAL TYPES HELVETICA CONDENSED, SNELL ROUNDHAND, AND BODONI
DIMENSIONS 13 × 21 IN. (33 × 53.3 CM)

We're looking for a
sharp operator who
can get our photo
lab back in focus.
Must have 2-4 years'
experience and not
be afraid of the dark.
For a clearer picture
call Randy Ivey at
Metzdorf Advertising.
526-5361. (We're an
equal oppurtunity
employer)

ADVERTISEMENT
TYPOGRAPHY/DESIGN CHARLES HIVELY, HOUSTON, TEXAS
TYPOGRAPHIC SOURCE TYPE INC.
AGENCY METZDORF ADVERTISING
CLIENT METZDORF ADVERTISING
PRINCIPAL TYPE TIMES ROMAN
DIMENSIONS 3⅛ × 4¼ IN. (7.9 × 10.8 CM)

TYPE DIRECTORS CLUB

OFFICERS 1990/91

President • Ed Benguiat
Vice President • Allan Haley
Secretary/Treasurer • Kathie Brown
Directors-at-Large • Peter Bain, Sharon Blume, Matthew Carter, Richard Moore,
Brian O'Neill, Alan Peckolick, B. Martin Pedersen
Chairman, Board of Directors • Jack Odette

OFFICERS 1991/92

President • Ed Benguiat
Vice President • Allan Haley
Secretary/Treasurer • Kathie Brown
Directors-at-Large • Peter Bain, Brian O'Neill, B. Martin Pedersen, Roy Podorson,
Howard Salberg, Mark Solsburg, Ilene Strizver
Chairman, Board of Directors • Jack Odette

COMMITTEE FOR TDC 37

Chairman • Alan Peckolick
Designer • Jessica Weber
Coordinator • Carol Wahler
Calligrapher • Robert Boyajian
Assistants to Judges • Mary Ahern, Peter Bain, Ed Benguiat, Sharon Blume, Kathie
Brown, Delgis Canahuate, Adam Greiss, Lisa Halperin, Bonnie Hazelton, Erica
Kightlinter, Marilyn Marcus, John McCarthy, Howard Salberg, Klaus Schmidt,
Martin Solomon, Ilene Strizver, Katherine Topaz, Adam Wahler, and Allan Wahler.

TYPE DIRECTORS CLUB PRESIDENTS

Frank Powers, 1946, 1947
Milton Zudeck, 1948
Alfred Dickman, 1949
Joseph Weiler, 1950
James Secrest, 1951, 1952, 1953
Gustave Saelens, 1954, 1955
Arthur Lee, 1956, 1957
Martin Connell, 1958

James Secrest, 1959, 1960
Frank Powers, 1961, 1962
Milton Zudeck, 1963, 1964
Gene Ettenberg, 1965, 1966
Edward Gottschall, 1967, 1968
Saadyah Maximon, 1969
Louis Lepis, 1970, 1971
Gerard O'Neill, 1972, 1973
Zoltan Kiss, 1974, 1975

Roy Zucca, 1976, 1977
William Streever, 1978, 1979
Bonnie Hazelton, 1980, 1981
Jack George Tauss, 1982, 1983
Klaus F. Schmidt, 1984, 1985
John Luke, 1986, 1987
Jack Odette, 1988, 1989
Ed Benguiat, 1990, 1991

TDC MEDAL RECIPIENTS

Hermann Zapf, 1967
R. Hunter Middleton, 1968
Frank Powers, 1971
Dr. Robert Leslie, 1972
Edward Rondthaler, 1975
Arnold Bank, 1979

Georg Trump, 1982
Paul Standard, 1983
Herb Lubalin, 1984
 (posthumously)
Paul Rand, 1984
Aaron Burns, 1985

Bradbury Thompson, 1986
Adrian Frutiger, 1987
Freeman Craw, 1988
Ed Benguiat, 1989
Gene Federico, 1991

SPECIAL CITATIONS TO TDC MEMBERS

Edward Gottschall, 1955
Freeman Craw, 1968
James Secrest, 1974

Olaf Leu, 1984, 1990
William Streever, 1984
Klaus F. Schmidt, 1985

John Luke, 1987
Jack Odette, 1989

INTERNATIONAL LIAISON CHAIRMEN

Ernst Dernehl
Dernehl & Dernehl
Design Consultants
Box 150 60
S 400 41 Goteborg
SWEDEN

Japan Typography Association
C C Center
4–8–15 Yushima
Bunkyo-ku
Tokyo 113
JAPAN

Christopher Dubber
FACE Photosetting
4 rue de Jarente
75004 Paris
FRANCE

Bertram Schmidt-Friderichs
Universitatsdruckerei
 und Verlag
H. Schmidt GmbH & Co.
Robert Koch Strasse 8
Postfach 42 07 28
D 6500 Mainz 42
GERMANY

David Quay
Studio 12
10–11 Archer Street
SoHo
London W1V 7HG
ENGLAND

David Minnett
President
Australian Type Directors Club
P.O. Box 1887
North Sydney 2060
AUSTRALIA

Type Directors Club
60 East 42d Street
Suite 1416
New York, NY 10165–0015
212–983–6042 FAX 212–983–6043

**CAROL WAHLER,
EXECUTIVE DIRECTOR**
For membership information please
contact the Type Directors Club office.

Mary Margaret Ahern '83
Victor Ang '91
Leonard Bahr '62
Peter Bain '86
Don Baird '69
Colin Banks '88
Clarence Baylis '74
Felix Beltran '88
Ed Benguiat '64
Anna Berkenbusch '89
Peter Bertolami '69
Emil O. Biemann '75
Godfrey Biscardi '70
Roger Black '80
Anthony Block '88
Sharon Blume '86
Art Boden '77
Karlheinz Boelling '86
Friedrich Georg Boes '67
Garrett Boge '83
Bud Braman '90
Ron Brancato '88
David Brier '81
Ed Brodsky '80
Kathie Brown '84
Werner Brudi '66
Bill Bundzak '64
Aaron Burns '80
Jason Calfo '88
Ronn Campisi '88
Tom Carnase '73
Matthew Carter '88
Ken Cato '88
Kai-Yan Choi '90

Alan Christie '77
Ronnie Soo Chye Tan '88
Robert Cipriani '85
Ed Cleary '89
Travis Cliett '53
Mahlon A. Cline* '48
Elaine Coburn '85
Tom Cocozza '76
Barbara Cohen '85
Angelo Colella '90
Ed Colker '83
Freeman Craw* '47
James Cross '61
David Cundy '85
Rick Cusick '89
Susan Darbyshire '87
Ismar David '58
Cosmo De Maglie '74
Josanne De Natale '86
Robert Defrin '69
Ernst Dernehl '87
Ralph Di Meglio '74
Claude Dieterich '84
Lou Dorfsman '54
John Dreyfus** '68
Christopher Dubber '85
Rick Eiber '85
Joseph Michael Essex '78
Eugene Ettenberg* '47
Leon Ettinger '84
Florence Everett '89
Bob Farber '58
Sidney Feinberg* '49
Amanda Finn '87

Lawrence Finn '87
Janice Prescott Fishman '91
Kristine Fitzgerald '90
Yvonne Fitzner '87
Holley Flagg '81
Norbert Florendo, '84
Tony Forster '88
Dean Franklin '80
Carol Freed '87
Elizabeth Frenchman '83
H. Eugene Freyer '88
Adrian Frutiger** '67
Patrick Fultz '87
Andras Furesz '89
Christof Gassner '90
David Gatti '81
Stuart Germain '74
John Gibson '84
Lou Glassheim* '47
Howard Glener '77
Jeff Gold '84
Tan Gordon '90
Alan Gorelick '85
Edward Gottschall '52
Robbie Goulden '88
Norman Graber '69
Diana Graham '85
Austin Grandjean '59
James Jay Green '91
Adam Greiss '89
Jeff Griffith '91
Kurt Haiman '82
Allan Haley '78
Edward A. Hamilton '83

Mark L. Handler '83
William Paul Harkins '83
Sherri Harnick '83
John Harrison '91
Knut Hartmann '85
Reinhard Haus '90
Bonnie Hazelton '75
Eileen Hedy Schultz '85
Elise Hilpert '89
Diane L. Hirsch '89
Michael Hodgson '89
Fritz Hofrichter '80
Alyce Hoggan '91
Kevin Horvath '87
Gerard Huerta '85
Donald Jackson** '78
Helen Kahng Jaffe '91s
John Jamilkowski '89
Jon Jicha '87
Allen Johnston '74
R. W. Jones '64
Michael O. Kelly '84
Scott Kelly '84
Renee Khatami '90
Zoltan Kiss '59
Robert C. Knecht '69
Steve Kopec '74
Bernhard J. Kress '63
Pat Krugman '91
Mara Kurtz '89
Sasha Kurtz '91s
Gerry L'Orange '91
Raymond F. Laccetti '87
Jim Laird '69

Guenter Gerhard Lange '83
Jean Larcher '81
Judith Kazdym Leeds '83
Louis Lepis '84
Olaf Leu '66
Jeffery Level '88
Mark Lichtenstein '84
Clifton Line '51
Wally Littman '60
Sergio Liuzzi '90
John Howard Lord* '47
Gregg Lukasiewicz '90
John Luke '78
Ed Malecki '59
Sol Malkoff '63
Frank Marchese '88
Marilyn Marcus '79
Michael Marino '91
Stanley Markocki '80
Adolfo Martinez '86
Rogério Martins '91
James Mason '80
Les Mason '85
Jack Matera '73
Egon Merker '87
Frederic Metz '85
Douglas Michalek '77
John Milligan '78
Michael Miranda '84
Oswaldo Miranda (Miran) '78
Barbara Montgomery '78
Richard Moore '82
Ronald Morganstein '77
Minoru Morita '75

Tobias Moss* '47
Richard Mullen '82
Antonio Muñoz '90
Keith Murgatroyd '78
Eriik Murphy '85
Jerry King Musser '88
Louis A. Musto '65
Rodney Mylius '89
Alexander Nesbitt '50
Paschoal Fabra Neto '85
Robert Norton '88
Alexa Nosal '87
Brian O'Neill '68
Gerard O'Neill* '47
Jack Odette '77
Thomas D. Ohmer '77
Motoaki Okuizumi '78
Bob Paganucci '85
Luther Parson '82
Charles Pasewark '81
Alan Peckolick '86
B. Martin Pedersen '85
Robert Peters '86
Roy Podorson '77
Will Powers '89
Vittorio Prina '88
Richard Puder '85
David Quay '80
Elissa Querzé '83
Robert Raines '90
Erwin Raith '67
Adeir Rampazzo '85
Paul Rand** '86
Hermann Rapp '87

Jo Anne Redwood '88
Bud Renshaw '83
Edward Rondthaler* '47
Robert M. Rose '75
Herbert M. Rosenthal '62
Dirk Rowntree '86
Joseph Rubino '83
Erkki Ruuhinen '86
Gus Saelens '50
Howard J. Salberg '87
Bob Salpeter '68
David Saltman '66
John Schaedler '63
Jay Schechter '87
Kathy Schinhofen '89
Hermann Schmidt '83
Klaus Schmidt '59
Bertram Schmidt-Friderichs
 '89
Werner Schneider '87
Eckehart Schumacher-Gebler
 '85
Robert A. Scott '84
Michael Scotto '82
Gene Paul Seidman '87
Paul Shaw '87
George Sohn '86
Martin Solomon '55
Jan Solpera '85
Mark Solsburg '89
Jeffrey Spear '83
Lisa Speroni '88
Erik Spiekermann '88
Vic Spindler '73

Paul Standard** '86
Walter Stanton '58
Rolf Staudt '84
Mark Steele '87
Carole Steinman '88
Sumner Stone '88
William Streever '50
Ilene Strizver '88
Hansjorg Stulle '87
Ken Sweeny '78
Dian Tanmizi '91s
William Taubin '56
Jack G. Tauss '75
Pat Taylor '85
Anthony J. Teano '62
Bradbury Thompson '58
Paula Thomson '91
D. A. Tregidga '85
Susan B. Trowbridge '82
Paul Trummell '89
Lucile Tuttle-Smith '78
Edward Vadala '72
Roger Van Den Bergh '86
Jan Van Der Ploeg '52
James Wageman '88
Jurek Wajdowicz '80
Robert Wakeman '85
Tat S. Wan '91
Julian Waters '86
Janet Webb '91
Jessica Weber '88
Kurt Weidemann '66
Seth Joseph Weine '90
Sue Wickenden '91

Gail Wiggin '90
James Williams '88
Conny J. Winter '85
Bryan Wong Siu Kzung '90
Hal Zamboni* '47
Hermann Zapf** '52
Roy Zucca '69

SUSTAINING MEMBERS

Adobe Systems, Inc. '90
Arrow Typographers '75
Boro Typographers '89
Character Typographic
 Services, Inc. '85
CT Photogenic Graphics '86
Graphic Technology '88
The Graphic Word '87
International Typeface
 Corporation '80
Letraset '91
Linotype-Hell Company '63
McGilvray & Glass, Inc. '91
Pastore DePamphilis Rampone
 '76
Photo-Lettering, Inc. '75
ROR Typographics, Inc. '89
219 Type, Inc. '89
Typesetting Service
 Corporation '88
Typographic House '60
Typographic Images '86
TypoGraphic Innovations Inc.
 '72
TypoVision Plus '80

* *Charter member*
** *Honorary member*
 s *Student member*
 Members as of June 30, 1991

INDEX

AGENCIES

Altman & Manley, 173
Ammirati & Puris, 241
Anderson & Lembke, 228
Babbit & Reiman, Atlanta, 242
Borders, Perrin & Norrander,
 226, 238, 239, 253
CeveyConcept, 29
Cipriani Kremer Advertising,
 200
Cramer Krasselt/Chicago, 252
Design/Art, Inc., 184
Eagle Advertising, 173
Frankfurt Gips Balkind, 17, 40,
 44, 45, 117, 169
Goodby, Berlin & Silverstein,
 211, 229, 230, 231, 236, 237,
 244, 245
Hesse Büro für
 Kommunikation, 130
Ketchum Advertising
 Singapore, 235
KMS Team, 72
Knape & Knape, 160
Lewis Moberly, 85, 135
Mariani, Hurley & Chandler,
 250
Metzdorf Advertising, 256
Muller & Company, 192
Murry White Drummond
 Lienhart, 133
Needham, Harper, Steers, 227
Ogilvy & Mather, 6, 131, 216,
 217, 218, 219, 232, 233, 234
Omon New York, 3, 251
Paganucci (Bob) Design, 255
Richards Group, The, 75, 91
Scali, McCabe, Sloves, 5
Sive Associates, 124
Sun Creative Services, 88
Van Dyke Company, 179, 197
Wagner Siebdruck, 41, 167
Wieden & Kennedy, 207, 220,
 221, 222, 223, 224, 225, 240,
 246, 247, 248, 249, 254

ART DIRECTORS

Bennassar, Lorenzo, 131
Cohen, Luanne, 189
Connelly, Walt, 131
Denton, Margi, 150, 194
Doyle, Stephen, 66
Flanagan, Skip, 131
Kelly, Mark, 131
Navas, Antonio, 131
Peckolick, Alan, 70
Rylander, Michael, 131
Schneider, Terry, 238
Walburn, Lona, 131

CALLIGRAPHERS

Bustad, Joe, 27
Green, Patti, 103
Hale, Bruce, 161
Houff, James A., 101
Lewis, Mary, 135
Mehler, Roland, 163
Sayles, John, 27, 111
Steiner, Peter, 41
Stewart, Charles, 134
Zimmermann, Betsy, 211, 237

CLIENTS

Abrams (Harry N.) Publishing,
 119
Addison World Wide Limited,
 34
Adobe Systems, Inc., 96, 189
Aetna Life and Casualty
 Company, 241
AGFA Corporation, 173
Agouran Pharmaceuticals, 92
Airport Restaurant Tokyo, 185
Alphabet & Imges,
 Incorporated, 113
Als Association, The, 194
American Airlines, 216
American Express, 131, 209,
 216, 217, 218, 219
American Institute of Graphic
 Arts, The/Chicago, 103
American Institute of Graphic
 Arts, The/Detroit, 101, 129
American Institute of Graphic
 Arts, The/Minnesota, 102
American Institute of Graphic
 Arts, The/San Francisco, 43
Amtrak, 227
Anderson (Charles S.) Design
 Company, 95
Apogee Designs, Ltd., 163
ARC, 151
Art Center College of Design,
 120, 165, 183
Art Direction Magazine, 128
Art Forum, 72
Art Institute of Boston, The,
 104
Artis Michael Moesslang, 126
ASDA, 135
Atlantic Records, 46, 63
Beach Culture Magazine, 38,
 142, 143, 144
Beam (Jim) Brands Company,
 147
Bianchi, U.S.A., 93
Bon Marché, The, 170
Boston Globe Magazine, The,
 180
Brooklyn Hospital Center, The,
 164
California Academy of
 Sciences, 149
California Institute of
 Technology, 150
Carole Shorenstein Hays
 Presents, 56
Cellular One, 75
Center on Contemporary Art,
 110
Centex Corporation, 60
Central Life Assurance, 27
CeveyConcept, 29
Champion International, 64
Chicago International Film
 Festival, 243

INDEX

Cloud and Gehshan Associates, Inc., 116
Code-A-Phone, 253
Coherent, 61
Cole Haan, 200
Commercial Saimaza, Spain, 157
Communication Arts Society of San Antonio, 125
Compuserve, 124
Contemporary Arts Center, The, 87
Cooper Union, The, 35
Cow Brand Soap Kyoshinsha, 132
Creative Education, Mankato, 186
Creda, 252
Curtin, Donald and Mimi, 154
Daiichishiko Co., Ltd., 47
Dallas Zoological Society, 141
Dansprodoktie, 171
Dayton Hudson Corporation, 187
Denis, Mike, 108
Designlabor Bremerhaven, 140
Display Lettering & Copy, 86
Documents of American Design, 119
Duffy Design Group, The, 39
E! Entertainment Television, 69
Episcopal School of Dallas, 91
Expeditors International, 179
Finch, Pruyn & Company, Inc., 121
First Impression Printers and Lithographers, Inc., 59
Flower Expo '90, 169
Focke-Museum Bremen, 79
Forsythe Design, 127
Fortune Magazine, 232, 233, 237
Foto, 130
Galerie Thomas, 72
General Information Inc., 42
Gerd, George, 130

Gorbachev Visit Committee, Minneapolis, 114
Gordon (Edward S.) Company, 255
Graphic Arts Center, 107
Graphic Specialties, 83
Greenleaf Medical, 105
Gritz-Ritter Graphics, 80
Grove Weidenfeld, 76
Heart/Capitol Records, 184
HMV, 44, 45
Horowitz, Ray Book Manufacturers, Inc., 121
H$_2$O Plus, Inc., 133
IBM Gallery, 100
Imcera Group, Inc., 146
Innoya, 85
Interbrew, 158
Iowa-Nebraska Farm Equipment Association, 111
Kazu Jewelry Design Studio, 198
Kemper Reinsurance Company, 90
Kentucky Center for the Arts, 162
Knape, Anthony and Susan, 160
Kodiak Canada, 250
Komag, Inc., 148
Kruty (Peter) Editions, 153
Kunsthochschule für Medien Köln, 78
La Vineraie, 134
Levi Strauss & Co., 112, 138, 139
Mackinnon-Mocour Limited, 83
Maletis Beverage, 136
Maritrans Operating Partners, L.P., 195
Marsh & McLennan Companies, Inc., 71
Mead Paper, 58, 83, 197
Merrill Lynch, 225
Metropolitan Printing Service, 182
Metzdorf Advertising, 256
Microsoft Corporation, 176

Ministry of Health, Singapore, 235
Monotype Corporation PLC, 118
Morisawa, 19
Museum of Modern Art of New York, The, 175
Museum of Photographic Arts, 80
Nature Company, The, 244, 245
Nicholls, Chris, 83
Nielsen, A.C., 169
Nike, 207, 222, 223, 224, 225, 246, 254
Nikken Sekkei Ltd., 23
Olive Garden, The, 218
Olympia & York, 66
Oppenheimer Capital, L.P., 70
Oregon Convention Center, 239
Pacific Lithograph, 155
Paramount Products, 174
Pella Windows & Doors, 213
Pepe Clothing USA, 247, 248, 249
Peters (Michael) Group, 39
Peterson & Company, 152
Pischoff, 89
Portland General Electric, 238
Potlatch Corporation, 62
Powell, Neil Douglas, 77
Premiere Foods, 159
Print Craft, Inc., 115
Puget Sound Marketing Company, 173
Rainforest Inc., 168
Resnick, Elizabeth, 193
Rex Three, 67
Rolling Stone, 25, 48, 49, 50, 51, 52, 53, 54, 55
Rood (Don) Design, 98
Rouse Company, The, 94
Royal Composing Room, Inc., 121
Royal Viking Line, 211, 236, 237
Ruhrlandmuseum Essen, 181, 201

San Francisco Examiner, 229, 230, 231

San Jose University Galleries, 84

Sanyo Department Store, 191

Scottish Rite Children's Medical Center, 242

Seattle Symphony, 161

Shaw, Paul/Letter Design, 153

Shigi Graphic Design Office, 166

Simpson Paper Company, 106

Sisley Italian Kitchen, 190

Smith Sport Optics, 226

Steigenberger Consulting GmbH, 163

Stewart, Tabori & Chang, 186, 199

Stiftung Kunst und Kultur des Landes NRW, 74

Sun Microsystems Inc., 88

Theater im Westen, 65

Theaterworks, 123

Theunis-Van der Zanden, 188

Time Warner, Inc., 117

Toyota Motor Corporate Services, 3

TV Guide, 220, 221, 240

Typobach, 29

Ulman Paper Bag Company, 177

USG Interiors, Inc., 122

US West Incorporated, 137

Vandamme Represents, 99

Vanderpoel, 228

Vaughn/Wedeen Creative, Inc., 156

Von Oertzen GmbH & Co. KG, 196

Waddell, Eskind, 83

Wagner Siebdruck, 41, 167

Warner Books, 17

Warner Brothers, 40

Weaver (Michael) Illustration, 192

Willow House Gallery, 57

WJMK, 145

Wooden-O-Drama Studio, 172

Works Gallery, 97

World Financial Center, The, 66

Write Now, Inc., 36

YMCA of Metropolitan Chicago, 178

Youth At Risk, 251

Yukichi Takada, 185

Zanders Feinpapiere AG, 82

LETTERERS

Barrett, Elizabeth, 68

Bass, Saul, 243

Benguiat, Ed, 113

Bustamante, Gerald, 38

Carroll, David, 124

Clarke, Greg, 190

Cloud, Jerome, 116

Crowe, Dennis, 99

Cuthbertson, Jane, 127

Delessert, Etienne, 199

Drummond, David, 109

Eilts, Patrice, 192

Escobar, Dan, 229, 230, 231

Forster, Tony, 57

Fortune, Leilani, 176

Girvin, Tim, 121

Gray, Paul, 134

Hale, Bruce, 170

Johnson, Haley, 39

Karl, Anita, 50, 53, 55

Koweiden-Postma, 171

Lee, John, 54

McCord, Walter, 37

Maniscalco, Melinda, 93

Medina, Fernando, 175

Miller, Joe, 84, 97

Moore, Norman, 184

Norman, John, 75

Ortiz-Lopez, Dennis, 25, 48, 51

Pappas, John, 99, 138, 139

Paranski, Scott, 152

Parisi, Joe, 63

Pham Nhan, 152

Phornirunlit, Supon, 177

Plunkert, Dave, 195

Powell, Neil Douglas, 77

Profile Design, 191

Rogers, Lilla, 187

Schuetz, Ralf, 67

Schulte, Lynn, 39, 114, 147

Shiffrar, Bob, 242

Shinnick, Bill, 88

Solotype, 139, 139

Stenz, Nancy, 173

Stone, Steve, 229, 230, 231

Vantal, Erik, 157

Waterbury, Todd, 39, 147

Werner, Sharon, 39

Woods, Paul, 189

Zimmermann, Neal, 99

PHOTOGRAPHERS

Manarchy, Dennis, 246

Nelson, Geoffrey, 105

Wagner, Franz, 167

Wojcik, James, 128

PRINCIPAL TYPES

Aachen Bold Condensed, 111

Adobe Garamond, 149

AG Old Face Bold, 29

A+K, 154

Akzidenz Grotesk, 44, 45, 188

Akzidenz Light Condensed, 29

Al Fotura Demi, 226

Alpha Bodoni Book, 103

Alphavanti Extra Bold, 102

Amex Gothic, 6, 131, 216, 217, 218, 219

Antique Shaded, 3

Antique Wood, 186

Art Deco Font, 53

Atlas, 76

Avant Garde, 185

Avant Garde Gothic Condensed, 167

Bank Gothic, 147

Bank Script, 56

Baskerville, 3, 120, 220

Bauer Bodoni, 122, 182

Bembo, 34, 151

INDEX

Berkeley, 169
Berkeley Old Style, 149, 239
Berling, 161, 244, 245
Berling Italic, 134
Bernhard Modern, 107, 211, 236, 237, 238
Bernhard Roman, 64
Berthold Garamond, 146, 165, 197
Binder Style, 46
Bodoni, 42, 116, 150, 168, 173, 255
Bodoni Bold, 241
Bodoni Italic, 39
Bodoni Open Face, 168
Bold, 72
Bordeaux Roman, 193
Carpenter, 145
Caslon, 153
Centaur, 5, 62
Cheltenham Old Style, 6, 131, 216, 217, 218, 219
City Medium, 43
Clarendon, 145
Cochin, 172
Compacta, 150, 156
Copperplate, 58
Copperplate Extended, 93
Copperplate Gothic, 56, 169
Corinthian Bold, 254
Courier, 155
Craw Modern Black, 229, 230, 231
Diskus Medium, 194
Eagle Bold, 68
Emigre Modula, 108
Empire, 56
Engravers Roman, 90, 200
Eurostyle, 63, 251
Excelsior, 49
Fenice, 70
Flynn, Dan, 156
Four-Line Block Gothic, 37
Franklin Gothic, 36, 40, 66, 84, 100, 104, 117, 143, 144, 175, 221, 224, 227, 246, 248, 249

Franklin Gothic Bold, 17
Franklin Gothic Condensed, 5
Franklin Gothic Heavy, 17, 59, 225
Franklin Gothic Heavy Condensed, 88
Friz Quadrata, 157
Frutiger, 116, 171
Frutiger Bold, 78
Futura, 36, 41, 42, 61, 70, 97, 104, 133, 150, 195
Futura Bold, 56, 75, 181
Futura Bold Condensed, 184
Futura Bold Oblique, 201
Futura Book, 106
Futura Condensed, 75
Futura Extra Bold, 98
Futura Heavy, 169
Futura Light, 72, 107, 189
Futura Light Condensed, 64, 94
Futura Medium Moderna, 60
Galliard, 36, 44, 45
Garamond, 29, 71, 81, 92, 117, 173, 195, 197
Garamond Condensed, 59
Garamond Condensed Italic, 193
Garamond Old Style, 137
Gill Sans, 89, 118, 120, 183
Gill Sans Bold, 187
Gill Sans Bold Extra Condensed, 65
Gill Sans Extra Bold, 128
Goudy, 80, 160, 180
Goudy Old Style, 228
Grecian Bold Condensed, 25
H 5, 129
Handlettering, 27, 37, 39, 41, 47, 54, 55, 57, 67, 97, 101, 111, 113, 114, 116, 135, 136, 147, 161, 163, 170, 171, 173, 190, 191, 243, 247
Helvetica, 63, 142, 173, 175, 232, 233, 234, 240
Helvetica Black, 176
Helvetica Black Condensed, 122

Helvetica Condensed, 43, 255
Helvetica Light Condensed, 194
Helvetica Medium Condensed, 194
ITC Berkeley, 98
ITC Fenice Light, 141
ITC Galliard, 173
ITC Garamond, 163
Janson Italic, 77
Janson Roman, 77
Janson Text, 123
Joanna, 118
Kabel, 52, 192
Kennerly, 119, 244, 245
Kuenstler Black, 128
Le Mercure, 252
Linoscript, 154
Long Tall Good Wood, 68
Machine Bold, 177, 250
Magnum Gothic, 101, 109
Matrix, 67, 148
Meridien, 136
Metropolis, 172
MM-A-OKL, 35
Modified Empire, 51
Modula, 178
Monotype Bodoni Book, 119
Nakhi Photographic Script, 73
New Baskerville, 35, 66
New Baskerville Bold Italic, 165
New Baskerville Italic, 164
News Gothic, 164
Novarese, 87, 162
Novarese Medium Italic, 166
Old Foundry Type, 180
Old Style Bold, 98
Onyx, 145
Palatino, 222
Peignot Demi Bold, 98
Perpetua, 60, 118, 242
Pineapple Face, 49
Piranesi, 199
Poster Gothic, 48
Rotis Grotesk, 140
RVL Gothic, 211, 236, 237
Sabon Antiqua, 90

Sabon Italic, 17
Sabon Regular, 17
San Serif Extra Bold
 Condensed, 180
Serifa, 36
Serif Regular, 69
Simoncini Garamond, 186
Snell Roundhand, 255
Spartan, 95, 115, 174
Syntax, 130
Ticonderoga, 235
Times Roman, 91, 173, 256
Trade Gothic, 85
Typo Roman, 253
Ultra Condensed, 156
Univers, 23, 74, 83, 92, 169, 179,
 196
Walbaum, 79
Weiss Initial Cap, 50
Weiss Roman, 121

STUDIOS

Addison Corporate Annual
 Reports, Inc., 34, 71
Adobe Systems, Inc., 96, 189
Anderson (Charles S.) Design
 Company, 95, 112, 115, 174
Art Center College of Design,
 120, 183
Artis Michael Moesslang, 126
Asaba Design Co., Ltd., 73
Barsuhn Design, 102
Bass/Yager and Associates, 243
Baxter (John) Design, 119
Behaegel & Partners, 157, 158
Besser Joseph Partners, Inc., 92,
 151
Brückner (Hartmut) Design,
 79, 140
Carron, Ross, 149
Carson Design, 142, 143, 144
Chantry (Art) Design, 110
Cloud and Gehshan Associates,
 Inc., 116
Coe (Laura) Design Associates,
 80

Crosby Associates, Inc., 103
Curtin (Paul) Design, 154
Delessert-Marshall, 186, 199
Denton Design Associates, 150,
 194
Design Board, 157, 158
Drenttel Doyle Partners, 66
Duffy Design Group, The, 39,
 114, 147
Escobar (Dan) Photography,
 229, 230, 231
EMA Design, 81
Forster (Tony) Typographics,
 57
Forsythe Design, 127
Fortune Design Studio, 159
Frazier Design, 43, 86
Freeman (Josh) Associates, 190
Gee (Earl) Design, 105
Girvin (Tim) Design, Inc., 136
Goldberg (Carin) Graphic
 Design, 76
Good Design, 162
Good (Peter) Graphic Design,
 123
Graffito, 63, 195
Gray & Stewart Design, 134
Hale (Bruce) Design Studio,
 161, 170
Hartmann (Knut) Design, 163
Horlacher, Peter, 65
Hornall Anderson Design
 Works, 42, 173
Houff (James A.) Design, 101,
 129
I.F. Planning, 185
Images, 87
KMS Graphic, 72
Koepke Design Group, 173
Koeweiden-Postma, 171, 188
Kunz (Willi) Associates, Inc., 23
Leu (Olaf) Design + Partner,
 196
Lopez Salpeter & Associates, 182
McCord (Walter) Graphic
 Design, 37

M Design, 93
Microsoft Corporate
 Communications, 176
Miller's (Joe) Company, 84, 97
Morton (Margaret) Design, 35
Myron, 250
Oldach (Mark) Design, 59, 122
Packaging Create Inc., 19, 132,
 169, 198
Pentagram Design, 62, 64, 107,
 125, 137, 165, 168
Peterson & Company, 60, 141,
 152
Photo-Lettering, Inc., 113
Pinkhaus Design, 67, 145
Platinum Design, Inc., 128
Powell, Neil Douglas, 77
Profile Design, 191
Pushpin Group, The, 100
Resnick (Elizabeth) Design, 193
Richards Brock Miller Mitchell
 and Associates, 75, 91
Rood (Don) Design, 98
Royal Composing Room, Inc.,
 121
Rutka Weddcock Design, 58,
Sage Design, 172
Samata Associates, 90, 146, 178
Sayles Graphic Design, 27, 111
Shaw, Paul/Letter Design, 153
Shigi Graphic Design Office,
 166
Shin Matsunaga Design Inc., 47
Siebert Design Associates, 124
Skolos/Wedell, Inc., 36
Stoltze (Clifford) Design, 104
Studio Bustamante, 38
Studio Dumbar, 82
Studio 12, 118
Stylism, 164
Sullivan Perkins, 94
Supon Design Group, Inc., 177
Taylor & Browning Design
 Associates, 109
Tolleson Design, 61, 106, 148,
 155

Triom Design, Inc., 175
Vanderbyl Design, 56, 89
Vrontikis Design Office, 69
Waddell, Eskind, 83
Weaver (Michael) Illustration, 192
Zimmermann Crowe Design, 99, 138, 139

TYPOGRAPHY/DESIGN

Anderson, Charles S., 95, 112, 115, 174
Anderson, Donna, 61
Anderson, Gail, 48, 55
Anderson, Jack, 42, 173
Anderson, James, 64
Asaba, Katsumi, 73
Ashworth, Lisa, 67
Aufuldish, Bob, 106, 148, 155
Baker, Peter, 108, 109
Barnett, Lori, 96
Barrett, Elizabeth, 68
Barsuhn, Scott, 102
Bartholomay, Lucy, 180
Bass, Saul, 243
Baxter, John, 119
Beard, David, 85
Bellows, Joseph, 80
Benguiat, Ed, 113
Bergmans, Helene, 82
Besser, Rick, 92, 151
Blumberg, Gail, 96
Bowerman, Toni, 200
Boyd, Brian, 91
Bricker, Thomas, 17
Brown, Kim, 96
Brückner, Hartmut, 79, 140
Bruhn, Lauren, 80
Buelow, Alicia, 96
Burrill, Elizabeth, 150, 194
Bustamante, Gerald, 38
Campbell, Paul, 109
Carroll, David, 124
Carron, Ross, 149
Carson, David, 142, 143, 144
Cevey, Michel, 29
Chandler, Tom, 250

Choe, Kyong, 104
Chwast, Seymour, 100
Clarke, Greg, 190
Cloud, Jerome, 116
Coe, Laura, 80
Cox, Thomas, 23
Craig, Don, 96
Crowe, Dennis, 99
Currie, Leonard, 118
Cuthbertson, Jane, 127
Dapkus, Dean, 96
Davis, Matthew, 58
Defrin, Bob, 46
Don, Friedrich, 167
Duffy, Joe, 39, 114
Eakins, Warren, 220, 221, 240
Eilts, Patrice, 192
Eisner, Ellen, 120
Ema Design, 81
Emery, Don, 59
Flaming, Jon, 94
Flynn, Dan, 156
Forster, Tony, 57
Fortune, John, 176
Fortune, Leilami, 159
Fowler, David, 241
Frazier, Craig, 43, 86
Friedman, Julius, 87
Gassy, Bobbi, 3, 251
Gavrielov, Ewa, 96
Gee, Earl, 105
Gericke, Michael, 64
Gerwig, Carey, 80
Gilmore-Barnes, Catherine, 50
Girvin, Tim, 136
Goldberg, Carin, 76
Good, Peter, 123
Gray, Andrew, 66
Griffith, Jeff, 242
Hagemann, Deborah, 86
Hagmann, Keala, 96
Hale, Bruce, 161, 170
Hamm, Garrick, 39
Heck, Matt, 125
Hinrichs, Kit, 125
Hively, Charles, 256
Hoffman, Susan, 36, 225

Horlacher, Peter, 65
Houff (James A.) Design, 101, 129
Ito, Makato, 19
Jenkins, David, 246
Jeung, Carole, 149
Johnson, Haley, 39, 174
Kalman, Tibor, 248, 249
Karen, Ann, 96
Karten, Vicki, 190
Keller, Michael, 72
Kelly, Mark, 218
Kelly, Tom, 239
Kim, Margaret, 88
Klein, Julie, 70
Koepke, Gary, 173
Koeweiden-Postma, 171, 188
Kosuk, Beth, 252
Kunz, Willi, 23
Lapine, Julia, 42, 173
Leu (Olaf) Design + Partner, 196
Lewis, Mary, 135
Lienhart, Jim, 133
Locke, Peter, 154
Loesch, Uwe, 74, 78, 181, 201
Long, Jennifer, 125
McCarthy, Clem, 241
McCord, Walter, 37
Macinka, Mary, 161
Maierhofer, Knut, 72
Maniscalco, Melinda, 93
Manley, Bob, 173
Mariani, Bob, 250
Marshall, Rita, 186, 199
Martin, Rodd, 251
Matsunaga, Shin, 47
Maude, Robert, 34
Medina, Fernando, 175
Mehler, Roland, 163
Méndez, Rebeca, 120, 183
Miller, Joe, 84, 97
Moesslang, Michael, 126
Moore, Norman, 184
Morris, Dean, 164
Morton, Margaret, 35
Ng, Lian, 173

Nishiwaki, Kenichi, 191
Nogami, Shuichi, 132, 169
Norman, John, 74
Norton, Melissa, 128
Oberman, Emily, 248, 249
Okeson, Jane, 36, 225
Okumura, Akio, 198
Oldach, Mark, 59, 122
Olson, Dan, 95, 112, 115, 174
O'Neill, Brian, 42
Paganucci, Bob, 255
Pappas, John, 99, 130, 139
Paramski, Scott, 152
Parisi, Joe, 63
Parker, Tim, 226, 253
Peckolick, Alan, 71
Pentagram Design, 62, 107, 137, 165
Peslak, Victoria, 128
Peterson, Bryan L., 60
Phornirunlit, Supon, 177
Pirtle, Woody, 64, 125
Pittman-Hensley, 224
Plunkert, Dave, 195
Postaer, Jeremy, 237
Powell, Neil Douglas, 77
Prieve, Michael, 222, 223, 224, 247, 248, 249, 254
Quandel, Roger, 29
Quay, David, 118
Quinlivan, Amy, 187
Ramirez, Veronica, 96
Ray, Scott, 141
Resnick, Elizabeth, 193
Robinson, Nat, 96
Rood, Don, 98
Roth, Tom, 228
Rutka, Anthony, 58
Rylander, Michael, 209, 216, 217, 218, 219, 232, 233, 234
Sage, Kim, 172
Salpeter, Bob, 182
Samata, Greg, 90, 146, 176
Samata, Pat, 146, 178
Sandoz, Steve, 221
Sayles, John, 27, 111
Scarlett (Nora) Studio, 131

Scher, Paula, 168
Schlegel Typography, 246
Schmal, Gerhard, 130
Schroeder, Jürgen, 72
Sethiadi, Riki, 17, 40, 117
Shaw, Paul, 153
Shigi, Susumu, 166
Siebert, Lori, 124
Singer, Steve, 227
Skolos, Nancy, 36
Skouras, Angela, 53, 54
Sly, Carol, 104
Solomon, Martin, 121
Spears, Harvey, 131, 216, 218, 219, 232, 233, 234
Steiner, Peter, 41
Sterling, Tom, 145
Stewart, Charles, 134
Stolze, Clifford, 104
Stone, Steve, 229, 230, 231
Suh, David, 45
Suter, Kent, 238
Swart, Sally, 158
Sylvester, Mark D., 36
Szujewska, Laurie, 96
Takada, Yukichi, 185
Tan, Gordon, 235
Tardif, Michael, 173
Thompson, Tim, 63, 195
Todaro, Frank, 5
Tolleson, Steven, 61, 106, 148, 155
Tutssel, Glenn, 39
Van Bokhoven, Marc, 82
Van Bragt, Tony, 82
Vanderbyl, Michael, 56, 89, 179
Van Dyke, John, 197
Vantal, Erik, 157
Vette, Laurie, 136
Vipper, Johan, 17, 44
Vogt, George, 254
Vrontikis, Petrula, 69
Waddell, Eskind, 83
Wakeman, Robert, 209, 216, 217, 218, 219, 232, 233, 234
Wang, Min, 96
Waterbury, Todd, 147

Weaver, Allen, Jr., 160
Weaver, Michael, 192
Weir, Denise, 173
Welt, Harald, 196
Werner, Sharon, 39
Winters, Nancy, 189
Wohlt, Carl, 103
Wolf, Michael, 34
Wong, Tracy, 236, 244, 245
Woodward, Fred, 25, 49, 51, 52
Wyatt, Ruth, 162
Yuen, Kin, 1689
Zimmermann, Betsy, 211, 236, 237
Zimmermann, Neal, 99, 138, 139

TYPOGRAPHIC SOURCE

Adpro, 87, 162
Affolter & Gschwend, 186
AGFA Postscript Type Collection, 173
Andresen Typographers, 56, 190
Art Attack, 159
Beatty Richard Designs, 119
Berkeley Typographers, 200
Berthold (A.) AG, 196
Bos, Eduard, 82
BP&N Typesetting, 239, 253
Characters Typographic Services, Inc., 241
Chiles & Chiles Graphic Services, 91
Composition Type, 92, 151
Cooper & Beatty, 83
Cooper Union, The, 35
Creative Typography, 141, 152
Crosby Typographers, 153
Dee Typography, Inc., 183
De Light, 157
Dewsnap (Don) Typographic Services, 193
Display Lettering & Copy, 43, 86
Drukkerij Rosbeek, 188
Electra Typography, 228

Ella Type, 150, 194
Emigre Graphics, 108
Eurotype, 93, 99, 139
Expertype, 68
Face Place, The, 85
Fotosetter, The, 235
Frank's Type, 84
Geisy Typography, 238
Gerard Associates, 128
Gloor Satz Repro GmbH, 72
Graphics Express, 127
Graphic Word, 46, 68
Graphiservice, 158
Hahn (Steffen) Fotosatz, 167
Harlan Typographic, 37, 77, 124
Headline Fotosatz, 79, 140
JCH Group, 168
Kismet, 123
Letraset, 175, 193
Letterworx, Inc., 102
Light Printing Co., Inc., 182, 255
Lineaux, Inc., 81
LinoTypographers, 95, 112, 115, 174
Lopez Graphics, 192
M & Co., 248, 249
Martini (Dick) & Associates, Inc., 129
Mastertype, 211, 237, 244, 245
Master Typographers, 122
"Mighty Mite" Label Maker, 110
Monogram, 64, 125

Monotext, 118
Off Typo, Inc., 35
Omnicomp, 88, 105
P & H Photo Composition, Inc., 102, 114
Pastore DePamphilis Rampone, 3, 5, 131, 251
PDR Computer Impressions, Inc., 216, 217, 218, 219, 232, 233, 234
Phil's Photo, 145, 177
Photocopied Newsprint, 229, 230, 231
Photo-Lettering, Inc., 76, 113
Pineapple Book, 49
Pittman-Hensley, 224
Printing Prep, 199
Push-Pen, Inc., 111
Rapid Typography, 89
Reardon & Krebs, 62
Royal Composing Room, 121, 227
RyderTypes, 252
Schlegel Typography, 220, 221, 223, 240, 246
Seve's House of Type, 106, 148, 155
Shore Typographers, Inc., 103
Sharp Fax FO-210, 69
Solotype, 138, 139
Span Graphics, Ltd., 134
Spartan Typographers, 56, 61,

107, 137, 148, 165
SSP-drukkerij/zetterij, 171
Stencils, 38
Studio Source, 98
Team '80, 163
Thomas & Kennedy, 161
Troy Graphics, Inc., 34, 70, 71
Typecasters, 59
Type Designs, 242
Type Gallery, The, 136
Typehouse, 147, 179, 197
Type House, The, 58
Type Inc., 256
Typemasters, 39
Typesetting Service Corporation, 250
"Types" GmbH Fotosetzerei, 65
Typeshooters, 39
Type Shop, The, 76
Typobach, 29
Typogram, 66, 153
Typographic Resource, Ltd., 90, 146
Typoservice, 145
University Typographics, 97
VIP Typographers, 226
Vogt, George, 222, 254
Yoon, K.C., 178

WRITERS/EDITORS

Thomas, Morgan, 105